THE CINEMA AND ITS SHADOW

THE CINEMA
AND ITS SHADOW

Race and Technology in Early Cinema

ALICE MAURICE

University of Minnesota Press

Minneapolis

London

An earlier version of chapter 3 was published as "What the Shadow Knows: Race, Image, and Meaning in *Shadows* (1922)," *Cinema Journal* 47, no. 3 (Spring 2008): 66–89, copyright 2008 by the University of Texas Press, all rights reserved. An earlier version of chapter 4 was published as "Cinema at Its Source: Synchronizing Race and Sound in the Early Talkies," *Camera Obscura* 17, no. 1 (2002): 31–71, copyright 2002 *Camera Obscura*, all rights reserved, reprinted by permission of the publisher Duke University Press.

Published by the University of Minnesota Press
111 Third Avenue South, Suite 290
Minneapolis, MN 55401-2520
http://www.upress.umn.edu

Library of Congress Cataloging-in-Publication Data

Maurice, Alice.
 The cinema and its shadow : race and technology in early cinema / Alice Maurice.
 Includes filmography.
 Includes bibliographical references and index.
 ISBN 978-0-8166-7804-4 (hc : alk. paper) — ISBN 978-0-8166-7805-1 (pb : alk. paper)
 1. Minorities in motion pictures. 2. Race in motion pictures. 3. Motion picture
industry—Technological innovations. I. Title.
 PN1995.9.M56M38 2013
 791.43'6552—dc23

 2012043821

Printed in the United States of America on acid-free paper

The University of Minnesota is an equal-opportunity educator and employer.

20 19 18 17 16 15 14 13 10 9 8 7 6 5 4 3 2 1

FOR MY MOTHER AND FATHER

CONTENTS

ACKNOWLEDGMENTS

THIS BOOK CAME TOGETHER because of the support and generosity I received along the way over many years. The seeds of this project were sown during graduate study in English at Cornell University, where I received a great deal of encouragement in my first efforts in this direction. I would like to thank Shirley Samuels, whose clear-sightedness kept me going. Thanks also to Mark Seltzer, whose work influenced and challenged me. And to Tim Murray, whose commitment to film studies was especially important to me; his boundless enthusiasm and active intellect were inspiring, and he has encouraged me throughout this project. Thanks also to others at Cornell who helped along the way: Jackie Goldsby, Harry Shaw, Amy Villarejo, Nicole Waligoria-Davis, Neil Saccamano, Laura Brown, Liz Deloughrey, and Mary Jacobus. Thanks also to Genevieve Love and Gabrielle McIntire for their friendship and for their advice on early versions of this work. Others who influenced early stages of this work include Patty Zimmermann, Jonathan Elmer, Jan Christopher-Horak, Jon Lewis, and Rey Chow. Rey Chow's seminar at the School for Criticism and Theory was especially important to the foundations of this project.

I could not have completed this book without the support I received in the form of grants and leave time from the English Department and the Humanities Department at the University of Toronto–Scarborough, the Connaught Fund, the Social Sciences and Humanities Research Council of Canada (SSHRC), and the Jackman Humanities Institute. I am also indebted to the English Department at the University of Utah for its support of my project early on. This support allowed me to visit archives that were crucial to my research. I am grateful to the archivists and librarians who offered me their invaluable knowledge and who helped me find my way as I conducted research at the Margaret Herrick Library of the Academy

of Motion Picture Arts and Sciences; The George Eastman House; the MOMA Film Study Center; the British Film Institute; and the Library of Congress Motion Picture, Broadcasting, and Recorded Sound Division.

This project has benefited from the input of many generous colleagues. While at the University of Utah, I received advice and support from Stuart Culver, Barry Weller, Vincent Cheng, Kathryn Bond Stockton, and Chris Lippard. Thanks especially to Steve Tatum, Kim Lau, Crystal Parikh, Corrinne Harol, and Brian Locke for their comments on portions of the manuscript. The feedback received at conferences, workshops, and colloquia was invaluable to the progression of the book. Thanks to audiences and respondents at the Society for Cinema Studies Conferences, the American Studies Association, the Western Humanities Alliance, the Jackman Humanities Institute, and the Centre for the Study of the United States at the University of Toronto.

I have the great good fortune of working with an incredibly engaging and intellectually stimulating group of colleagues at the University of Toronto and the University of Toronto–Scarborough. Their work is genuinely inspiring, their feedback always helpful, and their collegiality remarkable. Special thanks to Charlie Keil for his guidance and suggestions. I am especially grateful to Sarah Wilson and Rosanne Currarino for their comments on portions of the manuscript. Thanks also to Stephen Johnson, Nic Sammond, Andrew DuBois, Corinn Columpar, Cass Banning, Christine Bolus-Reichert, Bill Bowen, Alan Bewell, Brian Corman, Garry Leonard, Katie Larson, Alex Gillespie, Chris Warley, Marlene Goldman, Marjorie Rubright, Neal Dolan, Neil ten Kortenaar, Melba Cuddy-Keane, Maria Assif, Sarah King, Susan Lamb, Daniel Tysdal, and Karina Vernon. Special thanks also to Michael Cobb and Jeremy Lopez for many years of commiseration and wit. Thanks also to my graduate students in the English Department and the Cinema Studies Institute. Special thanks to Stephanie Kang for her work as research assistant.

For their help in bringing the book to fruition, my thanks to the editors and staff at University of Minnesota Press. Thanks to Douglas Armato for his early support of the project and to Jason Weidemann, and especially to Danielle Kasprzak for ushering the manuscript into its final form. I would also like to thank Sabine Haenni for her insightful review of the manuscript in its early stages.

My heartfelt thanks also go to my brothers and to my entire extended family. Sadly, my mother and father did not live to see the completion of

this book, but they were incredibly supportive of my scholarly pursuits, as they were of all my endeavors. This book is dedicated in their memory.

"Thank you" does not really begin to cover my gratitude to Mark Rigby. His boundless support has sustained me throughout this project, and his general brilliance in all matters cinematic has influenced me in countless ways. His insights were crucial in helping me see my way through to the light at the end of the tunnel. Finally, I save my most special thanks for the very best reader I know, my son Oscar.

Introduction
EMBODYING CINEMA

Every real effigy has a shadow which is its double; and art must falter and fail from the moment the sculptor believes he has liberated the kind of shadow whose very existence will destroy his repose.

—**ANTONIN ARTAUD,** *THE THEATER AND ITS DOUBLE*

It is undeniably a mere shadow on a plane surface.

— *INDEPENDENT*, 1914

THE 79TH ACADEMY AWARDS CEREMONY (2007) celebrated cinema by offering a spectacular reminder of its most basic elements—light and shadow. The ceremony featured several performances by the Pilobolus Dance Troupe, which specializes in a choreographic update of a proto-cinematic form: the shadow play. Pilobolus performances often directly reference early cinema, magic lantern shows and other screen practices, and even early comics.[1] On this night, the dance troupe introduced each Best Picture nominee with a "shadow dance": the dancers performed behind a screen, sculpting shadow shapes to symbolize the various nominated films. The dancers entered from the wings, on stage but still "off screen," their bodies briefly visible. Once they were behind the screen (and also "on screen") their multiple shadows morphed seamlessly into one image: a high-heeled shoe (for *The Devil Wears Prada*), a gun that shoots a bullet *(The Departed)*, a VW van with a man chasing it *(Little Miss Sunshine)*, and even a writhing airplane (for the cult favorite, but not nominated, *Snakes on a Plane*).[2] This combination of bodies and shadows—simultaneously revealing and concealing the making of the screen image—links the index and the icon. Cutting out the technological middlemen (the

camera, the projector) ensures that the direct link between the bodies and their shadows cannot be severed; at the same time, those bodies contort themselves out of existence in order to make images. The resulting conglomerate of dancers' bodies becomes a matrix for symbols that function both as emblems of particular movies and as reminders of the essential "material" of cinema itself. Leaving out the cinema's photographic base allows for a more archaic, mystical origin of the screen image while also claiming a bodily presence for the (literally) dancing shadow. The result does not strip the film image bare; rather, it provides a metaphor for it. And yet, even as the shadow dancers offer a way to celebrate cinema, their throwback to proto-cinematic illusions also suggests cinema's limitations, a hint that even in its strivings toward ever-greater realism and heightened, effects-heavy spectacle, something at once more basic and more magical eludes its grasp. Nonetheless, the performance allows cinema to claim an originary, primordial heap of bodies out of which it is born.

The shadow dancers at the Oscars represent a recent installment of a repeated ritual in the history of cinema: the move to celebrate all that is new and unique about the cinema by turning to nostalgic, even mythical representations of its own origins. The dances depict the cinematic image as a shadow, and that shadow gains presence and substance—it literally takes shape—by way of remarkable performing bodies. The relation between live dancers and dancing shadows in the Pilobolus performance produces a seamless, idealized version of the sometimes awkward relation between the performing body and the performing image in the history of the cinema. This work-in-progress was foregrounded in the silent era, when the cinematic image was popularly understood as a shadow. In the earliest motion pictures, the powers of the body and the powers of the apparatus were closely linked, and questions of substance and shadow, presence and absence, became central to how the cinema presented itself and how its unique powers were envisioned. Early on, the performing body was a key to displaying the apparatus, and fundamental questions about the new medium were often quite explicitly worked out through the relation between performing body and performing image, or more precisely, in the translation of the performing body into the performing image. As I argue, racialized bodies and the rhetoric of race difference were often central to this operation. Further, because the cinema and its shadow were bound up with representations of ethnic and racialized others from the very beginning, "race" became intertwined with what seem to be purely formal and purely cinematic concerns.

As early as 1896, Edison marketed the prowess of the motion picture apparatus via "race subjects." His catalog copy for *A Morning Bath* (which depicted an African American mother bathing her baby) declared, "This is a clear and distinct picture in which the contrast between the complexion of the bather and the white soapsuds is strongly marked. A very amusing and popular subject."[3] This was one of many instances in which producers exploited the links between black and white and Black and White. The link between a daily activity and the prowess of the apparatus is here made manifest by racializing the technical appeal of "high contrast." Race makes and relates two differences: the mundane daily activity becomes "highly amusing" when it involves a "Dusky African mother" and her "struggling pickaninny,"[4] and the recording of it becomes an interesting feat. And while the promotional material here explicitly links the subject and the apparatus, that link is implicit in all of the earliest motion pictures: that is, whatever the "amusing and popular subject," the new medium itself was always the underlying subject. The people performing in these early motion pictures enable the film's doubly dexterous display by denoting two simultaneous spectacles: in essence, these films say, "Look at what these bodies can do and look at what the camera can do."[5]

One of the premises of this book is that race difference—a subject inherited by the cinema from its precursors and contemporaries (especially vaudeville, blackface minstrelsy, and burlesque)—was fundamentally intertwined, nonetheless, with the cinema's self-fashioning. Particularly in its early years, the medium's specificity, its "difference," is often tied to the rhetoric of racialized difference. As I trace in the upcoming chapters, the tendency of racialized bodies to throw the powers (and limitations) of the apparatus into relief continues to be exploited as films move from pure display to narrative, and the often implicit links between "race" and cinema become clearest in moments of transition or technological vulnerability. As numerous historians have catalogued, racially and ethnically charged subjects became popular screen material as the emerging medium offered one more cultural site for grappling with the rapidly changing demographics of the turn-of-the-century urban landscape in America. But I am interested here not merely in the fact that "race" was a popular subject for motion pictures from its earliest days; rather, I am interested in how these subjects became central to the working out of specifically cinematic problems: the problem of the stationary camera, the problem of developing narrative form, the problem of realism, the problem

of synchronizing image and sound, and, perhaps most fundamentally, the problem of the absent or "immaterial" image—the cinema's "shadow."

In framing these issues as problems, I do not mean to imply that they were always negatives or limitations the medium had to "get over." Rather, these "problems" arise out of and constitute the definitive features of the cinema itself: the ability to record and represent "real life" in motion and to project a moving image composed of light and shadow. But I do mean to suggest that these attributes—and the possibilities and limitations associated with them—were actively, and often quite explicitly, being worked out during the silent era, both on screen and off. In particular, I am interested in the way the twinned displays of the performing body and the cinematic apparatus (often complementary in the earliest motion pictures, including *A Morning Bath*) suggest affinities that continue to be important to the cinema's signifying practices. In this context, "race" (under which heading I include the representation of racialized or "alien" subjects, the performance of race, and discourses of racial identity and race difference) becomes a significant rhetorical tool for the cinema's claims to presence, authenticity, and meaning. Further, race difference plays a crucial role in the effort to garner the audience's faith in the screen image, a concept that is related to, but not synonymous with, absorption in the cinematic narrative.[6] This suggests a model of spectatorship in which "race" enlivens the boundary between image and audience at particular junctures in the history of American film.

This goes beyond identifying stereotypes, and this study is not primarily focused on questions of representation (i.e., how particular ethnic or racial groups are depicted). My analysis does borrow, however, from the complex understanding of the stereotype's role in colonial discourse theorized by Homi Bhabha and developed further by scholars looking specifically at how ideas about racial difference and otherness were inscribed in film.[7] Departing from traditional understandings of the stereotype as a "fixed" form of representation, Bhabha argues instead for the colonial stereotype as "a complex, ambivalent, contradictory mode of representation, as anxious as it is assertive."[8] In Bhabha's formulation, the stereotype is "at once a substitute and a shadow."[9] This formulation is particularly apt for the cinema and for the concerns at the heart of this study. The moving image, too, is both substitute and shadow, though in a more literal sense than Bhabha intends. Like all signifiers, the film image is a substitute for the thing it represents, for the referent; at the same time, the

moving image only exists through the play of light and shadow. But, of course, even in cinema, the "shadow" is both literal and figurative. From Maxim Gorky's first encounter with "the kingdom of shadows,"[10] courtesy of the Lumières' cinematograph in 1896, the shadow itself becomes a privileged figure for the cinema. The sense of the moving image as a "shadow" was particularly strong in the early silent era, when it was meant to evoke both the cinema's uniqueness and its limitations. That shadow flits between presence and absence, between the cinema's unique powers of realism and its immaterial, spectral image. And, as I argue, the reciprocity between these two ambivalent shadows (the racialized body and the moving image) is key to the articulation and expansion of cinematic boundaries. The rhetoric of race helps to shape film form in fundamental ways, and at critical moments in the cinema's early history, racialized bodies function as powerful figures for (and supplements to) the cinematic apparatus, buttressing its claims to specificity as a medium and highlighting its unique signifying powers.

The challenge of analyzing how a racialized conception of difference informs cinematic meaning—how "race" is encoded into the cinema's signifying practices—is still an unfinished task. Recent work that has tried to bridge the gap between form and content in the study of race and cinema has focused on particular ethnic groups or racial identities.[11] While this work is extremely important, I am more interested here in "race" as a broader construct, as a structuring principle and rhetorical tool in the development of early cinema that would have lasting effects on film language and film narrative. At the same time, early cinema does not develop in a vacuum. My focus is primarily on American film, and much depends upon the fact that motion pictures make their entrance on an American scene marked by racial segregation, unprecedented immigration, nativist sentiment, and racially motivated violence. Culturally, motion pictures are part of an explosion of visual culture that not only transforms entertainment, leisure, and recreation at the end of the nineteenth century, but that is also central to fundamental shifts in scientific and medical discourses and foundational to regimes of knowledge including anthropology, sociology, and psychology. The links between these discourses and the form, display, categorization, and aesthetics of the human body were lively and productive forces in shaping early motion pictures.[12] Like sound recording and photography, the motion picture became an important tool for taxonomies of peoples, and the new medium quickly became fully

imbricated with the late nineteenth-century urge to visualize and natu-
ralize categories of race, gender, and sexuality—categories that have been
repeatedly defined by and through each other.[13]

Motion pictures played an important part in displaying and defining
racialized and exoticized bodies, in visualizing and justifying colonial ex-
pansion, and in circulating spectacles of racial violence. Whether at World
Expositions alongside re-creations of plantation life, accompanying or
reproducing "human zoos," in travelogues and filmic tours of exotic locales,
or as part of the circulation and trade in images of lynching, early motion
pictures take the stage at a time of voracious hunger for racialized spec-
tacle.[14] Importantly, in the increasingly varied turn-of-the-century land-
scape of popular amusements, the new medium did not only present these
spectacles, it was itself a spectacle, often sharing the stage, in its early years,
with vaudeville entertainers, museum exhibits and other curiosities. In
other words, the "cinema of attractions" was also the about the attraction
of the cinema.[15] In the era of actualities and pure display, it is perhaps
easier to see the ways in which the spectacle of race provides a means to
display the cinematic apparatus as much as the reverse is true. What is
harder to trace, and what I aim to trace in the coming chapters, is how the
affinity between these two "attractions" (racialized difference and the cin-
ematic apparatus) shapes film narrative and continues to help define the
cinema for decades to come.

The specificity of the racial imaginary at work in late nineteenth- and
early twentieth-century America is thus crucial to the emerging cinema,
as is the increasingly crowded landscape of visual culture against which the
cinema must define itself. While being mindful of this historical, social,
and cultural context, I am also committed, in this study, to the cinema as
cinema—that is, to treating cinema as a distinct medium, art form, and
industry with its own formal pressures, modes of address, textual strate-
gies, and production, exhibition and promotional contexts. If the "Amer-
ican imaginary insists on the essential difference of racialized peoples,"[16]
I am interested in how this essentialist model of difference—with its invest-
ments in the links between external and internal traits and in the "truths"
and symbolic resonances of the racialized body—informs cinematic nar-
rative and supplements the cinema's own "essentialist" claims to specifi-
city and realism in its early history. In discussing the production of what
she calls the "Ethnographic Body," Fatimah Tobing Rony captures the con-
sequences of this process for the cinema's signifying practices: "the Ethno-
graphic Body is always in a contradictory position, both 'real' and sign.

While cinema makes the white woman into an image . . . cinema makes the native person, man or woman, into unmediated referent."[17] The "ethnographic body" extends, of course, beyond official anthropology, since so many early "actualities" feature displays of various peoples, rituals, and "exotic" locales. And, I would suggest that the "contradictory position" that Rony identifies is a crucial one for emerging cinematic narratives as well; the position does not appear "contradictory" because race inheres precisely in that productive paradox. The racialized body makes the seemingly impossible, possible. For example, as I elaborate in my study of early film narratives in chapter 1, the racialized body often functions to bridge distances between literal and figurative meaning, between stillness and motion, and between spectator and spectacle. By playing with racial disguise, cross-racial identification, and the threat of miscegenation, a number of these early (typically one-shot) films extend past the limits of the still frame, substituting metaphoric movement (the crossing of racial boundaries) for actual movement through space. "Race," as a concept, binds the real and the symbolic, with the racialized body functioning as the site of that seemingly impossible union. In other words, "race" claims to be defined and grounded by the hard boundaries of the body, while also transcending them to reference all manner of abstract, spiritual, and intangible "essences." To understand how this becomes particularly advantageous for the cinema, we must look not just at how racialized figures function at the level of content (story) but also at how the rhetoric of race difference "figures" in cinematic meaning (even, as we shall see, helping to figure the apparatus itself).

As the passage from Rony suggests, work on race and cinema tends to make reference to feminist film studies, while also suggesting the ways in which the focus on gender that dominated film studies for many years tended to ignore or be less sensitive to issues of race difference.[18] In foregrounding race, I do not mean to suggest an undifferentiated term, or one that can be detached from gender, class, and sexuality. In most of the films I examine, race and gender function interdependently, although in varying ways. The threat of miscegenation (for both comic and dramatic purposes) runs through many of the films discussed here, which is no surprise given that the "policing of sexual boundaries—the defense against hybridity—is precisely what keeps a racial group a racial group."[19] In some films, racial and sexual disguises are equated, while in others, the freedom associated with one sort of disguise will be shut down by the other. Often, racial boundaries function as metaphors for other sorts of boundaries; at times

questions of "race difference" offer opportunities for testing or imaginatively crossing those boundaries, while also setting absolute limits for those transgressions. And while the racialized figure often functions to cement white characters' heterosexual pairings—buttressing white feminine identity or serving as a signpost for "appropriate" romantic objects and erotic spectacles—I also argue here for a variety of more subtle rhetorical functions for race difference. Even as race must be understood in and through gender and sexuality, the rhetoric of race difference itself seems to provide access to a different plane of meaning. It is particularly instructive, when looking at early cinema, to explore how race has functioned in mediating the tensions that have been read primarily in gendered terms (e.g., active/passive, narrative/spectacle, looking/looked at; corporeality/immateriality). And, as I suggest in the forthcoming chapters, we must also rethink fundamental debates that have already come under heavy scrutiny in recent work on early cinema—the classic distinction between realism and "formalism," for example, or between theatrical and cinematic modes—and ask how "race" changes our understanding of these debates and even negotiates the tensions between these often opposed styles and goals in film.

Since these categories and debates have often been defined in terms of classical Hollywood cinema, early cinema already complicates easy binaries and the gendering of their component terms. In the much more open-ended context of early cinema production and exhibition, the boundaries between spectator and spectacle, the "invisibility" of the apparatus, and the power dynamics of the gaze were much less a textual given. As a result, many early cinema historians have tended to gloss films rather loosely, citing the fact that these films were not the self-contained worlds/texts that classical narrative films aspired to be; their meaning, consequently, was much more dependent upon the vagaries of the exhibition context and the social milieu. Meanwhile, in the flowering of work in the past few decades that pays closer attention to the specificity, style, practices, and modes of address of early cinema, considerations of race came late to the table. In contrast, much work on early cinema will almost automatically gesture toward gender (even if only to point out the more complex gender relations on screen and off). For example, discussions of the different audience expectations and modes of address of early motion pictures often rely on peep shows and gendered spectacles to explicate the logic of anticipation and thrill associated with the "cinema of attractions." Much less is said about race difference at the level of its general impact on film form,

even though the tricks and surprises of early cinema just as often had to do with racial reversals, disguises, and displays as they did with the promise of looking up a woman's skirt.

The formal and stylistic categories defined by the work on early film narratives—"the cinema of attractions," "trick film," "one-shot film," and so forth—are crucial to this study. Looking at these categories through the lens of race difference (and thinking about racialized figures and racially charged subject matter via these formal and stylistic categories) is particularly important for understanding the relation of early cinema to classical and contemporary screen images. For me, this has meant thinking a great deal about the relation between figure and frame—that is, how narrative meaning is produced via the relation between what the figure in the frame is doing and what the film frame itself is doing.[20] In order to understand how the rhetoric of race difference informed the cinema's signifying practices, cinematic realism, and the "image" of the cinema itself, I explore these questions: What elements of the "cinema of attractions" remain in later narrative forms? How does racialized imagery affect the making of the screen image more generally? What is the relationship between "trick films" and so-called "race subjects"? How are the discourses of race and the discourses of cinematic specificity and cinematic technology linked? How can theories of presence and absence illuminate early cinema when this very interplay was an acknowledged part of the attraction? How might we see more and less overt treatments of "race" in cinema as, in part, compensations for formal and technical problems? In looking at these questions, I revisit theories of the fetish and theories of corporeality as elucidated in recent feminist and postcolonial criticism, but I do not retain the focus on identification and the gaze that has been so central to spectator theory. Rather, I consider the thorny binaries at the heart of silent cinema: motion and stasis, display and narrative, surface and depth. I think about these binaries, in part, through Gilles Deleuze's theorizations of the "movement image" and the "affection image." Looking at the early cinema in terms of the tensions between performing body and performing image, I explore how the performance of "race"—in films themselves and in the racialized discourses of authenticity and essence—played a significant role in negotiating those tensions. This, I hope, will give us a better purchase on the logic of the screen image.

A word on the particular subjects and the particular "racialized bodies" that appear and reappear in the films and historical moments analyzed here. When it comes to particular subjects, it is no mere coincidence that

many of the films analyzed here feature African American and East Asian (primarily Chinese and Japanese) performers (or "white" performers in blackface and "yellowface" disguises), and that the racialized categories "Negro" and "Oriental" do much of the rhetorical work in both the films and in extra-filmic materials. It is no coincidence because these racial categories are often spoken of in the same breath in nineteenth- and early twentieth-century America, with each occupying important positions vis-à-vis each other and vis-à-vis the shifting, hierarchical scales defining "white" and "nonwhite." In the "variegated" notion of whiteness that takes hold in the nineteenth century (in the face of unprecedented immigration), Africans and Asians represented prominent examples of races that were "entirely different" from "white," as opposed to "somewhat different."[21] In other words, African Americans and Asian Americans were largely depicted as most alien to the various European "races" understood as "white" and thus least eligible for inclusion and most threatening to American identity. This does not mean that these "races" were seen as equivalent to each other, nor does it dismiss the vastly different histories of these and other marginalized subjects.[22] But the concept of extreme otherness often yoked them together in legal rhetoric and popular culture, whether through comparison or contrast. While blackness in many ways structures an internalized otherness that alternates between poles of savagery and domestication, the "Oriental" (and particularly the Chinese subject) comes to symbolize the boundaries of America itself, and what should remain external to it. Perhaps one of the most striking examples of this occurs in the landmark *Plessy v. Ferguson* case, which upheld segregation under the provision "separate but equal" in 1898. Justice Harlan's remarkable dissenting opinion in that case uses the "Chinaman" as a foil to "citizens of the black race": "There is a race so different from our own that we do not permit those belonging to it to become citizens of the United States. Persons belonging to it are, with few exceptions, absolutely excluded from our country. I allude to the Chinese race. But, by the statute in question, a Chinaman can ride in the same passenger coach with white citizens of the United States, while citizens of the black race in Louisiana . . . who have all the legal rights that belong to white citizens, are yet declared to be criminals, liable to imprisonment, if they ride in a public coach occupied by citizens of the white race."[23] In Harlan's logic, African Americans are part of the body politic, having been adjudicated as such, and thus form an internalized other, rather than an external (and legally excluded) alien race.

In addition to the many films like *A Morning Bath*, which exploited the "high contrast" of black and white, Asians (especially Chinese subjects) appeared early and often on film. From numerous Chinatown scenes to vaudeville performers imitating Chinese laundrymen to the numerous Edison films documenting the 1896 visit of Li Hung Chang (former viceroy of China) to New York, the Chinese functioned as both the most "alien" of subjects and one of the early cinema's most interesting spectacles.[24] Each marginalized/racialized group has its own particular screen history, and each trails its own array of stereotypes and patterns of representation. Numerous scholars have pointed out that American cinema's signature moments have involved the representation of African Americans. Whether providing the suffering bodies so crucial to what Linda Williams has called the "American melodramatic mode," or functioning, as Michael Rogin argued, as the immobile, excluded other against which Americanization and upward mobility are achieved, "blackness" has been a remarkably useful and consistently exploited term, even when African American performers have been largely absent from Hollywood movie screens.[25] But I argue that there is something more basic underpinning the thematic obsessions of American film. My focus is on the way an intractable, essentializing, yet capacious understanding of "race" continues to underpin cinematic signification and the rhetoric of cinematic specificity itself. One way to combat the abstraction of "race" is to reclaim the specificity and complexity of people's identities and experiences and to insist on the material conditions of particular bodies at particular times and places. At the same time, in looking at the role race plays in cultural forms and aesthetic practices, it is important to examine how the rhetoric of race difference and the accompanying gestures of essentialism function across various groups in order to identify when—and to what end—appeals to race difference are made. My goal, then, is not to perform a one-to-one comparison between the representation of Chinese subjects and African Americans (or between Chinese and Japanese subjects, etc.); rather, I focus on particular junctures in the development of American cinema, and I take the appearance of racialized subjects at these moments as an opportunity for a different sort of comparative analysis. I am looking at how the cinema produces its own comparative structure, defining its difference and accommodating its essential paradoxes through a series of analogies, comparisons, and allusions to race. If the essence of cinema relies on the essentializing discourse of race, then it is important to analyze the continuity of racialized rhetoric as it functions at different moments and as it

is exploited through different (and differently racialized) figures. As we will see, the authenticity associated with the racialized body repeatedly functions to authenticate the screen image, and "race" bestows a kind of presence to the cinematic apparatus, a way to substantiate the screen image. Often this "embodied" presence depends upon the hyper-embodiment, disfiguration, or disembodied absence of the racialized figure.[26]

I begin this study with early motion pictures, focusing primarily on early narrative experimentation in films beginning around 1904–6. As it goes on, the study becomes increasingly interested in the way the cinema repeatedly confronts its own limitations and defines its own self-image. In the patterns and relationships I am tracing, including the links between the body and the apparatus, and between "race" and "cinema," I am interested in rethinking transitions. The transition from early cinema to "classical" narrative style is generally understood in terms of the shift in modes of address: the closing off of the film world from the spectator's world and the simultaneous incorporation of a spectator function within the film's visual field and narrative logic. During cinema's second decade, the film camera took on a more complex narrating function that produced an ideal (and disembodied) spectatorial position for the viewer to inhabit. This was an important part of standardizing the film viewing experience (key to expanding and consolidating audiences, improving the cinema's cultural status, and centralizing power in the hands of the producers). This standardization of reception was accompanied, numerous scholars argue, by a denial of (or escape from) "an awareness of [the viewer's] physical self in the theater space."[27] Or as Mary Ann Doane more ominously puts it, the "historical trajectory of the classical cinema was to defeat that body by annihilating its space."[28] In its earliest years, well before these various annihilations, the cinema's mandate was simpler: to reproduce motion. Tracing the way the cinema was entangled with larger social and cultural efforts to harness and organize unruly motion at the beginning of the twentieth century, Kristen Whissel describes the invention of the spectator in terms of traffic. In the early teens, feature films substituted "narrative traffic" for the traffic of urban modernity: "This shift entailed a marking out of the specificity of the moving picture as a technology of representation that played upon the structural affinities, extensions, and connections existing between modern technologies, but whose *specific pleasure depended on the gradual subordination of these affinities to the developing apparatus and, in turn, the apparatus to the narrative.*"[29] Whissel's account offers a glimpse of a particular moment in the narrative construction of spectatorship,

refining and contextualizing the story that ends in the "annihilation" of the (real) body and its space. But what I especially like, and what I want to emphasize here, is the evocation of the clunky, ungainly apparatus in its awkward teens—simultaneously asserting its presence and its difference and ultimately subordinating both in the interest of unity and coherence. The cinema would have many more awkward ages. In part, this book looks at moments that replay and resist the absorption of the apparatus (and of the image) into narrative.

"Apparatus" is certainly a loaded term in film studies, bringing with it resonances of "apparatus theory" and the more general sense of the cinema's ideological function.[30] While I certainly allude to these theories in the coming pages, I rely on a somewhat more limited sense of the word. Coming from the Latin for "prepare," "apparatus" reaches out to include almost everything. Most definitions include separate entries pertaining to mechanical, biological, and political systems while suggesting the links among these categories. The OED offers the following entries (after the obsolete usage, "preparation"): "2. The things collectively by which this preparation consists, and by which the processes are maintained; equipments, material, mechanism, machinery, material appendages or arrangements 3. a. The mechanical requisites employed in scientific experimentation or investigation; b. the organs or means by which natural processes are carried on." The many and various parts of the apparatus—its "material appendages" and "arrangements"—support the less tangible "processes" at work. The apparatus is very much akin to a body; in order for the cinema to "come to life," it must somehow be more than the sum of its parts. During the early silent era (and at moments of technological vulnerability, as in the early days of sound), the cinematic apparatus (the cinema's body/parts) was strongly linked to the bodies on screen. In particular, as I discuss in the coming chapters, discourses of embodiment and race (and related notions of authenticity and essence) were associated with—or appended to—the cinematic apparatus to supplement its own "presence," to limn and expand its very contours. The cinema has relied, in various ways, on the rhetoric and performance of "race": to show off its technology, to hide its flaws, to negotiate tensions between narrative and spectacle, and to ground its claims to authenticity and presence. This is especially clear in transitional moments or at times when aesthetic and technological shifts can seem "additive" and can thus foreground the apparatus in a way that detracts from the wholeness and self-sufficiency of its illusion. "Race," too, can be understood as a set of practices, props, appendages,

and systems (biological, cultural, legal)—in other words, as an apparatus. I am suggesting that, at particular junctures, the cinematic apparatus and the apparatus of race reinforce one another because of their mutual dependence upon discourses of embodiment, authenticity, and the evidence of the senses.

The junctures on which I focus include the early experiments with narrative and the move from one-shot films to films composed of multiple shots; the transition to the feature film; and the early sound era. In looking at these junctures, I focus on corresponding aesthetic practices or technical issues central to the cinema's association with realism and to discourses of "reality" and authenticity more generally: the reproduction of motion; the increasing use of the close-up; the relation between the two-dimensional screen image and the shadow; and the synchronizing of sound and image. Looking at films as well as material from the trade and popular presses, I identify moments when "race" supplements cinematic realism while also foregrounding the apparatus. The conventional wisdom suggests that foregrounding the apparatus—and self-reflexivity in general—detracts from "realism." But what I am identifying is the sort of reflexivity that works at the more basic level of image and meaning: by bolstering the rhetoric of presence or "embodiment," the racialized reflexivity I locate has to do not so much with "narrative absorption" as with projecting a screen image that bonds physical reality and spiritual or magical essence. And so, while the cinema provided the perfect medium for racist jokes, stereotypical portrayals, and racially charged melodramas at the beginning of the twentieth century, the subject of race also became the perfect medium for showing off, shoring up, and re-introducing the cinematic apparatus.

Organized around these pivotal junctures in cinema history and the definitive, medium-specific "problems" they addressed, my argument crystallizes around particular films that showcase the symbiosis between racialized rhetoric and self-reflexivity. I ultimately suggest that these moments can tell us something about the relation between image and audience, offering a way of thinking about the audience apart from (but, I would hope, complementary to) theories of spectatorship and the gaze or historical portraits of the "social audience." In looking at highly charged depictions of the screen image and the film audience in the teens and twenties, I suggest the continuity of these portraits with the tenuous play with the screen boundary from the earliest motion pictures. The imaginary crossing of that boundary, so often racialized, continues to define

the promise of cinematic spectatorship. In tracing these connections, I hope to illuminate a model of the film audience that is neither the textually constructed spectator of classical cinema nor the social audience—but rather an ideal audience upon which the cinema projects its ideal image. In these reflexive portraits of spectatorship, we can see how "race" helps to identify the film audience itself as a distinct group bound by belief in the image. In these ways, I argue that "race" has been integral to the way fundamentally cinematic questions got worked out in American film.

In the first chapter I look at how "race" helped early motion pictures make narratives out of (almost) nothing. Beginning with films that depict the cinematic apparatus (usually through analogies to other arts/technologies), I argue that these films stage a competition between the performing body and the performing image, comparing the powers of the body to the powers of the apparatus. Going on to link these early depictions of the apparatus to early "race subjects," the chapter considers how early "one-shot" narratives exploit racialized figures and racially charged subjects in order to transcend the limitations of the apparatus. In a number of these films, the racialized body acts as the camera's prosthesis, providing added motion, extending past the still frame, and linking literal and figurative meaning. Further, I argue that the links between racial and spatial boundaries are related to (and sometimes explicitly gesture toward) the boundary between image and audience. Essentially, I suggest that the fundamental tensions at the heart of these early narratives (e.g., between motion and stasis, narrative and spectacle, stage and screen) are implicitly and explicitly related to the boundary between image and audience, and that racialized rhetoric plays a crucial role in negotiating and even reflexively figuring these tensions. This establishes an important relationship between racial boundaries and cinematic boundaries that will reappear as the cinema continues to develop.

In the second chapter, I discuss debates about the close-up—focusing on both the discourse surrounding the close-up in the latter part of cinema's transitional era as well as on contemporary theoretical debates in film studies. Looking at two early feature films—*The Sign of the Rose* (NYMP, Reginald Barker, 1915) and *The Cheat* (Lasky, Cecil B. DeMille, 1915)—I identify what I call the "body-face," a hybrid formation that reveals the larger tensions about cinematic realism that underlie the responses to the increasing use of the close-up. Ultimately I focus on the figure of the "Oriental", suggesting that *The Cheat* makes an argument for the power of

the screen image—one that is tied to race difference. In discussions of Sessue Hayakawa's performance style as well as in the stylistic patterns of the film itself, we can see how race functions in the contest between the expressive powers of the body and the expressive powers of the face. This is key to the shift in performance codes so crucial to the transitional era and to the birth of the feature film. Discussing the interdependence of the face, the screen, and the concept of race in the making of an "iconic" screen image, the chapter also introduces the second half of the book, which takes up the relation between image and audience.

Continuing to explore the link between the "Oriental" figure and the nostalgic play with cinema's origins (via the shadow play), the third chapter looks closely at the 1922 film *Shadows* (Preferred Pictures, Tom Forman). This film features Lon Chaney playing a Chinese immigrant and is, stylistically and thematically, an American translation of German expressionism. The film exploits the Oriental figure to tell a story about faith and images, distinguishing the screen image from theatrical performance and revealing the role race plays in constituting the credulous audience. This chapter is not organized around a "transitional" moment in cinema, at least not in the same way as the chapters that precede it.[31] Rather, *Shadows* represents what many would consider the silent cinema at the height of its powers. The striking interconnectedness between the film's self-reflexivity and its racialized portrayal represents a sophisticated and surprisingly explicit example of the connection between audience formation and the exploitation of an ever-shifting, endlessly accommodating racialized figure. As such, this chapter functions as a pivot point between the book's consideration of formal concerns and its focus on the questions of faith and authenticity that inform the model of film spectatorship encouraged by the exploitation of racialized difference. This model of spectatorship can be traced back to the earliest motion pictures, when the relationship between body and screen image, and between the bodies on screen and those in the theater, was regularly in play. In *Shadows*, a communal experience is forged through faith in the image, a faith dependent upon the racialized figure.

In chapter 4, I look at the way African American performers and the discourse around the "black voice" figured in the early sound era. Ending with a reading of King Vidor's black-cast talkie *Hallelujah!* (1929), the chapter rethinks theories of the fetish in cinema. In *Hallelujah!*, I argue, black bodies in the throes of religious hysteria come to figure the cinema itself. As in the earliest days of the silent era, black bodies meld into the apparatus,

figuring a pure and legible motion, and sound is no longer a clunky intrusion: image, meaning, and audience are synchronized through race. In the conclusion, I suggest that the patterns established in early cinema and traced here continue to be relevant to our current moment, when the cinema must again define itself against (and within) the shift to digital formats and the proliferation of screen culture. I consider James Cameron's *Avatar* (2009) in this context.

Finally, a word about my focus on self-reflexivity. This is sometimes seen as inward looking, encouraging formal analysis as a kind of closed loop by saying, essentially, "film is only and always about film." My argument suggests quite the contrary. The imbrication of self-reflexivity and racialized rhetoric suggests the way cinematic self-portraits reach outside the frame—to social constructs, to real and imagined bodies—to add substance to the screen image. The "shadow" of my title references both the material reality of the screen image (its status as a two-dimensional projection) and its inescapable history (a history bound up with racist images). In the following chapters, I argue that the cinema repeatedly confronts its own "immaterial" image via representations of race difference. Further, I hope to draw attention to the continuities among early cinema, classical cinema, and contemporary screen culture. While it is important to retain the specificity of the early cinema's practices, material conditions, and exhibition contexts, we should be careful not to wall off the era from the rest of film history. In so doing, we risk repeating the same repressions and erasures upon which the classical cinema was based. The more we adjust our focus to include early cinema, the easier it is to see the central role "race" has played in the "evolution of film language"[32]—especially if we understand that process not as an "evolution" but as an ongoing dialectic between the performing body and the performing image. In 1914, one commentator reminded his readers that the images on screen were "undeniably mere shadows on a plane surface."[33] Through its births and rebirths, repressions and exhumations, the cinema has repeatedly, almost compulsively, attempted to remake its image—to (re)incarnate its shadow. "Race" has figured prominently in that definitive, repetitive gesture.

1 PERFORMING BODY, PERFORMING IMAGE

Race and the Boundaries of Early Cinematic Narrative

THE CINEMA SUFFERS NO SHORTAGE OF ORIGIN STORIES. Whether one dates the beginning from the Lumières' onrushing train in 1895 or from D. W. Griffith's onrushing Clansmen in 1915; whether you see the film spectator/subject receding to a vanishing point in the perspectival system of the camera obscura or flickering to life in the magic lantern shows and phantasmagoria of the nineteenth century; whether you choose to locate the ideal of pure cinema in silents from the 1920s or prefer to see the cinema only fulfilling its mimetic promise with the arrival of the talkies; whether you see the earliest motion pictures as the "primitive" precursors to or as the ruthlessly repressed "Other" of classical Hollywood style. . . . All of these moments, all of these births and rebirths (and even prebirths) of the cinema provided new ways to think about, and figure, the moving image. Various points in the cinema's development provided opportunities for the medium to restage its own technical, aesthetic, and cultural power—to cast its shadow, and its net, over audiences.[1] The earliest motion pictures almost immediately put the cinematic signifier on stage, performing its novelty, to be sure, but in the process also rehearsing fundamental problems and tensions that would continue to define and undermine the cinematic illusion for decades to come.

One such film is *Animated Picture Studio* (AM&B, 1903).[2] This short belongs to a group of trick films from the first years of cinema that stage pranks in still photography studios. This one unfolds in a particularly complex way, however, as the "animated pictures" become a trope for the cinematic apparatus. Like most of the films of this mini-genre, *Animated Picture Studio* features mattes and double exposures; it also uses frames within frames to create simultaneous planes of action. It opens with a woman entering a portrait studio. In the background of the scene, there

is a "Dark Room" sign over a black-curtained opening. To the right, another sign boasts "Animated Pictures While You Wait!," suggesting an instant motion picture studio for the public. The setup and framing look very much like other films of this period set in photography studios.[3] Wearing a voluminous white dress, the woman poses in front of a black cloth background and performs what looks like a "skirt dance" for the camera (which looks and is operated like a still camera).[4] When her session is over, the man she came with joins her, and they kiss, unaware that the camera is still "rolling." The photographer then goes to the darkroom and returns with the finished portrait. He sets up a large picture frame on an easel, and the moving picture we've just seen performed appears again, matted inside the picture frame (Figure 1). The subjects-turned-spectators react with glee, at first, until they see their hanky-panky replayed on the screen. It turns out that the "animated picture" is just that, as it takes on a life of its own—the hanky-panky goes on longer in the picture than it did in "real life." The picture gets even more "animated" when the woman reacts angrily, picking up the frame and smashing it to pieces on the floor. Rather than killing the picture, her action allows it to really "live," as the tiny figures break out of their frame and continue the show in the right corner of the screen, via double exposure (Figure 2). At this point, the photographer and his two subjects gather around to watch, clearly fascinated by this never-ending animation, a kind of soft-porn perpetual motion machine.

The film takes the situation of performing for a motion picture camera and envisions it in the private studio setting associated with portrait photography. In exploiting this setting, the film charts the journey from performing body to performing image, from substance to shadow. The photographer/filmmaker is depicted as some combination of magician, occultist, and puppet master. Here, we have not just a trick film, but a film that depicts cinema *as* a trick. While his clients wait for the picture to be developed, they look at a triangle with a circle inscribed in it on his table, which suggests a connection to spiritualism or the occult, and when he comes back with the picture, he climbs up on a chair behind it so that his head and arms are visible above the animated figures. From this position, he presents the portrait and also seems to control the figures as a puppeteer might. This pose suggests his ambiguous role as a maker of "animated portraits"—someone who simply records "from life," but who also *brings* images to life. Since the notion of bringing people in to perform for the motion picture camera was so associated with Thomas Edison at the time, we might think of this figure as a kind of diabolical Edison. As part

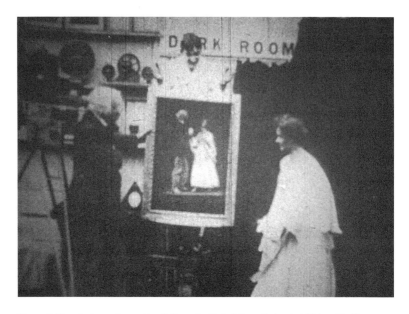

Figure 1. The photographer presents the animated picture. *Animated Picture Studio* (AM&B, 1903). From Library of Congress, Paper Print Collection, Motion Picture, Broadcasting, and Recorded Sound Division.

Figure 2. The images break out of the frame and continue the show.

of the genre of films that depict photography—and, in so doing, figure the relationship between still photography and motion pictures—*Animated Picture Studio* offers an example of the linked histories of film, photography, and spiritualism that Karen Beckman traces through the figure of the "vanishing woman."[5] While the woman in this film doesn't vanish as in the early motion pictures that reproduce the popular stage trick of the disappearing magician's assistant, she is the victim of a trick. First, she exhibits herself willingly (dancing for the camera); then she is caught in the act of "making love," and the evidence is displayed for all to see. In this trick film, double exposure helps tell the tale of a woman who is doubly exposed. Further, the images have the last laugh, as they take on a life of their own, fully alienated from their source material. Even the woman must simply stand back and watch.

The film thus also comments on spectatorship, as it suggests (and requires) multiple kinds of viewing practices. When in the picture frame, the little "movie" occupies center screen; when the tiny figures break out, they are in the right lower corner as the audience within the film stands to the left, looking down at them. The film directs the spectator's gaze in a way that calls attention to the dimensions of the screen. We follow the moving objects—first the woman performing at the extreme right of the frame, then the animated portrait at the center of the frame, and finally the little apparitions in the lower right corner. And the "animated picture" both duplicates and reverses the spectacle–spectator relations. The film implicates the audience's voyeurism, but those who were once the spectacle become the spectators as the man and woman in the animated picture step back to watch the show as merely curious observers. Interestingly, the figures in the "animated picture" are quite small and exist both within and outside of a frame. In this way, the film suggests the "peep shows" associated with the mutoscope or kinetoscope, while also including (and, of course, existing as) projections on a screen. While both the size of the images and their subject matter (lovers caught in the act) reference the peep show, then, these projections are not trapped inside a box. As a result, these moving images manage to figure the cinema while also referencing optical illusions, phantasmagoria, photographs, magic tricks, and other proto-cinematic spectacles with which the "cinema of attractions" was entwined.[6] They are also, of course, miniature versions of the very screen projections the audiences would be watching—a film within a film.

The "animated" picture equates movement with life and thereby reiterates the most popular argument for cinema's advantage over other arts.

The new technology (less than a decade old in 1903) offered "the possibility of representing, however crudely, the essence of reality, that is, motion."[7] But movement is not all that defines this living picture. The picture really "lives" when it breaks out of the frame, thus occupying the same space—the same plane—as the camera's original subjects. The animated figures claim a special status for the screen itself as an autonomous space, and the shadows that literally dance on the screen challenge the "reality" of the bodily presences they replace. In essence, the film stages the competing realities of performing bodies and performing images—with the "animation" of the pictures only fully achieved when they break out of the frame and onto the screen. As the viewer's eye is guided across the surface of the frame, it follows a trajectory from live performance (stage) to the recorded moving image (framed), and finally to dancing shadows, immaterial but "alive" (on screen). As a commentary on the performances captured for so many early motion pictures, the film charts the unpredictable dynamic between the material body in space (whether an urban street scene or a stage set) and the immaterial projection on screen. With this trajectory, the film also suggests the way the equation of life with motion ("animation") is rhetorically linked to questions of spatial dimension, presence, and materiality: in other words, bringing images to life entails a dynamic relation between stage "presence" and screen "absence," performing body and performing image.

In a sense, *Animated Picture Studio* prefigures the tension between figure and frame that will develop as the story film begins to dominate the market.[8] As cinematic storytelling becomes more clearly associated with particular demands for realism, the power of framing and montage will sometimes conflict with modes of performance centered on the body and on "histrionic" display. Years before continuity style and codes of realism will take hold, however, this film stages a more basic competition between the signifying powers of the performing human body and the cinematic counterparts who inhabit the frame or screen space. Here, the frame is acknowledged as a limit. The tiny figures break out of their framed "show" space and establish multiple planes, textures, and pictorial values even as they call attention to themselves and their "flesh and blood" counterparts as two-dimensional shadows. *Animated Picture Studio* offers a particularly vivid example of the fact that the "relative autonomy of the shot" in early cinema did not necessarily mean a greater "fidelity" to real space and real time. Nor does it necessarily make a film more like theater (and therefore, as the suggestion usually goes, less "cinematic"). The frame must

be read with greater care in the silent cinema; as Tom Gunning reminds us, "the tendency to rely upon the space within the frame rather than the possibilities of juxtaposition between shots involves a particular attitude towards the filmic illusion and one which is far from a Bazinian aesthetic of non-manipulation."[9] Like many other trick films, this one draws attention to the dimensions of the screen and to its flat, planar surface.

Arguing for the way the vanishing woman enabled the cinema to work out anxiety over its own (im)materiality, Beckman looks at films in which disappearing women elude men's grasps, arguing that "the films in this genre anxiously attempt to grab the 'truth' of a materiality marked female in the midst of an uncertainty of the body made newly visible by the invention of film."[10] She also notes the quite literal way that certain early films and photographs link this "materiality marked female" (71) with pieces of material, cheesecloth, or linen that appear as women disappear.[11] In *Animated Picture Studio,* the woman's skirt (which she lifts and flourishes) offers the excessive "material" that both covers and references her body and her sexuality (though with a wink to the existing films of such dances that already existed). But, there is another kind of tangible "material" remainder that confronts those who would try to "grab" these seductive but elusive film images: the movie screen itself. Produced just a year before *Animated Picture Studio,* Edison's *Uncle Josh at the Moving Picture Show* (Edison Manufacturing Co., 1902) offers a somewhat more typical (and more familiar) version of early cinema's self-portraiture. Edison's film is a bald imitation of the earlier *Countryman and the Cinematograph* (Robert Paul, 1901), with a slightly more elaborated set (and with the insertion of Edison's own films on the screen Uncle Josh watches). Uncle Josh is a recurring character in Edison films, another version of the comical "rube" figure that shows up in numerous early motion pictures. Here, he is duped by the movies. Mistaking the motion picture projections for real people, Uncle Josh repeatedly attempts to engage them and ends up fighting with the movie screen. For his finale, upon seeing a country couple "making love," he attempts to intervene. As the Edison catalog put it: "Uncle Josh evidently thinks he recognizes his own daughter, and jumping again upon the stage he removes his coat and prepares to chastise the lover, and grabbing the moving picture screen he hauls it down, and to his great surprise finds a kinetoscope operator in the rear. The operator is made furious by Uncle Josh interrupting his show, and grappling with him they roll over and over upon the stage in an exciting encounter."[12]

That *Uncle Josh* is an imitation of Robert Paul's film suggests just how early the portrait of the naive moviegoer was sketched. The image of a spectator running away from a moving train, for example, not only references the already fabled audience for the Lumières' *L'Arrivée d'un Train* (1895); it is already cemented as the image most associated with the confusion of moving images for reality. Stephen Bottomore traces various iterations of the "train effect" and the image of the "panicking audience," noting multiple instances—from advertisements, magazines, and other print sources—of train films as the iconic signifier of astonished or credulous audiences.[13] Since trains had already become one of the most popular film subjects by this time (featured rushing toward and away from the camera, offering viewers virtual rides through tunnels, etc.), the rube's reaction is "green" indeed.[14] This film also registers a period when the film screen was often literally "on stage," an attraction housed inside vaudeville, as the rise of the nickelodeons was just beginning. The movie screen is both character and backdrop, and the one-shot film takes full advantage of the frame: the camera faces the stage, with Josh's box at the theater occupying the left of the frame. The movie screen is centered and in the background, and when Josh jumps up on stage, he essentially leaves his own "frame" to engage with the screen, entering the internal performance space and sharing the stage with the screen. His struggle with the screen literalizes the competition between performing bodies and performing images. As in *Animated Picture Studio,* the "real" body is both performer and audience. Josh reverses the other film's trajectory, however, as he is first a spectator and then a performer, whereas the folks in the portrait studio first perform (for the camera) and then watch their filmic counterparts. In both films, however, the "real" person violently attacks the images. In *Animated Picture Studio,* the woman attempts to smash them, but this only enables their escape. Uncle Josh, meanwhile, is left wrestling not the images but their conditions of production—screen and projectionist. When he grabs the screen, it's as if he's grabbed a man only to have his body dematerialize, leaving a heap of clothes.

This is more like what happens in *Hooligan Assists the Magician* (Edison, 1900). In that film, a magician performs, and then Mr. Hooligan (another recurring character) enters from off screen; he enters from the bottom of the frame, suggesting he is a spectator who has come up on stage to get a closer look, to figure out the trick. He keeps trying to grab the women who keep popping up out of the two barrels on the stage. At one point, he ends up holding large pieces of white cloth as the women disappear. Again,

a rube is fooled by a trick that turns presence into absence. Ultimately, the magician returns and performs a series of tricks on Hooligan, as he becomes the spectacle. Uncle Josh's encounter is more ambiguously gendered.[15] Here is the lineup of Edison films that Uncle Josh watches from his box at the theater (the films are matted into the frame inside the stage curtains): first, *Parisian Dancer* (1897) followed by *The Black Diamond Express* (1896), and finally *Photographing a Country Couple* (1902). The first film features a woman performing a sort of can-can in which she lifts her long skirt to kick. The rube "joins" her onstage and dances, occasionally sneaking peeks, presumably trying to look up her skirt. Given that early motion pictures made for peep show formats (as opposed to screen projection) included those made primarily for men to get a glimpse up a woman's skirt, this isn't exactly the portrait of someone who doesn't know how motion pictures work.[16] He runs away from *The Black Diamond Express,* and when he finally attacks the screen, he is aiming at the man making love to the country girl. Thus, the images he "mistakes" for reality start out female (the dancer), but he only tries to "grab" the man whom he sees making improper advances. He ends up holding the screen, at first, and ultimately wrestling with a real man—the projectionist. So he both does and does not get what he's aiming for, as he does end up in a "real" fight. Indeed, in a comic strip version of the "rube" who mistakes the images on screen for reality from the same period, the final panel shows the rube in question ("Dooligan") being wheeled away after crashing through the screen and fighting with the theater manager. His speech bubble reads, "It was a real good fight though."[17] It is interesting that when the "material" the naive spectator grabs is an actual piece of the cinematic apparatus, it is gendered male.

The scenarios in *Animated Picture Studio* and *Uncle Josh at the Moving Picture Show* are representative—we see them not just in other films but also in comic strips, advertisements, and cultural commentary on the new medium. Specifically, the cinema is seen as, alternatively, "fooling" the naive/credulous audience by seeming real or as threatening the audience by "being" or becoming real. Both of the films described above stage the uneasy coexistence of "real" bodies and their screen counterparts; and both explicitly link this relationship to the boundary between spectator and spectacle. Miriam Hansen has noted that the comic spectator in the film "implies certain lessons for the spectator *of* the film" including "lessons concerning the spatial arrangements of the cinema, especially the role of the fixed screen . . . and lessons in film history."[18] But these lessons are

ambivalent at best, given the shifting power dynamics at play. If, as Hansen argues, the kinds of pleasures afforded by the films Uncle Josh confronts are "marked as regressive, partial, disorienting, and inappropriate" (28), this depends almost entirely upon the mediating figure and how he or she is "marked" as such. Like other early motion pictures that are seemingly "one shot" tableaux, the film is a clever piece of "editing" since it weaves a narrative out of separate "clips" by using the films within the film. Both stylistically and thematically, then, we might see the film, as Hansen does, as "[articulating] a pressure for these pleasures to become integrated, subordinated to a more mature mode of reception" (28). Hansen goes on to say that in *Uncle Josh*, "the cinema's sense of its own, albeit brief, history is inscribed with a tendency toward subsumption and integration characteristic of the later institution" (28). But to read the film in teleological fashion—in terms of later modes of spectatorship that will be constructed by editing and the move toward classical style—is to gloss over the multiple ways these self-presentational moments are intertwined with the particular goals and strategies of early cinema. There are other models of "subsumption" at stake here, associated with both pleasure and danger. Rather, we must think about why, at this early stage, we see the cinema performing its own "history" via the boundary between spectator and spectacle, and we must also look more closely at the role particular types of mediating figures play in these self-referential performances. It seems to have much to do with the ways in which early narrative depends upon the ability to play with this boundary (and with fantasies of crossing it). I am focusing here on the various ways the cinema puts itself "on stage" or makes a spectacle of itself (at risk of seeming like Uncle Josh). In this sense, Uncle Josh is not just a figure for the "inappropriate spectator." He is a figure for the cinema itself and thus is strategically positioned between the two.

In addition to being highly self-referential, both films define these relations in terms of gender and social class. While *Animated Picture Studio* seems to play on the practice of bringing vaudeville and other performers into a studio to perform for the motion picture camera, it also imagines "animated pictures" as a leisure activity or diversion for the well-to-do. Here, a middle- or upper-class couple can buy a moving picture of themselves as they might sit for a photograph or a painting. When the images take on a life of their own, the customers are horrified both because they have been exposed and because, when the images escape from the picture frame, they no longer belong to the couple. In this sense, we might

see this film as a counterpoint to Noel Burch's reading of the class hierarchy suggested in *The Clumsy Photographer* (Pathé, 1906). Burch argues that the film, which features a photographer in a series of misadventures, shows the division between working-class and bourgeois subjects in terms of differing, class-based attitudes toward ownership of one's image. In the film, working-class subjects pose happily for the camera, while the middle-class types attack the photographer for his audacity in trying to take their pictures. Burch claims that the class inflection over this issue is particularly telling in a time when "the cinematic image does not yet legally belong to anyone, belongs, in fact, to the poor . . . [who] certainly do not assume any right to their own images."[19] And yet, *Animated Picture Studio*, made three years earlier, seems to flip the script that Burch lays out somewhat by offering a cautionary tale precisely about the attempt to buy/own one's moving image, only to discover the inability to own/control that image now that it is "animated." Meanwhile, the joke in *Uncle Josh* draws on longstanding assumptions about the relationship of spectators to images, linking a naive credulity—a tendency to confuse images with reality—with lower-class, "primitive," or child-like behavior. Uncle Josh is "too close" to the images, emotionally and physically, as his inability to have a proper (knowing) distance from the spectacle is reiterated by his inability to keep a physical distance, to know his place, as spectator.[20]

Taken together, the films also suggest important similarities and differences in the kinds of bodies exploited for and by motion pictures. For the woman in *Animated Picture Studio,* dancing for the camera unleashes dancing images, and their reality threatens her—with exposure, and with never-ending mechanical reproduction. For Uncle Josh, the seeming reality of the images poses a challenge, and his susceptibility to images also signals the instability of his (social and spectatorial) position: he is also susceptible to slipping back over the boundary between spectator and spectacle. That is, his naive belief in the image turns him into a spectacle. She becomes an eroticized spectacle; he a comic one. For both the woman and the lower-class male subject, however, extricating oneself from the image (by attempting to destroy it) or from the apparatus (by exposing it) becomes impossible. These films and their scenarios suggest the importance of the imagined struggle between performing body and performing image to conceptions and representations of the cinema. More significantly for this study, they also offer early examples of the reciprocal relation whereby the motion picture represents particular kinds of bodies/subjects while those bodies/subjects represent or dramatize the power of

the motion picture apparatus. The woman in *Animated Picture Studio* stands in for the many eroticized and exoticized bodies that danced and paraded before the stationary camera, making pure exhibition and display more interesting with the erotic or exotic nature of the bodies and their movements. "Uncle Josh," meanwhile, is one of many figures—usually marked by class, ethnicity, or race—that function as mediators between the screen and spectators. These figures make spectators feel superior to those who are fooled by the apparatus, while also making them feel the power of that apparatus, in part by embodying it and making it "present." These scenarios stage presence and absence in terms of propriety and impropriety—understood or enacted through a bodily power dynamic. This operation becomes less explicit in later films, but it remains fundamental to the link between the rhetoric of race difference and the rhetoric of cinematic specificity.

The exploitation of "othered" bodies, and in particular the imbrication of these bodies/spectacles with the essence or prowess of the apparatus begins with the earliest motion pictures. As we saw with Edison's *A Morning Bath* (1896), numerous early films trade on the contrast between black and white, made more meaningful (and often comic) when tied to skin color. As the bathing scenario and others that highlight this contrast are repeated by various producers, the humor and visual interest must be continually updated and renewed via more exploitative material. While *A Morning Bath* offers a fairly uneventful, straightforward view of a bath, for example, *A Hard Wash* (AM&B, 1896) offers a more violent approach to the same material, with the baby struggling and crying as the mother holds him by his feet and scrubs him with abandon. The "contrast" offered by skin color is here pushed further to make the brief display a "joke" that turns on the impossibility of washing that skin color off. The tendency of racialized bodies to throw the powers (and limitations) of the apparatus into relief continues to be exploited as films move from pure display to narrative. The relation between performing body and performing image informs the productive tensions between spectacle and narrative that define early cinematic narrative. If the contest between bodies and images is related to the contested boundary between image and audience, how early films exploit and figure that boundary is also an important part of early narrative. As we move to a consideration of one-shot narratives, we see how fundamental tensions at the heart of these films (between motion and stasis, narrative and display) are implicitly and explicitly related to the boundary between image and audience, and how racialized rhetoric

plays a crucial role in negotiating and even reflexively figuring these concerns. In a number of films, racially charged gags and the rhetoric of race difference more generally function to connect and mediate questions of essence, materiality, and motion.

Essence and Motion

In focusing on the dialectic between the performing body and the performing image, I am drawing on Gilles Deleuze's theorization of the "movement-image."[21] Silent cinema's transition from moving body to moving image figures prominently in Deleuze's account, which discusses the substitution of camera movement for bodily movement in terms of the development of a "pure movement-image." As he puts it, the stationary camera depended on "elements, characters, and things which served as its moving body or vehicle," and thus in the earliest films, "the image is in movement rather than being a movement-image" (24). Camera movement and montage will then "extract" movement from people and things, and a "pure movement-image" is thus "emancipated" (25). Deleuze complicates this progress narrative, however, when he notes that the "primitive" moving bodies of early cinema always suggested or *tended toward* this emancipation: "The spatial and fixed shot tended to produce a pure movement-image, a tendency which imperceptibly came to be acted out *[passait a l'acte]* by the mobilisation of the camera in space, or by montage in the time of mobile or simply fixed shots" (25). Technical innovations "extracted" the movement from the body as we might extract the tenor or meaning from its vehicle in metaphoric language. Deleuze suggests that the "movement-image" is "pure" because it lacks a vehicle, a body. But doesn't something of the body remain in its extract? For Deleuze, the movement-image expresses a kind of cinematic essence, and although it no longer requires a body or vehicle, it retains the mixture of materiality and immateriality suggested by the language of extraction: "In other words, the essence of the cinematographic movement-image lies in extracting from vehicles or moving bodies the movement which is their *common substance*, or extracting from movements the mobility which is their *essence*" (23, emphasis added).

Those tiny apparitions in *Animated Picture Studio* prefigure the cinema's body-less movement, when multiple shots, camera movement, and above all montage will create a narrative space "emancipated" from bodies and any static understanding of the frame. The film's literalization of

this "emancipation" (the images, breaking out of the frame) establishes the screen as a contested site for the relation between moving bodies and moving images, but it also articulates and enlivens the screen as surface: as the place where the image comes to life. Indeed, the logic of early motion pictures does not seem so far from Deleuze's theory—in part because they co-existed with scientific motion studies, Bergsonian philosophy, and popular discourses identifying motion with the essence of modern life. Early motion pictures assume a special connection between the camera and the bodies that move before it. In the earliest motion pictures—especially those featuring vaudeville performers, exhibitionist displays, and bodies framed as "exotic" or alien—the pressure to move for the stationary camera is clear, as is the need to offer something extra, not just motion but interesting motion. Whether the displays staged for Edison's camera—from comic vaudeville bits like *Bowery Waltz* (1897) to filmed dances/customs fresh from the Wild West Show or the World Exposition, like *Sioux Ghost Dance* (1894) and *Princess Ali* (1895), to the distortion of bodies and faces in films like *Facial Expression* (1902), *A Street Arab* (1898), and *Sandow* (1894) —or other producers' films that offer exhibitions and displays, there is almost always a trace of something or someplace else.[22] In almost all cases, these early moving pictures offered a doubly dexterous display: a camera showing what it can do by showing what contortionists, strong men, dancers, and people with "peculiar customs"[23] can do.

Motion was the definitive feature of this new medium, but that too was doubled: the ability of the machine to capture motion and to reproduce an illusion of that motion became intertwined, by necessity, with those bodies and things in motion—with vehicles. If we follow Deleuze (but stay with the stationary camera that he wants to leave behind), those bodies are surrogates for the cinema's as yet unrealized potential; it's an odd moment when the body functions as the stationary camera's prosthesis (as opposed to the other way around). This is clear not only in "pure" attractions such as *Sandow*—in which the performer's dancing musculature offers movement both gross and fine—but also in acted scenes that create comic effects by playing on the "exhibition" or "attraction" mode. A film like *Bowery Kiss,* for example, shows actors in medium close-up taking turns smooching and talking, all the while showing off black eyes and missing teeth. They simultaneously demonstrate a "Bowery kiss" and an "enlarged view," as exaggeration is not only part of the comedy but also a way to make the exaggerated framing "worth it." Both kinds of performances/attractions enact particular kinds of movement adapted for and by the camera and

attached to or inscribing particular kinds of bodies, faces, and places. Both the films and their subjects go through the motions.[24] The performing body displays but also *extends* what the camera can do, and in so doing not only anticipates or tends toward the performing image but also prefigures it, providing a metaphor for that image and a figure for the apparatus.

Deleuze begins his discussion by reconsidering (or rather, re-imagining) the work of Henri Bergson, in particular his "discovery" of the movement-image in *Matter and Memory* (1896). He explains Bergson's "overhasty critique of the cinema" as due, in part, to the "primitive state" of early cinema, with its stationary camera and fixed frame.[25] That critique—that cinema produced only an illusion of movement, composed of still images and thus merely reproduced the limitations of the human eye—was not unique to Bergson, and Deleuze cites it as incorrect. Notwithstanding his critique of cinema, however, Bergson's theories of movement trickled into popular and critical discourse of the period, including an early column dedicated to motion pictures in the *Independent.* The magazine waited until 1914 to run a film column, signaling its wariness of the new medium as too low to be worthy of critical notice. By way of justifying the new column, the commentator turns to Bergson: "Bergson has shown us what a paralyzing influence static conceptions of history have had . . . and how futile have been all attempts to represent movement by rest."[26] By this time (as I discuss in more detail in the next chapter), the concern, for critics and audiences, had turned to realism. Movies had outgrown many of the early limitations of the apparatus, and yet motion, that most basic of cinematic conditions, would still be singled out as essential: "There is no such thing as still life. . . . We have now for the first time the possibility of representing, however crudely, the essence of reality, that is, motion" (8). Although the popular and critical responses to cinema represent a different register than Deleuze's theorization of the movement-image, the emphasis on essence (via Bergson) joins them. If motion is related, at both levels of discourse, to cinematic "essence," then how might this accepted idea relate to—or even cover over—the function of other kinds of essentialist models of meaning in the development of cinema? How are motion, the body, and cinema linked through the rhetoric of "essence"? How might the essentialist connections between the body's physical attributes and its "meaning," so important to the earliest motion pictures, impact the rhetoric of cinematic "essence"? And how, in turn, does the rhetoric of cinematic essence impact cinematic representation? Untangling these intertwined notions of essence can help us to understand the role race difference and

racial essentialism have played in the cinema's signifying practices. In order to understand this—or even to recognize it—we must first think about how race difference functioned to mediate and visualize the perceived relation between motion and essence.

We might think about this relationship in terms of the way motion studies impacted the history of cinema: both in establishing the elusiveness of "true" representations of motion and in revealing the desire for a perfect legibility based on graphic depictions of bodily movement. Étienne-Jules Marey, whose motion studies and chronophotography were important to the development of motion pictures, was ultimately (like Bergson) uninterested in cinema. Again, for Marey, cinema merely reproduced the limitations of the naked eye. He was not looking for the illusion or reproduction of movement; rather, he wished to depict movement, to capture it with no missing moments. As Mary Ann Doane points out, his desire for total storage (of time) was equaled by his desire for absolute legibility, but the two goals interfered with one another. That is, the more he tried to capture duration photographically, the more the multiple images overlapped on the photographic plates, becoming blurred and hard to read.[27] And, inevitably, there were still temporal gaps. Because of this, Marey favored graphic techniques because they could better combine "complete continuity" and perfect legibility.[28] His early graphic method involved physically connecting wires to bodies in motion and attaching them to machines that would mechanically graph their movements (a proto-cinematic precursor to contemporary "motion capture" techniques). Even when he turned to photography, he devised what he called "geometric chronophotography" to produce graph-like geometric patterns: not pictures of the bodies in motion but rather graphic depictions of motion itself and its duration. Here we see a real attempt to "emancipate" motion, while also capturing and visualizing it.

We also see this drive for a perfect legibility associated with bodily movement in early uses of film and photography in anthropology. Fatimah Tobing Rony uses the example of Felix-Louis Regnault's work on West Africans, including chronophotography and cinema, to trace the continuities between Marey's work, motion studies, and a project like Regnault's, which "conceived the ethnographic film archive as a visualizing technology for the taxonomic ranking of peoples."[29] His work focused on what he called "le langage par gestes," and his particular fascination with movement and gesture was fundamental to what Rony calls the "writing of race," since "he thought that the races revealed themselves in movement" (46). Interestingly, just

showing the subjects' bodies in motion was not enough. "Racializing" these bodies involved turning gesture and movement into hieroglyphics, as Regnault supplemented his subjects with techniques that highlight the intertwining of cinematic and racial signifiers. Rony points to something revealing when she notes that the bodies of the West African subjects in Regnault's films "are rendered as *shadows*," dressed and filmed such that their faces are obscured, and they appear, as she puts it, "to be behind a screen, like shadow puppets" (54). Like Marey's graphic depictions, this "shadow" method translates bodily motion and gesture into highly expressive and legible figures, but here those figures are explicitly racialized, transforming individual gestures into a kind of alphabet for reading racial meaning.[30] In Regnault and Marey, then (and the scientific discourses in which they participated) a definitive tension exists between the desire to track movement and time (both "essential" qualities of life) and the desire to read the surface. The racialized body highlights, even epitomizes, the way meaning is created through these seemingly antithetical drives. In other words, the rhetoric of race (and the depiction of the racialized body) intervenes in order to accommodate the paradoxical urge to capture movement in order to fix meaning.

In the drive to unlock "essence," then, fundamental tensions exist between bodies, their motion, and their meaning. To produce meaning, these various graphic methods attempt to "emancipate" the essence of motion from bodies by bringing it to the surface. What might this have to do with the strategies of early motion pictures—particularly those that meld the logic of display with a basic narrative structure within the boundaries of the single shot and the still frame? In his influential work on early cinematic narrative, Noel Burch identified two modes of cinematic storytelling: Passions and chases. He argues that the earliest chase films, which typically unfold over three shots, represent a crucial transition that ultimately makes possible the classic continuity system. In short, the chase film was the earliest example of a narrative logic leading to the next shot. Since the camera was stationary in these early films, the shot change made up for the camera's inability to chase after the chase. The Passion film functions in Burch's argument as the chase film's antithesis, since filmed versions of the Passion utilized to its greatest extent "the tableau-like scene having its own dramatic momentum."[31] The interweaving of these style-genres was crucial, Burch suggests, to the development of narrative forms in cinema. The move from what he calls the "autarchy of the primitive shot" to the "linearization" of multiple shots will make possible the definition

of offscreen space, spatial contiguity, and temporal continuities necessary for the centering and inclusion of the spectator/subject that will come to define the classical continuity system.[32]

Interestingly, Burch begins his discussion of the chase film with a kind of proto-chase film, *The Miller and the Sweep* (Hepworth, 1897). Variations on this subject would be made many times by many filmmakers in the cinema's early years, but the central joke remains the same: one way or another, the titular characters meet and, through a fight or some unhappy accident involving the "tools" of their respective trades (flour and soot), they "blacken" and "whiten" each other. In the 1897 example, after the miller and sweep have chased each other out of the frame, a hitherto unseen crowd appears and runs across the frame after them. Because it is a one-shot film, it ends there—it does not pursue the pursuit. Burch suggests this film offers a glimpse of things to come, pointing, perhaps unwittingly, "to the historical need which was answered by the chase film."[33] A few years later, *The Chimney Sweep and the Miller* (AM&B, 1900) offers no chase, nor any suggestion of one. It just repeats the joke. Miller and sweep approach each other from opposite sides of the frame, the miller dressed in white, his face dusted with flour, and the sweep dressed in black, his face blackened by soot (Figure 3). They proceed to have a sack fight; black soot and white flour billow out and fill up the screen, almost entirely obscuring the two men (Figure 4). It seems significant that the 1897 treatment of this subject serves, if not a transitional role, then a prophetic one in the trajectory of narrative cinema traced by Burch. That is, what if it's not just a coincidence that this proto-chase moment occurs in a film about the substitution of black for white (and vice versa)?

The sheer number of films of this period that feature versions of the blackening/whitening gag—films that rely on any number of props including barrels of coal, chicken feathers, cream, soap suds, and so forth—points to the popularity of these jokes and to their perceived suitability for cinema.[34] But what might the adaptation of these jokes for the cinema tell us about these liminal moments when "pure spectacle" seems to gesture toward something else? What if the "special effect" of flour and soot flying across the film frame contained, in and of itself, a fundamental strategy for limning and exceeding the boundaries of the frame? If *Animated Picture Studio* literalized the "emancipation" of the moving image, then the miller/sweep films offer another kind of emancipation: the ecstatic release of flour and soot emancipates and combines essence(s) that "become" motion. Rather than picturing motion as essence, the film offers

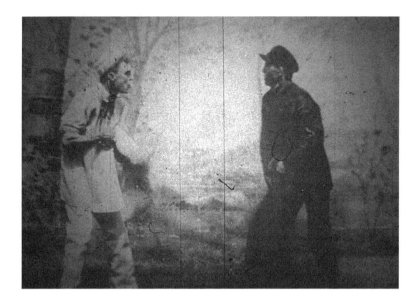

Figure 3. The chimney sweep and the miller prepare for a sack fight. *The Chimney Sweep and the Miller* (AM&B, 1900). Library of Congress, Paper Print Collection, Motion Picture, Broadcasting, and Recorded Sound Division.

Figure 4. Black soot and white flour fill the screen. *The Chimney Sweep and the Miller* (AM&B, 1900).

us essence-in-motion. While the miller/sweep films are not technically "trick films," they certainly present a popular trick based on immersion, transformation, and exchange. And this recurring (and often racialized) "trick" played a role in accommodating the sometimes-conflicting demands of "attractions" to those of narrative. As I later suggest, the "trick" of black/white exchange bears a special relationship to early narrative and to the ultimate "trick" of the cinema itself.

The potential racial meaning of these jokes is explicit in some of these blackening/whitening films, while others seem only to gesture in that direction, to highlight a character's skin color by (temporarily) changing it. But it's hard not to see all versions of the blackening/whitening joke as underwritten by racial meaning, especially given the close relation between these films and the gags coming out of the tradition of blackface minstrelsy. When the subjects in the film are African American (as in *A Morning Bath, A Hard Wash,* or *A Bucket of Cream Ale,* for example), the racist nature of the joke is clear in the setup and often in the way these films were described in catalogs. As noted above, early "race subjects" not only continued the racial/ethnic humor from vaudeville stages; they also provided opportunities for showcasing the new medium's ability to represent real life in all its contrast and clarity. The "high-contrast" spectacle of films such as *A Morning Bath* and *A Hard Wash* reinforces race difference and depends upon the "indelibility" of skin color (in particular, the "amusing" futility of trying to wash off blackness). But in a film such as *The Chimney Sweep and the Miller,* which features "white" men, the scenario references skin color while playing with the "pure" pleasure of essences and opposites.[35] In other words, the playfulness is here enabled by the fact that the miller and sweep are both white and male. *The Chimney Sweep and the Miller* offers the perfect visual for early cinema—the dust here offering "a lively mix-up of black and white,"[36] as the Biograph catalog put it, one of those "effects" typically emphasized in catalogs for exhibitors, like the smoke of train films or battle re-enactments. At the same time, however, it differs from *A Morning Bath* in that the spectacle of miller and sweep also obscures vision, and thus the joys of visual contrast coincide with a "realistic" effect associated with other senses: as black and white fill the screen, the "effect" is the possibility of its presence, of its billowing out and covering the audience with dust.[37]

While the miller/sweep films do not explicitly reference race, then, identity exchange is certainly a part of the ecstatic joy evoked by the exchange of the materials with which the laborers are quite physically identified.

The potential for mistaken identity also links it to a common theme of more explicit race subjects.[38] As simple as the joke is, its richness comes from the play between physical material and social function: the yoking and unyoking of who you are to what you do. In the case of the miller and the sweep, how you look is inescapable evidence of what you do—the miller cannot escape flour just as the sweep cannot escape soot. The miller and the sweep are physically, economically, and conceptually attached to their respective materials. The meet-up offers an analogical relation (miller: flour :: sweep:soot), but one in which each side of the equation offers the "opposite" image of the other because of the representational power and social or aesthetic significance of black and white. In other words, the analogy offers a mirror image that is also a negative image (in the photographic sense). At the same time, taken together, all of the elements figure the perfectly symmetrical, "total" transformation of black-to-white and white-to-black. In Burch's account of the 1897 Hepworth film, he sums up the nature of the joke with a reference to the end of the film when "the miller runs out of frame pursued by the sweep (or is it the other way around)?" (147). The set piece thus tends toward (or teases us with) racial significance. Like the blackface mask (and unlike skin), soot and flour are removable. And yet the joke depends upon the physical attachment of laborer to material—certainly a notch down from skin color in terms of permanence, but to the degree that the link becomes iconic (defining the man with his function), it becomes *like* identity based on skin color. And so, while the material becomes a metonym for the laborer's identity, the whole transaction between the two iconic laborers becomes a metaphor for irreconcilable (social/racial/aesthetic) difference. The metonym bonds the body to both social function and physical material, and that bondage underwrites the joy and freedom represented by letting the dust fly. Yet, the reversal only reinforces the representational poles of black and white, as essences are merely traded. The two men remain yoked to each other by the force of opposition and the lure of symmetry. The transaction offers motion, framed and contained—essences are "in motion" but the setup (which stands in for physical, structural, and social limits) creates a closed loop.

Formally, however, this set piece also extends the possibilities of motion within and beyond the static frame. Particularly in Biograph's *The Chimney Sweep and the Miller*, the gag extends the frame by extending the metaphor: the analogical relation between miller/flour and sweep/soot creates another one between the faces of the men and the screen itself.

The Chimney Sweep and the Miller is more intent on the display rather than the joke or the cause-and-effect relation—it functions like a dance, with a large part of the satisfaction coming at the surface level as the dust engulfs the screen. In this sense the film's pleasures are pictorial, and the film is suggestive of both photography and proto-cinematic illusions and screen practices including phantasmagoria. In phantasmagoria, projecting on smoke gave an undulating, spectral life to its subjects; here, clouds of black and white recall a kind of smoke screen, activating the surface of the screen as the site where images come into and out of focus. Flour and soot announce themselves as essential materials—that is, as both essential and material, both necessary for and representative of specific kinds of labor. They offer difference, boiled down. Yet essences are not only traded but dispelled as the dust flies, suggesting the mixture of materiality and immateriality on screen, where particles of dust and light take shape. This is significant because it suggests a metaphoric link between the black/white exchange (understood as the crossing of physical, material, and social boundaries) and the breaching (and re-establishing) of the boundary between image and audience.

One way to understand this is to read the 1897 moment to which Burch points a bit differently. For Burch, when the "previously unseen" crowd enters the frame in Hepworth's *The Miller and the Sweep*,[39] the important thing is the initiation of a chase and the suggestion of multiple-shot films to come. But what if we instead understood this moment in terms of the audience entering the frame, crossing a previously unacknowledged boundary to become part of the spectacle? Rather than seeing this moment as an invitation to the chase, then, we might see the representative sack fight as an invitation to the spectator—an invitation that creates a link between on-screen transformations and the act of watching films. It is a given in film studies that the starkest difference between early cinema and classical cinema lies in their modes of address. To varying degrees, early motion pictures utilized direct address, acknowledging the audience and "playing to the front," until classical style ultimately closes off the narrative space from the theater audience and incorporates a spectatorial position into the text in order to establish spatial and temporal coherence, encourage identification, and produce meaning. And yet the notion of the relatively "direct" relation between early motion pictures and the audience has been understood rather transparently, its shifting usage and purpose largely ignored. Characterizing early films as "enframed" rather than "emplotted," Tom Gunning has noted that "spectator relations

are direct and relatively unmediated by concern with story."[40] Yet to varying degrees, this direct relationship with the spectator, while "unmediated" by story, itself mediates the relation between narrative and spectacle, a function that still needs decoding. The metaphoric link between on-screen motion/boundary crossings and the screen boundary itself is crucial to constructing a particular kind of audience address, both direct and "indirect." The films we are discussing are "in-between" —that is, they meld the "pure" spectacle of performance or exhibition films with basic narrative. The combination of direct and what I am calling indirect address (that is, the indirect or metaphoric gesture toward the screen boundary) helps take these one-shot narratives away from pure movement and exhibition to an intermediary mode that both turns toward and away from the audience, even if the narrative world is not yet closed off from that audience. The film turns away from them but still references them. Understood in this way, the 1897 miller/sweep film gives a taste, not just of the chase, but also of the double "face," if you will, of these early narratives. The fight between the miller and the sweep is happening on screen and "somewhere else," but the crowd/audience can still take part.

As noted above, Biograph's 1902 treatment of the miller/sweep scenario contains no suggestion of a chase and no gesture toward a possible "next shot." In *Peeping Tom in the Dressing Room* (AM&B, 1905), another one-shot film, we see a different treatment of a similar joke: more blackening and whitening, this time with tools of a different trade. Although it ostensibly treats a very different subject, we can read this film as a later, more narrative-oriented version of the miller/sweep scenario. The film in fact combines two subjects that were already iconic by 1905: gags involving blackening or whitening and those centered on the capture and punishment of a Peeping Tom. Peeping Toms almost immediately became apt subjects for the movies, as some of the earliest motion pictures offered up portraits of male voyeurism to the very men looking through peephole devices. Biograph made its first *Peeping Tom* in 1897 (for the mutoscope) and returned to the subject in its 1905 film *Peeping Tom in the Dressing Room*.[41] The 1897 film offers a frame within a frame, as the peeper appears at a window; the 1905 film, meanwhile, utilizes what would by then have been the familiar divided frame: on the left we see a ladies dressing room; on the right, another dressing room in which a man peeps through a hole in the wall that divides the two spaces. The characters' costumes suggest we are backstage at a vaudeville show. Two men enter the room on the right and catch the peeper in the act. One of the men is dressed in blackface

and wears the checkered suit and top hat associated with the "Zip Coon" figure from minstrel shows. He grabs the Peeping Tom and blacks his face with a towel. The two men then drag him to the ladies dressing room. When they re-enter through the door in the background of the left frame, the two women attack the peeper with their powder puffs, dusting his (blackened) face with white powder (Figure 5). Here, the suggested "racial" transformation is also an emasculation. After breaching the boundary between gendered spaces by looking through the wall, he first gets "blacked," and then, after physically crossing the spatial boundary and entering the women's room, he is simultaneously whitened and feminized with powder. With that, the transformation is complete, as the various reversals all reference the overarching one: the spectator/peeper becomes the spectacle.

While *The Chimney Sweep and the Miller* emphasizes the picture plane and the spectacle unfolding within the frame/shot, *Peeping Tom in the Dressing Room* emphasizes spatial and temporal sequencing, creating the feeling of a two-shot film by using the divided frame. An action occurs in the frame on the right—the capturing/blackening of the peeper—and upon completion of that action, all the actors leave that frame (though the door) and re-enter on the left, where the punishment continues

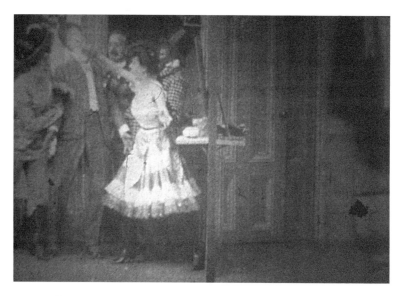

Figure 5. The Peeping Tom gets punished with powder. *Peeping Tom in the Dressing Room* (AM&B, 1905). Library of Congress, Paper Print Collection, Motion Picture, Broadcasting, and Recorded Sound Division.

through reversal (the whitening). This is similar to the way early chase films work, even though they would unfold over several shots (and this one-shot film would have co-existed with multishot narratives).[42] In those early chase films, we don't cut to the next shot until everyone involved in the chase has left the frame. Here, we don't have a chase so much as the kind of one-two punch or "before and after" logic of the comic strip or sight gag.[43] In the American context, we might also think about the prints published and sold by Currier and Ives in the late nineteenth century, which included the popular "Darktown" series featuring racist stereotypes and humorous scenes, many of which were published as two-part, before-and-after "companion pieces."[44] This film does not emphasize the picture plane or visual effects in the way that *The Chimney Sweep and the Miller* does, as it is more concerned with causality and the story space. And yet *Peeping Tom* retains its connection to the audience via the blackening and whitening of the face. In *The Chimney Sweep and the Miller,* the black/white "mix-up" exceeds the faces of the men and invades the surface of the screen, emphasizing the picture plane while also obliterating the screen boundary. In *Peeping Tom,* the movement from one frame to the next is accompanied by the blackface/whiteface routine. The powdering of the victim's face is played more squarely to the front than the rest of the action, but more importantly, the film creates a link between the black/white transformation, played on the face, and the movement from one frame (functioning like a shot) to the next.

In this sense the blackening/whitening in *Peeping Tom* functions like the "pie in the face" of slapstick comedy (substituting blackface and powder in the face). It's worth noting that the blackface is applied, in this and many other films of this era, with a white towel, and thus the action resembles a pie in the face as much as the powder puff does. In his work on slapstick, Donald Crafton adapts Gunning's discussion of the "cinema of attractions" to recast the narrative/spectacle divide in terms of the "pie and chase" logic of comedy. In his argument, "pie" refers to "pie in the face" but stands in for the pure spectacle of the gag. He represents the "irreconcilable differences" between these two modes in terms of directionality: the "vertical, paradigmatic domain of slapstick" as opposed to the "horizontal, syntagmatic domain of the story" associated with "chase."[45] The version of spectacle or "attraction" represented by slapstick conjures the physical/sensual "impact" on the spectator as theorized by Eisenstein, but in a particular way.[46] The gag, in other words, needn't be a literal "pie in the face," but it works like a pie in the face(s) of the audience. Crafton

is discussing later films—slapstick comedies from the teens on—and he wants to maintain the equation of narrative with forward progression and of spectacle with interruption. But in these early narratives, the blackening/whitening gags do not really stop the action or interrupt the narrative with spectacle, since, in these one-shot films, the narrative or "chase" logic is limited. In other words, when all you really have is "pie" (or display), it does not necessarily function as stoppage—but rather as another way to move, to "break out" of the limitations of the frame. The blackening/whitening doesn't work like just any gag, however. It offers a particularly effective, even emblematic, way to relate the movement and transformations on screen to a movement toward the audience, essentially creating a metaphoric relation between two different kinds of boundary crossing.

Of course, the miller/sweep joke—and others like it involving black/white "mix-ups" and exchanges—predates cinema and vaudeville. As Susan Gubar has noted, the representation of "racechange" in Western art has ancient roots. She begins her study of the phenomenon with a consideration of a Janiform vase from the sixth century B.C. depicting two female heads—one European, one African—facing opposite directions, a racialized version of the two-faced form associated with the Roman god Janus.[47] Janus was the Roman god of portals, and the Janus face gives definitive shape to ambivalence, freezing a moment of coming and going in order to suggest man's essential dualism. Similarly, black/white intersections and reversals of the miller/sweep variety contain motion within stasis—a figure for the "change" that does nothing to interrupt the fundamental binary. I want to stay with the notion of portals here in order to further explore how these scenes of black/white boundary crossing point to other kinds of boundaries—in particular, the filmic boundaries represented by the frame and by the screen itself. Gubar suggests that race-change is inherently self-reflexive, identifying it as "an extravagant aesthetic construction that functions self-reflexively to comment on representation in general, racial representation in particular."[48] I want to suggest that in early cinema this commentary plays out in terms of linking on-screen boundary crossing to crossing the screen boundary. In the one-shot film, this has the effect of pulling the audience in, using the boundary between spectator and spectacle to expand/exceed the frame. Ultimately, this creates a back and forth between the trick/transformation of race-change and the power of the cinematic apparatus to trick or transform the spectator.

In *Jokes and Their Relation to the Unconscious*, Freud, too, makes a reference to the Janus-face, though not with specific reference to "racechange"

or race jokes. Freud maintains that all jokes "present a double face to their hearer, forc[ing] him to adopt two different views of them."[49] By "two different views," he means one that just takes in the surface sense (or nonsense) of the words, and one that "passes along the path of thought through the unconscious" (266), where a totally different, deeper, perhaps even opposite sense might be understood. The pleasure in the joke, Freud theorizes, derives from the "difference between these two methods of viewing it" (292). I would suggest that there is a relation between the Janus-face as a figure for the ambivalence of "racechange" (as in Gubar's example) and as a figure for the "two-faced" nature of jokes in general. In the latter sense, jokes produce humor by condensing two (opposed) meanings or ways of seeing. Both Gubar's and Freud's examples are about seeing doubly: about seeing (or being) more than one thing and by being in more than one place at a time. In this way the ambivalence in terms of content also works structurally; that is, it (appropriately) points in both directions: to the subject of the joke and to the listener. Earlier, I mentioned the "double face" of early films that gesture toward the audience while also maintaining a narrative framework. "Racechange" offers a particularly reflexive marker of this doubleness by linking the "back and forth" of black and white to the "back and forth" of spectacle (gag) and viewer (listener). Racial and ethnic humor already brought "something extra" to pure spectacle in the earliest motion pictures, and racial boundary crossing offered one of the most effective ways of exploiting this "multidirectional" approach to motion and (narrative) meaning.

When I was young, one of my uncles used to take a conspiratorial tone with my cousins and me and ask, "Do you want to hear a dirty joke?" When we nodded, he would say, "Three white horses fell in the mud." I seem to recall this happening repeatedly, though it's hard to know why we would have fallen for it more than once. But, of course, we didn't "fall for it" more than once. The joke was supposed to disappoint, to hit its target by pulling its punch (line). This was one of those jokes in which the gullible listener is mocked or punished. What we didn't know at first was that the question "Do you want to hear a dirty joke?" was actually part of the joke. In other words, the joke worked like a trick (or perhaps more accurately, the trick worked like a joke). The joke is *knowing,* self-referential—and it takes advantage of an unsuspecting listener. It worked, in other words, a lot like the many early motion pictures that would set up the spectator with a question or another kind of title that would be recognized as the setup for a joke or as a barker-like invitation to see something titillating

(e.g., *What Happened on 23rd Street; What Demoralized the Barber Shop; How They Do Things on the Bowery,* etc.). But more importantly, in this joke, to fall *for it* was to fall *in it.* That is, the unsuspecting listener is like the horses that fell in the mud. Why? Because when asked if she or he wants to hear a dirty joke—if she or he wants to "get dirty"—the listener says yes. It mingles the desire to be titillated with the tendency to believe, to be gullible. To fall in the mud is to fall for the trick, but also to believe in, to be absorbed (and even changed) by an illusion. And so the hilarity comes not from imagining the horses fall but in seeing the listener fall (and thus it's funnier for the teller than it is for the listener). This failed or trick joke would likely fall into the category of "the comic" for Freud (given its variation on watching another person fall), and its dependence on evoking the visual makes it a verbal reference to a sight gag—akin to the blackening/whitening gags of the miller/sweep films, *Peeping Tom in the Dressing Room,* and countless others. But more importantly, like those screen jokes, the verbal joke links the falling/blackening scenario *in* the joke to the relationship created *by* the joke. When the listener says "yes," he or she crosses over the boundary between joke and listener . . . and falls in the mud. As a result, the mud puddle refers simultaneously to the joke-telling scenario, to the most basic of narratives (something happens), and to the interplay between joke, teller, and audience. This is precisely what's happening in the early film narratives or gags we've been discussing—especially those that take advantage of black/white boundary crossing.

The black/white exchange discussed here works as both a trick and a joke, creating movement that expands the frame, merging essence and motion, and linking on-screen (and racialized) boundary crossing to the boundary between spectator and spectacle. In these films, these links work through metaphor. In the early narratives in the next section, the mediating function of race difference and identity exchange is more literal, as are the references to the screen boundary. And although we are still primarily discussing one-shot films, the narratives are slightly more developed versions of the black/white mix-up spectacles described above. The "tricks" in these films are associated with a tricky use of the frame. These narratives—primarily one-shot films that open up, segment, divide, or otherwise exploit and play with the frame—represent an intermediary mode that seems to perform or hesitate the translation of body to image. These films create narrative interest by exploiting the relation between static framing and moving bodies, highlighting the triple function of the screen as surface, as boundary between image and audience, and as the "frame" or

delimiter of narrative space. In particular, a number of these films use the racialized black/white binary and related plays on presence and absence to link motion to boundaries of one kind or another. As critics who resist the identification of early films with theatrical modes of address suggest, the emphasis on the frame in many early films actually alienates them from the theatrical model. Although limited in many cases to the one-shot, frontal perspective mode, these films often used that limitation to call attention to the space of the screen, to the very conditions of their performance, rather than to mimic theater. Here, I am concerned with the way these films connect the logic of movement with a "screen logic" associated with both an awareness of the picture plane and with reflexive playfulness about the movie screen as the boundary between image and audience.

Speed/Limits: Metaphor, Metonymy, and Motion

In the last section, I noted the way the stock miller/sweep gag took advantage of metonymy and metaphor. Soot and flour metonymically figure the "opposed" labors, and this physical connection to their materials makes the two laborers "like" each other even while they represent absolute difference. Further, to the degree that the whole transaction plays with identity exchange, with white becoming black and vice versa, it becomes a metaphor for or fantasy of racial transformation. As figures of speech, metaphor and metonymy are related but different approaches to renaming. Metaphor (from the Greek word for "to bear or carry over, to transfer") is defined as "the figure of speech in which a name or descriptive term is transferred to an object different from, but analogous to that which it is properly applicable." Metonymy, meanwhile, "consists in substituting for the name of a thing the name of an attribute of it or of something closely related."[50] In choosing to expand the meaning of an object by changing its name, the question would seem to be: how far do you want to go? With its emphasis on transfers, "metaphor" implies motion, a movement from one thing or place to another. Metonymy, on the other hand, stays close to home; it renames by choosing something nearby, attached to, or associated with its object. In metonymy, renaming does not involve relocation or removal, but rather a shift in perspective in which the attribute replaces or expresses the entity.

As I discuss in more detail below, these figures of speech—and specifically their role in psychoanalytic theories of the fetish—have been important for discussions of sexuality, race, and the stereotype. The play of

presence and absence, and of closeness and distance, suggested by the fetish is taken more literally, as we shall see, in these one-shot narratives that face the double challenge of creating motion in the still frame and creating meaning (especially narrative meaning) out of motion. The racialized figure offers one way to meet this double challenge by being both fixed and mobile. If the "racialized" or "ethnographic" body is, to use Rony's formulation, "always in a contradictory position, both 'real' and sign" (62), then this contradictory position allows the racialized figure to function both metonymically and metaphorically. This figure that takes you somewhere while staying in the same place turns out to be crucial to these early narratives, which must, in a sense, do the same thing.

In thinking about early films that play with the frame, critics often point to British producer James Williamson's *The Big Swallow* (1901). In this one-minute film, a man approaches the camera and "swallows" it—that is, he opens his mouth in a close-up, the gaping chasm creating a blackscreen, obliterating the picture by seeming to swallow the source. He then retreats, thus appearing back in frame, and laughs.[51] The "swallow" has been read as aggression against the camera—but of course the audience, too, is being swallowed. In a sense this film is like the many very popular tunnel films (Hale's tours, etc.), which gave the feeling of riding through a tunnel. In these, the fade to black is caused by movement through a tunnel; in the *Big Swallow,* a body moves toward us (rather than the spectator moving through the tunnel), and the blackscreen is the inside of someone's mouth. While both these fades to black are actually caused by physical movement and are attached to real spaces, in Edison's 1903 film *What Happened in the Tunnel,* there is no "real tunnel," only one suggested by blackscreen. This substitution takes on added levels of meaning via the film's racially charged subject matter. The symbolic relationship between black and white and Black and White creates a complex relationship between what is seen and what is not seen. That is, "race" multiplies the play of presence and absence in the film, linking metonymy with metaphor, in order to tie physical/spatial referents to symbolic meaning and substitution.

What Happened in the Tunnel is one of the earliest examples of another racist-comic "subgenre": the interracial kiss film. The film, which is about a minute in length, shows a white woman and a black maid sitting together on a train. Behind them sits a white man, a "masher" who won't stop flirting with the white woman. The train then goes through the tunnel (represented by a fade to black), and when it emerges (fade up), we discover that the man has taken advantage of the darkness to steal a kiss.

We also discover (as does the man) that he has been "tricked." The women have switched seats, and he apparently has kissed the black maid by mistake. We only see the kiss briefly; he is kissing her cheek when we fade up, but he pulls away quickly as he discovers his mistake. He is angry, and the women, meanwhile, are convulsed in fits of laughter (Figure 6). As noted earlier, filmmakers began exploiting the potentially symbolic relation between black and white and Black and White with the earliest motion pictures, exploiting this connection to show off the sharpness and contrast of the photography. *What Happened in the Tunnel* takes this connection further, however, by linking racial meaning to the cinema's nascent signifying practices.

This film, and the women, pull off the trick with the help of darkness. The women fool the man, and the film creates something—in fact, the key to this little "joke"—out of "nothing." That is, the fade to black here forms part of the narrative. The blackscreen suggests the darkness we suppose the characters to experience, and it denotes a specific amount of time (not a metaphoric time lapse as in scene changes). Tunnels themselves

Figure 6. The "misdirected kiss" in *What Happened in the Tunnel* (Edison, 1903). Library of Congress, Paper Print Collection, Motion Picture, Broadcasting, and Recorded Sound Division.

had already been established as attractions in train films. *What Happened in the Tunnel* references one of the most successful cinema spectacles ever shown on the vaudeville stage: Biograph's *Haverstraw Tunnel* of 1897. In this "travelogue," the camera is mounted on a moving train, and the audience gets to "ride the movie," hurtling through space with the train. The film "was designed to produce an almost physiological thrill in audiences by giving them the illusion of . . . actually moving through space."[52] Or as one British reviewer put it in 1897, "Instead of the scenes and figures coming towards you, you seem to be going to them, and the effect is decidedly strange."[53] In the Edison film, however, our viewpoint is utterly changed; we are in the train, and the racially and sexually titillating scene is substituted for "beautiful scenery on each side."[54] While we glimpse moving scenery out the window, the movement is merely suggested; this movie does not offer the audience the vicarious tour of a faraway place or a known geographic edifice such as the Haverstraw Tunnel. But the film's use of blackscreen not only signifies a specific kind of movement (through a tunnel), it also enables transgression and substitution—in effect substituting racial boundary crossing for movement through space. Here, the suggestion of a tunnel produces its own "almost physiological thrill," not by offering the viewers the feeling of "moving through space," but by representing (and enabling) sexual and racial transgression.

By this time, a train moving through a tunnel had already been established as a metaphor for sex; the blackscreen-as-tunnel offers a shorthand for that connection, while also functioning as a cinematic sleight of hand that uses one meaning (movement through a tunnel) to distract viewers through misdirection, as all the real movement (side-to-side movement, not forward progression) is happening inside the train. Although that kind of movement doesn't go anywhere in the literal sense, it suggests possibilities that take the people on the train (and the spectator) much farther—even to a place they are not willing to admit they want to go. The motion picture had the power to reproduce the world in motion—but the fade to black makes meaning out of motion not by showing it, but by suggesting it, by being a metaphor for it. At the same time, race difference functions as a substitute for "real" movement—a supplement that makes the illusion of motion even more convincing. The fade to black substitutes an editing technique for the display of bodies/trains in motion, and racial difference is crucial to the symbolic connections being made. This is why the "tunnel" in this film can do so much rhetorical and narrative work: represented by the fade to black, it covers up a potentially

transgressive act while the fade itself suggests the substitution of black for white. The "tunnel" functions less to represent distance or even time than to make meaning, and the link between the two acts of substitution (the cinematic fade and the women taking each other's places) helps to adapt the cinema's most basic conditions (motion, darkness, and light) to narrative.

A number of critics have discussed *What Happened in the Tunnel* (and other "interracial kiss" films) in terms of the way it suggests the blurring of boundaries and the threat to hierarchies represented by the technological and social upheavals of urban modernity. In her study of trains and cinema, Lynne Kirby notes how the film takes advantage of the train as an "in-between space" where social codes can be (at least temporarily) transgressed or upended. Train films were like trick films, she points out, in that they "allow[ed] quick appearance and disappearance to occur within the diegetic space."[55] Kirby focuses primarily on gender roles and sexuality, but Jacqueline Stewart, in her study of urban migration and black moviegoing, places the film in the context of "accidental" interracial kiss films and focuses on the "Black female domestic" as a complicated "assertive mediating presence."[56] She notes the way this film—and the role of the Black female domestic in these interracial jokes and sexual encounters—suggests the ways that "Blacks are both transgressing and blurring the boundaries between white public and private spaces" at the turn of the century.[57] And a number of other critics have focused on the cooperation between the white woman and her black servant in playing tricks on white men.[58] But I want to place the film in a slightly different context—comparing it not merely to other train films or to other interracial kiss and racist joke films, but to films that equate literal, physical boundaries with other kinds of boundaries—social, sexual, racial. This is particularly clear in one-shot films that split the screen or that create multiple frames using walls, doors, windows, and so on. Further, I want to suggest the way race difference offers a way for early films to make the transition from literal to figurative levels of meaning and to create or suggest motion in the context of the still frame. Both are crucial operations in negotiating the relation between display and narrative and in accommodating the different, but related, pleasures associated with "attractions" and stories.

In *The Unappreciated Joke* (Edison, 1903), a train scene leads to another joke involving a "switcheroo." The one-shot film takes place on a subway car. The passengers sit, facing the camera, their backs to covered windows. A man reads something funny in a newspaper and shares it with the fellow next to him, who laughs as the man elbows him and shows him

the paper (both men are white and seemingly middle-aged). Unbeknownst to the man with the paper, the other man gets off the train and is "replaced" by a white woman, an "elderly woman" (as the catalog describes her) who takes the seat. He continues to laugh, poking her in the ribs repeatedly and slapping her leg. She is angry, and when he discovers his mistake, he "sinks to the floor."[59] Since we can't see out the windows, there is nothing in the frame to suggest movement except for our knowledge that they are on a train car. The switch from one passenger (and one gender) to another provides both the movement and the "action"; the switch leading to inappropriate physical contact is what "happens" here, just as the interracial kiss is what "happens" in the tunnel. Again, this film suggests the way trains and other modern contrivances threaten boundaries and social mores (especially in ways that endanger women's virtue). But those threats are not just a product of the train's motion—rather, the sometimes inappropriate mixing and mingling of different bodies results from the mixture of motion and stasis. Just as trains offer both an example of and a figure for the restless motion of modern life and for the ability to bridge distances and close gaps, they are also a site of physical and social imprisonment. That is, on a train, one is both moving and sitting still, hurtling through space and trapped in a box. This is one of the many "parallels" between cinema and trains, as we could say the same thing for audiences who sit still and move or travel vicariously by watching films that offer their own "panoramic" views.[60] But I am thinking more of a formal parallel. These early narratives must do more than display moving bodies or machines, and whether they unfold in one shot or more, for the most part they must make something happen by exploiting the still frame. Like so many of theses early narratives, *The Unappreciated Joke* creates movement within the still frame—at the end, the man not only sinks to the floor but completely out of frame, leaving an empty seat. His ability to "disappear" is not facilitated by the train, but by the frame. When the "switch" involves substituting a black woman for a white one, as in *Tunnel,* things also get more complicated, adding another level of meaning to a filmic device (the fade). In other words, the film's meaning depends upon editing and the changing "frame" of reference, not merely on bodies moving within the frame. Just as a fade to black represents simultaneously a movement through a tunnel, a potential sexual transgression, and the substitution of black for white, the trading places device—perhaps especially in a relatively simple film like *Unappreciated Joke*—works as a kind of "internal edit" that links *moving* from one place to another to

being one person or another, and finally to *occupying one social position or another.*[61]

In *Black Skin, White Masks,* Franz Fanon encounters his own objectification—the knowledge that he is "an object in the midst of other objects" in the white world, overdetermined by what he calls the "racial epidermal schema."[62] It is perhaps no accident that his emblematic story of interpellation takes place on a train: he situates this cruel knowledge by recounting a story that unfolds on a train when a little white girl points and shouts, "Look, a Negro!" Fanon speaks of this moment not in terms of attaining what W. E. B. Du Bois famously called a "double consciousness," but rather in terms of "exist[ing] triply": "In the train it was no longer a question of being aware of my body in the third person but in a triple person. In the train I was given not one, but two, three places" (112). Fanon both moves and stands still; he "occupies space" and is occupied by the colonizer, whom he both projects and introjects: "I moved toward the other . . . and the evanescent other, hostile but not opaque, transparent, not there, disappeared. Nausea" (112). The description is one of motion sickness caused by the collapse of the physical and the fantasmatic: for Fanon, the "racial epidermal schema" *takes the place of* the "corporeal schema" (112). The train, then, is an apt setting for such a realization, but at the same time, it is itself a metaphor. In a film like *What Happened in the Tunnel,* the train setting only partially accounts for the film's ability to connect physical boundaries to social, sexual, racial, and visual/filmic boundaries; just as crucial is the function performed by the black female body as the threat of miscegenation. In particular, the racialized body is more properly thought of here as a figure that occupies multiple places and connects multiple planes of meaning. In so doing, that figure enables the film to work out the productive tensions between motion and stasis and between seeing and meaning. It turns out that narrative—especially in the context of static framing and the seemingly continuous view (that is, a film that looks like a "one-shot" film even though it contains an edit)—is not merely about forward progression but also about the exploration of multidirectional and multifaceted motion within literal and metaphoric limits.

Homi Bhabha makes reference to the moment of interpellation described by Fanon in his elucidation of the stereotype as fetish—that is, as the colonizer's response to racial difference as represented by the colonial Other. He defines the stereotype as "at once a substitute and a shadow,"[63] by which he means to suggest the interplay of metaphor and metonymy in the psychoanalytic concept of the fetish. The fetish functions as a substitute

for the perceived lack (classically, a woman's lack of a phallus) and thus works like a metaphor, but on the other hand it also reminds us of that lack by being linked or contiguous to it (metonymically, like a shadow). Bhabha sees Fanon's scene on the train as part of the "scenario of colonialist fantasy": "By acceding to the wildest fantasies (in the popular sense) of the colonizer, the stereotyped Other reveals something of the fantasy (as desire, defense) of that position of mastery."[64] In other words, the stereotype is a productive but also potentially disruptive site for colonialist projection and fantasy. I want to think about metaphor and metonymy as they relate to the different kinds of motion in these one-shot films—and to the rhetorical work done by the black body and by the substitutions and interminglings of black and white in these visual jokes. This is another way of thinking about the "tunnel" in *What Happened in the Tunnel*. The fade to black both substitutes for actual movement (a metaphor for movement through space) and metonymically suggests movement through a tunnel via the darkness associated with it. This mode of "being and not being" links its meaning to the meaning of the action going on inside the train car: a kiss that both is and isn't and a racial identity that both is and isn't exchangeable. That is, the substitution of the black maid "negates" the suggested kiss between the white man and woman, while a kiss still "happened" but remains mostly unseen. Similarly, the women switch places but not races, and any "commingling" is displaced onto the forbidden/rejected interracial kiss.

And thus the signifying power of the simple fade to black grows, fusing and expanding the literal and metaphoric levels of meaning in which it participates. While this may seem like a lot of pressure to put on a fade to black (and on one one-minute film), if we think about the "tunnel" as one of the various kinds of boundaries and frames created in one-shot films involving other potentially transgressive scenarios, we can see it as part of a significant pattern. In looking at these films together, we can understand how the play of metaphor and metonymy so crucial to the productive function of the racial stereotype can help us better understand the role race difference plays in turning the limitations of the early film frame into possibilities for narrative. The manipulation of presence and absence is key to early cinematic narratives and to the "cinema of attractions." As Gunning has noted, the "cinema of attractions" differs from the classical narrative trajectory in that it depends on surprise and exhibition, and on the "alternation of presence /absence," rather than on a chain of causality and the solving of an enigma.[65] Gunning's examples are primarily

concerned with gender and erotic display in films such as *What Happened on 23rd Street?; Pull Down the Curtain, Susie;* and others. But when race difference is central to the titillating "now you see it / now you don't" formula, how does the logic of display (and the narrative logic it compels) shift? The manipulation of presence and absence—always connected to assumptions about what the spectator expects or desires—defines the relation between screen and audience in terms of corresponding binaries. "Now you see it / now you don't" implies a theoretically endless back and forth that links what you *can* see with what you *want* to see. But it's not just that the appearances and disappearances of the trick film and the related switches, mix-ups, and misidentifications of early narrative and joke films can "go both ways." The inclusion of race difference in the "mix" reveals the falseness of the binaries. On the surface, the concept of race defined according to a Black/White binary seems to reinforce the boundary between presence and absence so important to these films. Yet race difference functions more properly as a supplement, at once defining and revealing the trick: making bodies appear and disappear, or substituting a black body for white only makes clear the importance of misdirection in constructing (rather than interrupting) desire. The back and forth, the ride through a tunnel—these elements that are crudely associated with sexual desire now must also be freighted with racial meaning, trading places, racial mix-ups, and miscegenation. As such, the "alternation of presence/absence" exceeds any binary definition and reveals a multidirectional, multifaceted motion. The play of presence and absence becomes less literal than metaphorical, condensing unspoken connections between physical/sensory shock, mis- or dis-identification, and desire.

If we return for a moment to the Janus-face as a figure frozen between coming and going, we can think about the multiple functions of portals and boundaries in these early films and their association with racial and sexual boundaries. Like Michael Rogin and other scholars who have dealt with blackface, Gubar identifies "racechange" (in all its forms, not just blackface) as a "trick" that "participates in the illicit, the liminal, the transgressive, the outré, the comic, or the camp."[66] I would intervene here to argue that the "racechanges" and other race gags I discuss here are not tricks to be displayed or enhanced by cinema, even if they are presented that way. Rather, race difference itself works, rhetorically, like a trick, one that enables or supplements screen tricks. Films like *What Happened in the Tunnel* are, in fact, tricks, even if they don't always employ technical tricks. They are about playing tricks, and they play tricks on the spectator.

To focus on the way literal boundaries (frames, screens, windows) are used in these early films is to think seriously about how filmic boundaries are supplemented by racial boundaries, and vice versa. And it also offers the opportunity to think about how this play on boundaries connects the back-and-forth, presence/absence dialectic to the more fundamental boundary between spectator and spectacle, a boundary that, in early cinema, is often quite explicitly represented by the screen itself—by the frame and its multiple on-screen iterations and proxies.

In these early films, the joke is always, in some sense, on the spectator. Many film titles beckon to the spectator, promising something titillating. A number of these films at least partially deliver on their erotic promise to the spectator. On the other hand, a number of films mock the male spectator by punishing his on-screen proxy (e.g., mashers, Peeping Toms, cheating husbands). If the spectator for these films is understood to be largely male (and white and heterosexual), then the "punishment" typically has to do either with the man in the film getting caught in the act or with the spectator getting a kind of "anti-erotic" punch line. Of course, these films may also provide a little payback for the increasing number of women in the crowd. So, in one film a wife or older woman might pour a bucket of water on a male peeper's head *(The Animated Poster);* in another, the object of desire turns out to be something "undesirable"—for example, a man instead of a woman *(Barber's Dee-Lite);* or the man in the film gets what he wants, but with the "wrong" object (the films in the "misdirected kiss" genre).[67] The connections between movie viewing and voyeuristic peeping are as old as the movies themselves, but perhaps more importantly, the erotic connection between seeing and touching—a physical connection that was reinforced in the viewing practices associated with hand-cranked devices like the mutoscope—informed popular understandings of and figurations of the movie spectator.[68] As mentioned above, some films offered dream-come-true scenarios for the male spectator, while others played with and played on the typical desired connections between looking and touching.

Girl at the Window (AM&B, 1903), for example, sets up certain expectations with its title. A number of films offered silhouette scenes of women dressing or undressing behind a shaded window. Here, however, a young woman sits at her window and looks out toward the viewer. Framed in a medium shot with her upper body (chest up) framed perfectly by lace curtains, she takes turns looking through binoculars and then lowering them and just looking around unaided. Finally, she finds her target—a

man comes to the window, and she grabs him and kisses him (Figure 7). She then lends him her binoculars, and he looks toward the viewer with them as she smiles knowingly to camera. Not only does this film reverse the expected looking/looked-at roles in terms of gender—it winks at the viewer, at what he might have expected from a woman at a window. He would, at the very least, expect to *see*, not be seen. She is the "bearer of the look," even the user of a technology associated with voyeurism. Yet she also gives the man—who enters the frame as if he has emerged from the crowd in the theater—what he wants.[69]

A Kiss in the Dark (AM&B, 1904) has much in common with *Tunnel*, but it also plays on the "girl at the window" scenario. As in the earlier Edison film, a white woman enlists the help of her black female domestic to play a trick on a would-be suitor, and the film ends with an "accidental" interracial kiss. Rather than taking place on a train, however, *Kiss* unfolds in another liminal space: outside a house, in front of a set of windows. The window acts as the boundary between public and private space as the suitor, playing Romeo, attempts to woo a white woman standing at her window. The frame consists of three windows, with the main action taking

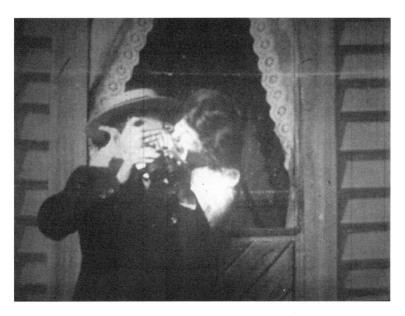

Figure 7. The woman covers her suitor's eyes and kisses him. *Girl at the Window* (AM&B, 1903). Library of Congress, Paper Print Collection, Motion Picture, Broadcasting, and Recorded Sound Division.

place at the center window. The film begins with the man flirting with the white woman; when he turns his back in frustration, she disappears, and her maid (a large "mammy" figure wearing a kerchief) takes her place.[70] The interior of the house is not visible to the spectator—the characters in the window are highlighted by the total darkness of the interior. Thus, when the white woman leaves, she seems to disappear, and her servant seems to come out of nowhere to take her place. While the man still faces the camera, his back to the window, the servant covers his eyes, looks at us knowingly, and kisses him (Figure 8). Here again, the film differs from *Tunnel.* The kiss is performed to camera, and it is relatively prolonged, as the maid and the man hold hands, arms outstretched (Figure 9). There is no cover offered by a tunnel and no interruption of the kiss. The Biograph catalog description puts it this way: "[The white mistress] plays a joke on him by causing a colored maid to take her place. The young man does not notice the change, and kisses the wench rapturously."[71] During the kiss, the man enjoys *being kissed* (despite the active voice in Biograph's description); he is clearly in the subservient position, as the woman stands above him and controls the action.

Figure 8. Another "blind" kiss: the mistress watches while her maid prepares to surprise the suitor. *A Kiss in the Dark* (AM&B, 1904). Library of Congress, Paper Print Collection, Motion Picture, Broadcasting, and Recorded Sound Division.

Figure 9. The man reacts with joy to the "rapturous" kiss. *A Kiss in the Dark* (AM&B, 1904).

This is a specific example of what Jacqueline Stewart suggests when she notes the "assertive mediating presence" of the black female domestic in these early films.[72] Certainly, these films use the black maid in order to play out titillating scenarios and forbidden desires between white men and white women. The black domestic figure mediates the romantic/sexual possibilities between the white couple by enacting a romantic/sexual "impossibility" (interracial intimacy, posed as an absurdity or a mistake, only possible via the white man's temporary blindness). The "blindness" that enables the transgression stands in for a larger cultural blindness—a willing suspension of belief, if you will—about white male desire for black women, particularly when it came to the history of sexual relations between white men and black women during slavery. The commanding physical presence and strength of the "mammy" figure mitigates or undercuts her sexuality, while also allowing her to usurp the man's role as sexual aggressor.[73] She comes between the white couple, "rescuing" the white woman (again, taking on a role typically performed by a man) by both acting out and defusing any sexual desire (simultaneously "punishing" and fulfilling the white man's advances). Even if we read this film, as some have read *What Happened in the Tunnel,* as depicting the cooperation and

camaraderie between women (against the aggressive, unwanted advances of white men), that would really only increase the axes of desire along which the black servant's body serves a mediating or screen-like function. She smiles broadly as she performs this task, as the mammy figure must when doing the white woman's dirty work. Thus if the white woman's sexual desire is projected onto the black servant, her virtue is also guaranteed by the substitution, and this transaction involves both a racial "switch" and a reversal of gender/sexual roles. In this context, the film's logic is continuous with nineteenth-century scientific discourses that contracted biological theories of race difference via gender and sexuality and that defined issues of sexuality via racial categories. Particularly in studies of the black female, there was a tendency to define her body in terms of sexual attributes that connoted sexual appetite and promiscuity against a white femininity understood as a site of virtue and restraint.

But I would argue that her mediating function goes further than this, especially if we think seriously for a moment about the sparse but telling mise-en-scène. If *What Happened in the Tunnel* took advantage of its train setting to create visual metaphors for sex and mobility, *A Kiss in the Dark* reverses the train scenario in order to create movement within the still frame while also maintaining the man's situational blindness. Rather than placing us inside a train car, with moving scenery visible out the window, here we are on the outside looking into an apartment building. The scene and the building are stationary; all the movement is on the inside (though framed, again, by windows). The switch from white woman to black woman is not enacted by a simple trading of places, as on the train. Here, the white woman disappears; only after the black woman appears in the window do we see the white woman come into frame (within her own frame) at the next window. While the tunnel provided the fade to black that represents both a real space (the tunnel) and a real (and metaphoric) substitution, here the mise-en-scène sets up a succession of images. The man first flirts with the white woman, and then she leaves; he looks in the window, now just an empty space represented by total darkness. When he turns around, a woman reappears at the window—the black woman comes into view. The row of windows is reminiscent of a series of train cars with passengers at each window, but more important here is the need for the woman to "come out" or emerge from her window frame. The window setup also emphasizes the doubled spectator function, with the audience represented by the male suitor, beckoning and poking his head at the middle window, and also by the white woman, who watches from her separately

framed space at the next window. The multiple-window framing links spectatorship, the screened/framed image, and the succession of images/shots suggesting physical motion. And so rather than the train being like cinema, the cinema here suggests the ways it can be like a train, with a very different method for taking us places. The linear progression of the woman from one window to the next is combined with the more magical appearance and disappearance of the women coming into and out of the darkened window frame. To further understand this, we must compare *A Kiss in the Dark* to other kinds of films—in particular those that involve women emerging from posters and paintings.

A Kiss in the Dark strongly resembles this genre of trick films that capitalized on stage magicians' tricks involving two-dimensional pictures coming to life. One of the more popular involved beautiful women emerging from posters, often to bestow a kiss on a male admirer. Erik Barnouw traces a number of early film versions of this trick to an 1893 illusion by David Devant called *The Artist's Dream* in which a portrait turned into a real woman.[74] Two versions of this trick show the rewards and punishments associated with male voyeurism—on the one hand, the object of fantasy come to life is the dream come true; on the other, the films, taken cumulatively, follow a "look, don't touch" logic. In *Kiss Me!* (AM&B, 1904), the trick is offered at its most basic: a man encounters a poster of a scantily clad woman, among other posters for burlesque shows; unlike the other posters, which are light colored and pasted to the wall that forms the backdrop of the film, this one offers a white woman against a black background (so as to accommodate the real woman). The frame she inhabits is "torn" at the upper left corner to aid in the sense that she is merely a two-dimensional picture. He leans in for a kiss (Figure 10), but his wife appears and shoos him away. The spectator who wishes to become something more—one who touches and is touched by the picture—goes away unsatisfied.

Released just a year before *Kiss Me!*, Edison's *The Animated Poster* (1903), riffs on the poster-woman formula. Here, a man pastes up a poster for a burlesque show (in thirds); with two-thirds of the poster up, we see the wall "open up"—it turns out that he is about to poster over an old woman's window. She opens the shutters and pokes her head out, effectively "finishing" the poster by adding her face to the scantily clad dancing girl's body. This is the joke—and the poster hanger and a male passer-by point and laugh as the poster-hanger closes the shutters. But the woman gets her revenge: she opens the shutters and pours a bucket of water on the

Figure 10. One man leans in to get a kiss from a poster in *Kiss Me!* (AM&B, 1904). Library of Congress, Paper Print Collection, Motion Picture, Broadcasting, and Recorded Sound Division.

Figure 11. Another man waits for a woman to lean out a window in *A Kiss in the Dark* (AM&B, 1904).

men's heads. The Edison film plays with the trick/formula not only by substituting an "undesirable" woman for the desirable one and by allowing the woman to have the last laugh, but also by doing away with the "trick" element. The work done by mattes, editing, double exposures, or other techniques is here executed by simply opening and closing the shutter. The trick of turning two-dimensional pictures into living women is here a matter of adding "dimension" to the screen: no trick transformation, just a manipulation of the frame that plays on the relation between the flat image plane and real, live bodies. *A Kiss in the Dark* plays on both the "woman at the window" scenario and the living picture trick—making it clear that both scenarios offer a trick, even if they don't always utilize illusionist methods. The film links the Black/White switch with the reversal of gender roles. The aggressive male spectator loses the power to watch as the white woman gains it, and the erotic charge of passivity is linked to being "taken in," with crossing the plane and entering the frame. One of Méliès versions of the living picture trick emphasizes the screen as the boundary between three-dimensional bodies and two-dimensional images. In *The Living Playing Cards* (1904), a series of cards "come to life." The first giant playing card is a queen—a dissolve allows the picture to become a real queen who gracefully steps out of the picture and onto the stage. Then, a king "comes to life" in a different way: he bursts through the card. Finally, Méliès, who has been presenting the trick, shows us a blank white playing card, which he then jumps into and disappears. In other words, the fantasy goes both ways, and for the powerful magician/male spectator, diving into the frame (or being pulled across the boundary by the living picture) can be a desirable way to lose that power.

In this context, it might be more fruitful to think about these films of cooperation between a white mistress and a black maid not as "buddy films" but as the female version of films (and stage shows) featuring a male magician and his (usually female) assistant. But who is the magician and who is the assistant? The black domestic appears at the window, conjured by her white mistress. As the servant, she "assists" the white woman in pulling off the joke; but through her, the white woman also "vanishes" (temporarily, only to reappear somewhere else). The greatest difference between the standard magic trick film (e.g., "vanishing lady" tricks) and these "misdirected kiss" films is that the latter are not just about appearing and disappearing, or transforming one person into another: they are largely about doing versus watching, and through the trick, the white woman gets to both watch and (through a mediator) "do." In *A Kiss in the*

Dark, the switch is not only about the black woman taking the white woman's place; it is also about multiplying the places the women are able to occupy. Their switch allows them to take the (typically male) positions of spectator and sexual aggressor. Their cross-over both enables and references the crossing of racial, sexual, and physical boundaries, with the interracial kiss breaching those boundaries and, in so doing, standing in for the erotics of being "taken in" by a trick. The multiple boundaries in the film (the building between the man and the woman, the multiple window frames) compensate for the forbidden nature of the kiss, but the abundance of frames and boundaries is also reiterated by the excessiveness of the kiss itself. The more exaggerated the gag—the more overpowering and broad the mammy stereotype, the greater the joy expressed by the man—the "funnier" the joke and the more successful the deflection of any actual desire. The transgression can thus both exceed the frame and be contained by it.

If we think about the "excessive" framing and the excessive nature of the spectacle, it is not so difficult to link *A Kiss in the Dark* to one of the films with which we began this chapter, *Uncle Josh at the Moving Picture Show.* Remember, in that film (made two years earlier), a man stands in front of a screen framed by curtains, trying to interact with the images. In *A Kiss in the Dark,* the man tries to touch what he sees in the "frame"—a real woman who nonetheless vanishes just as surely as the moving images Uncle Josh "embraces." When he finally gets what he thinks he wants, it turns out to be the "wrong" woman; when Uncle Josh finally grabs what he wants, he gets the wrong man—the projectionist. Miriam Hansen has noted that Uncle Josh seems to be the victim of an "excess of appeals."[75] But he is also "excessive," as is signified by his inappropriate spectatorship, and ultimately by the reversal in which the spectator becomes the spectacle. We see this reversal, and its relation to excess, in *A Kiss in the Dark,* but the triangulation of desire and the exploitation of race difference in that film function to multiply both the positions that can be occupied and reversed and the directions and symbolic "places" the narrative can go. Like Uncle Josh, the man in the kiss film stands between us and the framed images (the women), but the black maid figure serves a more significant mediating function—she stands between the internal spectator (the white woman) and the spectators of the film, looking directly at us as the joke unfolds. And so while this film may construct the white woman as image, like the other films described above, it plays with this notion; but much more narrative "hay" can be made from this play on

images because of the racial charge. The black woman mediates the relation between the white woman and the white man, as well as the relation between spectator and spectacle, and in so doing she connects and directs these various planes of action.

The more we widen the context in which we view these misdirected kiss films, the more we can see the multiple levels on which they work to maximize the narrative potential of the static frame. This context of course includes films that utilize similar setups and punch lines, without necessarily involving an obvious "race angle." Another important subgenre, particularly for the working out of male/female power dynamics, offers love triangles or scenes in which men are brought up short by a pair of women; many of these also make particular use of windows, doors, screens, and other props to provide division and movement within the still frame. Films like *A Kiss in the Dark* and *What Happened in the Tunnel* offer triangles that aren't really triangles, or that don't want to admit they are triangles: both because she seems to do her mistress's bidding and because she is perceived as an inappropriate or undesirable object for the white man, the maid cannot be the "other woman." But the scenario does provide a kind of mirror for the "other woman" scenario, in the sense that it offers a fantasy in which the (white) woman gets to control and redirect the man's desire. In the more prevalent love triangle films, a wife catches her husband cheating, usually with either a (white) maid or with his secretary. The wronged wife gets to be the secret peeper in these films, but she is punished rather than empowered or titillated by what she sees.

Silhouette Scene (AM&B, 1903) unfolds over three shots. In the first, we see a husband and wife sitting at a table having a meal; the set is fairly sparse, offering a dining room with a window in the background. In the next shot, the wife walks down the sidewalk in front of the building; in the window (the same window we saw from inside, we must presume), she sees a man and a woman kissing, in silhouette against the shade; this is accomplished not with actual shadows on a window shade but with a separate film matted into the window frame (Figure 12). In the next shot, the wife re-enters the dining room, breaks up the hanky-panky, and chases her husband around the room. The film ends with the (now fired) maid entering the frame in street clothes to receive her wages. In *A Kiss in the Dark,* the white woman enjoys her spectatorial position, one "frame" over from where the action is in the next window. Here, the wife is on the outside looking in, the unwilling/unwitting spectator looking at another kind of "kiss in the dark." With the multiple shots, the window becomes a more definitive

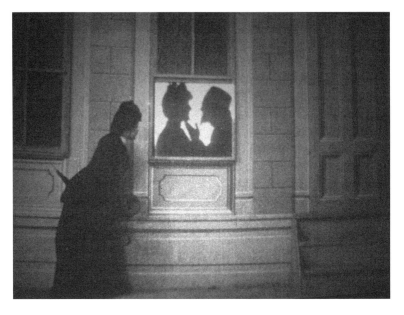

Figure 12. A wife sees her husband's infidelity on screen in *Silhouette Scene* (AM&B, 1903). Library of Congress, Paper Print Collection, Motion Picture, Broadcasting, and Recorded Sound Division.

boundary: the site of the girl at the window in the earlier films is now a movie screen, and the wife must go over to the door at the right of the frame to get back in the house and "interrupt" the picture in the next shot.

Blackmail (AM&B, 1905) offers another picture of female collaboration (this time between two white women whose class and marital status is a bit unclear). Like many films from this period, *Blackmail* utilizes a divided frame to delineate two rooms separated by a wall. On the right, a door and entryway; on the left, an office with a man sitting at a desk. In this film, the function of the setup is primarily to allow us to watch two simultaneous actions going on, to spy on things in much the same way as the two women do. In the entryway, two women hatch a plan. One of the women enters the office through a door visible in the background of the office frame; as she flirts with the man at the desk, the other woman enters and snaps a photo. When both women are back in the entryway (the frame on the right), they continue to collude. Then the woman with the camera enters the office and blackmails the man while her accomplice eavesdrops at the wall. Together again in the entryway, the two women celebrate while the man gesticulates and fumes at his desk. This film offers a typical

scenario in which the "detective camera" (and sometimes the motion picture apparatus) is used to capture private, embarrassing moments. The camera here (as opposed to a domestic servant) grants power. The fact that women are the detectives (and even blackmailers) here is less typical. As Tom Gunning has noted, the detective camera, with its power to lay bare private moments, was often associated with mischievous boys.[76] The more typical model—a boy or young man making private, embarrassing moments public—shows up in *The Story the Biograph Told* (AM&B, 1904). In that film, the crime is the same—hanky-panky in an office between a man and a secretary—but a young man captures it all with a motion picture camera. Later, we see the resulting movie screened in a theater—with the adulterous man and his wife in the audience. But that film unfolds over several shots and thus does not utilize the split screen setup we see in *Blackmail.*

If we return to Biograph's *Peeping Tom in the Dressing Room,* which was released the same year as *Blackmail,* we can compare the way split screen offers opportunities for both the serial "before and after" logic of the joke and for the development of narrative based on simultaneous actions and contiguous spaces. While both films are about "peeping" of one kind and another, *Blackmail* makes greater use of both the simultaneous action and contiguous spaces, making the divided frame seem more a part of the narrative world, rather than just a pictorial, comic strip–like device. Both sides of the divide are used throughout *Blackmail.* Early on, one woman listens in behind the wall while the other entraps the man. As the film ends, the two women celebrate on one side while the man fumes on the other, and the setup enables the audience the simultaneous, opposing views. *Blackmail* plays much less to the audience, however, than *Peeping Tom in the Dressing Room;* in that film, as mentioned, once the action in the right frame/room is finished, all of the actors leave that side and continue the action in the left frame/room. With its references to male voyeurism and blackface minstrelsy, *Dressing Room* is more oriented to the spectacle, and the blackening/whitening gag enables the linking of more than one kind of movement, including the gesture toward the audience in its multiple reversals and boundary crossings. The misdirected kiss films, meanwhile, make even more efficient use of racialized rhetoric, exploiting to the greatest degree the symbolic possibilities of identity exchange and interracial desire in order to exploit to the greatest degree the boundaries of the static frame. *Blackmail* is like *A Kiss in the Dark* in the sense that it is a setup—that is, it is not a love triangle, but rather a

scenario in which two women play a trick on a male victim. But the use of the frame and the nature of the "reversal" are fairly straightforward. Through metaphor and metonymy, the racially charged misdirected kiss films combine the gag based on the manipulation of presence and absence, and before and after, with the creation of symbolic connections between physical and symbolic space. The various kinds of "back and forth" (including the gestures beyond the screen, toward the spectator) turn the frame into a complex symbolic nexus, as spectatorial expectations and desires help the film "move" in both directions while standing still.

In cinema's earliest signifying practices, then, we see a linkage of miscegenation and racial boundary crossing to motion and its limits. While cinema *is* motion, cinematic signification is encoded through the limitation or disciplining of its defining condition, particularly in the development of narrative cinema. With the move to longer, multishot narratives, the logic of racial disguise, reversals, and miscegenation continues to meld stasis and motion and to link physical, social, and filmic limits. Let's consider a fairly typical post-1905 chase film—one that ends up with another meeting of a train ride and a black/white reversal. *The Subpoena Server* (AM&B, 1906) begins with a man sitting comfortably in his living room. When the subpoena server finds him, a chase ensues. The server chases the man in and out of the three doors visible in frame and up and down the staircase that occupies the background (the camera is stationary). In the next shot, the man enters the kitchen, and the cook helps him disguise himself as a woman. He escapes in a dumbwaiter that takes him outside. He then catches a cab and drives off with the subpoena server chasing on foot. The man winds up on a train. Still trying to elude the server, he dresses up as a waiter. A black waiter furthers the disguise by "blacking" the man's face for him, and he succeeds in eluding the server. Some confusion follows as people run through the car, and a hobo enters and sprays the man with a seltzer bottle. The man wipes his face, inadvertently removing his "disguise," and he is caught.

Like other early chase films, *The Subpoena Server* hasn't quite got the rhythm of the chase down yet. There are long gaps when the chasee seems in little danger because we really have no idea where the subpoena server is. The "demand" for the next shot is often belatedly obeyed, and the thrill of the chase gives way to the comedy of the server's inadequacy. We see the man drive off in the cab in a long shot, for example, and only after the car has left the frame does the subpoena server appear, running a distant second. The two share the frame only at the beginning and end of the

film. The disguise moments work two ways to help increase the tension of the chase: they increase the chances that the man will be caught because he must stop while his costume is being created, and they also keep the chase going, adding a new way for the chase to go, and a new way for the pursued man to escape. Like doors, stairways, windows, and dumbwaiters in the film, the gender and racial disguises act as portals that open up the frame and redirect the chase in increasingly unique and ingenious ways. Ads for the film acknowledged that the public might already have grown tired of the typical chase film, and the ads tried to distinguish the film by claiming it "embodies so many novel situations that it is in no respect like its predecessors."[77] In other words, the film is "novel" because it contains so many constantly changing situations. With each disguise, the chase seems to start anew. Cross-gender and cross-racial disguises keep the chase "going." But the racial disguise also marks the end of the line, a place reached, not surprisingly, by train. Again, a train is both a means of escape and a trap. Once the man is caught, there is no place to go. Disguise is the only refuge.

The tension, then, does not come from a rapid foot race or a rhythmic succession of shots. The tensest moments—in the kitchen and on the train—are also the "stillest": in both the chased man waits until his disguise is complete. In both scenes, a servant dresses the man in his or her likeness. The white maid puts a skirt and shawl on her employer, and the black waiter applies blackface to his white customer. In between, another servant, who seems to work in the furnace room of the house, delays the subpoena server after he comes out of the dumbwaiter—by throwing coal in his face. All of the servants are "in on it" with the well-to-do man, their labor supporting his threatened freedom. This is not unlike the maids in the misdirected kiss films, whose function is to help their white mistresses escape. On the train, the man asks the waiter for a disguise; the (white) conductor comes along and negotiates with the man; money is exchanged. The waiter goes off screen and comes back with an apron, but he then gestures and points to his face, suggesting the inadequacy of the disguise and the need for blackface. He exits again and comes back with a bucket, from which he applies the blackface (with a white towel) to complete the man's disguise (Figure 13). This disguise/gag has its own logic, of course, and the wiping on of blackface must be followed by its wiping off (much like the blackening/whitening gags above). When the man gets sprayed with water, he wipes his blackface off with a similar towel. More important than the chase, it seems, is bringing this circuit to completion. Indeed,

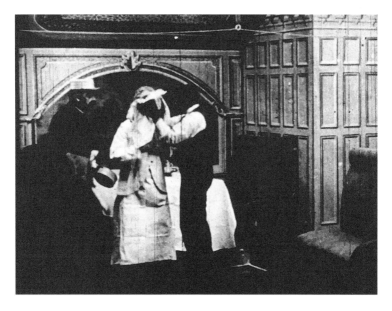

Figure 13. Applying the blackface disguise in *The Subpoena Server* (AM&B, 1906). Library of Congress, Paper Print Collection, Motion Picture, Broadcasting, and Recorded Sound Division.

these comic chase films are more about getting from one gag to another than anything else.

In the living room scene, they are given some room to move via doors and a stairway that suggest the rest of the house. The last scene, however, takes place on a train, and the characters are confined to the dining car. Interestingly, on the train, neither the man nor the server is running around. All the "action" of this scene takes place in front of that window, where a moving backdrop provides the illusion of movement. The racial "quick-change" takes place right in front of the window and is played to the front. The easy wipe-on/wipe-off gesture creates a kind of movement within the frame. The moment on the train is not opposed to the narrative motion of the "chase"; rather, the blackface routine stands in for motion, suggests it, much like the moving backdrop out the train window. But like the moving backdrop, racial disguise ultimately signifies stasis: like the backdrop, it re-emphasizes the fact that while one element is moving, something else (the train car, the man's "real" racial identity) is standing still.[78] As multi-shot narratives develop, cross-racial identification acts as the meeting place of speed and its limit. The well-established on/off blackface

switch allows the man to give his predator the slip while also inevitably leading to his capture. The gag keeps things moving within the static frame, but more importantly, as I have tried to suggest throughout this chapter, the racializing of the black/white gag signifies a coexistence of motion and stasis that is key to the linking of literal and metaphoric meaning in these early narratives.

This connection is particularly important for expanding and playing with the limitations of the frame in the one-shot narrative, but the logic continues to inform cinematic narrative as montage and camera movement take over for the "performing body." The relation between narrative and spectacle (and related oppositions between stasis and forward progression, and between passivity and activity) have long been understood, in film theory, through the male/female binary, especially within readings of classical cinema that depend upon identification and the gaze. These categories are more complex and fluid prior to the classical style, but by looking at the earliest motion pictures, we can also begin to understand how race disturbs these theoretical formulations. The tensions between passivity and activity—between display and narrative drive—predate the star fetishism of classic Hollywood cinema. The racially and ethnically charged gags in early cinema negotiate the space between these seemingly competing cinematic modes, often condensing motion and stillness and mediating "active" and "passive" models of spectatorship. These early narratives play with more fluid spectatorial positions (watching and doing, looking and touching, on screen and in the theater) by linking the boundaries of the static frame to spectator/spectacle relations; and these boundaries are repeatedly exploited, transcended, and figured through racialized bodies.

2 FACE, RACE, AND SCREEN

Close-ups and the Transition to the Feature Film

IF, IN THE FIRST YEARS OF THE TWENTIETH CENTURY, the cinema was finding many ways to turn exhibition into narrative, by the teens American cinema turned its attention toward realism and respectability, which often meant turning away from its past. As American cinema stood at the threshold of the feature film era, cinema's realism and cultural status would depend upon formal techniques that would ensure spatial and temporal coherence and encourage the spectator's identification and "incorporation" into the cinematic text. As the narrative system developed and films moved toward realism, "restrained" performance codes, and classical style, no single formal technique was as debated, derided, and celebrated as the close-up. As numerous scholars have charted, the shifts in the narrative system and modes of address were defined, in part, by the severance of the bodies on screen from the bodies in the theater—which really amounts to the (fantasmatic) severance of the spectator from her own body. In the coming pages, I consider how the cinema's realism and cultural status will depend upon a further division, a kind of decapitation: the severance of the face from the body in the making of the "screen face" or close-up. As we will see, "race" plays an important role in the making of the screen face. But this operation depends, first, on the detachment of the screen image from the performing body—and the weight of this is felt most clearly in the rhetoric surrounding the close-up. The uneasy (even monstrous) relation of performing body and performing image will be erased, repressed with the rise of classical style, when the cinema will try repeatedly to outrun its past, especially its relation to minstrelsy, magic, "low comedy," and other stage spectacles. But various moments in cinema mark the return of that repressed relation. Anxieties about the signifying powers of the film image are displaced onto the contest between the expressive

powers of the body versus those of the face, and as American cinema stood at the threshold of the feature film era and the threshold of respectability, the racial dimension of those boundaries emerge.

Six years after having dismissed the cinema as something to be enjoyed only in the "poorer sections of the city where innumerable foreigners congregate,"[1] The *Independent* belatedly heralded the "birth of a new art" in 1914: "We have now for the first time the possibility of representing, however crudely, the essence of reality, that is, motion."[2] Almost a decade after the birth of motion pictures, the *Independent* saw fit to dedicate a regular department (titled "The Moving World") to the cinema, testifying to its increasing significance and rising cultural status. These different attitudes toward the cinema—from dismissive disgust in 1908 to begrudging belief in 1914—roughly encapsulate what scholars typically refer to as the "transitional era" in American cinema. While the exact dates differ slightly from one scholar to the next, the period from around 1907 to around 1915 saw major changes as well as increased standardization in production, distribution, and exhibition practices. Among these were the formation (in 1908) and dissolution (in 1913) of the Motion Picture Patents Company; the increased output of films to match unprecedented demand; and the dominance of the narrative film in the market and the relative standardization of its form and length (most films were around a thousand feet). Toward the end of this period, the feature film arrives and brings with it new experimentation and standardization leading to "classical" style and industry integration.[3]

While the comments from the *Independent* are in tune, then, with their historical moment—even proclaiming the "birth of a new art" just a year before D. W. Griffith's *Birth of a Nation*—I want to look closer at the way the magazine's newfound interest in film as "art" signals related efforts to define and renew the cinema at this (still) transitional moment in 1914. In another installment of "The Moving World," the *Independent*'s reviewer focuses on two elements as uniquely cinematic: the camera's ability to capture motion (the "essence of reality") and the revelatory power of the close-up. Referring to the latter, the reviewer extols the expressiveness of actors' faces: "[W]hile we cannot know what the characters say, we can know what they think much better."[4] Ultimately, it is not so much about the value of the art as it is the quality of the illusion, however. In a wistful nod to disavowal, the reviewer reminds readers that the images are "undeniably mere shadows on a plane surface" (165), but notes that the increasing realism and expressive power found on movie screens made this easy

to forget. The transitional era was also one in which the industry (producers, exhibitors, and the trade press) was engaged, as Eileen Bowser puts it, in a program of "uplift"—making the cinema more respectable in order to appeal to a wider audience (and to charge higher prices).[5] In that project, defining the cinema's specificity is key: do these "mere shadows" constantly reference all that is missing from the cinema (e.g., sync sound, realistic color) or does the screen's image, its shadow, offer a substance unavailable on stage or anywhere else?

In a sense, this is a more historically specific way of thinking about what Christian Metz famously called cinema's "imaginary signifier"—imaginary because "what is characteristic of the cinema (as opposed to, say, the theater or a novel), is not the imaginary that it may happen to represent, but the imaginary that it *is* from the start" (because what we see before us is not really before us, but has been recorded).[6] While this notion (and Metz's semiological approach to cinema in general) has been critiqued of late, I am interested in taking Metz at his word(s). Interestingly enough, Metz described this imaginary, this absence, in material terms: "For it is the signifier itself . . . that is recorded, that is absence: a little rolled up perforated strip which 'contains' vast landscapes, fixed battles . . . and whole lifetimes, and yet can be enclosed in the familiar round tin, of modest dimensions, clear proof that it does not 'really' contain all that."[7] Now, the "little rolled up perforated strip" is not, itself, the signifier—Metz knows this, of course; it's part of his point. But what I like is the clear preference, in Metz's comment, for disbelief, for that unthreatening little tin ("familiar" and of "modest dimension"). It's almost as if, for Metz, it's not the cinema's "lack" that must be covered up (as demanded by the logic of the fetish); rather, it's the cinema's abundance that must be denied, covered over by the tin. He cuts the cinema down to size—castrates it, if you will. Metz sounds very much like the reviewer for the *Independent*, reminding viewers and himself that the images they see are "undeniably mere shadows on a plane surface." The tug-of-war that we see, even in Metz, between the immaterial and the material—between vast shadow landscapes and little round tins—is vivid, ongoing, and explicit in the silent era. And the degree to which viewers and critics ponder the medium—its magical potential along with its sometimes clunky reality—reveals the knowing back and forth between belief and disbelief, hope and disillusionment. The power of the cinema in these early years (and well beyond, I would argue) depends upon the knowledge that these screen images are

"mere shadows"—because those shadows have both the power to repro-
duce real life and to transfigure it.

The *Independent's* move from the cinema as technology (capturing
motion, composed of light and shadow) to the cinema as convincing illu-
sion and finally to the cinema as art suggests the greater concern, in the
early teens, with delineating the definitive features of this new art. Still,
accounts like this one tend to pivot between the cinema's ability to repro-
duce the real world and its special access to a spiritual essence, between
motion and emotion. The play of light and shadow and the expressiveness
afforded by close-ups are most frequently emphasized as uniquely cine-
matic in the press, including the trades and the nascent fan magazines.
During the transitional period, and especially in the early teens, efforts to
define the cinema as an art often depended upon comparisons to—and
differentiations from—the stage. When *Photoplay* begins a regular movie
review department in 1915, for example, it is titled "The Shadow Stage."
The title reflects a typical strategy of borrowing prestige from the theater
while attempting to distinguish the cinema from it.[8] In addition to explor-
ing the close-up here, I also take seriously the representation of the cine-
matic signifier as a shadow and trace the ways in which the relationship
between the close-up and the shadow inform questions of realism during
this period. How does the notion of the "shadow stage" define the cine-
matic illusion as one in need of (and deserving of) the audience's belief?
I consider how the screen image—especially as understood through the
"surface aesthetics" of the close-up and the shadow play—enlivens the
boundary between image and audience, revealing the way audience for-
mation and group identity are linked through structures of belief and
credulity. As I argue, race figures in this rhetoric of cinematic specificity,
supplementing the representation of cinema as a transaction between
material and immaterial, body and shadow. In the first part of this chap-
ter, I discuss the way the discourse around the close-up in the early teens
suggests the tensions between the performing body and the performing
image; in this working out of the "aesthetic of the surface," the rhetoric of
race reveals the larger issues at stake in the relation between surface and
depth, body and sign. In the latter part of this chapter and in the next chap-
ter, I consider the way the "Oriental" stereotype relates to the cinema-as-
shadow. Here, I look closely at the way the cinematic signifier becomes
the subject in *The Cheat* (Cecil B. DeMille, 1915). DeMille's film features
Sessue Hayakawa as a villain in the "yellow heavy" mold, and it also puts the
cinema itself—figured through shadow plays—on stage. Hugely influential

and part of an international validation of the cinema as art, the film is part of the "rebirth" of cinema that makes 1915 a threshold for the feature film and the classical era to come. In its style and themes, the film plays out the links between the rhetoric of face, race, and screen that can be traced in discussions of the cinema in the early teens.

Figuring the cinema as "shadow" involves equal parts novelty and nostalgia. In thinking about the role of reflexivity and nostalgia in the "rebirth" of the cinema, I want to suggest that these encounters between the Oriental stereotype and the screen image (both imagined as shadows) can tell us something about the way race difference informs cinematic realism, spectacle, and narrative. These encounters highlight the issues of materiality and embodiment crucial to shifting notions of realism in the silent era. In particular, the uneasy relationship between performing image and performing body, a fundamental problematic at the heart of cinematic representation, is thematized via race difference. Returning for a moment to the connection made in the last chapter between this tension and the related binaries of presence/absence and motion/stasis—it is important to emphasize that the shadow is only a figure for the cinema's materiality, a metaphor for the cinema's physical conditions that does not reveal those conditions but rather provides an "intermediary" presence in order to re-mystify the cinematic apparatus.[9] In the rhetoric of cinema's specificity so important in the later transitional era, it seems clear that the "shadow stage" will not succeed by mimicking or approaching live theater, but by surpassing it. The films discussed here and in the next chapter really play out the characterizations of the cinema already apparent in the discourse of the early teens surrounding the close-up, realism, and the cinema's "essence." And in the often nostalgic representations of the cinema's magical powers, we see how imagining "race" allows the cinema to re-imagine absence as presence, turning "mere shadows" into pure cinema.

The Body, the Face, and the "Essence of Reality"

While we are concerned here with American cinema in the early teens, I want to return, for a moment, to another genre of early motion pictures: the barbershop film. The barbershop is one of the cinema's earliest subjects, borrowing heavily from the vaudeville stage but immediately exploiting specifically cinematic tricks and turns; they represent early versions of the analogy between the "cutting up" of the scene (in this case, the static frame) and the cutting up of the body. Because of their particular

obsessions, these films can help us understand the relation between the cinema's repressed past and the formal, aesthetic, and spectatorial issues at the heart of the cinema's transition to the feature. If the cinema makes cultural gains during this transitional period in part by differentiating itself from earlier forms and pleasures, what exactly is being repressed, and what remains? And how can racialized bodies function, in this period, both as reminders of that repressed past and as figures for the power of the newly "emancipated" screen image? In barbershop films, we can see the way fragmentation and literal decapitations play on and with race, ethnicity, and gender. In early motion pictures, when the enlarged view was still a novelty and the face had yet to become the primary site of character psychology, the head (rather than the face) often played a starring role.[10] In dividing up space and playing on the relation between the head and the body, barbershop films defined varying ways of dividing the look from the subject as the body itself is cut into pieces. Displacing anxieties about race, ethnicity, and gender, these films demarcate the different kinds of looks and different models of coherence associated with different kinds of bodies—and the dangers inherent in the kinds of transformations that only a barber (or a film) should perform.

Barbershop scenes appeared in some of the earliest motion pictures. *The Barber Shop* (1893), one of the first films made for Edison's kinetoscope, simply featured a man getting a "lightening fast" shave.[11] Barbershop scenes were also a staple of vaudeville stage comedies in the nineteenth century, in which the barbershop became a representative setting for commentary on the changing "face" of the nation.[12] In the era of the one-shot film, the barbershop offered a familiar setting for the physical comedy, camera tricks, peep shows, and gags that made up the "cinema of attractions." These early barbershop films seem to have come in two basic categories: trick films that involved the barber doing funny or horrific things to people's heads, and films that turned the barber shop setting into a kind of peep show. Edison's *What Demoralized the Barber Shop* (1897) is a well-known example of the latter category. In it, the barbershop set acts as an elaborate frame for the central items on display: women's legs. The barbershop is below street level; the frame shows the entrance and stairway leading to the shop at center. To the (audience's) right is the barber's chair, and to the left is a shoeshine chair. As two women walk by on the sidewalk, their legs are framed in the doorway. Their knee-length skirts and striped stockings suggest they may be showgirls or burlesquers, and as they pause in the doorway, they seem to pose and "show off" their legs.

The male customers watch with increasing excitement, falling all over one another to get a glimpse. The film cleverly references the relationship between the largely male audience and the "peep show" offered by early motion pictures, and the frame centered within the frame very much resembles a movie screen. In another version of this gag, *The Barber's Dee-Lite* (AM&B, 1905), the joke is (ultimately) on the male spectators. The set looks very similar to the earlier Edison film (and like many other films set not just in barber shops but in manicure parlors, massage parlors, and "physical culture" emporiums), but this time the men watch various women walk by until the final object of their gaze walks down into the shop. Much to their surprise, "she" turns out to be a man in a Scottish kilt. At this, the men all fall fainting to the floor.

These self-referential gags are made with male audiences in mind, and they are very much about watching—like the *Peeping Tom* films described earlier, comic portraits of the voyeur for voyeurs. The other category of barbershop films—the trick films—are focused more squarely on the (male–male) relationship between barber and customer and on the potential for sometimes violent transformation there. One such film, *The Maniac Barber* (AM&B, 1899), features a barber who (with the help of a dummy and splicing) cuts the head off his customer, shaves it, and then magically reattaches it to its owner.[13] Judging from catalog descriptions, this scenario seems to be repeated in a number of films, some of which have not survived. The following year, the same company released *The Barber's Queer Customer* (1900); in this film, the customer "loses his head," but in an entirely different way, as he goes through multiple transformations over which the barber has no control. A white man enters and sits in the barber chair, facing the camera. Before the barber (also white) can work on him, the customer's face magically changes: first he becomes a man with a beard, next a man with a mustache but no beard, and then he suddenly acquires the head of an ape. The final transformations are pictured in Figures 14 and 15 below: the penultimate head features a ghoulish, skeletal mask, and finally the man becomes a black man. At this point, the barber regains his control: he throws the customer out of his shop, kicking and throwing objects at him even after he's off screen. The barber then collapses on his chair.[14]

Both models of the barber shop film focus attention on spectatorship. But in the "peep show" format of *What Demoralized the Barber Shop* and others, our gaze is directed to the scene outside the shop, and we are identified and implicated with the male spectators. In *The Barber's Queer*

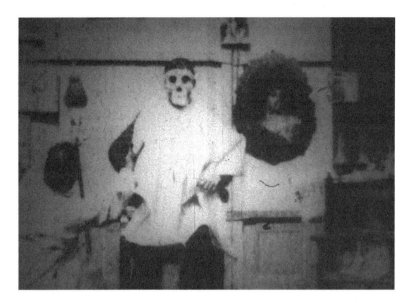

Figure 14. The barber watches in fear as his customer's face becomes a ghoulish, skeletal mask. *The Barber's Queer Customer* (AM&B, 1900). Library of Congress, Paper Print Collection, Motion Picture, Broadcasting, and Recorded Sound Division.

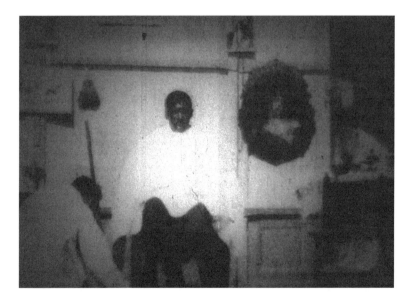

Figure 15. The final transformation: a black customer. *The Barber's Queer Customer* (AM&B, 1900)

Customer, however, the scene is oriented quite differently. While the barber does take on the role of spectator when the customer transforms, he is an unwilling, uncomprehending one—not the comfortable voyeur. Unlike the other films that focus on the barber/customer dynamic, the barber is not the magician who decapitates or transforms his customer's looks (and identity). The bit is "played to the front": the "queer customer" in the chair faces us—and we, in turn, are "faced with" his changing faces.[15] Meant to inspire pleasure, shock, or amusement—the film, like the customer, takes charge, aggressively reconfiguring what it means to be the object of the gaze. We are not peeping—rather we are confronted with something unusual and unpredictable. And while this is part of the model of spectatorship offered by the "cinema of attractions," we should not forget that the discomfort comes, in part, from men looking at men. The barber's collapse at the end echoes the men fainting with shock when it turns out the woman they admire is a man in a skirt in the *Barber's Dee-Lite*.

If films like *The Maniac Barber* play on the legacy of the "barber-surgeon"—barbering's former association with bloodletting and other "medical" practices—the interaction in *The Barber's Queer Customer* seems to condense the anxieties around the barber shop as a homosocial site of ethnic and racial mixing. The initial transformations possibly suggest the facial hair choices of different ethnicities; but if there is an ethnic component to the transformations, it moves toward extreme otherness, with ape and monster coming before "Black." In this way, the progression can be seen as creating an even more racist scale of humanity than usual, but the African American customer might also be seen as a return to a recognizable "otherness" that falls within the bounds of social regulation. That is, the final transformation brings the situation to a halt because it returns the white barber to a position of power. He may not know what to do with the ape or the ghoul, but he can throw the black man out of his shop. Up until the mid-nineteenth century, barbering had been almost exclusively a Black trade in the United States. With the waves of European immigration after 1850, immigrants, especially Germans, competed with Blacks for a share of the market, and by the 1890s, barbershops had become as racially segregated as the rest of society.[16] And thus the black customer in this film represents a potential threat to the barber's business and to the barber himself—whose own claim to "whiteness" and "Americanness" might be tenuous.

So, by the time of early motion pictures, the barbershop was well established as a setting for comic bits featuring racial or ethnic stereotypes. But

I want to suggest that the dichotomy posed by the two types of barbershop films—the male–female peep show on the one hand and the male–male transformation scene on the other—offer a key to how these different modes get translated (or absorbed) into the realistic codes of later narrative films, and how race and gender function differently in the process. One way or another, these barbershop films sever the head from the body. The fragmentation of the female body is typical—so typical that we don't read the framing of legs alone as a severance. But the female legs in the shop window offer a corollary to the (temporarily) decapitated male customer. The framing of the women's legs, and the movie screen's reiteration/accommodation of male voyeurism, will remain quintessentially cinematic. But the shot of magical transformation and interchangeable heads will come to seem monstrous—not merely in its subject matter, but also in its aggressive confrontation of the spectator. The two situations conform/relate to different scenic principles and different modes of address—the performing and distorted racialized body versus the screened image of female spectacle. The "scene" of female exhibition excites the barbershop customers and disturbs business as usual, to be sure, but the gendered divide between male/viewing and female/viewed remains intact, as does the organization of the viewing space around a "screened" or framed spectacle. The boundaries are less clear when barber and customer transform each other. The racial and ethnic transformations of the male body depend not on a lower part of the body defined in terms of erotic spectacle, and not on the face as defined by later close-ups, but rather on a head constantly threatened with detachment from the body.

Although *The Barber's Queer Customer* does not use close-ups, the performing heads in the film are consistent with the way close-ups of the face were used in early motion pictures. Facial close-ups were typically used for comic, exaggerated, and even monstrous effects, even after films began to unfold over multiple shots. As Tom Gunning puts it, the facial close-up tended to highlight "the uncivilized aspects of the body, the contortions rather than the expressions of the face."[17] Again, these "uncivilized aspects" were often displayed via "uncivilized" subjects—not neutral faces but "bowery" types, racialized others, and so forth. These close-ups did not provide access to character psychology as later close-ups would—in fact, they denied that access. If these sorts of close-ups "display[ed] monsters and giants,"[18] that monstrosity was tied to physicality—the face as part of the body, and a particularly grotesque one at that. In detaching the head from the body, the barbershop films suggest the precariousness of identity,

with the slippage between human and monster, human and beast, expressed along racial and ethnic lines. But these tricks also prefigure the ways in which that physicality, tied to racialized and body-centered spectacle, will inform and intrude upon the making of the screen face: a fuller decapitation that will work through the denial of the very severance upon which it depends. The racial transformation associated with this sort of spectacle will rear its ugly "head," if you will, in cinema's transitional era, when cinema's realism and cultural status will depend upon formal techniques that ensure bodily coherence through increasing fragmentation; along with achieving distance from earlier, "low" popular forms, films must ensure that the screen face avoids the grotesqueries of early cinema's performing heads.

As sociologist Georg Simmel put it at the turn of the century, "The face as a medium of expression is an entirely theoretical organ; it does not act, as the hand, the foot, the whole body."[19] The face differs from the body, and from everything else in the world, because of its ability to express so much while seeming to "do" so little. Another observation, from Simmel's 1901 essay "The Aesthetic Meaning of the Face," suggests that the face is a site of a profound (and profoundly meaningful) ambivalence between motion and stasis: "It might even be said that there is a maximum quantity of movements invested in its resting state or, further, that the resting state is nothing but that moment, without duration, in which innumerable movements have converged, from which innumerable movements will diverge."[20] In positing a "moment without duration," Simmel offers up the kind of paradox that will form the basis of Gilles Deleuze's work on the cinema. In his theorization of the "affection-image," Deleuze expands upon this definitive ambivalence: "It is this combination of a reflecting, immobile unity and of intensive expressive movements which constitutes the affect. But is this not the same as the Face itself?"[21] This seamless harmony between motion and stillness that may be naturally achieved by the face, as Simmel claims, is still a site of tension in silent cinema on the cusp of the feature film era. This tension is not only clear in reactions to the close-up, but also, I would argue, in the larger discussions of cinematic realism and "essence" in which the rhetoric of "action," physical labor, and danger co-exist with that of high art, proper (restrained) pantomime, and the plasticity and expressiveness of actors' faces. Distilled even further, these divergent values of realism reveal a kind of negotiation between the performing body (the vehicle for large gesture and dramatic action and the guarantor of the "real" actor's presence) and the performing image

(redefined, in part, by the face in close-up, which offers legibility and emotional depth with minimal movement). In reactions to the close-up, in particular, this boundary between the body and what it can do versus the face and what it can (or should) do reveals tensions around other boundaries as well.

In the popular and trade press in the early teens, the much discussed topic of realism in motion pictures led in sometimes contradictory directions: the increased insistence on (and demand for) a "realism" that has to do, on the one hand, with accuracy and attention to detail in production (in the service of verisimilitude) and, on the other, with the individuality and psychological realism made possible by screen acting. In a sense, the "accuracy" category relates to the care taken by filmmakers and to the overall quality of the product, while the focus on realistic performances had more to do with the desire to position film as a unique (and high) art. But in both tendencies, we see the desire to endow the cinema with something extra—whether through a rhetoric of physical labor and even danger or through a kind of magical access to the essence of human communication and sympathy. And in some cases, critics' attempts to "boil down" the cinema to its "essence" resulted in the claim that the cinema's specificity lay in the ability to boil down reality to *its* essence. At the same time that the relatively high-brow *Independent* saw the "essence of reality" captured by the cinema's essential characteristic (the ability to capture motion), the trade magazine *Motography* defined the cinema's mission, and life's essence, just a bit differently: in "Life Boiled Down," the author argues that "the motion picture [must] reduce the drama to its essence, which is action. . . . It is not what people say but what they do that counts in real life, and that is what the photoplay presents to our eyes."[22] Action is more than mere motion, and the author is not so concerned with what characters "think" as with what they do. In March 1912, *Photoplay* ran a feature on "Madame Alice Blaché" and her very successful production company, Solax, in which she stressed the need for realism on artistic grounds and railed against censorship: "In France all artists aspire to get 'realism.' The more realistic, the more like the realities of life are our creations, the more pleased the public. . . . Here . . . we find conditions such as that the showing of a revolver or the jimmying of a desk, or the cracking of a safe, is objectionable."[23] She goes on to suggest that silent acting is in particular need of dramatic situations: "Pantomime is the most difficult form of expression, and to limit it to mere namby-pamby milk and water themes manacles its chances of development in this country" (38). Blaché's comments

echo the calls for action and suggest that silent film acting must have things to do—that pantomime must move freely and does so best in dramatic situations. Only a few months later, the magazine featured another headline about Solax: "Solax Burns Auto for Realism."[24] The same year, the magazine also published several reports on Frederick Rodman Law, "by profession an aeronaut and parachute jumper," who performed highly publicized stunts for films, including a jump from the Statue of Liberty—all, the reports tell us, "for realism."[25] The turn to action also seems to mark a return to the body, but not for its gestures. Rather, motion pictures become associated with the "reality" of physical labor and the risk of bodily harm. The word "realism" refers increasingly in popular magazine accounts to the "real" conditions in which the screen actors worked—particularly the dangers they faced and the risks involved in making movies.

Meanwhile, even non-film-oriented magazines like the *Woman's Home Companion* ran multiple stories of plucky young actresses taking on dangerous stunts, long days, and physically punishing work. These articles market danger to an increasingly blasé and savvy audience, but the actors' bodies take on a dimension apart from either their character or their budding star "personalities."[26] Their bodies perform a unique and life-threatening or "death-defying" act, much like a contortionist or tightrope walker—or even a song and dance man of the vaudeville stage. Death is at once the extreme guarantor of realism and just another interesting movie fact. So a headline that reads "Actress Lost Life Making This Film" is subtitled "Grace McHugh Drowned." But the article then begins not with an account of the death, but like any other film review: "Few pictures have such a wonderful background for their action as has "Across the Border."[27] In fact, the review only references the death once, in a short sentence that informs us that the actress and a cameraman were killed. Other than that, the review shamelessly touts all the realistic and exciting action: "The picture is full of action and is interesting from the start. In the first reel, after the exciting chase . . . the ranger and his horse take a terrifying fall down the side of a hill, romance is introduced into the picture and plays a prominent part till its *[sic]* finished" (171). The picture is exciting because it involved danger, and there are dead bodies to prove that it wasn't all just a "fake." Interestingly, only a few pages after this article, a short blurb appears in which Horace Plimpton, a manager for the Edison Company, argues that "the risks to life are unnecessary . . . [and] [t]here are ways of faking almost every risk."[28]

Many of these articles, whether explicitly or in passing, still attempt to distill the cinema into its essence, its unique raison d'être; and in the

rhetoric of danger, physical labor and death-defying feats, the cinema brings with it some of the pleasures of vaudeville and burlesque shows, while also continuing to offer the twinned displays of the earliest motion pictures: the prowess of the body and the prowess of the cinematic apparatus. As performance codes and production practices changed during the transitional era, reactions to the close-up suggest a deeper confusion about the relation between the face and the body in terms of their changing roles and status in screen acting. Increasingly prevalent in films made after 1909, closer framings brought a new intimacy between face and camera, to be sure, but also, importantly, between the audience and the image.[29] This led, in some cases, to uneasiness and confusion about how the face should "act". In *Eloquent Gestures*, her study of silent film acting, Roberta Pearson points out the complexity of what she calls the shift toward a "verisimilar code" in performance style. D. W. Griffith is often credited with bringing "realistic" acting to the silent cinema, and he went on record more than once to declare his preference for the screen actor over the theater player. The theater was the domain of small figures who exaggerate while the cinema offered the "subtle" close-up and the "restrained" expression of emotion.[30] Despite Griffith's rhetoric, Pearson points out that the more "histrionic" or theatrical acting style still flourished, often coexisting with the "realistic" code in the same films (including films featuring actors with whom Griffith worked extensively). The notion of restraint becomes synonymous with "realism" in many discussions of screen acting during the later silent era, and Pearson traces the way this "restrained" or "quiet" performance style tended to be associated with representations of the middle or upper classes. I would add that this figurative silence is touted, in part, because it raises the status of the cinema—that is, with increasing use of close-ups and changing performance codes, one of the cinema's greatest deficiencies (vis-à-vis real life), its silence, can be better understood as a definitive feature of its art. The transition is hardly seamless, however. We see this most clearly in the discussions of the close-up, especially as they become more widely used and increasingly understood as uniquely cinematic.

Often, the shifting responses and attitudes suggest the way close views of the face reminded critics of early motion pictures and the popular forms and pleasures the cinema was trying hard to forget. At times, these discussions suggest, it's hard to separate facial "plasticity" and expressiveness from facial acrobatics and even contortion. And while the restrained, silent face could speak volumes, some viewers seemed to want to turn the

volume up. The increased prevalence of the close-up in American films after 1909 was met, initially, with skepticism and even disgust.[31] But even as more positive reactions appeared, the tension between the movement toward a "quiet" or restrained notion of realism and a desire for absolutely legible expression on the part of the face—the organ already "acting" under a highly disciplined and curtailed range of motion—became clear. In a 1911 article entitled "Eyes and Lips," the author swings between praising a screen actor's ability to portray the entire gamut of emotions "almost entirely by the intelligent use of wonderfully expressive eyes"[32] and the wish that, with the close-up, actors may be allowed to speak every line of dialogue in order that we may read their lips, since "language forms the readiest instrument of thought and words may be suggested by labial expression" (349). He takes his cue here from "an instructor of deaf mutes" who notes that "what actors say in the photoplay is perfectly intelligible to deaf mutes in the audience" (348). (He seems to think this would take no special training on the part of the hearing audience.) He notes that "an entirely new art is coming into existence through facial expression in the photoplay," and he goes on to roughly sketch the history of motion pictures, from "primitive exhibitions" to the present day, in which the screen "rival[s] imitatively and competitively the play on the stage," and hopes to "excel" via its greater potential for "character portrayal" (348). And so on the one hand, the actor's face expresses "nearly all the varieties of emotion," while on the other, it might be a lot easier to understand them if they just used words.

As in many discussions of screen acting during this period, the author saves his highest praise for actors who can show dynamic shifts in emotion from one moment to the next—in the case of one actress the "mental dissolution and [its] restoration" or the "vanishing of human reason" (349) by another. Actors who can meet the incredibly plastic requirements for the believable expression of emotion are rare and highly praised for being contortionists of sorts. Heralding the appearance in motion pictures of established European stage actress Lyda Borelli in 1914, *Motography* raves, "No more interesting performance has probably ever taken place before a motion picture camera. . . . At one moment she is gay and vivacious . . . a second later we behold her roused to intense jealousy, her eyes alight with passion and her whole body fairly radiating vengeance and hatred."[33] Discussing the "facial expression" films that were popular in the cinema's first decade, Tom Gunning notes that "the face cavorts on an open playing field" as "the performer faces the camera and viewer directly and goes

through a succession of expressions dazzling in their range and rapidity."[34] Not only do these faces not provide access to inner psychology; they actually seem to mock this connection, "celebrating the meaninglessness" (24) of expressions by showcasing the ease and swiftness with which they can change. The discussions of the dazzling range of facial expressions displayed by those at the height of film acting in the teens show just how important the narrative and formal structure surrounding the close-up is in framing these rapid transformations as revelatory and reflective of emotion rather than as demonstrations of "meaningless" facial plasticity. But these discussions also suggest that the actor's face on screen is still a contested, evolving medium—one that is absorbing and translating the expressive powers of the body, with varying results.

By 1915, the use of the close-up had become a widely accepted norm, and *Photoplay Magazine* (the fan-oriented magazine that began its run in 1912) dedicated the first several pages of every issue to "star" shots of favorite screen actors. The articles featured many stories about directors and producers that showcased them as artists carving out the future of the motion picture as a respected art form as well as popular entertainment. A 1915 feature article on Thomas Ince's *The Sign of the Rose* (NYMP, 1915), for example, demonstrates the importance of the close-up to claims about the cinema's specificity and to its status as an art form vis-à-vis the stage. The article documents an experiment with a hybrid stage/screen spectacle: the premiere of Ince's film, adapted from George Beban's popular stage play about an Italian immigrant, combined screen acting with live performance. At a climactic moment in the film, the reviewer reports, "the screen does a rather startling 'fade out,'" and "the very actors whose silent shadows have been creating very real emotion appear in person and carry the story swiftly to its logical completion."[35] According to the *AFI Film Catalogue*, Ince's film opened in Los Angeles on April 1915 at Clune's Auditorium, where *Birth of a Nation* had just finished a nine-week run. The film then opened in New York under the title *The Alien* on May 31, 1915. In both the L.A. and New York premieres, "the film ended as the character Pietro enters the flower shop to buy a rose for his daughter's coffin. The curtain then rose and lights came up on a stage set of the flower shop. The actors from the film then appeared live and enacted the denouement, which lasted for approximately thirty minutes."[36] This was apparently repeated in a number of theaters, but when the film was released nationally, a filmed ending was added to replace the one performed on stage. While the reviewer at *Variety* believed that the experiment in "half

real—half reel life and picture drama" had "undoubtedly opened a new field . . . carrying unlimited possibilities,"[37] the *Photoplay* critic sees in this "combination of the photoplay and the spoken drama" a keen demonstration of the screen's advantage: "Those who have seen this production say the demonstration is a surprisingly strong argument for the photoplay: that Beban's facial emotion, magnified to intense proportions in the 'close-ups' of the picture, is infinitely more convincing than the patently false illumination, the confined settings, and the more or less distant figures of the theatrical stage" (32). The commentator's particular praise for the close-up—going so far as to identify this cinematographic choice with the specificity of screen acting—attests to the prevalence of these shots and to their wider acceptance among viewers and critics by 1915. The praise also makes sense for *Photoplay,* a magazine that catered to movie audiences' appetite for stars, with the first few pages of the magazine dedicated to glamour photographs of fan favorites. The interdependence of "picture personalities," the close-up, and the success of the feature film was already clear to Thomas Ince: "I am a firm believer in the magnetism, the commercial value, of a prominent actor or actress in motion pictures."[38] Assuring exhibitors at a national convention in 1915 that "the feature has a future," he recollects his work with George Beban for *The Alien* (a.k.a. *Sign of the Rose*). He notes that while he appreciated Beban's work on "the speaking stage," it was only when he "observed the very lines in his face, as his emotions dictated their formation—when I saw them on the screen" that he truly understood his power as an actor. Interestingly, when Beban expanded his one-act play to a full-length version in 1911, the *New York Times* gave it a mixed review but called it "an excellent vehicle for Mr. Beban, who has long been regarded as a clever delineator of Italian roles."[39] The fact that Beban could definitively "delineate" the face of the Italian immigrant—understood as a clear and recognizable type—suggested to Ince his suitability for the film medium, or, more precisely, the suitability of the medium for Beban. His power as an actor is directly linked to the power of the "photodrama" itself, as the "limitless powers of the camera will seek out and give expression to his pantomimic abilities,"[40] thereby surpassing the stage.

Ince's comments and *Photoplay's* assessment of the screen and stage performance both show how silence was promoted, taken up not as a deficiency of the cinema but rather as one of its defining qualities—"photoplay" and "photodrama" compete with the "spoken drama" or "speaking stage." While recent scholarship has reminded us that the cinema was

never really "silent"—it was accompanied by music, lectures, live actors, and sound effects—we should not forget the degree to which the cinema was often characterized and understood as primarily visual.[41] This seems especially true as the move to feature films coincided with efforts to promote the cinema as a respectable form of entertainment and an art in its own right. The turn to deaf mutes in the review above as the exemplary movie audience suggests as much. And in 1912, the editor of *Photoplay* wonders "what name could be applied to the patrons of a picture show, since the word audience comes from the Latin gerund, 'Audiens,' meaning 'to hear.' How about 'Vidience,' which means 'to see or to witness.'"[42] This suggests the way the rise of feature films and the concomitant standardization of exhibition practices—the consolidation of the movie audience—were accompanied by attempts to direct a hierarchy of the senses. Continuing a flair for neologisms not unusual in the silent era—when names not only shifted according to changes in the production and exhibition of motion pictures, but also reflected industry and press efforts to dictate its status as low or high art—the review of *Sign of the Rose* praised Beban as a great stage actor and cheered his "debut . . . into the arena of shadowgraphy."[43]

The happy marriage of "convincing" realism, performance codes, and shot scale registered in the review of *Sign of the Rose* was, however, the result of negotiations and adjustments between viewers and films. Only a few years earlier, the increasing use of the close-up had garnered mostly negative responses in the press. The quarrels with the new practice often devolved upon realism and whether the close-up added to or detracted from it, but inherent in these critiques were efforts to grasp the cinema's specificity. Commentators seemed concerned not only with differentiating the cinema from other arts but also from its own origins—its reputation for "low" subject matter projected in "low" settings (and thus aimed at "low" patrons). The 1915 hybrid performance unwittingly staged a competition between performing bodies and performing "shadows" that stood in for other contested boundaries: between high and low art, reality and illusion, silence and speech. The responses it provoked suggest that, in the translation of bodies into shadows, there is more at stake than the legitimacy of film as an art form. While the close view of a face guarantees a "convincing" expression of emotions to the *Photoplay* reviewer cited above, such shots bordered on the grotesque for earlier critics. One of the things the silent cinema attempted to repress as it adopted more "realistic" performance codes was its debt to vaudeville, minstrel shows, and other

burlesque stage culture. In reactions to the close-up, the links among particular kinds of performance styles (physical displays, untamed or monstrous expressions and bodily movement) and socially coded modes of spectatorship are at play. And in the varying definitions of "realism" during this period, the tension between the "real" bodies (and physical labor) of the performers and the proper screen face becomes particularly clear when the cinema's status depends upon its unique ability to reveal intangible qualities. And so while negative reactions to the close-up result, in part, from the ways in which the shot reminded viewers of the cinema's potential for the grotesque, the close-up's success depended upon its denial of the body and of body-centered forms of spectacle and performance. At the same time, as the screen face comes into its own in the teens, it is also invested with these modes and the potential for (possibly monstrous) transformations which they imply.

If, in early motion pictures, the active, monstrous facial close-up was "meaningless," the incorrect or inappropriate face would signify quite a bit in the transitional era and early teens, including that grotesque early cinema face. In other words, the condition that Gunning describes of the free, "cavorting" face itself becomes the signified—a potentially frightening, nightmarish memory. An exaggerated face had the potential to reference the links between "low" spectacles and potentially unwanted transformations (of those on screen and those in the audience), and this dangerous potential becomes particularly clear in one critic's response to the clash of technology and performance codes brought on by advances in cinematography and montage. In the context of the early teens, when films featured a narrative world closed off from the theater audience, "the carnivalesque pleasure of the open orifice"[44] returns not as a playful big swallow, but rather as a frightening, devouring image. Here, the close-up threatens the audience by making the screen an unstable boundary—and by bringing other threats to the surface, it fails to mark its distance from early spectacles (including those monstrous heads from the barbershop films).

Despite the more frequent use of the close-up in the early teens (or perhaps because of it), the possibilities signified by the screen face burst forth in Harry Furniss's 1913 article "Those Awful Cinematograph Faces." Furniss, a British illustrator and critic who would later make animated films, registers the uneasy relation being worked out between actors and the camera—especially in terms of the distinct expressive powers of the body and the face. His reaction to what he sees as a transitional moment suggests that shifts in aesthetic practices (and their reception) can reflect

more than the cinema's growing pains—they can point to deeper problematics underlying the cinematic illusion. Furniss notes that "films of both English and American manufacture, but particularly the latter, are displaying a marked and unfortunate tendency towards quite abnormal facial contortion, and a complete overdoing or ultra-emphasizing of what should rightly be the natural expression."[45] His suspicions about the absurdity of this technique are borne out, he reports, by the reactions of those audience members who should be the cinema's most forgiving fans: children. He makes a disturbing discovery (almost anthropological for him) when he witnesses children playing a hilarious new game: they make faces that mimic the exaggerated expressions they see on the movie screen. Furniss is specifically concerned with the face; he doesn't mention the exaggerated gesticulations and poses struck by the actors. And he belies the progress narrative about the evolution of the "realist" acting style by noting that this problem is a new one: "Cinema faces, as a matter of course, should be absolutely natural, and up to a year or so ago it must be said that they practically were so" (329). He suggests that technical changes in the cinema are to blame for his discomfort when he points to the increasing prevalence of the close-up. But he doesn't say that the older modes of acting are inadequate because the camera is now closer. Rather, he blames the studios for their "mawkish" reliance on the face, "which has led to the play of the features, instead of the play of the author, being made the main consideration" (329).

Paradoxically, the emphasis on the face dehumanizes the actors in Furniss's estimation. The exaggeration of the face strips cinema actors of their personalities and identifies them instead with more body-centered modes of performance: "These camera contortionists . . . have become such abject slaves to their own mannerisms . . . [that] some of those who erstwhile were considered to be in the first flight of cinema performers have now descended to the level of mere pantomime" (329). Throughout silent film history, "pantomime" retains its respectability; some of the greatest actors of that era were commonly referred to as "pantomime artists" as a way of distinguishing the nature of their talent from stage acting.[46] But Furniss opposes pantomimists to "cinema performers" in order to demarcate low and high art. By denigrating a slavish dependence on mannerisms and replacing "performer" with "camera contortionist," Furniss identifies screen actors with bodily movement of the sort on display in the "cinema of attractions", vaudeville, and the dime museum. These "grinning," "gaping," "goggling" faces are not acting like "natural" faces. Again, Simmel suggests

that we draw a sharp distinction between the face and other body parts since the face does not "act" or move in the way the body does. Faces are communicative but primarily passive and reactive mediators between the person and the external world. Thus we do not typically speak of faces in terms of action. And, in fact, the facial expression films of early cinema tended to generate their comic, monstrous effect through a focus on "the mouth in action,"[47] which would be the farthest thing from the "fine" movements of expression; the mouth's actions are "gross" in both senses of the term. For Furniss, these awful cinema faces stand in synecdochi-cally for the "burlesque" body—vaudevillian, freakish, and unrestrained. This new creature, which we might call the "body-face," threatens early cinema's vulnerable status as art by recalling vaudeville and other "low" popular forms—in particular, blackface minstrelsy.

The body-face is not merely an object of ridicule for Furniss. It is a fright-ening apparition that destabilizes the relationship between spectator and spectacle by shifting power relations. The face that acts like a body is "awful" because it is threatening, aggressive, and voracious—simultane-ously an impenetrable surface and devouring orifice: "There would seem to be no escape from this aggressive grin that spreads and spreads until one feels in imminent danger of disappearing into the vast grinning mouth, but in addition to this, we are confronted on the screen with the cine-matograph eye" (330). This offensive screen creature blurs racial bound-aries as well, threatening the racial identity of the actor, it turns out, as the exaggerated face retains stubborn traces of what should be a removable mask. Furniss's quarrel with make-up throws the real "awful" cinema face into relief: "both male and female performers . . . go so far as to give one the impression that they have blacked their faces to play coon parts, and afterwards only washed their cheeks and foreheads, leaving a heavy deposit of black in the concavities of the face, particularly around and under the eyes" (330). The blackface minstrel, gruesomely recalled via remnants of grease paint, has his frightening negative image here. This is a new kind of cinema apparition, and audiences leave the theater "haunted by that face, with its staring, goggling, rolling eyes, and the cavernous mouthing" (330). And in that grotesque face, British critic Harry Furniss glimpses the specter of racialized performance haunting the cinema's artistic potential.

Furniss's "awful cinematograph faces" distort performances and alien-ate audiences because they are both "unreal" and too real—that is, they bring too much of the real conditions of the performance (too-visible

makeup and the too-imitable mannerisms) with them. For Furniss, this is a disturbing example of cinema harkening back to "lowbrow" forms like minstrelsy. One might say that, like the actors Furniss references, the cinema is trying to wipe away its debt to minstrelsy and vaudeville but has not yet succeeded in doing so. But I am particularly interested in the way the improper face activates the screen in disturbing ways, suggesting a link between a destabilized racial identity (here a racial disguise not properly erased) and a destabilized relationship between spectators and spectacle (played out on the surface of the screen). The effects are lasting. There is "no escape" from these faces: children leave the theater imitating them, while whole audiences leave the theater haunted after being hypnotized—even devoured—by the cinema.[48]

Faces and Screens

In a way, Furniss's article offers an early, intermediary example (albeit with a very different inflection) of what Jacques Aumont tells us in his interpretation of the theories that developed around the silent face in close-up: "In the close-up, it has been said, the screen is completely invested, invaded; it is no longer an assemblage of elements of representation within a scene but a whole, a unit. If this close-up is a close-up of a face, the screen becomes all face."[49] In discussing "concepts of the silent face"—including but not limited to theories of *photogénie*—he recognizes the importance of the physiognomic imagination running through much of this work. If the screen is fully "invested" it becomes a communicative boundary, a surface that expresses or promises depth (and thus the screen/face can "open up" and swallow us as in Furniss's account). That such an encounter would become racialized is neither surprising nor atypical, as the physiognomic concept has much in common with the "race concept." Physiognomy attempts to divine the nature of a person from the features of the face. In the history of racial taxonomies, physiognomy has played a role as the "visible morphological characteristics of skin, hair, and bone"[50] have been aligned with matters less visible, less tangible (intellectual capacity, sexuality, humanity). In other words, both work according to an essentialist logic in which surface elements express profound (hidden) truths. If the fledgling close-up promises a new screen presence—a shadow that might eclipse both the stage and its own past—the rhetoric of presence, embodiment, and essence often associated with race helps to materialize that shadow, throwing the screen image into relief.

The physiognomic imagination seems everywhere to inflect reactions to the close-up, whether in the popular and trade presses or in European art circles. For Béla Balázs, the close-up "transpose[s]" the human face "from space into another dimension."[51] This dimension had no spatial coordinates—he quickly sweeps aside "the cinema screen and the patches of light and shadow moving across it, which, being visible things, can be conceived only in space" (120). In the twilight zone of the close-up, "we find ourselves in another dimension: that of physiognomy" (120). In dismissing physical space, he means that we can "see" things that have no existence in space (emotions, for example). But, of course, physiognomy is a theory of spatial relations—a map of the terrain of the face, telling us who people are based on how they look. For Belázs and for French proponents of *photogénie,* the equation is not so gross as that, of course—the dimension opened up by the face in close-up takes us to almost mystical places. Regardless of the desire to leave the physical plane, however, the "cinema screen [with] patches of light and shadow moving across it" is a contested site for real and imagined boundaries; the magnified human face spreads across a flat screen, and a two-dimensional space becomes a pool into which the spectator dives (or by which he is swallowed). For Balázs and others, this is the ecstatic version of Furniss's nightmare.

In her work on the close-up, Mary Ann Doane has noted the privileged place this particular shot has had in the history of film criticism, its significance becoming, she suggests, as blown out of proportion as the face in close-up itself.[52] She traces the various ways in which critics—from Jean Epstein and other proponents of *photogénie* to contemporary critics like Jacques Aumont and Gilles Deleuze—invest the close-up with a mystical quality, likening it to a "vertical gateway to an almost irrecoverable depth behind the image" (97). Doane critiques these theories for their lack of specificity—that is, for the way that they often seem to apply to the face itself as much as to the face in cinema. Perhaps more importantly, she argues that they reflect the role close-ups play in our memories of the cinema. "In the close-up," she argues, "the cinema plays simultaneously with the desire for totalization and its impossibility," and this "confusion" is "crucial to the ideological operation of the close-up, that which makes it one of our most potent memories of the cinema" (108). She questions the degree to which the close-up is "severed" from space, "disrupting" the narrative, as many theorists of the close-up have suggested. We don't read a close-up outside of the "lines of force of the gaze" (104), she insists—at least not when we watch a film (as opposed to remembering it).

While I think it is fair to be suspicious of the "découpage" practiced by many who analyze the close-up, it is important not to dismiss the many ways in which the close-up "disrupted" cinematic practices and spectatorship on its way to becoming a key element of classical Hollywood realism. In looking at sequences pulled from *The Cheat* (1915), *Sabotage* (1936), and *Queen Christina* (1933), Doane elides the differences in the way the close-up was used and received between the silent and sound eras—and especially between a preclassical era film like *The Cheat* and films from the 1930s. Although *The Cheat*'s techniques are in some ways in line with classical studio-era cinema, the film still includes earlier codes associated with films of the transitional era (such as the combination of "histrionic" and "verisimilar" performance styles). Focusing on close-ups of Sessue Hayakawa—a key figure for theorists of *photogénie*—Doane notes Hayakawa's restraint while ignoring the hysterical and often racist readings of that restraint. These reactions exert a force on the close-ups entirely apart from their insertion in a series of shots from which they derive narrative meaning. Doane looks at a sequence from the climactic courtroom scene in *The Cheat,* arguing that "Hayakawa's face would be a complete cipher without its implantation between shots of a hysterical Ward, her fearful husband, and the voyeuristic courtroom spectators, all mediated, again, by the lines of force of the gaze" (104). But they are mediated by much more than that. There is no doubt that the close-ups of Hayakawa do not simply exist in some nether region detached from the other shots, but we should not underestimate the degree to which Hayakawa's face was promoted and understood precisely *as* a cipher, something that inflects its meaning at every crucial moment in the film. Thus his face functions as a cipher even (and perhaps especially) within the context of the "lines of force of the gaze." Paying attention to this aspect of the close-up reveals the way Hayakawa's "race" informs the relation between spectacle and narrative, helping to construct the cinematic face. Along with the editing of this particular scene, constructed and directed by the gaze, then, any consideration of the close-ups in this film—and of Hayakawa's cultural significance more generally—must consider the convergence of multiple contexts: the Orientalizing strategies in the film and in extra-filmic discourse; the role of the close-up in the shifting relationship between silent film acting and audience expectations of realism; and, as I discuss in depth below, the thematic focus and style of the film as a whole—one that repeatedly brings meaning to the surface, creating multiple screens upon which the racially charged narrative plays. How do close-ups figure when

the screen becomes a character, receptive surfaces proliferate, shadows speak, and the mark of "race" is literally written on the skin?

Although *The Cheat* has been much discussed in terms of the representation of the Asian subject and the intersections of racial and gender politics more generally, I want to revisit the film here in the context of its expressionistic style and reflexive tendencies. These "formal" issues are crucial to both the film's racial rhetoric and to its place in film history and theory. Released the same year as *Birth of a Nation*, DeMille's film is somewhat overshadowed by Griffith's incendiary epic and its primary place in both the history of film language and the history of cinematic racism (and the connections between the two). *The Cheat* melds dramatic use of light and shadow (including the use of silhouettes and shadow play) with representations of race difference and miscegenation, making a highly reflexive argument about the power of cinema all the while. I want to explore this combination of self-referentiality and Orientalism further. Links between Asian subjects and the motion picture apparatus exist even in the earliest motion pictures. Chinatown, in particular, was an extremely popular subject, providing the setting for numerous actualities as well as comic bits borrowed from vaudeville. As Sabine Haenni has noted, some of these include early motion pictures that associate Chinese figures with various kinds of (often impossible or acrobatic) mobility, magic, and theatricality, sometimes even connecting these figures to the motion picture camera and its magical or transformative powers. Analyzing films including *Chinese Rubbernecks* (AM&B, 1903) and *The Deceived Slumming Party* (Griffith, AM&B, 1908), Haenni traces the way that both the cinema and ethnic others enable the spectator to "transcend the physical limits of the body."[53] She discusses these films in the context of the expanding visual culture of the early twentieth century, particularly the urban tour. I would argue that the examples Haenni discusses also transcend the moment in urban visual culture that she elucidates. As discussed in the previous chapter, early cinema exploited the performing body in order to showcase (and sometimes analogize) the prowess of the apparatus. This creates a kind of twinned display of bodily and cinematic acrobatics that lays the groundwork for the cinema's ongoing meditation on the relation between physical/material existence and immaterial projection. Race difference then becomes an occasion for and reflection of the anxious playing out of this relationship. Like cinema, race can be seen as part intransigent materiality and part spectral fiction. The temporary bodily transformations showcased in these films explicitly reference the experience of slumming while

implicitly referencing the cinema's dependence on the link between excessive bodily display and racial otherness.[54]

And so the cinema's absence—its spectral existence as a shadow on a plane surface—must be presented, figured, and refigured. The tendency, in the silent era, to refer to the screen image as a shadow comes, of course, in part from the popularity of proto-cinematic attractions such as magic lantern slides and phantasmagoria. The association between these and Asian shadow puppetry created a kind of built-in link between the cinema's "shadow" and an Orientalist image of the Asian subject. *The Cheat* takes full advantage of this; released in 1915, its breakthrough lighting and use of shadow play predates the rise of German Expressionism in the 1920s (as well as the short-lived experimentation with animated "shadow films"). These dramatic lighting effects would become associated with films produced by Lasky (Jesse L. Lasky Feature Play Company) in the midteens, when "Lasky lighting" became a common phrase. As Lea Jacobs notes, while DeMille and his production team were not the first to experiment with low-key lighting, the films made with Lasky during this period were important in developing this style and in exploring the ways in which these pictorial effects could be exploited in terms of narrative.[55] And, importantly, the filmmakers' "self-conscious efforts to create arresting pictorial effects" also marked out films like *The Cheat* for critical acclaim, as the lighting was often noted in accounts of the films' high standards and artistic qualities.[56] In this sense, *The Cheat* is positioned at the convergence of multiple aesthetic and industry transitions: the transition to the feature, the increasingly effective use of the close-up, the demands for and aspirations toward "realism" in cinema, the claims for cinema as an art form, and the experimentation with low-key lighting.

While in some senses heralded as "new," the film also draws on already established connections between the shadow play and the "Oriental," and between moving pictures and shadows, hieroglyphs, and other sorts of writing with or on the body, including the ethnographic/physiognomic language used in the intersections of cinema and anthropology. In the American context, the silent cinema also took advantage of the shadow as a figure for the black subject. As Michael Rogin puts it: "Shadow stood for soul in European gothic tales, for black in the American imaginary, and for the motion picture image itself."[57] These are not separate categories, I would point out, but interrelated notions of "essence" that deal with the relation between materiality and immateriality, with embodiment and spirituality. These concerns link representations of race and representations

of the cinema's own technological and artistic potential, and those links are not limited to race subjects featuring African Americans. The treatment of the racialized body in early cinema offers one of the many ways in which African Americans and Chinese immigrants were linked in discourses on race, ethnicity, and assimilation.[58] Early ethnographic films, for example, used the filmic shadow as a way of visualizing racial taxonomies. As discussed in the last chapter, Fatimah Tobing Rony has noted that in Félix-Louis Regnault's ethnographic films of West Africans, subjects are clothed and shot in such a way as to render them faceless "ciphers" who, despite their bodily presence before the camera, "often appear to be behind a screen, like shadow puppets."[59] In American films featuring "race subjects" and stereotypes for pure entertainment value, the "expressionistic" shadow merges with the "ethnographic" shadow—a tool for rendering the body as pure sign. While the extension of the shadow metaphor to the Asian subject suggests the dependence of the Orientalist/ethnographic gaze on the persistence of the physiognomic imagination, the Asian origins of the proto-cinematic shadow play (and the Orientalizing discourses about those origins) created another set of images in the "American imaginary." Consequently, in the case of the Asian subject in American cinema, the relationship between the racialized body and the "kingdom of shadows" is an intimate one.

A summary of the *The Cheat*'s plot shows the combined threats (both violently contained) of a "New Woman" gone wild and a Japanese merchant aspiring to gain acceptance in upper-class Anglo-American society.[60] *The Cheat* tells the story of a spoiled socialite (Edith Hardy) and her financially beleaguered husband (Richard Hardy); Edith and Richard are at odds over Edith's spendthrift ways. She prefers her social life to him, and that life includes spending a lot of time with Tori, a wealthy Japanese ivory importer. Mrs. Hardy embezzles $10,000 from the Red Cross Fund (of which she is treasurer) and gambles it on the stock market. When she loses the money, Tori offers to bail her out in return for sexual favors. Serendipitously, her husband makes a killing in the market, and she immediately goes (without Mr. Hardy's knowledge) to repay Tori. He won't be "bought off" with money, however, and he accuses her of trying to "cheat" him out of their deal. He attempts to rape her, first branding her shoulder with the mark of his ivory empire. She shoots him and leaves. The husband arrives, having followed her, takes responsibility for the shooting and is arrested. At the trial, he is found guilty, but his wife bursts forth and presents herself to the crowd and jury, admitting to the crime and showing Tori's

brand as her defense. The mob attacks Tori; the case is thrown out of court, and Mr. and Mrs. Hardy live happily ever after.[61]

In his book-length study of Sessue Hayakawa and "transnational stardom" in the silent era, Daisuke Miyao discusses the way Lasky constructed Hayakawa's star image leading up to the release of *The Cheat*. As part of Lasky's "strategy for Orientalizing Hayakawa for product differentiation," promotional materials represented Hayakawa's acting style by comparing it to that of kabuki actor Danjuro IX.[62] While Miyao traces the way those in the American press confused various actors and styles of kabuki theater, he notes that the strategy effectively authenticated Hayakawa's style as the mark of his Japanese origins. The success of this strategy is borne out in responses to *The Cheat* and in the characterizations of Hayakawa's star quality. Critics resoundingly praised his acting skill, but that skill was always in some sense defined by his Japanese origins. In 1919, *The New York Times* would rave: "He is easily one of the most capable of screen actors, and there is additional interest in his work because he is a Japanese and usually brings with him some glimpse of life among his own people."[63] In its review of *The Cheat, Variety* especially applauded the choice of Sessue Hayakawa, noting that it resulted in "the best example of the yellow heavy" yet seen on screen.[64] They go on to say that Sessue Hayakawa's performance was "so far above" the other actors that he "really should be the star in the billing" (18). Ultimately, they suggest that the film would in fact make no sense if he were not "of an alien race": "[The filmmakers] are to be congratulated in having found him, for without the third point of the external triangle having been one of an alien race the role of Edith Hardy . . . would have been one of the most unsympathetic that has ever been screened" (18).

As Miyao suggests, the packaging of Hayakawa exploited the way Japan and "the Orient" figured in the American cultural imagination, and thus Hayakawa's various choices as an actor were infused with racialized meaning. While Hayakawa used a range of different approaches, including the more exaggerated and the more "restrained" styles that were part of any silent film actor's toolbox in 1915, these approaches were overlain with cultural significance. With Hayakawa the "star" carefully positioned as the "Americanized Oriental," he "was placed in another movable middle-ground position with regard to acting styles: ambiguity versus clarity, that is, Orientalized versus American."[65] We can compare this to Roberta Pearson's categories of silent film acting, what she calls the "histrionic" and "verisimilar" performance codes. As referenced earlier, the "histrionic" is

associated with large gestures and exaggerated expressions while the "veri-similar" code she identifies is defined by restraint (and typically associated with middle- or upper-class characters). Pearson emphasizes that these styles co-existed, often within one actor's performance over the course of a film. This notion of restraint becomes synonymous with "realism" in many discussions of screen acting during the later silent era. The persis-tence of the histrionic style in *The Cheat* is perhaps best displayed by Fanny Ward (who plays irresponsible socialite Edith Hardy). In a scene in which she is told that all her money has been lost in the stock market, for exam-ple, she literally pushes the messenger out of the frame, and proceeds to react with grand gestures and poses—with the camera framing her in a long shot—for about thirty seconds until the scene ends with her out-stretched on the floor in despair. Indeed, the reading of Hayakawa's style—both by contemporaneous critics and by current historians, including Miyao—seems to depend quite a bit on the fact that he shared the screen with Ward so often in the film. The "ambiguity" equated with his race, in other words, benefits by juxtaposition with the emotional excess associ-ated with Edith's profligate femininity.[66]

Although tastes were changing, the melodramatic poses that Fanny Ward and others strike in the film would have been understood in a richer context than we tend to credit. This context tells us something about the uneasy relation being worked out, sometimes awkwardly, between body-centered and face-centered acting (or between the expressionism of the body versus the expressionism of lighting and camera work) in *The Cheat;* these tensions between shifting film language and performance codes help to construct the responses to Hayakawa as well. The relationship between bodily gestures and camera movement becomes clearer when the earlier ("histrionic") acting technique is seen as a technique rather than merely exaggeration. Roberta Pearson discusses the complexity of the more ex-aggerated style as a signifying practice in its own right. The range of options available to an actor included the duration of the gesture (which some-times meant holding a pose long enough so it could be "read"), the "stress and speed" of the gesture, and the "direction" of the gesture—orienting your body toward the sky suggested acceptance or pleading, while point-ing "down" in some way conveyed more "active" emotions or meanings.[67] These descriptions of bodily movement are interestingly proleptic of the range of cinematographic options that will increasingly come to enunci-ate film narratives (i.e., camera movement, angle, varying distances, shot duration, editing). As noted in the last chapter, silent cinema's transition

from moving body to moving picture figures prominently in the theorization of the "movement-image." Deleuze discusses the substitution of camera movement for bodily movement in terms of the development of a "pure movement-image." Technical innovations "extracted" the movement from the body as we might extract the "tenor" or meaning from its "vehicle" in metaphoric language. Deleuze suggests that the "movement-image" is "pure" because it lacks a vehicle, a body. But, as I have suggested, something always remains. If we think about the various styles (both in performance styles and cinematographic practices) in *The Cheat* as a kind of poetics of the body versus a poetics of the face, we can better understand the yoking of cinematic meaning to racialized meaning.

The cultural-aesthetic mapping that Miyao discusses plays out in the film in a number of ways. As other critics have pointed out, different stylistic choices—in terms of costuming, scenery, lighting, and shot scale—obtain in *The Cheat*'s two primary settings, its two "worlds": the home of Edith and Richard Hardy, a wealthy Anglo-American couple, on the one hand, and that of Tori, the Japanese Ivory merchant, on the other. The differences between the two worlds—a pictorial rendering of the familiar "East is East and West is West" refrain—is heightened not only by different performance styles but by the increasing use, in Tori's domain, of closer framings, expressionistic lighting, and prominent use of screens and shadows. As reviewers noted in 1915, the lighting effects in this film are dramatic, and in some cases new to the screen. Most reviewers take special notice, for example, of a jail scene in which the bars of the cell are suggested only by the shadows they cast on the wall behind the inmate. The film, especially in its more traditionally well-lit scenes (again, in the Hardys' home, the courtroom, and other representative Anglo-American spaces), emphasizes depth and the tableau-like setting that shows action going on in many different planes of the space. The starkly different lighting styles employ what I have been calling the tension between figure and frame. In this film, that tension is translated into even more basic elements—space and screen. The scenes in Tori's space feature low light and shadow plays—expressionistic effects that bring the surface to life in a way that suggests the film's own undeniable presence as "shadows on a plane surface." The link between the "Orientalized" figure embodied by Hayakawa and the film's self-referential quality—in particular, its formal and thematic concern with eloquent shadows and blank surfaces—has not been fully explored. The film's tensest moments (moments that hinge on the threat of miscegenation or violence) are also the most reflexive. The film repeatedly

brings the surface of the screen to life, linking what is written on the screen to what is written on the body.

Expressionistic films draw attention to the cinema's basic elements: light and shadow. The shadow play is a bit different in its presentation within film, however, than the lighting effects typically associated with German Expressionism.[68] The shadow play in film is usually presented as a separate spectacle (separated, that is, from the bodies that are supposedly casting the shadows), and as such it offers an interesting combination of flatness and theatricality. The shadow play is just that—a play—and yet it also draws attention to the space of the movie screen, which is highlighted as a site of inscription. This exaggeration of the surface again suggests Gilles Deleuze's theorization of the "affection-image." Deleuze defines the affection-image in terms of the close-up, which presents us with an image that is all surface, abolishing the sense of perspective and depth. The typical close-up of a face is clearly about affect, but Deleuze's formulation goes further than that: "The affection-image is the close-up, and the close-up is the face."[69] Yet the close-up needn't be *of* a face. Rather, the close-up is an affection-image in so far as it acts *like* a face. The affection-image brings meaning to the surface and exhibits "faciality": a "combination of a reflecting, immobile unity and of intensive expressive movements which constitutes the affect. But is this not the same as the Face itself?"[70] Deleuze's notion (influenced by the semiotic of Charles Sanders Peirce) of the equivalence of image and matter or the sense that the flat, iconic image opens itself to a "spiritual" dimension seems to resonate both in silent era films and in contemporary responses to them.[71] The affection-image is about states of being, about the expression of those states of being. In this sense, we can think of the close-up not merely as spectacle, but as a signifier of signification itself: an image of the translation of internal feeling to external sign. As Jacques Aumont has put it, the close-up "produces a surface that is sensible and legible at the same time."[72] His notion of the close-up as combining a "deeply experienced" sense of presence with a "sign, a text, a surface that demands to be read," is related to Deleuze's conception of "faciality." Put another way, the affection-image "underwrites a crisis in the opposition between subject and object."[73]

I would argue, then, that the shadow on screen, while not a traditional close-up, does function as an affection-image, or like a face in Deleuze's sense. Like the face, the shadow play offers flatness or screen presence through a combination of immobility and intense expressiveness. The shadow renders the body as sign, not of emotions as in a face, but of

states of being, of "spirit" or "essence." This is crucial, of course, to representations of race. Scenes emphasizing shadows exhibit a particularly literal and reflexive brand of "faciality": "The face, at least the concrete face, vaguely begins to take shape on the white wall. It vaguely begins to appear in the black hole. In film, the close-up of the face can be said to have two poles: make the face reflect light or, on the contrary, emphasize its shadows to the point of engulfing it 'in pitiless darkness.'[74] The shadow play activates the screen as face (and, in *The Cheat,* links it to the "Oriental" face as screen), highlighting that moment when meaning "takes shape on the white wall." As noted earlier, Mary Ann Doane observes that, for many critics, the close-up seems to pose a semiotic threat. But this threat, I would argue, is not merely about the disruption of narrative space; the affection-image suggests a ground zero of signification—and the "semiotic threat" is also a semiotic abundance associated with a risky revelation of origins that "materializes" the cinematic signifier. In *The Cheat,* the processes of cinematic meaning and racial meaning are both revealed, and if there is a "semiotic threat," it has crucially to do with seeing the process of using the presence and absence of "race" to embody or materialize the screen image.

The scene in which Edith makes her fateful deal with Tori features the most extreme combination of these effects, and the scene sets off a chain of associations that develop as the narrative progresses toward its violent resolution. When she is informed that she's lost her money, she is in Tori's "rooms," a private space separated from the rest of the house. The space is confusing and had already been established in various ways; mostly, what had seemed like a small space had subtly "grown" through a gradual exploration involving increasing depth of focus and changing camera angles. When Mrs. Hardy hears the news, she swoons and falls to the floor. Alone with her, Tori turns off all the lights, picks her up, and carries her toward the right of the frame. In the style of earlier films that persists through the transitional era, the next shot offers an empty frame at first; Tori and Edith enter frame left and crouch at the bottom right. He poses her limp body and then kisses her while she is unconscious. In the next shot, the left side of the "wall" is even lighter and now shows the shadows of crisscross bars—now we can recognize this formerly blank space as a paper screen (or Shoji screen). As Tori and the now-awake Edith watch, crouched in the darkness, one shadow walks across the screen, and another follows. They are men's shadows. The reverse shot reveals one of the men to be Edith's husband. Their conversation reveals Mr. Hardy's own

money troubles. Once the "shadows" leave, the next shot is a medium close-up of Tori and Edith, surrounded by total darkness. As Tori offers to bail her out of her jam, the black space to the right of Edith "opens up" as an iris reveals a kind of "thought balloon" in the form of a newspaper headline decrying her embezzlement (see Figures 16 and 17).

All the play on screens and darkness in this scene evokes the space of the movie theater itself; Edith and Tori are the spectators who watch the "shadows" on the screen. The Shoji screen is itself a kind of character, and the movie screen also gains "presence" as the scene ends with Edith conversing, as it were, with the blackscreen that shares the same "plane" with her. That is, the darkness becomes more than darkness, more than blackscreen. The headlines read as thought balloons (as Tori whispers in her ear on one side, her fears take shape on the other), but in this strange setting, once a dimensional room that has been flattened out for this sequence, the space of the screen becomes more articulated (and articulate). Here, the more "theatrical" set is utterly done away with, and the action has unabashedly come to the surface. Not only can two pictures occupy the same plane, but the darkness radically alters its status as "background." The remarkable shot in which Tori and Edith share the frame with the silhouettes on the paper screen functions as an "affection-image" without being a traditional close-up. The space is radically altered and the flattened space offers that combination of immobility and intense expression associated with "faciality." The following shot, the medium close-up of Tori and Edith (this time sharing the space with the newspaper headlines appearing at the right of the frame) makes the process of representation even clearer. Tori and Edith are positioned in between the two modes of figuration (reflecting, perhaps, the East/West relationship). The two suspect bodies (the Japanese man and the "New Woman") are trapped in the middle, between the law as determined by white masculinity on one side and the publicity-turned-infamy threatening the woman on the other. Forced together, they are flattened into a kind of icon of adultery by the two-dimensional image.

This scene also represents a culmination of the tension between figure and frame, between "stage" space and screen space. These different modes of representation have important repercussions for the "embodiment" of film subjects. *The Cheat* exploits the link between the Asian subject and the shadow play by continuing to use the Shoji screen as more-than-backdrop in its most sensational (and violent) scenes; these scenes will feature other receptive surfaces as well. When Edith later refuses to grant Tori the sexual favors she has promised, he brands her with his mark. Earlier

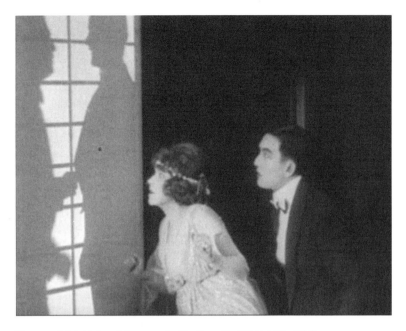

Figure 16. Edith, Tori, and the screen in *The Cheat* (Cecil B. DeMille, 1915).

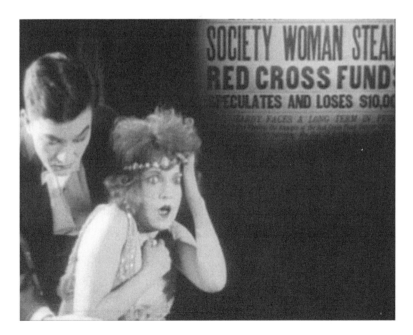

Figure 17. The blackscreen opens up and "speaks" of Edith's disgrace in *The Cheat* (Cecil B. DeMille, 1915).

in the film, we see Tori branding his ivory pieces, to mark them as his. He brands Edith in the same setting, with similar lighting effects. The penetration of her skin figures the sex act specifically as miscegenation; the brand—the mark of his national origin (and his "race")—penetrates her glowing white skin. Edith is plunged into a surface-saturated darkness out of which her overexposed white face shines like a disembodied icon. Edith's whiteness (her white femininity) is fetishized here—she is like a piece of ivory, and she is about to become another possession of the Ivory King. When he brands her, however, we do not actually see the brand go into her flesh—her shoulder is off screen. The shadows on the screen in the "contract" scene described above offer a kind of visual corollary to this unseen branding moment. By making the screen a crucial prop, the play of racial signifiers on the skin is displaced onto the play of shadows on the screen. This pattern continues as other penetrations and markings of the skin are linked to shadows on the screen. These scenes of sexualized violence pivot on the threat of miscegenation, rehearsing questions of race, gender, and embodiment through obsessive references to skin and surface.

After branding Edith, Tori attempts to rape her, and she shoots him and flees. When her husband comes to look for her, he sees Tori's hunched silhouette on the now bloodstained screen (Figure 18). Tori has been penetrated by a bullet, and though his silhouette shows through the screen, so does his flesh and blood—his arm pokes through it, leading Hardy to burst through to the other side. These moments suggest that the branding—the marking and penetrating of the white woman's skin—has been transposed onto this other surface, the movie screen. Further, with the tearing of the screen, multiple boundaries are breached: the screen figures the gap between "East" and "West," it figures the penetration of white femininity (Edith), and it figures the boundary between reality and (cinematic) representation—between body and shadow. Here, finally, bodies mingle with shadows; the image on the screen is written in blood. The impression on the flesh signifies racial transgression as the darkness and light create (racialized) meaning on the screen. Figured as a mark on the body, the "sign" of race becomes material, tangible, granting an added presence and visibility to the normally invisible movie screen in the process. The screen is simultaneously embodied and established as the true site or origin of cinematic meaning. The embodiment (enabled via the appeal to race) makes up for any "lack" that the screen's two-dimensionality represents. The play of shadows and surfaces here links cinematic boundaries (screens) to racial /bodily boundaries (skin); cinematic signifiers (light and shadow)

Figure 18. Blood on the screen. *The Cheat* (Cecil B. DeMille, 1915).

to racial signifiers (penetration, blood). In this sense, *The Cheat*'s "expressionism" is not expressive of psychological states but of social relations and, even more fundamentally, of the relation between surface and depth.

The final penetration of the screen brings Tori into the light, to his real (lack of) status in the world of U.S. law and racial prejudice—while the "kingdom of shadows" may have belonged to the Ivory King, the courtroom is emphatically not his domain, as he winds up fodder for a righteously angry lynch mob. There are no shadows left at the end of *The Cheat*—only real bodies and real violence. The trial makes up the final scene of the film, and close-ups from this scene show up repeatedly in readings of Hayakawa's performance. Since the courtroom scene is so pivotal for accounts of Hayakawa and of the face in close-up more generally, I want to look closely at it. Although most accounts of the scene focus on the series of close-ups of the three major characters—Tori and Edith and Richard Hardy—the scene is actually very crowd focused. It begins with a wide shot from the back of the courtroom, the full audience taking up much of the frame, with the witness stand barely visible in the background. As Tori takes the stand, we get a series of close-ups of him and of Edith, watching his testimony anxiously, since she knows he could reveal the truth of their

illicit contact and her broken contract (not to mention the fact that she shot him). Richard Hardy is the one on trial, as he has confessed to the shooting to protect his wife. Tori backs this up on the witness stand—it's clear that this story benefits him as well, as news of his dealings with Mrs. Hardy would certainly put him in danger. When Richard takes the stand and claims that he shot Tori, we get reaction shots of Edith and also of a group of women in the crowd. A medium close-up of Tori follows, sneering and looking off to the side (perhaps at Edith; that's unclear). That shot irises out to the title "The Verdict." The conclusion of the courtroom scene begins with the jury, and before the verdict is read, we cut to a sequence of shots to prolong the suspense: first, a group shot of men in the audience; then a two-shot of Edith and Richard, anxiously clutching each other. After the "Guilty" verdict is pronounced, we cut back to Edith and Richard, surrounded by the crowd, as Edith breaks free in order to confess.

As she takes her place in front of the bench, like an actor taking center stage, she repeatedly says "I shot him," pointing to herself and using large, frantic gestures. A reaction shot of the crowd follows, with people craning forward to see her. After more of Edith's performance, we get an irised close-up of Tori, also craning forward to see, visibly shaken. Finally, she announces "I shot [Tori] and this is my defense." We see her reveal her shoulder, first in long shot, and we then get a wide shot of the crowd, with many people lurching forward in their seats, jostling each other for a glimpse. We then cut back to a close-up of Edith, with the brand clearly visible on her shoulder (Figure 19). A shot of the jury shows some of them standing as they all try to get a look at the "evidence." As she points at Tori, we get a two-shot of him and his assistant; Tori has a frightened look on his face, his mouth open, his brow furrowed—again, hardly impassive (Figure 20). He also looks around nervously at the increasingly agitated crowd. The rest of the scene could have been introduced by another title: "The Lynch Mob Is Born." After Edith finishes addressing the crowd, exhorting them with arms outstretched, she buries her head in her hands and cries. The scene crescendos, focusing exclusively now on the angry crowd surging forward toward Tori, who has taken up refuge beside the judge. After a sequence of shots focusing on groups of white men, we get a wide shot of the crowd pushing past court officers until the whole frame fills with struggling bodies in a chaotic swell of motion (Figure 21). The next shot uses an even tighter framing of the crowd, accentuating the violence and aggression of multiple bodies acting as one. The reverse shot shows us the progress of the attackers, some fighting with officers in the foreground

Figure 19. Edith reveals the brand. *The Cheat* (Cecil B. DeMille, 1915).

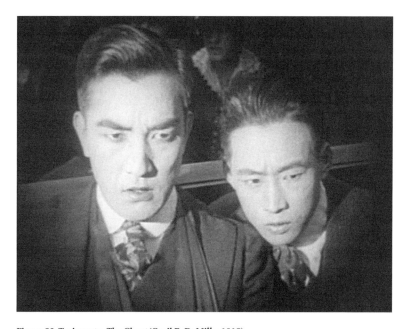

Figure 20. Tori reacts. *The Cheat* (Cecil B. DeMille, 1915).

Figure 21. The lynch mob. *The Cheat* (Cecil B. DeMille, 1915).

while others reach Tori in the back right of the frame. We then get a medium shot of the judge and Tori as he is led away, bruised, swooning, and holding his hand to his chest. The film ends with Edith and Richard processing down the courtroom aisle toward the camera, flanked by an applauding crowd.

I recount this scene in detail in order to suggest the way Hayakawa's face becomes a screen for the projection of Orientalist fantasies and to trace the way the final scene links the formation of the audience and the formation of the lynch mob. As discussed earlier, Hayakawa's is one of the definitive faces in accounts of the close-up in cinema; the distance between contemporaneous reviewers' reactions, and those of later proponents of *photogénie*, theorists of the close-up, and contemporary scholars is not, it turns out, so great. Whether describing Hayakawa's face as "immobile," "stony," "impassive," "ambiguous," or "mask-like," contemporary critics seem to reiterate a racialized rhetoric whereby the reading of his face is largely dependent upon a reading of his race and vice versa.[75] As the account of the courtroom scene attests, his face is not always "immobile" and is often not ambiguous (as when he expresses the fear of the mob, or when he wears a knowing grin as lies are told); it seems clear that what is

represented as his "immobility" or "mask-like" face are simply elements of the "act" that made him "the best example of the yellow heavy" yet seen on screen in 1915. That is, this is a performance received as both novel in its style and recognizable in its effects, as both inimitable and iterable, equal parts what he projects and what audiences project onto him. These seem to me to be the paradoxes Hayakawa embodies, as, due in large part to his role as an authentic "Oriental," he can inhabit both the flat stereotype and the profound (and profoundly mysterious) character; his face animates the screen in a way that produces precisely the effect that thrills the average viewer and the European art critic alike: an image that is both skin *and* deep.

Because of this, we can think about the way the film draws together Tori's face, the Shoji screen (and the shadows that play upon it), and Edith's brand. In the courtroom scene, Edith's brand saves her husband and dooms Tori. A brand unites body and sign—no longer a flat 'immaterial shadow' on a screen, but rather a tangible mark impressed into flesh, it is an inextricable, visible and tangible symbol of racial identity and transgression. Importantly, the film uses the brand to incite the audience—in fact, as noted in the description above, the courtroom crowd behaves most like a theater or movie audience when Edith presents the brand. The film takes full advantage of the theatrical nature of the courtroom setting, with many layers of performance capped off by Edith's swooning monologue. But the brand proves the truth of what she says, offering an undeniable reality that expresses much more than she can with words or gestures. As evidence, a brand goes one better than a smoking gun. It tells the audience not only what happened but "whodunit"—it leads directly back to Tori, to his presence, his hand, and the fact that he has touched Edith. In other words, it is an indexical sign, even better than a fingerprint because it speaks a different language—it is the mark not only of Tori, but of "the Orient." Thus his personal mark is conflated with that of his nation, deftly forming a racialized sign. This combination makes it "more-than-indexical," with indexicality and iconicity supplementing each other via race. In this sense, the brand is like the shadow. The shadow, too, is an indexical sign, and more. It offers a direct link to the body while also seeming to divulge its secrets or "essence." In the scene in which Tori is shot, (bleeding) body and shadow share the screen, offering a particular take on the Christian imagery of the union of body and symbol. That special connection to a "more than real" (a supplement to mere legal truth) depends upon embodiment and "race." The racialized boundary between

East and West is finally linked to the boundary between reality and representation, body and image.

But what of the relation between this face and the crowd (including the courtroom audience and the movie theater audience)? Through the use of the brand, the importance of embodiment and race to notions of "essence" and "truth" are thoroughly linked, in the courtroom scene, to audience formation and audience credulity. The film ends with an applauding crowd (the same crowd that had been a lynch mob only moments before); the Hardys' walk down the aisle suggests that this incident has essentially remarried them. This galvanizes the movie audience as well, as even the *Variety* reviewer attests when he notes that the whole film (and Edith in particular) would be unacceptable without "the third point in the triangle being one of an alien race."[76] I want to suggest that this film achieves an even deeper level of unity—while the racially charged storyline galvanizes the crowd (both in the courtroom and in the theater), the linking of Tori's face, the shadows on screen, and the mark on Edith's skin re-presents the screen image, granting specificity and presence to the cinema and its signifying practices. This kind of unity—between image and audience—is achieved in part through the logic of the lynch mob. *The Cheat* was released the same year as *Birth of a Nation*, another film in which lynching and other racialized violence figures prominently. Protests over Griffith's film resulted in the excising of the graphic lynching scene.[77] *The Cheat* features only a "near-lynching," but this achieves the scene's primary goal—to unite the crowd (the internal and theater audiences) against Tori (and with the Hardys). But the link between real bodies and cinematic shadows had been made via lynching long before Griffith's or DeMille's films, and as Jacqueline Goldsby has pointed out, the dissemination of lynching via photographs (and later motion pictures) played a key role in constructing the audience for modern spectacle at the beginning of the twentieth century. She recounts, for example, a *New York Times* account of a lynching in a movie theater in which the victim was bound and placed on stage, allowing spectators to shoot at him; in another eerie connection between lynch mobs and movie audiences, a 1908 film featured the turn-of-the-century lynching of Henry Smith, with sound recordings taken at the scene used as the accompanying "sync" sound.[78] I would suggest, and argue in the coming chapters, that representations of race, race difference, miscegenation, and racialized violence offer a specific, and specifically cinematic, synchronization: a never fully achieved unison between body and screen image, sound and silence, image and audience.

Reactions to *The Cheat* in its time, particularly on the part of the French artists and critics associated with *photogénie,* tell us something about the way the rhetoric of the film crystallizes a link between race, the screen image, and the formation of the cinema's audience. Essentially, the film's yoking of Orientalism and racialized logic to reflexive meditations on the cinema itself—the way the film's expressionism is not about externalizations of particular psychological states, but rather about the relation between surface and depth in general—plays out in the ecstatic reactions to the film. In "Grossissement" (1921), Jean Epstein describes Hayakawa's face in close-up with the characteristic hyperbole that Doane interrogates: "Hayakawa aims his incandescent mask like a revolver. Wrapped in darkness, ranged in the cell-like seats, directed toward the source of emotion by their softer side, the sensibilities of the entire auditorium converge, as if in a funnel, toward the film."[79] What interests me here is that the emphasis is not so much on the image itself (the close-up of Hayakawa's face), but on the audience. The revolver points out in order to "funnel" the audience inward. The camera may focus on Hayakawa, but Hayakawa "aims his mask" at the spectators; he focuses on them and focuses them. Epstein's reference to the audience's "softer side" also points to the sexual suggestiveness of being enveloped by Hayakawa's image. Are the audience members feminized by Hayakawa's "revolver," or is Hayakawa feminized as his attraction is like that of a "funnel"? Epstein's depiction suggests the pleasures of having it both ways.[80] Perhaps this is why the response of French intellectuals is not far from that of American fans, particularly women. As Sabine Haenni and Daisuke Miyao have both discussed, female fans were mesmerized by Hayakawa's screen image, which seemed to promise to take them places, to allow them "to cross into 'another world' (to borrow Epstein's term), into another dimension . . . that provides uneasily pleasurable dramas of identity and identification."[81] Perhaps more significant here is the fact that in the presence of Hayakawa's face, the silence of the cinema is no longer a deficiency but an achieved goal, silencing all distractions from this pure image: "It takes away our ears" Epstein notes, adding that the cinema is "exclusively optical" (240). If we think back to the discussions of the close-up in cinema from the beginning of this chapter, we see that Epstein does not exist in a vacuum, his reactions utterly apart from popular or trade press representations of the cinema. In the later transitional era, the acceptance of the close-up coincided with an effort to differentiate the cinema from the theater—and to raise its cultural status—through an appeal to its silence, to its specificity as a medium.

The close-up makes silence eloquent. Epstein's description sounds like the ecstatic flip side of Harry Furniss's abject fear of "disappearing into the vast grinning mouth." Both are overwhelmed, but Epstein likes it that way. And "race" informs both responses: or at least a sense of the cinematic art that is explicitly or implicitly tied to racialized performance.

In her 1916 review of *The Cheat,* French novelist Colette asks, "Is it only a combination of felicitous effects that brings us to this film and keeps us there? Or is it the more profound and less clear pleasure of seeing the crude ciné groping toward perfection, the pleasure of divining what the future of the cinema must be when its makers will want that future"? She also praises both the realism and the art of the piece, singling out an element of lighting: "we also have characters on screen who are followed by their own shadows, their actual shadows, tragic or grotesque, of which until now the useless multiplicity of arc lamps has robbed us."[82] Like so many other French critics, Colette heaped praise on Sessue Hayakawa, the "Asiatic artist whose immobility is eloquence itself."[83] Again, the supposed "immobility" of Hayakawa's face is linked to a more silent silence. In response to news of a proposed operatic adaptation, Colette imagined a dialogue about who would play the roles originated by Hayakawa and Ward. In it, she suggests that the Japanese character be mute, "as mute as a screen."[84] Colette and other French artists and intellectuals of the period repeatedly identify Hayakawa with the cinema itself. I am suggesting that this is due not merely to the "hyperbolic" and sometimes mystical rhetoric of *photogénie,* but to the fact that *The Cheat* insists on this identification, Orientalizing Hayakawa in order to invest the screen image with a mystical power associated with racialized meaning. When Colette suggests the pleasure in "seeing the crude ciné groping toward perfection," she is responding, on some level, to the film's dramatization of its own signifying practices. By invoking the shadow play, in the context of an Orientalized setting, the film revisits (and rebrands, if you will) the birth of the cinema, juxtaposing its expressive powers to those of theatrical sets and gesticulating bodies. The film exploits Hayakawa's face as a screen, but it is also a movie about screens—as such, it enfolds the birth of cinema into its storyline. Screens, faces, and other surfaces all function as contested sites for the making of racial and cinematic meaning. Equally important, these efforts to claim the specificity of the cinema also promise a new intimacy between image and spectator, suggesting a rebirth of the audience as a cinema audience. As discussed in the next section, while audiences may project Orientalist fantasies onto Hayakawa's face, the

"Oriental" (and other "alien") faces in the crowd provide screens upon which the cinema can project itself.

The Nostalgia for the New

Nostalgia for the birth of cinema—specifically for the magic, novelty, and even shock associated with its earliest displays—seemed to take hold almost instantly. As noted in the last chapter, motion pictures mocking such naive reactions to the cinema were being produced only a few years after Maxim Gorky's report of having witnessed a "kingdom of shadows" and the likely mythical stories of people screaming and running in fear from the onrushing train in the Lumières' *L'Arrivée d'un Train* (1895). While the "average" moviegoer was a wise, even jaded one already by 1905, the succeeding years produced numerous stories of new, naive viewers mesmerized by the cinema's magic. Typically, these stories featured some exoticized or marginalized group: natives in faraway lands introduced to motion pictures for the first time, or new immigrants watching the movies with childlike innocence/ignorance.[85] These out groups offered commentators the chance to re-create cinema's originary moment while also saying something about the nature of the film audience. In 1915, a writer for *Photoplay* reported on the state of the movies in Honolulu; at the same time, he reported on the state of racial "intermingling" and assimilation: "If you can call Honolulu, as they do, the melting pot of the races, then surely it is the moving picture that stirs it."[86] After describing the "strange, shabby structure with tin walls" that functions as a movie theater there, he goes on to describe the appearance and dress of the Japanese, Chinese, Hawaiian, Filipino, Korean, Portuguese, and "few whites gathered there" (147). The thrust of the article reiterates the familiar notion of "the universality of the motion pictures," claiming "dignity" in the fact that they are "doing more to level race barriers, to bind the ties of humanity" (149) than any other art form. But the article reads like a travelogue, offering a print version of the very sort of panorama of faraway places spectators might still see at the movies: "Walk three blocks down Fort Street . . . and you will pass people of seven or eight different nationalities and shades of color, wearing clothes of as many different kinds and colors, reading newspapers in as many different languages, conversing in as many different tongues. Follow each to his home and it will be as if you had with dreamlike swiftness visited as many different parts of the world" (147).

The description works like a montage sequence, or a dissolve that takes us both into a dream and to another land. Nowhere could *Photoplay* readers move "with dream-like swiftness" so well as in a movie theater. More interesting for our purposes is the study of these "exiles" as audience, as the writer watches the faces that watch the screen: "It is a study in sociology, psychology, ethnology—what not?—to sit in such an audience and watch the play of emotion across those faces as one of the old-time, hair-raising, blood and fire melodramas or a Keystone comedy is flashed on the screen. For the assortment of films is as odd as the audience." (148). Emotion flashes across those faces as pictures flash across the screen—they offer this white spectator a better spectacle than the tired movies. These "odd" filmgoers, of course, appreciate anything—the writer goes on to discuss the fact that Whites in the better parts of the city "demand better theaters and films"—but it is precisely their naïveté, their appreciation of cinema as universal language, that makes them interesting. The many-hued faces are both screen and image, spectacle and audience. They are, at once, a confusing, crazy quilt of ethnicity and a blank screen to be played upon. They are cinema *and* they reflect the cinema to itself; so, when Hayakawa becomes, in Colette's imagination, "mute as a screen," it is a telling distillation of the rhetorical strategies of the film and the (Orientalist) marketing and reception of his performance—but it also points to a larger function for the "alien" or "Oriental" subject in the cinematic imagination. As we have seen with representations of the African American, the concept of "race" (here linked to the "concept of the face") helps the cinema re-introduce itself at various junctures, as technology, aesthetic practices, and audience expectations continue to shift in the silent era. A kind of nostalgia for the new—for the novelty of cinema as an "attraction"—returns, driving a related nostalgia for a lost innocence or naïveté on the part of the audience. What is the relation between this nostalgia and the exploitation of race? I would suggest it has to do with the desire for (and ambivalence about) origins.

Earlier in this chapter, I referred to Christian Metz's theorization of the imaginary signifier. Metz's work was important to the development of psychoanalytic film theory and feminist accounts of the fundamental role sex difference played in Hollywood cinema's narrative codes. As I continue to argue here, a less discussed part of Metz's theory is key to understanding how race difference is encoded into cinematic narrative (and into the spectator's experience of the cinema). Metz notes that some portion of the viewing audience will fetishize the cinema as a technology; this is

particularly true, I would add, at transitional moments when the powers (or limitations) of the apparatus are more clearly on display (e.g., with the increased use of the close-up, or the addition of color, sound, or, later, immersive "3D" effects). If we are to explore how the rhetoric of race figures in the development of the screen image (and in the development of the screen's image), then the understanding of the "cinema as fetish" can be more fruitfully developed in connection with Homi Bhabha's theorization of the stereotype as fetish. As I discussed in the context of early motion pictures, Bhabha argues for the stereotype as fetish, speaking to colonial discourse and its desire for a pure nondifferentiated origin. As the nondifferentiated origin is disturbed by the discovery of sex difference and the accompanying threat of castration in Freud's theorization of the fetish, the colonial desire for pure origins, this "desire for originality" is "again threatened by the differences of race, color, and culture" in Bhabha's formulation.[87] In order to understand fully the way race difference supplements the cinema's signifying practices, we must consider the way the racial stereotype as fetish informs the cinema as fetish. In particular, I am interested in the way the cinema negotiates issues of materiality and embodiment—especially its own (im)materiality and (dis)embodiment—via race. Silent films depicting Asian Americans are part of this larger pattern, as the Asian or Asian American subject has been a favorite for contemplations of and analogies for the cinema's origins. In the next chapter, I explore how the "Oriental" stereotype and the nostalgia for cinema's origins come together to figure the power of the screen image and to solidify group identity: to create meaning by creating an audience.

3 RECASTING *SHADOWS*

Race, Image, and Audience

ON OCTOBER 27, 1922, after months of prerelease publicity, *Shadows* (US, Preferred Pictures, Tom Forman) premiered in New York to a crowd of producers, exhibitors, actors, academics, and press. The film, an adaptation of the 1917 short story "Ching Ching Chinaman" by Wilbur Daniel Steele, starred Lon Chaney as the Chinese launderer and outcast Yen Sin. A week later, the producers took out a full-page ad in the exhibitors' trade magazine, *Moving Picture World.* Under the banner "We are Proud," the producers declared the premiere a rousing success. They described this success by first describing the audience: "October 27th was the greatest day in our history! This was the day *Shadows* was first shown to an audience . . . an audience that was as representative of the world and its viewpoints as an audience could possibly be. It comprised people from all walks of life and from every quarter of the globe . . . there was Hayakawa . . . Abe Blank of Des Moines . . . E. V. Richards of New Orleans . . . Sam Katz of Chicago."[1]

"Hayakawa" refers, of course, to Sessue Hayakawa, whose celebrity was well established by 1922. As we saw in the last chapter, *The Cheat* established Hayakawa's international fame; after that, he made several films with Lasky and went on to form his own production company, Haworth Pictures, in 1918. He was motivated to do so, in part, by his stated desire to present "authentic Japanese characters" on screen, as opposed to the fictions and stereotypes he had been portraying with Lasky.[2] By this point, Hayakawa had played both heroes and villains to critical and popular acclaim, with roles that sometimes played on, and sometimes challenged, the Oriental stereotype in American culture. And while promotional materials traded on Hayakawa's Japaneseness, he also "fit" (from the perspective of producers and American audiences) a more generic, interchangeable

"Oriental" type. He had played many different kinds of roles, including numerous Chinese characters.[3] By 1922 he was the screen's most famous, successful, and authentic "Oriental," and his presence at the premiere of *Shadows* was no accident. The ad's barrage of endorsements for the film begins, significantly, with Hayakawa's: "Lon Chaney's characterization of an Oriental is the truest and most realistic impersonation an Occidental could possibly portray." Two screen "Orientals" come together here—the "real" one authenticating the impersonator. Together, they authorize the film as acceptable and believable, and around these two figures a "representative" audience gathers. The enthusiastic response to Chaney (which was not limited to Sessue Hayakawa) recalls the long history of racial disguise and minstrelsy, especially in terms of the way this particular kind of special effect brings together the realistic and the spectacular. While the actors playing "white" characters in the film stay within realistic performance codes, Chaney's racial disguise draws equally on the realistic and the expressionistic. Chaney's transformation is just incredible enough to be credible. The boundaries between reality and representation are blurred here, and with them, the seemingly indelible line between East and West fades, if only for a moment, as Hayakawa's endorsement deftly erases and underlines it at the same time.

The last chapter ended with another picture of a representative audience—various "races" and kinds undergoing the melting pot alchemy of the cinema. This chapter begins with another representative audience—comprised of "people from all walks of life and from every quarter of the globe." Only here it is not the people who need the film (to teach them how to watch films, to astonish them, to "stir" the melting pot); rather, it is the film that needs the audience to validate its subject matter and to authenticate its racially disguised star. In this case, the focus on the gathering of an audience around the film echoes the subject of the film itself, which is largely about community formation and hinges on the question of whether the alien figure (the Chinese immigrant) threatens or consolidates that community. *Shadows* was the second release from independent producer B. P. Schulberg's fledgling Preferred Pictures. In articles and advertisements in the trade press, Schulberg promised to deliver quality films featuring all-star casts and adapted from "worthwhile" literary sources. *Shadows* certainly followed this formula; not only did it feature well-known actors including Chaney, but the short story upon which it was based had been chosen as one of the best short stories of 1917.[4] Despite the film's respectable credentials, the publicity leading up to the film's release

shows a fair amount of overcompensation for the subject matter, which suggests the marketing challenge posed by a film about a Chinese immigrant. While one reviewer notes that the film's name was changed to *Shadows* because exhibitors feared that the public didn't "want anymore of that Chink stuff,"[5] Schulberg himself explained the title change differently. In a prerelease interview with *Moving Picture World,* he explained that *Shadows* was a better title because "it incorporates the suggestion of mystery which is the keystone of the plot," adding, somewhat coyly, that "by changing the title we are aiding exhibitors in conveying to their patrons just what the true nature of the picture is."[6] Schulberg wanted to capitalize on the prestige and popularity of Steele's short story while also downplaying the Chinese angle, and this marketing bind produced interesting tactics. The ads that announced the film as an adaptation of "Ching Ching Chinaman," for example, often also included the subheading "a great American short story by a great American writer." Essentially, the publicity campaign for *Shadows*—culminating with the New York premiere—recast the story of a Chinese immigrant looking for acceptance in terms of the film's own struggle to find an audience.

While the film marks a pivotal and precarious moment for Schulberg's independent production company, it also comes at a time when American silent cinema was coming into its own and when the thought of "artistic" motion pictures was no longer a laughable goal. By 1922, the prominence of the feature film had been established, and the moviegoing experience had been transformed by higher ticket prices and the increasing number of large, elaborate, dedicated movie theaters offering feature films surrounded by shorts, sophisticated theater design and other promotional gimmicks as part of a well-orchestrated "evening's entertainment."[7] In the march toward the "vertical integration" (of production, distribution, and exhibition) and audience consolidation that would eventually define the studio era, 1922 served as both a gateway and a bump in the road. The year 1922 marked a tough time for some in the industry, with profits down, banks losing faith, and audiences boycotting on moral grounds. And the unpredictability of exhibitors was still a thorn in the side of producers who were jockeying for position. In other ways, it was a year in which the seeds of the future were sown. Soon to be an industry powerhouse, Warner Bros. began producing films in the early twenties, and the Motion Picture Producers and Distributors of America (MPDA) was founded in 1922 (with Famous Players–Lasky, Metro-Goldwyn, and First National joining forces). This organization, led by Will Hays, would ultimately be responsible for

the Production Code (or "Hays Code") that would govern Hollywood productions in the studio era. Indeed, much of what we identify with the classical Hollywood era "had its roots in the twenties."[8] But in terms of style, narrative form, cultural centrality, and "star power," American film was both a force to be reckoned with in 1922 and a cultural force still testing and expanding its power.

With *Shadows*, director Tom Forman turned to expressionistic style, following German examples and translating them to a distinctly American milieu. But like DeMille and the team at Lasky years before, Forman was also self-consciously emphasizing film's artistic qualities and the specifically cinematic narrative strategies and thematic possibilities associated with its visual palette. (It's worth noting that producer Schulberg had begun his career at Famous Players–Lasky, as a publicity director, and his ties with Adolph Zukor remained, as he would later join Zukor at Paramount). While in terms of plot the film stays true to the short story, its visual style and themes exploit every opportunity to reflexively depict the screen image and to comment upon the audience's relationship to that image. In fact, the film seems at times to replay and condense the history of the cinema and the apparent vanquishing of the stage by the silent screen. Chaney's Yen Sin is the pivotal figure in this simultaneous gesture of looking forward and looking back: the racialized portrayal allows the film to have it both ways, satisfying the nostalgia for origins while celebrating the cinema's ascendency as a definitive break with the past. Coming as it does at a moment of relative confidence for American film, we might ask why a racialized figure is still key to this sort of cinematic self-portraiture.

This gesture of looking forward and looking back recalls the Janus-face figure discussed in the first chapter, and the mediating function performed by racialized bodies and the rhetoric of race difference, racial boundary crossing, and disguise. In the days of the early motion pictures, racialized bodies helped films transcend the limitations of the apparatus while also serving, at times, as figures for the signifying power of the apparatus. These figures provided literal and figurative movement within the still frame, expanded the narrative possibilities of "display," and often functioned to gesture toward and mediate the boundary between spectacle and audience. Here again, the positioning of the racialized figure between stillness and motion, spectacle and narrative, enables the productive paradoxes that define the cinema's power. Embodying opposing poles of the Chinese stereotype—on the one hand, ancient, fixed, unchanging, and on the other, magical, elusive, and transformative—Yen Sin represents both

the past and the present. If he is understood in the film according to his fixed, "Oriental" ways (associated with "stagey" sets and exaggerated performance codes), he functions, both narratively and symbolically, according to a logic of mobility and magic. Linked in many ways to the film image itself, he is a shadow that provides access to the essence or truth of the matter. In a sense, the patterns we have been tracing in formative and transitional moments come together here at a moment of seeming stability and cultural centrality for film, in one of the parables the cinema tells about itself. Indeed, the film reveals the underlying uncertainties of this moment, for it suggests that in the quest to define cinema's uniqueness, and in the march toward realism and the "integration and sublimation" of the increasingly self-contained cinematic illusion, something always remains. Even at the height of the silent era, a story featuring a marginalized, racialized figure becomes an opportunity for reflexive contemplation and celebration, for showing off and shoring up the screen image and its audience. In looking closely at this film, we can see how the patterns established in the cinema's earliest days remain crucial to defining the screen image, establishing its difference from other forms, and to developing and exploiting links between on-screen boundaries and the boundary between image and audience. Further, the links between questions of audience formation and the formal, stylistic, and rhetorical functions of race difference become especially clear here precisely *because* the film comes at a time when the feature film was increasingly a force to be reckoned with and when the moviegoing experience was increasingly a standardized ritual. In discussing this film I hope to illuminate a model of the film audience that is neither the textually constructed spectator of classical cinema nor the social audience. Rather, this model suggests that the film audience is imagined and idealized as a group identity, and that "race" defines and reinforces that identity as a distinct group bound by belief in the image.

Shadows demonstrates the importance of the racially marked body to both the "mythology" of cinema and to the structures of fantasy and belief involved in film spectatorship. This chapter focuses primarily on a close analysis of the film and the complex connections it makes between the racialized "Oriental" and the screen image. In particular, I look at how the film calls upon early cinema and proto-cinematic forms (including the shadow play and phantasmagoria) in order to define Yen Sin and to tell a particular version of film history. Because the film is in many ways a metacommentary on acting and performance, I also discuss it within the

larger context of Lon Chaney's persona—in particular his association with extreme physical transformation and disguise. Chaney's association with elaborate make-up effects offers another way of approaching the questions regarding the face and the body discussed in the last chapter. Chaney's work destabilizes the opposition between "realism" and "expressionism" (and the related opposition between the face and the body) in performance styles, revealing the role race plays in defining the acceptability and "believability" of these different modes. On the one hand, Chaney's racial disguise illuminates the interaction (and seeming blind spots) between "yellowface" and "blackface." On the other, this commentary on racial "impersonation" also provides a telling comparison with the work of "authentic" (but racialized) actors—not just Sessue Hayakawa, with whom the comparison would be direct, as above, but also with African American performers, who, as we see in the next chapter, are exploited for their authenticity in the transition to the sound era.[9]

Shadow and Substitute

As noted above, the rhetorical link made in the publicity for *Shadows* between community acceptance and audience formation continues in the film itself, through both its thematic concerns and its expressionistic visual style. A social melodrama dealing explicitly with issues of prejudice and implicitly with U.S. exclusionary policies toward Chinese immigrants, *Shadows* also comments on the origins of cinema and the power of the screen image.[10] As I argue, Forman's 1922 film turns a story about shadows, substance, and racial stereotypes into one about the interdependence of image and audience. Since it tells the story of a "heathen" Chinese launderer who converts to Christianity on his deathbed, *Shadows* focuses, not surprisingly, on issues of faith and belief, deception and illusion. Interestingly, however, these issues play out in terms of the status of images. *Shadows* exploits the relation between religious faith and faith in the image, and as a result the film reflexively comments on movies and spectatorship. The film highlights the power of the image to capture an audience—and also suggests the importance of group identity in constructing that audience. Further, *Shadows* dramatizes these issues through a nostalgic depiction of cinema's origins that hinges on the performance of race. This combination of Orientalism and self-referentiality produces the defining tension at the heart of *Shadows*. The power of the screen image depends upon the audience's credulity, and the Chinese figure in this film guarantees the

truth of the image for the audience (by which I mean both the movie's internal audience and the film audience). Ultimately, any rift in the relation between image and audience is healed through race difference—specifically through an appeal to the "Oriental" stereotype. With this operation, a film aimed at challenging prejudice ends up depending, both thematically and aesthetically, upon the very stereotypes and myths—the very "shadows"—it seeks to dispel.

By most accounts, *Shadows* is a mediocre melodrama redeemed only by Lon Chaney's "sensitive" portrayal of Yen Sin, a "heathen" Chinese laundryman. Yet Chaney's role is a supporting one. *Shadows* tells the story of young Minister John Malden (Harrison Ford) whose devotion to his wife and community is matched only by his determination to convert Yen Sin to Christianity. Neither the minister nor Yen Sin is part of the community as the story begins. We are first introduced to the small fishing village of Urkey, where a beautiful young woman named Sympathy (Marguerite De La Motte) is unhappily married to Daniel Gibbs (Walter Long), the abusive, drunken admiral of the fishing fleet. The entire community laments her situation, especially Nate Snow (John Sainpolis), a wealthy businessman who harbors a secret love for Sympathy. Sympathy's fate and the fate of the community change when a terrible storm hits. Daniel Gibbs is among those killed at sea.

The same storm brings Yen Sin to Urkey's shore. His origins are unclear, although he is referred to by the surviving fishermen as a "chink" who has "probably been cook on one of the coast boats that went down." Yen Sin takes up residence in a houseboat, and he gradually becomes a marginal member of the community as its launderer. Later, the minister comes to town and falls in love with Sympathy, whom he marries. At the peak of his happiness, Minister Malden receives a blackmail letter, seemingly from beyond the grave, from the late Daniel Gibbs. Gibbs writes that he did not, in fact, die at sea; he is alive and thus still married to Sympathy. He demands money to stay away. The minister submits to the blackmail, but he is wracked by guilt. Meanwhile, Yen Sin becomes gravely ill. On his deathbed, he calls for the minister and his "friend" Nate Snow. As the community gathers around, Yen Sin reveals the truth: motivated by his jealousy, Nate Snow has plotted against the minister. He forged the letters from Daniel Gibbs, who was, in fact, dead. He stood by and watched as the minister suffered. Initially enraged, the minister forgives his enemy. Seeing Christianity in action inspires Yen Sin to convert at last, just before he dies.

Although 1922 is not as clear a "transitional" moment in cinema (in terms of technology, narrative/formal structure, or legitimacy) as some of the earlier periods looked at so far, there are many ways in which the film does speak to a borderline moment both politically and in terms of the strategies for representing racialized others. As Sara Ross puts it, "In a surprising number of spheres, this year may be regarded as a pivot point between the traditional and the modern."[11] In many ways *Shadows* seeks liminality: both in its subject matter and in its reflexive commentary, it seems bent on claiming a productive marginality. The increasing nativism and anti-immigrant sentiment of the late nineteenth and early twentieth centuries led to a period of intense political debate and increasing popular scrutiny in the early 1920s that culminated in the Immigration Act of 1924. The historic legislation not only continued and extended exclusionary policies toward the Chinese but also drastically reduced immigration to the United States more generally, especially from southern and eastern Europe. The early 1920s thus marked a crucial period for immigration policy, and the interrelated discourses of eugenics, racial quotas, and national gatekeeping emerged as the potential consequences of the shifting racial and ethnic profile of the nation were being explicitly and extensively debated.[12] B. P. Schulberg leaned to the liberal end of the political spectrum, and thus his attraction to a story that depicted a Chinese immigrant in a sympathetic light was not surprising. Nonetheless, that depiction is caught between seemingly progressive ideas about racial prejudice and the stereotypes, exoticism, and creaky performance codes inherited from the vaudeville stage and popular culture. As in other films released the same year (including Robert Flaherty's *Nanook of the North* and D. W. Griffith's *One Exciting Night*), *Shadows*' seeming gestures toward sympathetic (or at least softened) portrayals were still grounded in the idiom of racism and exoticism. The "heathen Chinese" was one of the most prevalent and pervasive stereotypes of the latter half of the nineteenth century, when white working-class antipathy toward the Chinese grew as Chinese immigrants were seen as a threat to the labor force. Yen Sin's name even references the villain of Bret Harte's 1870 poem, "Plain Language of Truthful James" (popularly known as "Heathen Chinee" and featuring Ah Sin), the source text for the widespread circulation and multiple iterations of the stereotype that would follow.[13] Even if the film uses these popular images from stage and song in order to cast doubt upon them, the "Oriental" stereotype still carries most of the weight in making the aesthetic, symbolic, and narrative goals of the film come together. In this sense we can see the limitations of

focusing on "negative" versus "positive" images in questions of representation. As this and other "sympathetic" characters suggest, the persistent, ever-evolving racial stereotype functions as the hinge that joins positive and negative portrayals.

As mentioned, 1922 featured the release of Robert Flaherty's groundbreaking *Nanook of the North,* which would transform the travelogue into romantic ethnography and establish Flaherty (in the eyes of later filmmakers and critics) as the father of documentary film. Less groundbreaking was D. W. Griffith's *One Exciting Night.* Often charged with being Griffith's worst film, it comes at the latter stage of his career, when he was still attempting to outrun the racism of *Birth of a Nation* and when he was struggling to remain relevant as a filmmaker. The film imitates a popular play of the time (Mary Roberts Rinehart's *The Bat*) and attempts to bring this modern type of storytelling (the haunted or "dark house" mystery) to the screen. Griffith writes his own version of the tale, and as Linda Williams has pointed out, he turns a mystery about hidden money and murder into a racial mystery as well. The film heaps suspicion on a black character (Sam, played by a white actor in blackface) before finally revealing him as a hero, and a number of scenes play with and on white racist assumptions in order to upend or at least acknowledge them. At the same time, the film contains numerous comic scenes featuring a minstrelized, blackface caricature in the "Zip Coon" mold.[14] While stylistically and in terms of plot *One Exciting Night* bears little resemblance to *Shadows,* they are linked not only by their release dates but also by their attempts to exploit racist assumptions in order to produce suspense and to deflect attention away from the real villains. Yen Sin acts suspiciously (and his secretive, suspicious nature is linked to his Chineseness), but he also shames the whites in the film (and, by extension, those in the audience) who have suspected him by turning out to be the hero who reveals the real villain and saves the community. In both films, the "suspicious" figures provide evidence that reveals the truth; both seem to have almost magical powers, and both come from elsewhere and disappear in the end (in the case of Sam, he has come from Africa, seemingly just for the purpose of solving the mystery).

These films also came out at a moment when the rules around the portrayals of nonwhite characters, and the interaction between whites and nonwhites on screen, were in flux. As Williams puts it, this particular pre-Hays Code moment (1922) "catches Griffith and American film history in a kind of interregnum, neither entirely proffering the incendiary, soon-to-be-outlawed depiction of "miscegenation" and racial offenses of the

previous decade nor yet proffering the neutral safety of omitting black representations and 'serious' relations with whites altogether" (126). Williams argues that Griffith's film represents "a *modernization* of his own previous uses of blackface" (122, original emphasis), and that the film's "very modernity" is tied to its ambivalence—to the fact that we don't know "from one moment to the next, who is the racial villain, who is the racial victim, of this work" (127). Not surprisingly when considering Griffith's body of work, his attempts to critique racism produce more confusion and overcompensation than progressive statements. *Shadows* seems a more genuine attempt to comment on a real life problem (the exclusion of Chinese immigrants), but it, too, seems caught in a middle ground in its attempts to represent the relations between whites and nonwhites. While featuring a sympathetic Asian character, the film avoids the incendiary subjects (assimilation and potential miscegenation) of *The Cheat,* offering instead an asexual figure that consolidates the white heterosexual couple. In part this is because it focuses on a Chinese immigrant (as opposed to the Japanese merchant in *The Cheat*); in part this is because its antiprejudice message works by making the Chinese figure as unreal (and thus nonthreatening) as possible—he is more fairy godfather than person.

Griffith is able to have it both ways, delineating the varying codes of realism guiding the black characters, in part, by virtue of varying levels of blackface for different characters (from the subtler dark makeups to the exaggerated caricature of the minstrel mask). Lon Chaney's performance, on the other hand, encompasses the complementary and sometimes contradictory elements of the Oriental stereotype, just as it accommodates both "realistic" characterization and the portrayal of a symbolic racial type. While even on stage, the portrayals of Chinese characters by whites had become more complex (offering a larger array of types, including women, and making more references to sexuality and modern dilemmas), the "heathen Chinese" and the Chinese laundryman remained stock comic figures. And in the case of *Shadows,* the play on the racial stereotype is intimately connected to the film's visual style; the film's stylistic experimentation—*its* claims to modernity, if you will—depends equally upon its exploitation of the racialized figure and its use of shadows. The film puts the shadow to use in multiple ways, and it becomes the primary figure through which it comments on film's unique power. The emphasis on shadows offers a way for the film to depict its "Oriental" while also announcing its departure from the caricatures and representational strategies of the past. Yet it

proves difficult to detach these "new" shadows from the legacy of racialized and disfigured bodies that casts them.

Shadows features the visual patterns, performance styles, and chiaroscuro lighting effects associated with German Expressionist films of the Weimar period. Most strikingly, the film makes extensive use of shadow plays. At key moments in the plot—as when Yen Sin exposes Nate Snow's villainy—shadow plays reveal the hidden fears and desires of the main characters. Silhouettes and shadow plays showed up in both animated and live action films in the 1920s. American animators experimented with "shadow films" in the teens and twenties, and that technique reached its peak in 1926 with the first feature-length animated film, German artist Lotte Reiniger's *The Adventures of Prince Achmed*. Reiniger's work came out of German Expressionism, and a number of German films of that period utilized silhouettes and shadow plays to heighten the supernatural elements of their films. There is a direct relation between those better-known German films and Forman's *Shadows*—the director enlisted Engert, the renowned German silhouette artist, to create his film's shadow plays. Engert would also work on Arthur Robison's *Schatten* (translated as *Warning Shadows,* 1923), the German film in which shadows warn partygoers of what might happen if they act on their adulterous desires.[15] The emphasis on shadow plays and silhouettes is important for a film stressing faith n images. The silhouette references physiognomy and the essential truth of body language, while shadow plays take on a life of their own: shown in their own frame, these shadows possess their own iconic existence (as opposed to shadows shown in the same frame with the bodies that cast them).

The 1920s saw renewed interest in shadow puppetry, and it was not limited to films. The renewed interest in shadow puppetry and silhouette art in the United States shows up in a number of cultural contexts: popular magazines, art criticism, and theater, as well as in film. Since the silhouette was favored by John Caspar Lavater and figured prominently in his *Physiognomy* (1775–78), which featured "character studies" drawn from silhouettes of famous people, twentieth-century advocates of the silhouette never failed to cite his work. While physiognomy remained a quaint artifact of the eighteenth century, the words of twentieth-century critics suggest that while Lavater's theories were long dismissed by science, they were still relevant to art and still occupied a place in the cultural imagination. Silhouettes of actors were featured in *Photoplay* in the late teens and twenties, often presented with physiognomic readings of the actors' features.

And apparently silhouettes still appealed to middle-class readers looking for design ideas. One writer, chronicling the new "vogue for silhouettes" to potential collectors, noted that Lavater's physiognomy was a "pseudo-science," but suggests that the value of the silhouette greatly increases when one consults his text. The article ends with Lavater's words, which sum up the silhouette's paradoxical value: "What can be less the image of a living man than a shade? Yet how full of speech! Little gold, but the purest."[16] Again, the physiognomic imagination accommodates "speech" and silence—a much-touted goal of silent film acting in the teens, as we saw in the last chapter. The value of silhouettes and shadows lies in the promise of linking pure meaning and pure image. Just a year before *Shadows* was released, a New York performer prepared to launch a series of Chinese shadow plays using authentic Chinese puppets and a centuries-old scenario. One reviewer applauded the attempt at "resurrecting Chinese movies a thousand years old": "It appears that motion pictures, along with so many things that are supposed to be of modern creation, are of Chinese origin."[17] The link between the "photoplay" and the "shadow play" was already a part of the popular imagination, but in the glib reference to shadow puppetry as "Chinese movies" we see the importance of origin stories in linking old and new, exotic and familiar: movies are authenticated as part of an ancient tradition, while Chinese shadow plays are domesticated as something already known. *Shadows* uses its "Chinaman" in a similar way, as the connection between the Chinese figure and the origins of the screen image becomes key to the film's rhetorical strategies.

Yen Sin is introduced in the film as a kind of shadow—one reminiscent of the cinematic "shadow." We first see him when he is brought ashore. When he refuses to pray with the villagers, they shun him, but the intertitle tells us he decides to stay despite this. The film introduces his character more fully in the next scene, when he has already taken up residence on the literal margins of the community (a houseboat docked on the shore) and has begun taking in the town's laundry. The scene establishes a romanticized setting for him.[18] In a wide shot of the dock, Yen Sin's houseboat occupies the bottom right of the frame. While Yen Sin is not visible in the establishing shot, his laundry hangs on the lines, setting up the metonymic relation made explicit in the next intertitle: "Early and late, his steam-blurred silhouette swayed over his tubs and irons." This line is taken directly from Steele's "Ching Ching Chinaman," and the sequence that follows offers one of the many examples of the way the film expands upon and intensifies the silhouette and shadow imagery found in the story.[19]

The shot of the dock slowly dissolves to a medium shot of a window through which we see Yen Sin at the ironing board. At this point, his face is obscured, and we see merely a head and arm moving back and forth with the iron (see Figure 22). This brief shot offers multiple frames. In addition to the film frame, two windows set off the ironing figure. He stands by the front window, silhouetted by a brightly lit back window. After only a second or two, this remarkable shot dissolves inside to a medium close-up of Yen Sin, smiling. Now his face is fully visible; no longer merely a symbol, he enters the story as a character interacting with the world around him, as a group of children on the dock distract him from his work. This sequence establishes his literal and symbolic place in the film. The ironing figure is the first of the film's many meaningful "shadows." Flattened by the backlighting, Yen Sin's moving body is identified with the film image itself—a two-dimensional moving picture in a brightly lit frame. And the screen image is in turn identified with the iconic "Chinaman": the two-dimensional, romanticized stereotype that sways "steam-blurred" over his tubs and irons.

This image is immersed in labor and materiality, yet it also transcends both: the laundryman's "silhouette" (not his actual body) "sways" over the

Figure 22. "Early and late, his steam-blurred silhouette swayed over his tubs and irons." *Shadows* (Tom Forman, 1922).

hardware. His flattened image sways in the wind like the billowing sheets and shirts hanging on the clothesline, as a film image might float on a piece of white material hanging from the rafters. Here, the racialized body turns the specific history of Chinese immigrants and physical labor into the racial hieroglyph, raised above the material to the spiritual/symbolic realm. This is a cinematic manifestation of the transaction that David Palumbo-Liu describes in his attempt to specify the notion of a "racial-ized" body: in reading the transaction between "the objective body, with its particular inscriptions in material history, and the way that body is semiotically deployed in social and cultural discourse," he notes the need to "maintain a focus on the material densities of bodies placed in the cir-cuits of labor and consumption. Without such a focus, the body threatens to become disembodied, a free-floating signifier released from historical materialism, disjoined from the very productive forces that have given us Asian America."[20] In the sequence on the houseboat, and in subsequent scenes featuring Yen Sin in his function as launderer, we see the way the two registers (material and symbolic) are combined to poetic effect— making the "Chinaman" simultaneously a symbol of his race, of labor stereotypic to it, and of the making of the screen image.

In addition to condensing the history of Asian American labor, this and other houseboat sequences visually link Yen Sin to multiple kinds of image making, multiple strands of cinema history and prehistory. The back-lit image of Yen Sin at work calls to mind the earliest motion pictures, since "Chinatown" was a popular subject of early actualities, and Chinese laundry scenes show up in early Edison and Biograph shorts.[21] As noted, this imagery also invokes the tradition of Chinese shadow puppetry. The introduction of Yen Sin on his houseboat precedes the true shadow play work featured later in the film, however, and the imagery surrounding him in this early scene suggests other proto-cinematic techniques as well—par-ticularly those associated with magic and early special effects. In particular, his "steam-blurred silhouette" sways like nineteenth-century phantasms. Popularized in 1797 by Belgian magician "Robertson" (Étienne Robert), phantasms were created by projecting images (from a magic lantern) onto smoke, creating ghostly, undulating apparitions. The practice spread to England and the United States, where various versions of *Phantasmago-ria* shows appeared in major cities during the first half of the nineteenth century. In the phantasm, the moving image is also a spectral one, offer-ing "apparitions of the Dead or Absent."[22] The image of Yen Sin as a "steam-blurred," swaying figure condenses the various precursors of the cinema.

While at other moments in the film Yen Sin occupies a theatrical space that aligns him with stage melodrama, here he symbolizes cinema's prehistory. More importantly, especially for understanding the function of the film's reflexivity, Yen Sin's "steam-blurred" image yokes together the ghostly apparition, the racialized figure, and the cinematic illusion. In this way the scene prefigures the way the film will repeatedly unite the shadow play and the racial stereotype, granting both a spiritual presence associated with physical absence.

Yen Sin's marginal status in the community positions him as both present and absent. He resides on the literal margins of the village—in a houseboat docked at the shoreline. He washes ashore in Urkey only to be turned away, and his (absent) presence just offshore clearly suggests the exclusionary U.S. immigration policies of the period. Constructing the unwanted or disregarded immigrant as a shadow is clearly meant by the filmmakers to be a progressive move. Yen Sin's position between China and America is represented, however, as a nether region between past and present—granting the character (and the space he inhabits) a mythical status that undercuts the potential for social critique. The social and political valence of Yen Sin's marginal existence is further complicated by the multiple meanings of "shadow" that come together in Yen Sin. He is a shadow because he functions in the community as a kind of phantom or "shade," but he is also closely linked to the shadow plays that figure prominently in the film and that reveal hidden truths. Yen Sin seems to function like a shadow or doppelganger might in a German Expressionist film. Like the shadows in *Warning Shadows,* Yen Sin reveals the truth that has been hidden or repressed. Like the doppelganger in *The Student of Prague* (Germany, Henrik Galeen, 1926), Yen Sin does the minister's dirty work (he finds out who the blackmailer is and lays a trap to reveal him).[23] But the various types of "shadows" and their functions can be distilled into the two categories most at odds in *Shadows:* elusive or illusory phantasms on the one hand and immediately legible expressions of hidden truths on the other. Yen Sin is linked to both kinds of shadow and ultimately joins the two. Through Yen Sin, shadow-as-illusion and shadow-as-substance are linked.

As such, Yen Sin perfectly embodies the stereotype—not merely in terms of its content ("the Chinaman" or "Oriental") but in its form, its *modus operandi.* The oscillation between seemingly contradictory positions expresses perfectly the way stereotypes function—in the film and in the culture more generally. If the stereotype is in fact "a complex, ambivalent,

contradictory mode of representation,"[24] then it functions as a productive site that encompasses change, fluidity, and even magical transformation within it. Interestingly, this play of differences is also reflected in the content of the Chinese stereotype embodied by Yen Sin. While at times he seems to represent "the Orient"—the ancient, fixed culture permanently set in a mythic past—the film also deploys another aspect of the Western stereotype that identifies the Chinese with mystery, elusiveness, and mobility (even the ability to be in two places at once). Or as the narrator of "Ching Ching Chinaman" puts it, Yen Sin is the "familiar and inscrutable alien."[25] The association with magic, theatricality, and transformation existed not only in early cinema but also in stage culture and in the way Chinatown was imagined and consumed in the early twentieth century. From the mid-nineteenth century on, some of the most popular Chinese performers on the American stage were acrobats, jugglers, and magicians. By the end of the nineteenth century, Chinatown became a destination for white tourists, and Chinatowns appeared on stage, screen, and in song as "a site of both danger and pleasure."[26] As Sabine Haenni has noted, these associations were translated to early cinema, as a number of early films featuring "Chinese" figures focused on the mutable, strange body and featured tricks that defied physical limitations. What she describes as these films' "fascination with mobility, mutability, and bodily transformations"[27] suggests the complexity of this particular stereotype; these images seem to contradict the notion of the static, unchanging "Oriental," yet these very contradictions help to sustain and empower the stereotype by providing multiple points of identification, projection, and fantasy for the dominant culture.

In *Shadows*, these contradictory/complementary images function formally as well as thematically, as the Oriental stereotype plays a crucial role in negotiating the tension between spectacle and narrative drive. The conflicting projections onto the Chinese body work together in *Shadows* in order to produce a melodramatic, theatrical spectacle on the one hand (tableaux displaying ancient "Oriental" ways) and suspense and narrative drive on the other (Yen Sin's spooky, secretive movements helping to drive the plot). Yen Sin's immutability is best represented by his refusal to convert, and the film exploits his "Oriental" customs for their value as spectacle. Yen Sin resists the minister's evangelism repeatedly, and the film juxtaposes his religious practices with those of the villagers. We see him on his houseboat, lighting candles to his Buddhist shrine; this scene suggests potential common ground between the "heathen" and the villagers

(prayer) while simultaneously reinforcing difference. Composed of one wide shot, the scene offers viewers a quaint tableau. The static framing, even lighting, and frontal mode of address put Yen Sin on display, enhancing the feeling that he occupies a separate sphere. In essence, Yen Sin gains the Western audience's sympathy without challenging the notion that "East is East, and West is West." In scenes located off the houseboat, Yen Sin is either framed alone or off to the side of large crowd shots. His assimilation represents the impossible object of the melodrama—especially since he is valued (by the community and by the narrative) only for his "heathen" and "Oriental" qualities. The film also exploits Yen Sin's resistance to change for comedy: at one point, seeing that Yen Sin sleeps on a hard bed with no pillow, Sympathy embroiders him one. Yen Sin promptly uses it as a cushion for his cat while he continues to sleep on a board. In this sense, Yen Sin's houseboat seems more firmly anchored to his ancient culture and customs than to the American shore. The boat provides a temporary stage linking Yen Sin to Urkey, but it remains ready to unmoor, to float "back Chinaway," as Yen Sin repeatedly puts it. The houseboat perfectly figures the seemingly impossible combination of stasis and mobility that Yen Sin embodies.

Different representational strategies underscore his dual role in the narrative, as the spectacle and stage business mentioned above give way to "camera business" once Yen Sin's secret movements enmesh him in the blackmail plot. In these crucial scenes, the audience is kept in the dark (literally and figuratively), as double exposures and chiaroscuro lighting effects shroud Yen Sin in mystery. The combination of withheld (or misleading) information and Sin's enigmatic status produces suspense. Yen Sin's mobility tends toward the magical or spooky, and he possesses an uncanny ability to be everywhere at once. He watches and follows the townspeople, and as he magically appears from behind bushes and around corners at crucial moments in the narrative, he becomes a suspect. When the minister learns the real identity of the blackmailer (Nate Snow), he expresses relief that his fears were "mere shadows." While these fears exist only in his tortured mind, they do not go unrepresented. Importantly, however, they are *not* represented by shadows. As is discussed in detail later in the chapter, shadow plays are reserved for moments of truth and are always framed as public spectacle. Minister Malden's fears haunt him in private, in the dark of night. Only the movie audience and Yen Sin are privy to his secret, and we see the ghosts along with him. His "shadows" are, in fact, apparitions: he is pursued by the image of Dan Gibbs, his

alleged blackmailer. The spectral image of Gibbs (produced through double exposure) appears on the minister's lawn, taunting him with the possibility that he will reveal himself and ruin the minister's life. The Dan Gibbs apparition appears twice, but other figures also move fleetingly, stealthily in the night. When the minister finally tells his wife about the blackmail plot, she too is haunted by the thought of her abusive first husband. Just after she finds out, the ghostly image of Dan Gibbs appears to her in her yard. She runs off in fear, and when the camera cuts back to the yard, a shrouded figure comes out of the bushes. We expect Dan Gibbs, but the figure in the bushes is Yen Sin; this is just one of the ways the film at first seems to implicate Sin. There are multiple examples of Sin spying on the minister and his wife, his existence outside the houseboat seemingly reserved for this function.

Even at times when he remains on his houseboat, he is able to project himself elsewhere. In an earlier scene, the minister receives his first letter from Gibbs when he and Nate Snow are out of town at a conference. Since the minister has never seen Gibbs, he trusts Nate Snow to meet with the author of the letter—to see if it is, in fact, Dan Gibbs. Neither he nor the audience has any idea at this point that Snow himself penned the letter. As Snow leaves for his nighttime meeting with the non-existent blackmailer, someone crouches in the shadows, watching. At first, this suggests that there is a blackmailer, that Dan Gibbs is alive and stalking the minister. But the stalker turns out to be Sam Low, a friend of Yen Sin's. Sin had given the minister his friend's name—as a trustworthy laundryman to whom he could send his shirts while out of town. He has also asked his friend to keep an eye on the minister, and that he does. As a result, he sees Nate Snow's machinations and communicates the dastardly plot to Yen Sin. Here, Yen Sin once again sees without being seen, but he does so through a proxy. His omniscience/omnipresence (which can be seen as godlike, magical, or simply spooky, depending on his status as villain or savior) is here brought down to earth. The remaining mystery surrounds the shadowy social existence of immigrants—not only does Yen Sin have Chinese friends in other American towns, but they even have a secret line of communication. Only at the end of the film do we find out how Sam Low informed Yen Sin of the blackmail plot: he wrote a message in Chinese on a shirt collar and sent it with a batch of dirty laundry. Early in the film, after Yen Sin has won over the little boy he calls "Mista Bad Boy" by giving him candy, he explains the system that ends up making it possible for Low to communicate the real identity of the blackmailer to Sin. Yen

Sin routinely writes on the collars of his customers, he explains, in order to tell their bundles apart. He labels the collars in Chinese—but not with his customers' names. Since he doesn't know their names (one more level of barrier between Sin and the community), he creates names for them based on their memorable characteristics. Under double cover of the laundry and the Chinese characters, this mail—itself a kind of "blackmail"— is secret and potentially suspect until we know the truth.

Secretive, marginal, and even (by virtue of his transactions with Sam Low) multiple, Yen Sin moves in mysterious ways. With scenes showing the villagers taunting him, as well as those that emphasize his domestic existence on the houseboat, the film does give a nod to the social realities and labor relations inherent in the Chinese immigrant's shadowy existence: as laundrymen, Sin and Low do the town's dirty work, and in this function, they also see the town's dirty work (blackmail, adulterous desires, deceit). Yen Sin sees without being seen, and the film portrays this talent as a product both of Yen Sin's "invisible" social standing and his inherent racial characteristics. In its characterization of "the Oriental," the film toggles between racial/biological and social readings of difference. In a sense, the film's ambivalence is part of the ambivalence of the period, especially in the discourse around immigration and the potential of various races to assimilate to "American" culture. Repeatedly in these debates, the "Oriental" must be excluded from the nation because of the extremity of his physical and cultural difference and the consequent impossibility of his assimilation.[28] Even in more social and cultural accounts, the social outcast status of the immigrant becomes intractable when the immigrant in question is also a racial outcast—one whose racial characteristics set him utterly apart from whites. At the same time, the migrant becomes a figure of fascination for some. In his movement from one place to another, this hypothetical figure brings divergent cultures together, and his hybridity and marginality become aligned with the modern condition.

In his discussion of eminent sociologist Robert Ezra Park's writings on race and culture, David Palumbo-Liu has noted the "uneasy slippage between cultural and racial hybridity. At times they are synonymous, but at others race persists in being much more visible and problematic—sometimes racial others are read as synonymous with the general exotica of modern forms; at other times, they are markers of a "racial frontier" that cannot be crossed without cost."[29] Indeed, in Park's writings, Asian immigrants are doomed to forever exist on the margins largely because their physical differences will naturally be misread by the dominant culture.

Park notes that "race prejudice is a function of visibility," and "where racial characteristics are marked . . . the stranger remains strange; a representative of his race, but not a neighbor."[30] Yen Sin cannot be assimilated, but his marginal position grants him access to knowledge—from his space on the margins, he can see precisely what the villagers, the insiders, cannot see. And the sideshow exoticism of his quaint customs co-exists with the magic and mobility that seem more in line with the "exotica of modern forms"—most particularly the modern form of the cinema itself. The figure of the outcast of course helps to produce the polarization and victimization central to melodrama, but the film also wants to link marginality to the cinema's essential modernity.[31] It's not that the film represents Yen Sin as a modern cultural hybrid—indeed, he is quite the opposite. Nonetheless, he functions in a way that links marginality and fluidity to newness and truth—to the act of lifting the veil of "old" superstitions and prejudices. So it's not about the content of the racialized figure—the way he is represented—so much as the way he functions as a rhetorical device. The film doesn't upend the stereotype because it needs it. Despite his friendships and his ultimate transformation (his deathbed conversion), Yen Sin remains "unmoved"; he is unassimilable and floats "back Chinaway" in his elaborate death scene. By embodying the impossible configuration of fixed mobility or transformative immutability, Yen Sin expresses the anxious coexistence of racial and cultural understandings of identity.

He functions as a shifty signifier, and that "shiftiness" is matched only by the shadows that give the film its enigmatic title. The film's title has numerous referents, and thus the meaning of "shadows" is appropriately elusive. Yet, at key moments in the film, both Yen Sin *and* the expressionistic shadows provide access to a clear and stable truth. By embodying these shifting meanings, Yen Sin paradoxically anchors the meaning of the film's ultimate shadow: the screen image itself. Thus the shadow is not only a privileged figure for the liminality and marginality of the social outcast—it also announces the "newness," the threshold quality of film itself. While the film utilizes Yen Sin's outcast status in order to arouse sympathy, it also wants to claim a marginal status for the film image—a marginality identified not with exclusion but with a privileged view, a window between two worlds that allows us to see both sides. In this sense, the "Oriental" figure (like the film image) allows us to see both internal and external, both matter and spirit.

All of the elusive figures, double visions, and spooky apparitions coalesce—coming into sharp focus in the crisp shadow plays that finally, with

Yen Sin's help, reveal the truth. Yen Sin foils the blackmail plot, or as one reviewer put it, he "launders [the villagers'] very souls, cleansing them of the hypocrisy with which they had been smeared."[32] Like the short story on which it is based, the film exploits the link between cleaning laundry and redeeming souls, turning the "heathen" into a Christ-like savior who sacrifices himself in order to save the community. The overt Christian symbolism works with the Oriental stereotype (and the presumed audience prejudices) to produce the ironic reversals already apparent in the characters' names ("Snow" is impure of heart; "Sin" will become the savior). Yen Sin redeems the town's soul(s), but he also redeems the image. As explored in the next section, the crisis of faith in Urkey plays out in a series of performances. Yen Sin reveals the truth in a meticulously staged performance of his own, reinstating the truth of performance and re-creating a credulous audience—a community of believers. In order to heal the community, Yen Sin must redeem the image, cleansing it of its association with illusion and deceit.

It is fitting, perhaps, that the screen shadow must be legitimized, even consecrated, by a shadow. If we return to the metonymic image that introduces Yen Sin—"early and late, his steam-blurred silhouette swayed over his tubs and irons"—we can see the way the film literalizes Homi Bhabha's characterization of the stereotype as "both a substitute and a shadow."[33] If, like the fetish, the stereotype serves a double function as substitute (or metaphor) for the site of difference and as the (metonymic) fragment or reminder of that difference, then Yen Sin's doubleness serves a similar function. The metonymic image introduces Yen Sin as a shadow; he then acts like a shadow, clinging to the edge of the community and inhabiting its alleyways. In the end, he must leave, and in this way *Shadows* maps the uninhabitable space between substitute and shadow—the ever-receding stage (here a houseboat) upon which the marginalized subject may act. In leaving, he prepares Urkey for the reign of the substitute—for image worship. The cinematic image itself is likewise both substitute and shadow, and the film cannot uncouple the two shadows (Oriental stereotype and moving image) despite its ostensibly anti-racist goals. Although the film attempts to replace that shadowy figure with the friendly, truth-seeking Yen Sin, it depends on the constant oscillation between image and body, shadow and substance. The Oriental figure looms large here—the silhouette that swayed over his tubs and irons becomes the racialized sign that replaces the real immigrant. That image makes image worship possible. This positioning of the Oriental stereotype as mediator between the image

and the (internal) audience suggests ways of thinking about spectatorship more generally. Specifically, I would argue that Yen Sin's symbolic function helps us to understand the role race difference plays in binding image, meaning, and audience.

Performance, Image, and Audience

Lon Chaney's performance as Yen Sin was praised all around. There is no doubt that Chaney is an "Occidental" impersonating an "Oriental," as Sessue Hayakawa put it, but his role in this film is best understood if contextualized not only within the history of "yellowface" performance, but also in terms of Chaney's own unique persona. By the latter part of the nineteenth century, the practice of white actors in yellowface had been fully codified and expanded to include a variety of types. As Krystyn Moon traces, the increasing "realism" of these practices was tied to developments in makeup techniques but was also driven by the influx of Chinese and Japanese performers on American stages. By the twentieth century, Moon relates, "Drawing a line about three-fourths of an inch beyond the eye and adding a highlighter on the lid were techniques used to slant the eyes. In more elaborate characterizations, systems of tape and putty were implemented to slant the eye, a method used predominately in the movie industry" (Moon, 116–17). Indeed, the "putty" process she describes is essentially the method Chaney used, not only in *Shadows* but also in a number of other films in which he played "Orientals." In the first published handbook of makeup for the screen, written in 1927 by MGM makeup director Cecil Holland, directions are given for an array of different types. The book was intended as a textbook for the industry, and Lon Chaney, whose many contributions to makeup effects influenced Holland, wrote the preface. Under the section on "The Chinaman," Holland includes the following description: "An Oriental, stupendous in numbers, moderate in achievements, magnificent in honesty, stoic, stubborn, secretive. A sleeping dragon, drugged by traditional and national addiction . . . The Chinaman."[34] He details the makeup technique, which featured the use of fish skin at the corners of the eyes and clear tape around the head; he then adds that "false teeth add greatly to a Chinese and Negro make-up, to make the lips protrude" (Holland, 71).

That the Chinese and "Negro" types drew on the same bag of makeup tricks is no surprise, as yellowface and blackface shared the vaudeville stage, and twentieth-century performers inherited many of the elements

of their stock portrayals from minstrelsy. Portrayals of Blacks and Chinese figures by Whites were intertwined on stage, in song, and on screen. By the early twentieth century, there are even examples of African American stage performers dressing as Chinese characters and performing comic bits and songs set in laundries and opium joints, as well as some Chinese Americans performing in blackface.[35] This history demonstrates the many continuities and connections between yellowface and blackface performance, but in Chaney's performance style and in responses to it, we can also see the way these different iterations of racial disguise were perceived and judged differently, especially with respect to notions of "realism" and "authenticity" and the level of credulity and sympathy expected from audiences. Holland's textbook gestures toward the different types of racial disguise—specifically, to how makeup choices both determine and are determined by whether a character is comic or dramatic, according to different levels of caricature versus "character." The very last category in his book (after "cauliflower ear" and "hairlip") is "Negro," and the entire section is taken up with differentiating the "Negro" from the "minstrel." Mistakes in a "Negro" makeup, he warns, will result in the "minstrel effect."[36] And while there was an array of Chinese figures on the vaudeville stage by the end of the nineteenth century, and a seeming shift toward "realism," the clear demarcation between full "Chinaman" caricature and "realistic" portrayals seems less clear, as if the "yellowface" disguise is not recognized as an extreme racial mask.

This may have something to do with the Western tendency to depict or perceive the "Oriental" face *as* a mask. This was clear in the responses to Sessue Hayakawa, as we saw in the last chapter. His restraint and his ability to "aim his mask" at the audience were both tied to his "race." Interestingly, Hayakawa's mask seems to represent something new and modern on the screen (to French intellectuals and American fans alike), whereas Chaney's mask (which essentially represents Yen Sin's face as mask-like) would seem to suggest the ancient, unchanging, "inscrutable" qualities of the stereotype. Again, Park's comments are telling. In his 1926 essay "Behind Our Masks," he notes that we all wear "conventional masks" that define our social personhood, but he also characterizes the "racial type" as a mask that hides the individual. He notes this of every ethnic group, but he also specifically associates the "Oriental" face with a mask. In this sense, the Oriental is doubly masked, because he "lives more completely behind the [conventional] mask than the rest of us"[37] and because his specific Oriental traits make his face an impenetrable, irremovable mask: "The Oriental

in America experiences a profound transfiguration in sentiment and attitude, but he cannot change his physical characteristics. He is still constrained to wear his racial uniform; he cannot, much as he may sometimes like to do so, cast aside the racial mask" (252). This sense of masking or unreadability makes "yellowface" racial disguise—even a highly exaggerated one—acceptable or unremarkable. Lon Chaney's portrayal of Yen Sin is about as exaggerated and caricatured as can be, and yet critics—many of whom were quick to deride "burnt cork" stuff when discussing blackface portrayals—praise his work as "excellent" and believable. Chaney's portrayal includes his typical "Oriental" makeup ("slanted" eye, protruding teeth, etc.), but his bodily poses and gestures are equally important to constructing the character. Yen Sin is often seen crouching, his hands often held out in a claw-like manner, emphasizing his long fingernails. In general, his movements might be described as cat-like, and he is associated with cats in the film—both his pet, whom he treats with great indulgence, and in the revelation scene in which he imagines Nate Snow as a cat playing with a mouse (the victimized minister). In the case of Chaney's "Orientals," it seems that a "sympathetic" portrayal stands in for a "realistic" one, as the makeups and gestures change less than the character and the situation.

Nonetheless, Chaney's association with makeup effects tended to both bolster and undercut the realism of a character and, by extension, a film. Perhaps more importantly, all of Chaney's performances were to some degree "about" disguise. Contemporary reviewers usually commented on the degree to which a white actor was successful in playing a nonwhite character, but because Chaney was known for remarkable makeup effects, the rhetoric of masking and disguise was always foregrounded. Chaney's star persona was unique for its time in this sense—the more hidden Chaney's "real face" was in a film, the more his presence as a performer was referenced. In a review of *The Penalty* (Walter Worsley, 1920) the *New York Times* reviewer hearkens back to another Chaney film, *The Miracle Man* (George Loane Tucker, 1919). He recalls that viewers at the time were at first struck by his playing a man with no legs and wondered how the "stunt" was performed, but "after they have followed his acting a while, and felt the force of his presence on the screen, they will take it as just a part of his role that his legs are missing." This despite the fact that "in several side views, the outline of his legs strapped up behind him is evident. But in all that he does, the man he is supposed to be is present."[38] Reviews of Chaney's performances usually also tended to include a heightened awareness of

makeup effects and an appraisal of how well they worked. This attentiveness to the art of disguise is clear in a review of another of Chaney's "Orientals." While *New York Times* reviewer Mordaunt Hall called Chaney's performance in *Mr. Wu* (1927) "excellent," he also noted that "his makeup might have been more effective, by less perfect eyebrows and more perfect Oriental eyes." He notes, too, that Chaney is "in his element" as the "cultured but sinister Chinese mandarin," while the actress playing Nan Ping is "splendid" even though "her smile is far from Oriental."[39] Once Chaney was well known, critics often referred to his acting as a "stunt" or "trick," which again calls to mind the opposition of body and face in debates around screen versus stage acting, the close-up, and pantomime. His disguises (which included many legless or otherwise disfigured characters) associate him with body-centered modes of performance, as they emphasize the physical over the psychological. Certainly this devalued the performances in some critics' eyes, and Hall, at least, seemed to think (especially toward the end of the decade) that Chaney was better "in those features in which he did not change his countenance." Whether a rave or a pan, reviews tended to make a special note when Chaney appeared "without any twisted limb or facial disguise."[40]

The tendency of reviewers to critique an eyebrow or to draw attention to the presence of Chaney's allegedly absent limbs suggests the way the remnants of the real conditions of the performer can intrude upon the cinematic illusion in some cases while further authenticating it in others. If we think back to Harry Furniss and those "awful cinematograph faces," we will recall that it's actually a bad makeup job that triggers his spectatorial (and racialized) nightmare. In the responses to Chaney, there seems to be a comfort with his "Orientals," a feeling that he is "in his element," despite the potential for makeup to be a clunky prosthetic. And yet Chaney's performance is still foregrounded—not only in the publicity, as shown at the beginning of the chapter, but in the film as well. This only seems to further the film's goals, and his disguise is, in part, the subject of the film. The combination of Chaney's persona and the Oriental stereotype seems to further set the already marginalized "Yen Sin" apart from the other characters, doubling the film's commentary on performance, masks, and deceit. Chaney's performance seems to exist on a different plane than that of the other actors, while at the same time Yen Sin becomes the central figure in the movie's interrogation of (and ultimate validation of) performance itself.

Despite the film's sympathetic portrayal of a Chinese character and its potentially disruptive expressionistic and reflexive techniques, *Shadows*

ultimately remains a conventional melodrama. This uneasy combination (in both form and content) of the progressive and the conservative is perhaps responsible for the mixed reviews the film received.[41] Yet the ambitious visual and thematic patterns in the film reveal much about the subtle strategies and complex relations underlying the melodramatic plot. In this fishing village, survival depends upon unyielding nature, and a storm at sea can devastate the community's livelihood. Other forces prove equally devastating. Outsiders play crucial roles, as their arrival can bring division (the prejudice leveled at Yen Sin) or cohesion (the religion represented by the new minister). The expected opposition between insider and outsider is destabilized, however, by the film's emphasis on performance. Taking performance as its central metaphor, *Shadows* highlights the gaps separating public and private, individual and community, reality and illusion. Yen Sin closes those gaps by re-aligning external appearance with internal or essential truths. While this might suggest a move away from performance, Yen Sin accomplishes this trick by staging the film's final and most elaborate performance; his deathbed theatrics identify performance with truth.

Performance needs to be redeemed at the end of the film because it has become aligned with deceit. And yet, as the film repeatedly suggests, the community depends upon (and is in fact constituted by) performances of various kinds. When Yen Sin first arrives in Urkey (in the wake of the tragedy at sea), Nate Snow leads a group of villagers in prayer. When Yen Sin refuses to kneel with them, Snow casts "the heathen" out in a public display of righteousness. He points at Yen Sin and shouts, "Pray—or get out! We're all believers in Urkey—we want no heathens!" Yen Sin stands apart, framed alone in medium close-up as he looks back at the kneelers. Snow's grand gestures and melodramatic pronouncements before an audience accentuate the theatricality of the moment while illustrating the interdependence of the outsider and the group. The scene isolates the moment of group identity formation: the citizens of Urkey are believers, an identity defined by Yen Sin's exclusion and consolidated by the shared performance of a ritual (kneeling for prayer). The tensions and ambiguities surrounding community, identity, and belonging only increase once Minister Malden comes to town. Significantly, these tensions play out in a series of performances. As a community is constituted, so is an audience; again and again, major events in the narrative take place before an internal audience—usually an impromptu gathering of villagers. Consequently, the role one plays in the community (dedicated minister, wealthy businessman, long-suffering wife) becomes explicitly and dangerously aligned with

acting, with playing a role in the theatrical sense. Acting is dangerous in this setting because it suggests deceit: those who act righteous in public (Nate Snow, for example) may be wicked in private.

This becomes a particularly volatile possibility in the minister's case. With his arrival in Urkey (which occurs after Yen Sin's ostracism), the young, handsome minister becomes the hero of the film and the hero of the community. Not only does he gather his flock about him with his religious zeal; he also marries Sympathy. The villagers watch the progress of this romance with the same interest and excitement a movie audience might express toward a leading man and leading lady. The progress of their courtship, the minister's marriage proposal—all these events happen in public before an adoring crowd. Something was terribly amiss when Sympathy was married to the brutish Daniel Gibbs. With her marriage to the minister, the wrong at the heart of the community is righted, and the villagers unite behind the new couple. The minister holds the group together, and as the plot unfolds, any threat to him (or to his marriage) threatens the cohesion of the community. His image is sacred above all—if his image proves false, his audience will cease to exist. Any split between the minister's public and private selves represents a threat to the entire group. The villagers are defined early on as "believers"; if they can't trust their minister—if they can't believe—then who are they? With another set of events (the blackmail plot) unfolding in secret, this question becomes crucial as the minister struggles to keep up appearances and to hide his secret. The disjunction between his public persona and his private self threatens both his marriage and his flock as the rift between appearance and reality presages the rift that could tear the community apart. In this sense, the relation between image and audience is an intimate one.

Acting behind the scenes, the Chinese launderer ensures the stability of the community by restoring the minister's image. He does so by staging a climactic performance on his houseboat in which the villain is unmasked. Under Yen Sin's direction, Nate Snow is forced to confess before an audience of his friends and neighbors. Yen Sin's "scene" is aided by some special effects: telltale shadows on the wall play a starring role, telling the truth before the actors can speak it. In effect, Yen Sin closes the gap that had opened up between appearance and reality, and by revealing the truth he reunites shadow and substance in dramatic fashion. Yen Sin's success depends upon a climactic performance that is both theatrically and racially coded. It is not surprising that Yen Sin would be at the heart of this crisis; the film's emphasis on false appearances and misguided assumptions supports

its message of racial tolerance. The plot pivots on the disjunction between appearance and reality—between external and internal traits—because it pivots on prejudice. Despite the villagers' racist rejection of Yen Sin, the real threat to the community comes from one of its own, someone who seems, on the surface, like the most righteous of citizens. What is surprising is the way Yen Sin resolves the crisis—by making external appearance match internal traits (a method that would seem to reinforce an essentialist world-view). Yen Sin's alignment with both performative and essentialist models of identity produces the impossible contradiction at the heart of film, as he ultimately occupies an untenable position—one that redeems perform-ance and empowers the screen image by reinforcing the racial stereotype.

Yen Sin's deathbed scene features the last and most dramatic shadow play work, but an earlier scene sets up the relation between these screen shadows and hidden truths. Shadows appear at key moments in the plot—moments framed as spectacles for an internal audience. The most promi-nent example comes just after the minister has been blackmailed for the first time. His wife has given birth, and as the minister returns home to see his wife and child, the villagers are already gathered around his house to greet him with the news. What should be a joyful occasion turns to agony, however, as Minister Malden harbors his terrible secret. His private despair becomes public as he puts his head in his hands and rails at his fate—behind a shaded window. The villagers see his pose in silhouette. In the midst of this silent film (in which, of course, characters speak to each other, even if we can't hear them), the villagers watch pure pantomime, a shadow play that suggests that all is not well in the minister's home. We get several reaction shots of the crowd, watching with concern, and while the movie audience has information the internal audience lacks, the two are momentarily aligned with the shot of the minister's silhouette. As he walks away from his wife and enters the living room, he stops before the window and begins to raise his arms. There's an odd cut, midgesture, to the crowd outside. They look fearful and point, and the next shot gives us their point of view: from outside the window, we see the minister in sil-houette. First with arms outstretched, then with head in hands, the shadow presents a perfect figure of agony and despair. While the shot sequence begins inside the house, providing us a view unseen by the villagers, the cut to the crowd suggests they see something we haven't seen yet. The cut to the silhouette then re-aligns us with the internal audience. Another shot of the crowd follows as they decide to sing a hymn to help comfort the minister, even as the cause of his woes remains unknown. As they sing,

a cut back inside the house re-establishes the movie audience's view of the minister, yet our position is no longer privileged: whatever we see "in the flesh," the villagers also see in silhouette.

Shadows are also clearly linked to performance in the film, and consequently we should think of the shadow plays as reflexive moments—as films within the film. The villagers watch the shadows as we watch the villagers: as figures cast on a brightly lit screen. While they watch shadows on a window shade, we watch *Shadows* on a movie screen. And yet the resulting image of the cinema is a curious one. While framed as spectacle, the shadow plays reveal what the actor (the minister) hides in his public persona. Thus his public persona is a performance, while the shadows represent the truth or reality beneath the surface. He performs happiness, but his shadow performs otherwise. Rather than being aligned with illusion, these dancing shadows are opposed to illusion—the shadows reveal what people attempt to conceal. Here again there is a strange separation between shadows and the bodies that cast them; shadows seem to communicate information of their own accord, betraying the body's secrets.

The expressionism of the shadow-figure speaks clearly to the villagers; even without crucial information, they see as much as we do. The notion that shadows represent the essence or spirit hidden inside the matter is made even more explicit in the climactic deathbed scene on Yen Sin's houseboat. As noted above, shadows again provide a captivating spectacle, and again they seem to reveal the inner truth hidden behind a facade. As the villagers watch, Yen Sin tries to coax a confession out of Nate Snow. When Snow confesses some petty sins, Minister Malden is overcome with guilt. Believing himself to be the greatest sinner in the room, he confesses everything to the crowd gathered on the houseboat. Overwhelmed, he collapses, and Nate Snow begins his own performance for the crowd, railing at Malden, calling him a liar, and standing over him in a menacing pose. Here we cut to Yen Sin, pointing and looking frightened. As in the earlier scene when the crowd watched the minister's silhouetted figure, the next shot follows Sin's gaze, revealing the cause of his concern: on the wall, two crisp shadows appear, one towering with arms outstretched as if to attack the other. Another medium close-up of Yen Sin suggests a realization. The film cuts back to the shadows, which gradually dissolve into an image of a cat playing with a mouse, and then back again to the shadows. Yen Sin already knew the truth, but the shadows allow him to grasp the essence of that truth: Snow has been playing with the minister, and he now stands ready to pounce on his prey. Significantly, the cat and mouse

represent only what Yen Sin sees (or imagines). Yen Sin accuses Snow, revealing him as the blackmailer who has been torturing the minister. While Yen Sin seems eager to see Snow get his retribution in front of an audience of villagers, he witnesses Christian forgiveness in action instead. When we cut back to the men casting these shadows, the minister relents, forgiving his enemy. This spurs Yen Sin to his deathbed conversion.

This scene and the earlier window shade scene both offer shadow plays to the gathered villagers, but the process of interpreting those shadows is quite different. While the silhouette of the agonizing minister seemed instantly legible to the villagers, the image of Nate Snow and the minister playing "cat and mouse" must be translated and explained by Yen Sin. He alone holds the key to the mystery (the details surrounding the blackmail plot). In many ways this is Yen Sin's show—he stages it, not merely because his illness has brought the minister and the crowd of villagers to his houseboat, but because he directs the action. He coaxes a confession out of Nate Snow (who initially only confesses to small transgressions), and this leads first to the minister's breakdown in front of the crowd and then to Nate Snow's grandstanding until the two figures enact precisely the pose that will reveal Snow's true menacing nature. In essence, Yen Sin has blocked the scene. Finally, he reads the shadows on the wall. He also possesses this part of the show more fully than anyone else—he is here like a master of Chinese shadow puppetry, with Minister Malden and Nate Snow as his puppets. His identification with the shadows positions him between the mystical/magical and the rational. He acts as a kind of medium with special access to the truth figured by shadows on the wall. But while he may be associated with "Oriental mystery," Yen Sin also demystifies the illusion playing out before the villagers. In unmasking the villain Nate Snow, he reveals the truth behind the facade. He acts as translator of shadows and dispeller of illusions. Recalling the reference to phantasmagoria earlier (when Yen Sin was the ghostly, steam-blurred silhouette presented to us on screen), he is now both the caster of shadows and the figure who rationally explains away the ghosts and shadowy fears that have been haunting the minister and, by extension, his flock. This calls to mind the way eighteenth-century phantasmagoria shows were presented to the public. As Tom Gunning points out, the showman would introduce his spectacle with scientific information that clearly framed the optical illusion as just that: an illusion. The rational explanation did not necessarily make the illusion any less novel or the audience less startled by the effect. Gunning discusses the way the power of the spectacle can sometimes be

heightened by the reflexivity/demystification, working with mystification in a complicated dialectic. In other words, Robertson's *Phantasmagoria* mystified and demystified at the same time. In *Shadows,* Yen Sin is at the center of an operation that moves from mystification to demystification in order to make the re-mystification of the image possible.[42]

Yen Sin is able to provide the perfectly rational, if shocking, human explanation for these shadows and illusions because he knows Nate Snow is the blackmailer. Near the end of this scene, Minister Malden expresses his great relief, which doubles as the overt moral of the piece: "You mean that all my fears have just been . . . *shadows?*" Despite the minister's conclusion about his fears—that they were *mere* shadows and thus not real—the shadows featured in these scenes are real, and they even seem to provide access to a deeper reality, to the essence or heart of the matter. Because of the shadow-play technique (as well as the editing), these shadows take peculiar precedence over the real bodies that cast them. In the houseboat scene, we see shadows acting out the most dramatic gestures before we see their flesh-and-blood counterparts. And in the earlier scene, we never see the actor's body performing the gestures we see in shadow. These shadow plays offer the kind of pure legibility and direct access to the emotions so often associated with melodrama. Critics have often pointed to silent film as the more perfect medium for melodrama since it relies so heavily on pantomime and gesture.[43] Here, the shadow play goes the silent film one better—lacking the use of the most expressive human element, the face, the shadow presents the body as sign. All of this suspicion sets the stage for the climactic reversals at the end of the film, when the town's most respected members will confess their sins. The film plays with and on the presumed audience's assumptions in order to undercut them. While the film presents the flat, "steam-blurred silhouette" of the Chinese launderer at the beginning of the film, the rest of the film attempts to get beyond the abstract symbol. Ultimately, however, the film's narrative, thematic, and visual strategies depend upon that symbol/stereotype, yoking it to the very power of the cinematic image. The ending is all about redemption in the Christian sense, as Snow and Malden both confess, and Yen Sin converts. But the final scenes also redeem the image.

Redeeming the Image

The climactic scene (Snow's confession/Sin's deathbed conversion) is self-consciously stagey: Sin gives a great speech to the villagers gathered on

his houseboat, and Nate Snow and the minister confront each other in spotlight (see Figure 23). The lighting and the editing create a clear demarcation between real people and their shadows. In the end, this division disappears—or so it seems. In fact, the shadow/substance division is displaced onto the relation between Yen Sin and the villagers. The "heathen" Yen Sin becomes mediator and savior. He redeems the villagers, who have become his audience. Yen Sin fuses shadow and substance, guaranteeing the coincidence of image and meaning. His death (which is represented as a disappearance) allows the revitalized "shadow" to remain in the form of images that have gained an almost spiritual presence.

After Yen Sin converts, the villagers leave him. A protracted death scene ensues, and with melodramatic flourishes, Yen Sin stumbles and lurches his way to the edge of the boat. With his last breath, he unties the boat from the dock. When the child he'd befriended ("Mista Bad Boy") tries to stop him, Yen Sin points weakly toward the sea, saying "Yen Sin go back Chinaway pretty quick." With Yen Sin stumbling from one corner of the boat to the other, the setting and props are emphasized. The scene is evenly lit, and the way we have seen the audience (of villagers) come to

Figure 23. Villagers gather around Yen Sin's deathbed in the climactic scene. *Shadows* (Tom Forman, 1922).

the "show" and then leave paints Yen Sin as actor and the boat as his float-ing stage. Yen Sin's role in the plot, and Chaney's disguise, thus bring mul-tiple "backstage" elements to the story—emphasizing theatricality and opening up a metaperformance space in the film. In terms of the status of the screen image, the film may be read as an allegory of the cinema's own ascendancy—particularly in terms of its differentiation from (and competition with) the popular theatrical melodrama. Yen Sin's deathbed performance adheres to nineteenth-century conventions and perfor-mance codes, and as he exits, floating "back Chinaway" and out of the picture, he seems to take these old representational strategies with him, leaving a new—and newly empowered—cinematic image in his wake. This isn't so much a story of the actual relation between theater and cin-ema in 1922 as it is a kind of myth of the cinema's origins—and a celebra-tion of its unique powers.[44]

The series of cuts that follow his efforts to unmoor emphasize the the-ater/cinema opposition even further. The cut from Yen Sin crouching on the boat to the minister and his wife and baby on shore creates a stark contrast. After the evenly lit depth of the houseboat, we are confronted with the hero and heroine of the film spotlighted against a black night sky. We are back to expressionistic lighting style here, as the darkness almost completely engulfs their figures. Next we get an interesting sequence that offers multiple views of the newly restored nuclear family: the establish-ing shot shows the couple looking back toward Yen Sin's boat; the minister's takes his hat off, and Sympathy weeps. We then cut closer to a medium shot of the couple as they kiss. In midkiss, we cut back to the medium long shot, and then back again to the medium shot as the minister embraces the baby and Sympathy looks off into the distance dreamily. Finally, we cut back to the wider shot as the two look longingly at one other and then walk out of the frame. More precisely, they disappear into the darkness as they walk away from the camera—they don't actually leave the frame (see Figures 24 through 26). This sequence has an odd effect—fragmenting the reunion scene and offering the moment up as a kind of pictorial study. As Yen Sin finally exits the picture, the villagers watch, standing half-lit and monumental against the sky. As Yen Sin floats out to sea, he leaves a revi-talized community on shore (and revitalized images on screen).

If Yen Sin represented "theatrical" practices and the white villagers rep-resented the "cinematic," the film's representational strategies would be simpler. As noted earlier, however, Yen Sin is also aligned with the shadow play and with spectral cinematic (and proto-cinematic) effects such as

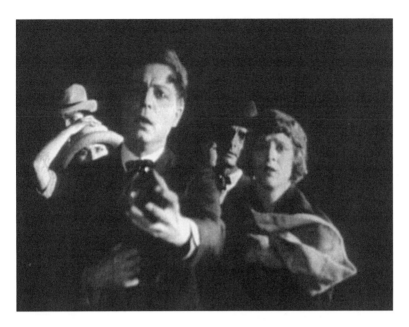

Figure 24. The community on shore. *Shadows* (Tom Forman, 1922).

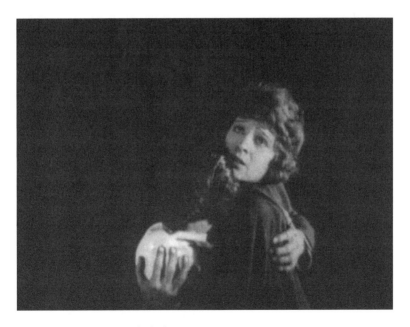

Figure 25. The family reunited. *Shadows* (Tom Forman, 1922).

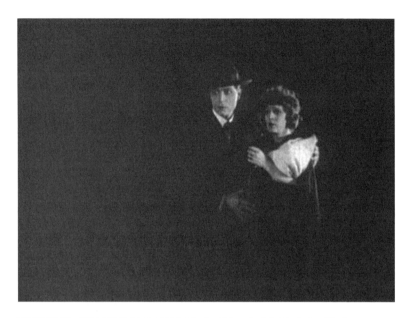

Figure 26. The flat, revitalized screen image, glowing against the darkness. *Shadows* (Tom Forman, 1922).

double exposures and phantasmagoria. Yen Sin occupies a transitional space between these two modes of representation—between performing body and performing image. As both actor and shadow, he achieves a reconciliation that resonates beyond the plot to the realist illusion of the cinema. That is, by redeeming the minister's image, Yen Sin redeems the very status of the screen image. Yet this isn't a case of a film merely staging the nostalgic exit of theatrical practices—it's not a matter of the moving image simply trumping the stage. Yen Sin's association with theatricality is crucial because it allows the narrative to play on the differences between theatrical and cinematic practices. By housing both in Yen Sin's body—by constructing him as both actor and shadow—the film endows the screen image with the material presence it lacks. By celebrating the cinema's origins and yoking them to a racialized figure, the film substantiates the shadow. This operation speaks to the multiple anxieties assuaged by the capacious Oriental stereotype, which is authentic, magical, mobile and anchored at the same time. Yen Sin's mediating presence re-unites image and meaning, illusion and truth. This unifying power is tied to his race, which marks him as both marginal and magical. The marginal and the magical come together under one sign in the film: the shadow.

The theatrical leaves with the racialized figure, and the shadows—the two dimensional projections that replace the live actor—gain new power. The glowing and resonant cinematic image remains, waving goodbye to the caster of shadows. Like the minister, these shadows are redeemed; they are no longer divided from reality. Rather, the cinematic "shadow" represents reality in ways the theatrical figure cannot. The cinematic shadow is no longer compared to the real bodies on screen; instead, those bodies are shadows—unsubstantial cinematic images—and yet they are all the more real, all the more present for it. Yen Sin's role in this film draws on and extends the role the racialized body plays in perfecting the screen image. In granting the screen projection a kind of material presence, Yen Sin joins signifier to signified, revealing the interdependence of image and audience in the process. "Yen Sin" figures the cinematic signifier while simultaneously disfiguring the Chinese subject. The final shot of the film shows the villagers huddled together on the shore, a picture of community. The film's social critique does resonate here, as the community of insiders is once again defined—and saved—by the sacrifice of the outsider. The image also powerfully figures the relation of the film audience to the images on screen. Like the film's internal audience (the villagers of Urkey), the community of film viewers is created through belief in the image. This definitive aspect of spectatorship draws together the bodies on screen and the bodies in the audience: a relation mediated through racial difference.

Shadows capitalizes on the link between the motion picture and its proto-cinematic forerunner, the shadow play, and like many American films it links the Chinese subject to shadow puppetry, theatricality, and magic in order to produce the mystical, mysterious "Oriental." The film's Orientalist discourse is routed through a nostalgic play with the origins of the screen image. The racialized figure that results stereotypes the Asian character while also creating a mythical status for the cinema. Despite the film's efforts to combat prejudice at the level of the plot, the link between the cinematic image and the racial hieroglyph is reinforced. In this sense, the film reveals the pivotal role race plays in the making of cinematic meaning. *Shadows* exploits the Oriental stereotype in order to foreground the cinema's "shadow": the "material" of its image. The film offers a chance to examine how race continues to function, even in a "mature" silent film, in that transaction between shadow and substance that we traced in the earliest motion pictures—a transaction crucial to both the rhetoric of race and the rhetoric of cinematic realism. Yen Sin functions as an excuse to look back, to recast the history of cinema as a racialized

myth of origins; once again, the racialized figure is aligned with the apparatus, translating and transfiguring its unique powers.

Yen Sin's body is a vehicle that makes possible the oscillation between literal and symbolic meaning, between past and present, and between the alien and the familiar. Like visitors to Chinatown, the villagers who travel to his houseboat are transformed (suggesting the same possibility for the theater audience). Through contact with this racialized figure, they have seemingly traveled to another world; he moves them while also seeming to represent stasis. The villagers also move from being spectators to spectacle and back again, as the actors in Yen Sin's "show" become his audience as he leaves the shore. He has guided them out of murky illusions and safely onto shore, a place where shadow and substance are finally one in the same. In this sense, this figure and his ability to bridge distances is not so unlike what we have seen before. The earliest motion pictures exploited racialized figures, racial disguise, and miscegenation in order to create movement within the still frame and to "move" audiences by connecting spatial boundaries, racial boundaries, and cinematic boundaries—including the contested boundary between spectator and spectacle. As in those early films, the racialized body is here tied up with the cinematic apparatus—here figuring its power to transcend limitations. Yen Sin's body substantiates the shadow and authenticates the image. He represents any number of impossible configurations and must disappear, leaving the redeemed screen image in his wake. This coincidence of the racialized body and an "embodied" apparatus reveals the anxious relation of cinematic realism to notions of embodiment, materiality, and presence. Yen Sin functions as a mediator between the apparatus and the audience, reinforcing the audiences' faith in the cinematic illusion. If this gesture seems gratuitous in 1922, it is not—it merely suggests that the cinematic illusion is never self-sufficient, and even proud, celebratory gestures reveal anxieties about what might still be lacking. In the next chapter we see how the discourse surrounding the early talkies relied on the "black voice" to once again unite shadow and substance at a moment of technological vulnerability—when audiences were experiencing a crisis of faith in cinema.

4 "CINEMA AT ITS SOURCE"

Synchronizing Race and Sound in the Early Talkies

IN RECENT YEARS, scholars hoping to redress the lack of attention to sound (or its treatment as a secondary aspect of a cinematic experience understood primarily as visual) have sometimes emphasized the primacy of sound recording and reproduction—technologically, chronologically, and conceptually—to the motion picture. In fact, in the wake of the work that has been done on the cultural history of sound and its relation to the development of the motion picture, it has become clear that although phonography "came first" with Edison's invention in 1876, the two technologies were in many ways on parallel paths: they were imagined together and conceived in conjunction with each other. Sound recording and reproduction (and later motion pictures) would separate hearing from the human ear, separate sound making from the human voice—disembody it and reproduce it via machines. At the same time, this move toward disembodiment and (in Tom Gunning's terms) "derangement" of the senses brought with it an anxiety that the presentation and promotion of these new devices would often try to quell—and thus promising a reunion of the senses was part of the promise of these new media. The desired reunion of the senses with each other, and with the body, was often accomplished in the late nineteenth century by recording devices and sound machines that mimicked the human body. As the work of Jonathan Crary, Tom Gunning, and others has shown, devices like these were not just about reproducing the real world (as cinema studies has often emphasized), but about re-creating the functions previously reserved for the human subject—re-creating movements, senses, perceptions, and memory.[1]

While sound cinema was imagined from the beginning, it nonetheless took a long time to arrive in the form of the fully sync-sound image represented by the talkies. If we think of that moment as a reunion of sight

and sound, it was certainly a troubled one. If the "talking picture" prom-
ised a reunion of vision and hearing through the combination of image
and sound recording, this multisensory experience would also depend
upon a tenuous new sense of bodily coherence and presence associated
with the apparatus. This kind of coherence was difficult to project in the
early years of sound, when things were often not quite "in sync" (both
literally and figuratively). The new technology, even with its goals of "syn-
chronicity," was experienced early on by audiences as, if not a derange-
ment of the senses, then as the rearrangement of separate parts. This
transitional moment registers a confrontation with something new, some-
thing else—not merely a new medium but a new sense created by the way
sound affects vision and vice versa: a result, as James Lastra put it, of "how
two new technologies with sometimes overlapping and sometimes quite
distinct histories—namely, cinematography and phonography—could
combine to form an integrated sensory experience that was neither audio
nor visual but distinctly audiovisual."[2] The many problems with early sound
films (lack of clarity, the drift in where the sound seems to be coming
from, not to mention the complaints that the talkies were boring—lots of
talking and little movement because of the limitations of sound equip-
ment) were known. And so synchronicity became not just a technological
goal, but a rhetorical one as well, as the "talking picture" looked outward
for performers, contexts, and distractions to prop up a cinematic illusion
too often disrupted and betrayed by glitches. And on a number of occa-
sions, the industry and the press looked to African American performers
to help solve those problems. In the wake of uncertainty about the appeal
of new, often flawed sound technology, "Blackness" was repeatedly ex-
ploited in the early sound era to promote the new medium. Both black
performers and blackface performance featured prominently in these
films, from *The Jazz Singer* and other films featuring blackface and "old-
fashioned" minstrel shows to a handful of all-black cast films.

This chapter considers the way the technological achievement of syn-
chronized sound was accompanied by a fantasy of synchronization that
went beyond the alignment of sound and image. It was not enough for
sound and image to come together; the new medium needed to be seen
as "whole" rather than as a merger of separate parts. This operation de-
manded that image and sound should not only be bound together seam-
lessly, but that they should also be bound to other "natural" links: external
and internal traits, body and essence, image and meaning must be "in
sync" as well. This fantasy of synchronization exploited "race" through an

appeal to the "black voice"—which, according to many among producers, promoters, and press, could cure what ailed the new sound cinema. Looking at the press and publicity materials surrounding the various black-cast films released by Hollywood in the first years of the "talkie," we can see the way rhetorical links are created between the "black voice" and the new sound technology. These links were carried over to the films themselves, in their visual styles and thematic emphases. This is perhaps clearest in King Vidor's feature film *Hallelujah!* (MGM, 1929).

One of MGM's publicity photos for *Hallelujah!* features two of its stars, Victoria Spivey and Daniel Haynes, looking at a piece of the movie's soundtrack. Titled "Pictures of their voices," the studio's caption copy reads: "Victoria Spivey and Daniel Haynes look at a sound track of their voices in Metro-Goldwyn-Mayer's 'Hallelujah!'" (Figure 27). The photo economically figures the discursive link created—by studios, critics, and the popular press—between African American performers and sound technology. The picture sums up a common strategy of the early sound era: selling the sound cinema via black performers and selling black performers (primarily to white audiences) via the sound cinema. The year 1929 saw the release

Figure 27. "Pictures of Their Voices": Victoria Spivey and Daniel Haynes look at a sound track of their voices in Metro-Goldwyn-Mayer's *Hallelujah!* [original text of studio credit]. Courtesy Museum of Modern Art Film Study Center.

of Hollywood's first feature length films with all-black casts. The Fox studio was first with *Hearts in Dixie* (featuring Stepin Fetchit), and MGM followed with *Hallelujah!*, acclaimed director King Vidor's first sound film. Both were musicals, and both capitalized on the combined "novelty" of an "all talkie" and "all Negro" spectacle. While African American performers had a long history in the silent cinema, their opportunities in Hollywood multiplied during the first years of sound. Feature-length and short musicals featuring black casts became integral to the way the new medium was publicized and received.

Robert Benchley articulates the link between race and the new cinema in his ecstatic 1929 review of *Hearts in Dixie:*

> With the opening of 'Hearts in Dixie,' . . . the future of the talking-movie has taken on a rosier hue. Voices *can* be found which will register perfectly. Personalities *can* be found which are ideal for this medium. It may be that the talking-movies must be participated in exclusively by Negroes, but, if so, then so be it. In the Negro the sound-picture has found its ideal protagonist.[3]

Benchley, the regular movie critic for the *New Yorker,* published this review in *Opportunity: A Journal of Negro Life,* and some African American writers drew the same connection between "black voices" and the new cinema in order to take advantage of and extend the growing opportunities for black performers in Hollywood. But this sort of fetishization of the "black voice" reveals the way in which the discourses of race and sound were intertwined during the transition to the talkie. The two discourses supported each other not because of the alleged suitability of "black voices" to sound recording, but because of what they already had in common: a dependence upon popular expectations regarding authenticity, the alignment of internal and external characteristics, and the evidence of the senses.

Critics like Benchley turned to "the Negro" for a remedy to the often clunky and disappointing marriage of sight and sound in the early talkies. The suggestion that "black voices" could cure the new cinema's technical difficulties highlighted a kind of synesthesia already at work in the representation and perception of race. I am using the term *synesthesia*—defined as the "production, from a sense-impression of one kind, of an associated mental image of a sense-impression of another kind"[4]—because it explains one of the primary (if implicit) mechanisms through which the discursive links between sound technology and race were created. Most dictionary definitions feature examples similar to the one offered by the *Oxford English Dictionary:* "e.g., when the hearing of an external sound carries with

it, by some arbitrary association of ideas, the seeing of some form or colour." The presumed perceptual link between color and sound offers the exemplary instance of synesthesia—a sensory wire-crossing helped along by imagination and the "arbitrary association of ideas." Synesthesia is also a literary device: "the use of metaphors in which terms relating to one kind of sense-impression are used to describe sense-impressions of other kinds." The persistent link between color and sound in both registers—the psychological/perceptual and the rhetorical—produced an effective and insidious strategy for promoting the "all-black cast" talkies. On a more general level, "synesthesia" suggests a model for thinking about the birth of sound film as a union of disparate elements—a challenge for the ear and eye at a moment when the terms of cinematic signification were themselves changing.

The aforementioned photo of Spivey and Haynes depicts a curiosity that audiences might have shared at the notion of *looking* for voices; the two actors essentially perform a desire to see something unseeable, something formerly intangible now newly materialized on a piece of film. One thing white producers and moviegoers were "looking for" in these new cinema voices was race. The very term "black voices" would of course make no sense in the absence of race; even if sounds can be said to evoke the visualization of color, the black of "black voices" signifies much more than color. And in the case of "black voices," the action is reciprocal: color/race promises a particular kind of sound, and that sound, once heard, is supposed to refer back to the color/race that produced it. Benchley declares that "[t]here is a quality in the Negro voice" that makes it the "ideal medium for talking pictures"; this simultaneously elusive and definitive quality can only be explained through an appeal to race. The rhetoric around the "black voice" suggests that racial identity must be seen *and* heard, or more precisely, that racial identity lies somewhere in the synchronization of sound and image. Claims that African American performers' voices could be reproduced more faithfully than others essentially promised that these voices would be "in sync" with their bodies—and with audience expectations about what should emanate from those bodies. In other words, the sound would be synchronized not merely with the image on screen but with the image or stereotype of the "Negro" long produced and exploited on stage, in literature, and on movie screens. The cinema always included sound—music, lectures, and other sorts of external sound accompanied the silent cinema—but the "talkies" synchronized sound and image, and African American performers defined and supplemented that synchronization.[5]

The focus on the racialized body—including the fetishization of body parts and bodily properties (e.g., the "Negro voice")—signaled the cinema's need to remake itself. In the publicity surrounding the black-cast talkies (and in the films themselves), the new apparatus was propped up through an over-embodiment of African American performers. By looking at *Hallelujah!* in this context we can see the ways in which the powers of cinematic expression were at stake. Like many directors of the silent film era, Vidor was not thrilled by the idea of sound cinema, but he saw in it an opportunity to make "a dramatic story of negro life."[6] He felt the studio would see the appropriateness of Negro spirituals for talking pictures, but his primary interest lay in portraying the "sincerity and fervor of [African American] religious expression . . . [and] the honest simplicity of their sexual drives."[7] These "truths" are expressed in the film not through words but through music and movement. The characters' bodies are by turns monumentalized and fragmented by the camera until they finally become the distorted shadows that dance across the screen in the film's most visually stunning and self-reflexive moments. As in the earliest days of the silent era, black bodies meld into the apparatus, figuring a pure and legible motion, and sound is no longer a clunky intrusion: image, sound, and meaning are synchronized through race.

Race, Sense, and Memory

As we have seen throughout this study, the use of racialized bodies to demonstrate the prowess of the apparatus was nothing new. It was a common and effective strategy from the very beginning. We have seen how early motion pictures simultaneously showed off the apparatus and provided racist gags based on the supposed humor and visual interest of the contrast between black and white. One might expect that the black and white cinema would seize upon the visual "opportunities" of Black and White, but the alignment of race with the apparatus in the era of sound suggests that something more is at stake than visual contrast.

Like the earliest motion pictures, early sound–era films faced technological limitations in delivering that most definitive quality of the cinema: motion. As noted in previous chapters, early silent cinema was defined by its ability to record motion, and motion guaranteed audiences the "essence of reality."[8] To find that essence, the stationary camera of early cinema looked not just to any moving bodies, but to those that could provide strange and interesting movement—those that expressed motion as their

very essence. Racialized others, "lower-class," and ethnic subjects often provided the early cinema with both real-life and burlesque display. In other words, these bodies were perceived as the perfect medium for moving pictures. And in 1929, when the sound recording apparatus was new and required a return to the stationary camera, "black voices" provided the perfect medium for the talking picture. A spate of all-black cast features and short subjects were hurried into production, and the demand for African American actors reached unprecedented levels. In 1927, a total of 3,754 African Americans were placed as extras in Hollywood movies; the numbers for 1928 jumped to 10,916 placements paying a total of $30,036 in wages. More importantly, black actors were beginning to get star treatment—high salaries and studio contracts. *Opportunity* reported that the first two all-black cast Hollywood films (*Hearts in Dixie* and *Hallelujah!*) set records for the highest salaries paid to black actors in Hollywood.[9] In October of 1929, the *New York Amsterdam News* reported that the employment of "colored" actors had reached an all-time high, with "350 extras . . . actively employed."[10]

In his memoirs, King Vidor remembers his disgust with the new sound cinema and its limitations; the camera sacrificed its "legs" in order to accommodate dialogue. Vidor recalls that the sound equipment brought back the "nailed-down tripod of the early days,"[11] and the change did not go unnoticed by audiences. In May 1929, the popular fan magazine *Photoplay* poked fun at the boredom of the new dialogue-driven movies: the issue featured Rube Goldberg's "No-Snooze-at-Talkies-Device" and a satire titled "The Great Talkie Sleep Test" on facing pages. Moviegoers were apparently complaining that the new features were slow, and D. W. Griffith agreed: "People say the dialogue is too slow. They are right . . . We must preserve all the speed, action, swirl, life, and tempo of the motion picture today."[12] Once again, motion is the raison d'être of cinema, the only way to keep the talking picture alive. It is not surprising, then, that the cinema must again turn to black subjects. With *Hallelujah!*, Vidor felt certain he could provide the cinema with the "fervor of [African American] religious expression"—or what one critic called the "intoxicating . . . dervish dance" of "Negro spiritual life."[13]

The desire for spectacle in an age of technical limitations produced a strange mixture of old and new. To accommodate the stationary camera, many of the early talkie shorts featuring black performers were shot in theaters such as the Manhattan Opera House "where the acoustics were good and the stiff musical vignettes demanded by the bulkiness and immobility

of the cameras seemed plausible."[14] The talkies ushered in a new era by harkening back to pre-cinema entertainment: vaudeville and minstrel shows. As Michael Rogin points out in his study of blackface performance, "[t]he first talking picture *[The Jazz Singer]* went backward in order to go forward and enter the era of sound."[15] Rogin argues that *The Jazz Singer* and other Jolson blackface vehicles offered stories of Americanization in which immigrants could celebrate their upward mobility by putting on (and taking off) the mask of the ethnic group whose racial identity was more fixed and oppressive: African Americans.[16] These sagas of Americanization offered the familiarity and comfort of vaudeville routines in times of technological and social change. This transitional moment in cinema reveals more, however, than a thematic concern with racial identity. The cinema's signifying powers—its language, narrative codes, and modes of address—are bound up with the representation of race. And while the resurgence of blackface brought back memories, it had a way of erasing them as well.

The return to vaudeville and burlesque activated some audience nostalgia and even some ridicule—one of the trade journals mockingly noted the sudden spate of movies "glorifying burnt cork" being produced on the heels of *The Jazz Singer.*[17] But many writers marveled at both blackface and African American performers in a way that obscured the racial history of silent pictures—the formative role that racist gags played in the medium's early days. Most writers marveled at (if they were white) and applauded (if they were black) the new opportunities for black performers in the sound cinema. And blackface garnered particularly odd responses: while the minstrel show was ostensibly enlisted on behalf of sound, reviewers reacted as if given a new chance to appreciate the cinematic image. Contemporary reviews of these musicals or filmed minstrel shows repeatedly accentuate the visual; specifically, the reviewers write as if the talkies somehow enabled them to see and appreciate blackface anew. In its review of *The Jazz Singer,* the *New York Times* dedicated a long paragraph to the film's "most interesting sequence" in which Jolson applies the blackface:

> It is done gradually, and yet the dexterity with which Mr. Jolson outlines his mouth is readily appreciated. You see Jack Robin . . . with a couple of smudges of black on his features, and then his cheeks, his nose, his forehead, and the back of his neck are blackened.[18]

The *Times* review of *Happy Days,* a "minstrel show imaginatively staged" from 1930, praises the scenes of group dialogue but goes on to discuss the

cinematography. The reviewer notes that the film is "beautifully photo-graphed" and gives the following example of what he means: "when one of the minstrels is called upon to do his stunt, the burnt cork suddenly vanishes from his face and his physiognomy is white."[19] This response is interesting, as this sort of trick is a holdover from the earliest days of cinema. The reviewer is mesmerized by this combination of an old vaude-ville routine and low-level cinematic trickery. And his comments were not singular. Michael Rogin notes that the reviews of *The Jazz Singer* "re-sponded as much to blackface as to Western Electric's new sound and film projection system, Vitaphone."[20] But this response to a visual trick is perhaps no coincidence. The resurgence of blackface minstrelsy in cinema deflected attention away from the new technology at a time when that technology could not bear much scrutiny.

Rogin suggests that blackface was a kind of magic trick, one that "allowed whites to turn black and back again."[21] The new cinema needed a few tricks, and once again Hollywood turned back to the lessons of the earli-est films. As discussed in chapter 1, the "race-change" gag was exceedingly popular in early silent cinema. Some of these films included staple tricks such as double exposures and hidden edits (splices that caused sudden appearances and disappearances in "one-shot" films such as those by Méliès); but the race-change was more often a kind of trick in and of itself. The race-change stood in for motion in films limited by a stationary camera or minimal editing. Some of these films included the putting on and taking off of blackface; others relied on the contrast between white things (feathers, soap suds) and black performers, and still others depended on mistaken identity or other tricks played between white and black char-acters. It is perhaps not surprising that the early talkies featuring black-face performers returned to outmoded tricks and that reviewers responded so favorably. Blackface was aligned with cinematic trickery—both the spe-cific tricks described above and the more definitive "fakes" such as editing and other methods of rearranging time, space, and race. But the interest in black bodies that was re-animated by Hollywood's all-black cast films produced at the same time had precisely to do with the real thing—this brand of cinematic magic depended not on tricks, but on substance and form.

While the number of featured roles for African Americans certainly in-creased (at least for the first few years of the talkies), many writers seemed to think that they'd never seen "real" black performers on screen before, and that the cinema had never exploited the kind of stereotypical antics

personified by Stepin Fetchit.[22] Much of the discourse about African American performers and the talkies suggests that for many, hearing race meant seeing it anew. This unexpected connection between sight, sound, and memory—the way sound affected the way audiences saw—is a specific and culturally significant example of a more general phenomenon. The sensory confusion that accompanied the reception of early sound film reveals the potentially dissonant mixture of experiences offered by the cinema. And when racialized rhetoric is added to this mix—as it is in unprecedented ways by the all-black cast talkies—the narrative and cinematic imperatives behind the synchronization of race, sense, and memory become clear.

The fact that silent cinema, too, made noise should not lead us to minimize the degree to which audiences and filmmakers saw the "talkie" as a break from what had come before. What was new, as the instantly popular term for the sound cinema made clear, was the talking. Rick Altman reminds us that "*The Jazz Singer* is commonly acknowledged as the first sound film not because it was the first to bring sound to film . . . but because it was the first to bring synchronized dialogue."[23] One need only look at the debates that raged in the popular and trade presses about what to call this "new" medium to realize just how much of a break was being designated—and how synchronized dialogue redefined the meaning of "sound." "Talkie" was widely criticized by reviewers, filmmakers, and industry executives as just another popular tag that would forever designate cinema as low culture. Many moviegoers agreed and joined in the search for a more respectable name worthy of the medium. The popular fan magazine *Photoplay* ran a contest in 1929 and (somewhat predictably) chose as its winner an entrant who had suggested "Phonoplay." The *Exhibitors Herald-World*, meanwhile, went with its own stiff coinage: "Audien." Robert Sherwood, commentator for the *New York Evening*, congratulated the *Exhibitors Herald-World* on its "classy word" but doubted the public would embrace it. He only begrudgingly admitted that sound film had enough of a future to deserve a name: "I believe that the squawks and the lisps will be cured and that characters' voices will be made to come from their mouths instead of from their hip pockets." The editors of the *Herald-World*, foreseeing, perhaps, the doomed future of "audien" as a household name, also solicited suggestions from readers. Their responses ranged from the somewhat clunky ("Photovoice," "Audiovision," "Sonofilm," "Viewtone") to the mind-boggling ("Oramatone," "Oragraphs," "Somatic," "Somo," and "Photox").[24]

Some of these responses show a concern for marking the specific, discrete sensual experiences provided by the talkies. As one reader put it, "the motion picture is for the ear as well as the eye, and . . . not all sound pictures are talking pictures." But most of these neologisms reveal a kind of sensual confusion or conflation: they either insist on the voice or collapse voice into sound, and all of the words negotiate the fusion of sight and sound, gesturing toward a kind of sixth sense. Current debates, in an attempt to compensate for the longtime critical neglect of sound, often hinge on hierarchical questions: Which came first technologically, recorded sound or image? Which is perceptually more significant or primary, image or soundtrack? Which dominates the other conceptually or practically in the production process? But the early struggles to classify sound cinema are not merely about a contest between two mediums; this transitional moment registers a confrontation with something new, something else—not merely a new medium but a new sense created by the way sound affects vision and vice versa.

Contemporary descriptions of the "talkie" production process also feature a mixing up of sound and silence, audio and visual—especially when negotiating a strained relationship to cinema's past. In a 1930 *Photoplay* article titled "How Talkies Are Made," the author attempts to familiarize audiences with the new cinema by describing the way technology is redefining the entire moviemaking process. The article claims that talkies "weld . . . stage and screen," but then goes on to chronicle a thoroughly foreign and modern production scene. He does so in order to win the patience of audiences who have noticed a "lack of movement in the early talking features and . . . have grown restless watching—or listening to—them."[25] The hesitation between "watching" and "listening" here is typical of the way the moviegoing experience was described at the time and suggests that audiences don't watch a picture that doesn't move. The new prominence of dialogue demanded listening and (consequently, it seems) provoked yawns. In his description of the production process, he focuses on a burgeoning professionalism that he attributes to new conditions demanded by sound recording. First among these conditions is silence: "The . . . most important requisite in the creation of these noisy shadows is 'Silence'" (28). While describing the new "silence" surrounding talking pictures (a silence that will also become a new requirement for audiences), he also paints a picture of silent filmmaking that identifies the old production process with noise. Ironically, by emphasizing the *noise* of the old process, he

distances sound film even further from the silents and draws a recognizable caricature of the silent era: "In other days . . . the director began shouting and his puppets talked or made love, smiled or wept, rolled an eye or heaved a bosom" (28). The exaggerated gestures and limited expressions are here equated with the director's shouting; even if the audiences in the movie theaters never heard them, the actors and crew made quite a ruckus in the cinema's loud, clumsy, and bumbling "old days." With sound comes white-collar professionalism and decorum, and film is taken out of the hands of apparently unskilled workers: "Even the lowly 'juicer' has a white collar job under the new order . . . [and] the cameraman no longer stands with cap reversed, turning his crank nonchalantly and looking about in a bored manner" (28).

With the increased awareness of silent cinema as something past and belonging to "simpler days," silent film acting was increasingly caricatured for its broad gestures and pantomime. This became commonplace even as the more "realist" acting style of the late 1920s silents gave way temporarily to the popularity of the minstrel show and other burlesque, pantomime-heavy displays in the first years of the talkie. Silent film acting had, in fact, become more silent—that is, actors talked less with their bodies, with large signs and gesticulations, and as discussed earlier, the realist style was increasingly associated with a "quiet" body and subtle emotions made legible via the close-up. But the reliance on pantomime increased in the early days of sound. Highly respected silent film actor-turned-director Lionel Barrymore identified two new "types of actors" demanded by the talkies. One was the "foreign type":

> So we have characters that must be French, but speak our language, and the mind of the audience loudly cries that these people cannot be French. Thus we have to make them so French to the eye that the fact that they're English to the ear is forgotten. It is done by choosing types that to the eye suggest nationality—and training them in pantomime and deportment that so carries the illusion that *the spoken words are not noticed*.[26]

Barrymore's theory belies the fact that the older style disappeared as the cinema became more sophisticated. He also offers another example of the way in which the early sound cinema revived the habits of the earliest cinema. Barrymore points out one of the ways in which sound paradoxically brings with it a greater emphasis on the visual. More importantly, this visual language that drowns out spoken words is put to work in the interest of representing nationality.

Michael Chion has noted that "the birth of the talkies . . . retrospectively made clear that the movies that came before were voiceless. Not that people didn't know that; they had simply forgotten."[27] But the process of remembering or realizing that silents were, in fact, silent involved a forgetting as well. There was a tendency on the part of advertisers, critics, and the popular press to forget all of silent film in an effort to make the cinema new again. And race figured prominently in this strategic forgetfulness. Perhaps this connection between race and forgetting provides one reason why cinema's defining moments have in one way or another been "accompanied by the portrayal of African Americans."[28] Skin color, an "obvious" visual signifier of race, was exploited as a way to attract the eye in a place where the ear threatened to reign, to help audiences "forget" sound. But the same "hyper-visibility" and sudden hyper-presence of African American performers was enlisted to showcase the marriage of color and sound, a link emphasized in the studios' aggressive promotion of "100% dialogue" features and "ALL COLORED CASTS." A Fox ad in the May 2, 1929, issue of the *Herald-World* boasted, for example, of "8 Fox 100% Dialog Features Now In Production" including *Hearts in Dixie* "with a cast of 200 Native entertainers."[29] The sometimes hysterical rhetoric around race served one of the cinema's definitive functions: inciting the audience's desire to see, with the help of the apparatus, like it has never seen before. Cinema's new modes of address erase old versions of spectatorship while at the same time relying on them. The alignment of black performers with sound cinema helped audiences and critics forget that cinema had been, since its inception, a highly self-conscious "affair of blacks and whites."[30]

The Color of Sound

African American performers "cured" the ills of the sound cinema in many critics' eyes because the fetishization of racial characteristics made up for what the new technology lacked. Stepin Fetchit was a key figure in this operation: in *Hearts in Dixie* he played the stereotypical "Gummy," the lazy, freeloading "colored boy" who only finds his feet when the music plays. When he danced on screen, even those who disliked the stereotype were blinded by the sheer physical "genius" of Fetchit's body.[31] The stereotype becomes the epitome of the "cinematic." In his introduction to the "Negro in Film" number of *Close Up,* Kenneth MacPherson notes that he is "dazzled by the hands of Fetchit," and beckons readers to "watch [Fetchit] move" in order to understand him as a "physical symbol": "something by

which we know without any further need to bother, that we are only at the outer edge of seeing."[32]

As mentioned above, Robert Benchley of the *New Yorker* found reason to "rejoice" with *Hearts in Dixie,* and Stepin Fetchit holds the key to this critical excitement:

> [Fetchit's] voice, his manner, his timing, everything he does, is as near to per-fection as one could hope to get in an essentially phony medium such as this. You forget that you are listening to a synchronized sound-tract *[sic]* which winds its way along side of a photographic film. . . .When Stepin Fetchit speaks, you are there beside him, one of the great comedians of the screen.[33]

Fetchit's presence is a hyper-presence ("you feel you are there beside him"), as he offers a powerful stereotype that allows audiences to do what they must do in order to experience the illusion of cinema: forget. While he stresses this need to forget the "essentially phony medium" (perhaps intending the pun), Benchley goes on to evoke the snaky materiality of the soundtrack "which winds its way along side of the photographic film." His attempt to oppose Fetchit to the medium does not last long because African American performers are too closely linked to the apparatus throughout the review. As in the publicity still that features the stars of *Hallelujah!* holding the film's soundtrack in their hands, a physical, even tactile connection between the performers and the apparatus persists. After declaring that the Negro's voice and personality are perfect for the talking picture, that the new medium has "found its ideal protagonist," Benchley goes on to describe these voices: "There is a quality in the Negro voice, an ease in its delivery and a sense of timing in reading the lines which make it the ideal medium for the talking picture" (122). Here, the Negro voice is the medium *for* the talking picture, and the talking picture is the protagonist in need of a stage. Sound cinema must capture the only object that can be reproduced properly; the public's faith in the new tech-nology depends upon the voices of African Americans. And thus the rela-tion between the apparatus and its subject becomes confused, with the medium (the talking, singing images projected on screen) and the subject (the black actors and their voices, captured via that medium) seeming to switch places. [34]

Benchley's review offers an odd combination of well-worn stereotypes about the Negro's special talents for song and dance and a new brand of pseudo-technical wisdom that had begun to creep into discussions of

talking pictures. And while he may have shown more enthusiasm than did critics in the popular press, his opinions about the "Negro voice" and sound recording were shared (or at least promoted) by many. Many critics and filmmakers declared that "the Negro" was perfect for talking pictures because of his proclivity for song and dance, but some fostered the belief (which seemed to gain the status of Hollywood "insider" information) that African American voices produced better and truer sound recordings. While more and more white silent film stars "[gave] themselves away by talking," African American voices were praised for having (as *Opportunity* editor Elmer Carter put it) a "rich resonance . . . in speech and in song"—a special timbre that would guarantee faithful recording and a reduplicable authenticity.[35] Some black critics and promoters saw the supposed technical fitness of African American voices as a way to throw open the doors of Hollywood to black performers. Bill Foster, a sometimes actor, sometimes agent with roots in vaudeville, claimed that "tests proved one great outstanding fact—the low, mellow voice of the Negro was ideally suited for the pictures."[36]

There are two rhetorical strategies at work here: emphasizing the hyperpresence of black bodies in order to deflect attention *away* from the apparatus and using those same bodies and their "inherent" talents to show off the prowess of the apparatus. The combined strategies reveal the classic gestures of fetishism, but in a particular circumstance that binds race and cinema.[37] This historical moment can help us think further about the potential of psychoanalysis for analyzing the undertheorized connections among race, fetishism, and cinema. The fetish, in psychoanalysis, is defined in terms of gender and sexuality; it is one of the "perversions" Freud identified, and it has become one of the most familiar. As the story goes, the child, realizing its mother's lack of a penis and "terrified by what it has seen . . . will have tried more or less successfully in different cases, to *arrest* its look, for all its life, at what will subsequently become the fetish: at a piece of clothing, for example, which masks the frightening discovery, or else precedes it (underwear, stockings, boots, etc.)."[38] The fetish thus becomes the object that simultaneously covers up the lack and symbolizes it, leading to the classic expression of disavowal: "I know, but just the same" Christian Metz theorized the fetish (among other psychoanalytic concepts) in his effort to explore the contribution Freudian psychoanalysis might make to his semiotics of the cinema. His adaptation of psychoanalysis initiated discussions of spectatorship that devolved upon notions of voyeurism and scopophilia that would become central to feminist film

theorists' gendered accounts of the gaze and identification in cinema.[39] But this description of Stepin Fetchit suggests the way the structure of fetishism can (and must) be understood apart from sex difference in order to account for the function of race in the construction of the cinematic apparatus here. Indeed, the description of Stepin Fetchit in *Hearts in Dixie* epitomizes the stereotype as fetish. Again, as in Bhabha's account, the stereotype's exaggeration and its seeming fixity compensate for its anxious status as a complex and shifting site of projection. In other words, the stereotype manages to seem static while in fact being quite capacious in both form and function. Here, the stereotype is doing (at least) double duty—obliterating the real African American performer Lincoln Perry *and* parrying the lack associated with the "phony" sound technology. In the unique association of race and the cinematic apparatus during the early sound era, we have a specific instance of the way the racial stereotype as fetish informs the cinema as fetish. To best understand this, we must turn to a notion of cinematic fetishism defined apart from sex difference.[40]

The function of race in the early talkies complicates the models of fetishism and disavowal developed by feminist film theorists.[41] But the contributions of psychoanalytically inflected feminist film theory—particularly around issues of corporeality and narrative—also offer important points of entry for the discussion of race and fetishism. Kaja Silverman's work on the voice is particularly relevant to the historical moment that produced *Hallelujah!* and *Hearts in Dixie*. As Silverman argues in *The Acoustic Mirror,* classic Hollywood films suggest that "synchronization is synonymous with a more general compatibility of voice to body—that a voice which seems to 'belong' to the body from which it issues will be easily recorded, but that one which does not will resist assimilation into sound cinema."[42] Synchronization goes hand in hand with corporealization. If we look back at Benchley's review of *Hearts,* his strategy becomes clear. Benchley cleverly places Stepin Fetchit and the film's soundtrack side by side: "[Fetchit's] voice, his manner, his timing, everything he does, is as near to perfection as one could hope to get in an essentially phony medium such as this. You forget that you are listening to a synchronized sound-tract *[sic]* which winds its way along side of a photographic film."[43] Benchley represents the soundtrack as a distinct and potentially intrusive element. Only Fetchit's "voice," "manner," and "timing"—in short, his race—can weld the sound and image tracks together for the viewer. The review draws upon what Silverman refers to as "that powerful Western episteme . . .

which identifies the voice with proximity and the here and now," but with an added measure of bodily presence guaranteed by Fetchit's race.[44]

Silverman is primarily concerned with defining the gendered division of voices in classic Hollywood films: male voices are aligned with the invisible apparatus, while female voices are identified with an "intractable materiality." Woman's identification with her body "magnifies the effects of synchronization" and relegates her to a "doubly diegeticized" space where she is contained as spectacle and framed as the object of the apparatus.[45] The rhetoric surrounding the "Negro voice" during the transition to the talkie clearly links racial identity to a continuity of internal and external traits; that corporeal continuity promises ease of recording and ultimately suggests the "Negro's" overall appropriateness for—even identification with—the new medium. This differs from the model Silverman sets up, as black bodies seem to lend a level of corporeality to the apparatus itself. While the black performer is aligned with spectacle, then, the division between apparatus and subject/spectacle is not as clear as it seems to be in Silverman's account of the cinematic representation of (white) female performers. This has to do again with the way in which powerful assumptions about race informed Hollywood cinema at this particular historical moment: at a time of technological vulnerability, the biologizing discourse associated with race naturalized (and domesticated) the apparatus as well.[46]

Metz's comments on the "cinema fetishist" take on a new relevance in the context of race and the sound cinema. This fetishist is "enchanted at what the machine is capable of," but this sort of pleasure is not limited to the "connoisseur." The average moviegoers "who just go to the cinema . . . [go] partly in order to be carried away by the film . . . but also in order to appreciate as such the machinery that is carrying them away."[47] This would have been particularly true of the "average moviegoer" who went to see the early talkies; the machinery in that case would have been the primary attraction. The cinematic apparatus, Metz explains, *is* the fetish:

> Thus, with respect to the desired body—to the body of desire rather—the fetish is in the same position as the technical equipment of the cinema with respect to the cinema as a whole. A fetish, the cinema as a technical performance, as prowess, as an *exploit,* an exploit that underlines and denounces the lack on which the whole arrangement is based (the absence of the object, replaced by its reflection), and an exploit which consists at the same time of making this absence forgotten.[48]

The cinema as "exploit" epitomizes the essential paradox at the heart of the fetish. This gesture of disavowal is repeatedly on display in the promotion and reception of the black-cast talkies (as well as in the representational strategies of the films themselves). But race intrudes upon this formula to produce a kind of double fetishism—an oscillating mechanism that depends upon a reciprocity between race and the apparatus. That is, the fetishization of "racial" characteristics makes up for the shortcomings of the sound cinema's machinery, and sound cinema's machinery (the "prowess" of the apparatus) makes up for the potentially "threatening" presence (for white audiences) of large numbers of African American performers on screen. This reciprocal fetishism parries another hidden "lack": the potential inadequacy of whiteness itself.

Sound still had the status of a kind of "secret" in the early talkies, since audiences did not know what their favorite stars would sound like. In a way, the "black voice" offers a kind of insurance, a preemptive defense against the revelation of a lack. After all, the publicity surrounding these films maintained that black performers' voices—all of them—posed no difficulties for sound recording. Thus before the performer opens his or her mouth, the audience "knows" what's coming, and this knowledge is borrowed from the visual "obviousness" of race. The focus on race in the early sound era points to different definitions of, and strategies for disavowing, cinema's lack. The now legendary stories of film careers ruined by "inappropriate" voices remind us of a time when the still new ego ideal provided by the film star was sullied by uncooperative materiality. That is, the "wrong" voices tended either to contradict the gender of a star (high-voiced male actors) or to be a mismatch with the well-known (white) movie star's type or character—this usually meant the voice retained too much of the actor's lower-class, regional, or ethnic background. Imperfections threatened the ideal whiteness associated with the Hollywood movie star. Critics in some quarters responded to this perceived lack by ceding the sound cinema to "the Negro": "Talking films took films from us but they have given us a glimpse of him,"[49] Kenneth MacPherson declares (apparently on behalf of Whites) in his editorial introduction to the "Negro in Film" issue of *Close Up*. Black contributors including Walter White of the NAACP, *Opportunity* editor Elmer Carter, and writer Geraldyn Dismond all point to sound cinema as a potential boon for African American–owned production companies.[50] And while Robert Benchley does not mention black directors or producers in his contribution to *Opportunity*—and in fact claims that white writers do a better job of writing comedy for black

actors—he is willing to give up on white stars altogether. "It may be that the talking-movies must be participated in exclusively by Negroes," he theorizes, "but if so, then so be it."[51]

In trying to cover over the deficiency of both the apparatus and the movie star, Hollywood turned to the black performer. Black performers eliminated the local problem—the perceived inadequacy of the apparatus—because their voices were supposedly more in tune with the machines. Perhaps more importantly, their voices matched their bodies precisely because, to white audiences, they "sounded" black—that is, their voices bore the trace of their race. On a larger level, they shored up the entire notion of a movie star or ego ideal precisely by being neither. They would make audiences forget the "phony" nature of the medium because they were not phony—they were not "actors." According to King Vidor, "The Negro is one of the greatest actors by nature principally because he doesn't act at all, but actually feels and experiences the emotions he seeks to portray."[52] *Opportunity* found this to be a common opinion, from central casting to Lon Chaney's assistant, who "gives Mr. Chaney's opinion in the matter by saying, 'You can pull any one of them out of the mob and they can act.'"[53]

This characterization of "the Negro" as especially "natural" mitigates the threat of black superiority while exploiting the status of race as a stabilizer of meaning in order to renew faith in the cinema. And the representation of African American performers, particularly in the popular (white) press, reinforces racial difference through the excessive diegeticization of black characters and performers. Movie magazines and trade papers raved about black actors in sound films in ways that kept them framed within stereotypes, racist anecdotes, and familiar characters and story settings. Stepin Fetchit, the most popular black screen actor of his time, was treated by the press as the wide-eyed, lazy "colored boy" that he played over and over on screen. And as Thomas Cripps points out, Fetchit was rewarded for his cooperation with racist expectations; his career was long, lucrative, and highly publicized, while some of the black blues performers and other cutting-edge artists who appeared briefly in short sound films disappeared quickly from the Hollywood screen.[54] *Photoplay*'s review of *Hearts in Dixie* declared, "At risk of giving that colored boy . . . a bigger opinion of himself than he now possesses—if possible, we are going to say that you should see that boy throw his feet around in 'Hearts in Dixie,' Fox's all negro picture."[55] The same issue of *Photoplay* featured a "biographical" article on Fetchit ("Stepin's High-Colored Past")—a racist parody, written

in mocking dialect and featuring a large picture of Fetchit's head (complete with a goggle-eyed expression on his face).[56] Like the female voice in Silverman's account, black performers and their voices are put on stage, where they occupy a doubly framed "inner textual space, such as a painting, a song-and-dance performance, or a film-within-a-film."[57]

Black performers are not made spectacles solely within films, however. As suggested above, they occupy a different kind of "space" in publicity as well. Al Christie was one of the first producers to see the box office potential of black performers in sound films. In 1929, Christie began producing a series of short films based on popular *Saturday Evening Post* stories by Octavus Roy Cohen ("Darktown Bummin'ham Stories," dialect stories set in the South featuring mocking accounts of "Negro Society"), and he promoted the films as "the most interesting experiment" in sound films.[58] In an ad for Paramount-Christie's new slate of talkies that ran in the March 2, 1929, issue of the *Exhibitors Herald-World,* the fetishized status of these films is clear. Under the heading "Speaking for Christie," small, oval-framed photographs of white movie stars cover most of a two-page spread. But a significant amount of space on the right side of the ad is dedicated to "[t]he greatest novelty yet in talking pictures . . . with ALL COLORED CASTS portraying those popular Darktown characters in their natural dialogue." The possessive pronoun slides here—whose natural dialogue: the Darktown characters or the "colored cast"? But the image makes it fairly clear that that would be a distinction without a difference. The picture accompanying this announcement occupies the bottom right corner of the ad and features a white hand holding five playing cards, each with a caricature of one of those well-known characters on it. While white actors are treated like movie stars, black performers are on a different plane of representation. They are rendered in pen and ink drawings, not captured in photographs, and they exist only within a familiar fictional space: Darktown. Pictorially, the cards draw more attention than the photographs: they and the hand that holds them are relatively large and occupy the foreground of the picture. Christie sought to make much of this "novelty," and the ad makes a kind of sideshow out of the black performers. The visual metaphor, a hand of "face cards," clearly turns on the racist term "spade," while also allowing Christie to represent his experiment—to audiences and competitors alike—as a kind of ace up his sleeve in the new and unpredictable talkies game (Figure 28).

Once again, as in the early days of cinema, black bodies serve simultaneously as burlesque, sideshow novelties and as guarantors of realism in

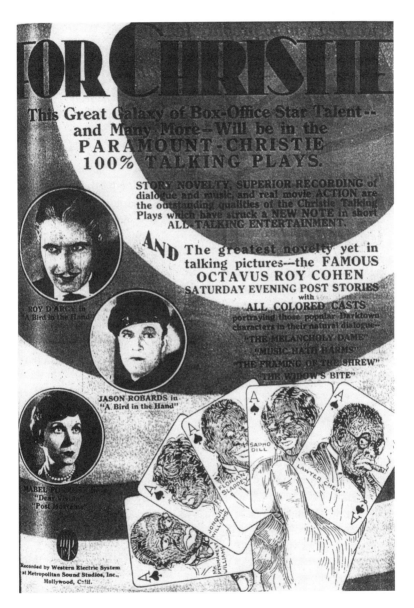

Figure 28. Advertisement, *Exhibitors Herald-World*, 1929.

order to ground cinematic signification. The relegation of black perform-
ers to cartoonish modes of representation reflects a strategy for racializing
their bodies in order to exploit and contain their meaning. As noted above,
Christian Metz defines the "cinema fetishist" as "the person who is en-
chanted at what the machine is capable of, at the *theater of shadows* as
such."[59] From the earliest days of motion pictures, as we have seen, the
fact that bodies on screen were merely dancing shadows served as a gentle
reminder of the material conditions of the cinema's most basic illusion.
But with the release of the black-cast talkies, the discussion of cinema's
"shadows" took on an explicitly racial meaning once again. In the rhetoric
surrounding race and the talkies, the evocation of dancing shadows offers
a figure for yoking the representation of black bodies to a definitively *cin-
ematic* art. In *Hallelujah!* this linkage creates a profoundly ambivalent
treatment of bodies, sexuality, and religious expression. In the film's scenes
of religious ecstasy, the camera confronts the bodies as "dynamic" sub-
jects, perfect for the cinema, but also as threatening sites of unrestrained
sexuality and otherness. The use of shadows in these scenes fuses these
bodies with the cinema's expressive genius. The *dematerialization* of the
threatening black bodies—their projection as dancing shadows—gives
body to the apparatus, guaranteeing the cinema's status as a new and im-
proved art by recalling its most basic conditions. In essence, the shadows
synchronize two formerly incompatible things: the absence of cinema's
objects and the racialized emblems of its realism.

"Black Shadows"

Unlike *Hearts in Dixie,* which presented an assortment of song and dance
routines loosely organized around a slim storyline, Vidor's film featured a
coherent narrative and ambitious (even expressionistic) sound and cine-
matography. Because of Vidor's reputation, many critics looked forward
to the film with hope, particularly those who were still lamenting the pass-
ing of silent cinema. Almost all the contributors to *Close Up* saw the death
of silent film as the death of the twentieth-century art form they had cher-
ished and tried to nurture; but they saw a future for sound cinema in the
representation of "Negro life." Many of the contributors to *Close Up* dis-
played the modernist tendency to romanticize the "primitive" in art and
to associate "primitive" expression with the clear expression of race. They
looked to "Negro life" in a search of a plenitude of meaning that they felt
was lost in an overcivilized and neurotic Anglo/European whiteness.[60] In

the "Negro in Film" issue, Robert Herring suggests that cinema can live on after sound, but only if it finds "new life"; just one look at "Negro art," he claims, and "you will find a new life, very rich, very swift, intense, and dynamic, unlike ours, but full of things which we cannot help knowing we lack."[61] "Negroes need simply to live on the screen" because the screen prefers the real to the artificial, and the dynamic to the still: only "Negro life" needs no crafting for the screen—in this life, cinema confronts its raw material. The contributors tended to deride Hollywood productions, and even Vidor's efforts were not enough to satisfy the lust for blackness expressed by some. Harry Potamkin, a critic who wrote frequently on African art, complains about Nina Mae McKinney, the light-skinned "bad girl" of Vidor's *Hallelujah!*: "And Vidor's *Hallelujah!* with a good-looking yaller girl. As for me, I shall be assured of the white man's sincerity when he gives me a blue nigger."[62] This performer, black enough so that "the sweat may glisten the more and the skin be apprehended more keenly," will usher in the cinema Potamkin wants: "cinema at its source."[63]

As the trade magazines reported, many in Hollywood were also look-ing forward to *Hallelujah!*, but they saw the film as a box-office gamble. With it, Vidor hoped to prove that "a dramatic story of negro life could be made into a box office picture."[64] As Geraldyn Dismond reported in *Close Up*, "several studios are holding up all-Negro productions until the fate of *Hallelujah!* has been pronounced."[65] The film was critically acclaimed, but many theater owners refused to book it, especially in the South. The film owed its eventually successful run in Chicago to one independent theater owner who decided to run it after the larger theater chains had rejected it. It took Chicago's black congressman Oscar DePriest's endorse-ment to rally support for the film in the African American community. On October 23, the *New York Amsterdam News* ran a picture of DePriest with King Vidor and Nina Mae McKinney in its entertainment section. The cap-tion read: "Congressman Oscar DePriest thought so well of 'Hallelujah!' he paid a visit to the MGM studio to personally thank King Vidor for hav-ing made and produced the picture." But even wary African American re-viewers such as W. E. B. Du Bois emphasized the importance of the scenes of religious ecstasy in the film.[66] This was Vidor's explicit motivation for making *Hallelujah!*—he was nostalgic about his own southern upbring-ing, his black nanny, and the familiarity of the Negro spirituals. But the song and dance numbers were not his main interest. The "Negro drama" he was most interested in portraying hinged on what he called "[t]he sincer-ity and fervor of their religious expression . . . [and] the honest simplicity of

their sexual drives."[67] In *Hallelujah!* these two things are interchangeable, and religious ecstasy is represented through excessive embodiment—an embodiment figured, ironically, through the distortion and fragmentation of the film's subjects.

Hallelujah! tells the story of a poor black family. The eldest son, Zeke (Daniel Haynes) falls onto the path of sin when he meets a sexy femme fatale named Chick (Nina Mae McKinney). He gambles, fights, and ends up shooting his younger brother by accident. In the wake of this tragedy, Zeke repents and has a conversion experience. He then becomes a preacher with a great following; even Chick falls under his spell. But her religion turns out to be a kind of sexual hysteria, and she lures him away from his calling. She ends up cheating on him with a villain named "Hot Shot" (William Fountaine), and Zeke finds them together. A chase ensues; Chick is killed, and Zeke kills Hot Shot in a vengeful rage. Zeke serves time in prison, returns to his family, and finally marries the good girl to whom he was originally engaged, his adopted sister Missy Rose (Victoria Spivey).

Vidor's description of his intent in making *Hallelujah!* ostensibly celebrates the "honesty" and "sincerity" of African American religious and sexual expression. But the film clearly represents the inevitable conflation of religious and sexual ecstasy as a threat to the idealized purity and strength of the African American family. The film's narrative frame offers familiar displays of cotton picking, set pieces, and song and dance numbers. In the opening scenes, the large, intact family eats together, marvels over the wonders of a watch that no one can read, and claps and sings while the smallest boys tap-dance on tabletops and truck beds. The cotton fields offer a romantic, pastoral setting, and the establishing shots are hazy around the edges. As the characters are established, however, Vidor's framing becomes strangely tight. His "two-shots" often lop off a good portion of one character's body, even in medium or medium-long shots, and characters (especially Zeke) don't always fit in the frame. This is sometimes due to the exigencies of sync sound—while the characters move, leaning in and out of frame, the camera remains still. As Zeke sings in these early scenes, he gestures broadly, and his head or arms often extend past the frame. The combination of tight framing, slightly low angles, and broad gesturing produces a monumentalized portrait of Zeke; we are offered a naturalistic, romanticized embodiment of rural African American life.

As things start to fall apart for Zeke and his family, Vidor begins to utilize more expressionistic lighting and framing. His use of the close-up becomes particularly striking as uncontrollable religious and sexual fervor

begin to erode the physical and emotional wholeness represented by Zeke and his family. We are made aware of the destructive power of sexuality as soon as Chick comes on the scene. Even in the context of a musical, Chick is introduced as spectacle—she is, to recall Silverman, "doubly diegeticized" as she dances and sings for an audience within the film. She struts her stuff for a crowd of men who encircle her. The scene features the film's first close-up: an insert shot of Chick's legs. The shot establishes her as a sexual object as it comes *before* a close-up of her face. But it is slightly disembodied since it is not yoked to Zeke's gaze (there is no eyeline match or any contiguity with a shot of Zeke's face). The disembodied and grotesque possibilities of the shot are reinforced later when Chick helps Hot Shot hustle Zeke out of all his money in a gambling club. A fight ensues, and Zeke's younger brother Spunk is shot and killed. When Zeke returns home to tell his family, they gaze upon Spunk's dead body lying in the back of Zeke's truck. All we see is a shot of Spunk's dead legs laid out there. This is a kind of rhyming shot to the earlier close-up of Chick's legs. Hers were dancing and eroticized; their power overwhelmed Zeke, whose lust for her led to Spunk's death and the mutilation of his family.

The close-ups in this film are particularly "unnatural" and sinister. Only one facial close-up in the film functions like a standard Hollywood close-up: a soft-focus "star" shot of Chick, which makes clear her role as the beautiful but dangerous object of desire.[68] Interestingly, Missy Rose, the darker-skinned and "innocent" character, is never treated that way by the camera. Most often in the film, the close-up denotes dangerous and uncontrollable lust and/or religious rapture. The first close-up of Zeke's face occurs when he is suddenly overcome by sexual feelings for Missy Rose. His eyes are wide as he looks at her with some combination of lust and confusion. As Zeke later comments, the devil is in him; far from being the expected star close-up that cinematic realism had already adopted, this shot and others like it emphasize the grotesque and disorienting features inherent in the close-up.

While the beginning and end of the film rely on predictable stereotypes, song and dance bits, and romantic depictions of cotton-picking, the heart of the film follows a series of religious experiences—from Spunk's funeral through Zeke's conversion, a group baptism, and various prayer meetings. With each, the emotional and sexual stakes seem to be raised, until the group hysteria of the final revival meeting ends with the newly converted Chick leading Zeke away from his flock and down a path of sin (a path that seems to have been opened up by the religious hysteria itself). I want to

look briefly at the conversion and baptism scenes as precursors to the final revival meeting; the last scene of religious fervor offers a startlingly economical instance of what the film suggests all along: the links between cinema's ground zero of signification and a racialized theory of expression.

As I noted earlier, the death of Zeke's brother initiates the fragmentation of the family, a process denoted by the increasing use of disembodying or distorting close-ups. Zeke's conversion experience takes place during his brother's funeral. He has separated himself from the crowd of mourners, and after a talk with his father he spontaneously (and literally) sees the light as the moon appears from behind a cloud. He begins to preach, and as he speaks, the crowd of mourners surrounds him; what was a scene of mass sorrow now becomes a celebration, and Zeke begins to sing "Swing Low, Sweet Chariot." As he does so, we cut to various members of the crowd, but two shots stand out, both because of their uniqueness and because they are repeated. One shot features Missy Rose, who kneels on the ground crying and clutching Zeke's leg (it is essentially a medium close-up of his legs, with the upper half of Missy's body in frame to the extreme right). This is her most expressive and overwrought moment, and it is the only time when she touches Zeke of her own accord (at other times he pulls her to him or they kiss each other in an unsexualized, brother/sister way). This is really the only time when Missy Rose can be read as a sexual being. Just before this shot, we get a memorable close-up of hands, several mourners' hands raised in the air and swaying to the music. As Zeke's preaching brings the community together, these shots prefigure the destructive power of heightened religious expression: the fragmented bodies haunt the ecstatic dance performed on Spunk's grave.

Chick is finally converted (after much resistance) at one of the prayer meeting scenes that follow Zeke's transformation into an itinerant preacher. When the group baptism scene begins, she takes her place at the head of a long line of people draped in white robes and waiting by the water. When she reaches Zeke in the water, she waves her arms wildly and can't stop screaming. Two close-ups follow that reiterate the link between this sort of ecstasy and a grotesque embodiment. I have been referring to some of these close-ups of body parts as "disembodied" or "fragmented." The distorted close-ups of faces in these scenes, however, can more precisely be called over-embodiments, as they imbue the characters' faces with a corporealized sense of movement and (sexual) hunger. When Chick is in the water, she looks at Zeke, and in the shot her head is tilted and moving toward the left edge of the frame. She grabs Zeke, and in the next shot

Zeke's face is at the extreme left of the frame, and only his eyes and nose are visible while an expanse of sky fills the rest of the frame. His head is also moving slightly during the shot; this kind of movement and framing are entirely opposed to the way close-ups would generally be used in classic Hollywood realism. And indeed, rather than shoring up star quality and stable character motivation, as close-ups normally would, both shots suggest instability and a kind of bodily takeover of identity.

In his theorization of the close-up, Gilles Deleuze equates the close-up with the face; again, for Deleuze, the close-up *is* the face. Like the face, the close-up presents a kind of expressive immobility: "It is this combination of a reflecting, immobile unity and of intensive expressive movements which constitutes the affect. But is this not the same as the Face itself?"[69] The close-ups of Zeke and Chick are not faces in the Deleuzian sense; these faces move with their ecstatic, gesticulating bodies and offer no subtle expressions of their own. This alienating use of the facial close-up becomes particularly powerful in the final revival-meeting scene. Chick arrives on the scene and almost instantly mesmerizes Zeke. He is lured from his pulpit to dance with her, and we get a shot-reverse shot sequence. The close-ups are extreme point-of-view shots; we see Zeke from Chick's perspective and vice versa. Each head bobs up and down with the music, often ending up half way out of the frame. These headshots signify as part of the "hysterical" religious experience, dancing to the music as part of the expressionistic atmosphere of the scene. The wide-eyed and maniacal close-ups are more "heads" than faces because of the way they move. They act like bodies and are, in fact, emblems for the spell of physical desire.

This is interesting given the history of the close-up discussed in previous chapters. In the transition to the feature, the power of the close-up was tied to its severance from the body and from body-centered modes of performance. This was crucial to the making of the screen face that functioned not only as the window to a character's thoughts and emotions, but also as a site of transformation and absorption for the audience. The close-up has been understood as providing access to another dimension (typically described in spiritual or essentialist terms), and as we saw in the responses to Sessue Hayakawa, "race" supplemented the spiritual aspects of the close-up, making his face both "mute" and "eloquent," akin to the surface of the screen, the perfect medium for projection and for a racialized fantasy of dissolution. In more general discussions of the close-up from that period, the expressiveness of the face was seen as definitive to cinema (especially in differentiating it from the stage), and the notion that

the face in close-up could speak—could make silence eloquent—was important to the rhetoric of both realism and cinematic specificity. In this sense, Hayakawa's acting style—and more specifically the Orientalist discourse around it—seemed to suit perfectly a silent medium looking to find its voice, its identity, and its cultural legitimacy. This transition was important to the development of the close-up as a register of character psychology and as a pivotal point of reference for narrative structure. That is why the close-ups in *Hallelujah!* register as so uncanny; by 1929, the more familiar use of the close-up was fully established, and these grotesque, bouncing heads deviate quite drastically from the usual pattern. As a result, race functions in a very different way than it did in the case of Sessue Hayakawa.

The emphasis on authenticity runs through both the film and the publicity surrounding it, as it does in the many discussions of the "black voice" referenced above. The reliance on the "Negro" as a "natural" actor and on *Hallelujah!*'s authentic locations are tied to the film's insistence on the truth of the body—the "sincerity," "simplicity," and "honesty" of the Negro's "drives." The fact that the actors' faces can turn into "heads" and yet still fully express the essence of the moment has everything to do with the bodily forces that have overtaken the characters; but even in their better moments, they are depicted as never far from those forces. And although the "realness" and "authenticity" of the performers was exploited in the publicity for these black-cast films, the legacy of minstrelsy was never far behind. Gaping, goggling eyes and facial acrobatics went hand in hand with the minstrel mask; and as we have seen in the history of the close-up, blackface minstrelsy was one of the body-centered performance modes from which the cinema had tried to distance itself in its quest for respectability. At the same time, the talkies had brought blackface minstrelsy back onto center stage (or center screen). Since African American performers were already treated differently by the camera than white actors (that is, since they were rarely featured with speaking parts, much less highlighted with "star" close-ups), the division between the face and the body, or between stillness and movement, seems easier to cross. And so the "Oriental" and the "Negro" provide access to different understandings of "authenticity." While the figures we have seen in the last two chapters have been associated with magical transformation and mythical images associated with racial and cinematic signifiers, the characters in *Hallelujah!* are grounded in rituals tied to the American South, with Vidor claiming an almost anthropological function for his film, which, he said, would provide "a sort of cross-section of an entire people."[70] And yet, despite the

differences in the representation of the "Oriental" and the "Negro," the links between racialized rhetoric and the apparatus remains—both in the effort to endow the cinematic signifier with bodily presence and in the tendency to exploit racialized figures in order to access and translate the ineffable into cinematic "speech." In a sense, both versions of racialized essentialism enable a merger of the authentic with the magical, and perhaps this is why they are so important to the cinema's self-definition, since it depends upon this same merger. While the close-ups in *Hallelujah!* distort the face and emphasize uncontrolled bodily motion, the body itself ultimately offers a surface legibility not unlike the "shadows" of the last chapter, a legibility that signals the suitability of "the Negro" for film and that "speaks" more clearly and fluidly than any dialogue, even in this sound film.

Hallelujah! figures hysteria through these distorting close-ups and through an expressionistic use of shadows. The climactic revival scene begins inside the little meetinghouse in the evening, with Zeke at the pulpit. He is delivering a sermon in which he imagines a boxing match with the devil. The scene then cuts outside, where we see Chick running toward the open door of the meetinghouse. In this extraordinary shot, Chick runs into the frame, her figure backlit by the light coming from the doorway. The wide doorway frames the scene within: we can see an indistinct crowd, but rising above them on the brightly lit white wall is the distinctly outlined shadow of Zeke waving his fists in his imaginary fight with the devil. Once Chick is inside, she is swept up in the scene. In an overhead shot of the crowd, several people writhe on the floor while others dance around them. And Chick is not the only hysterical woman—another woman is carried off and dunked in a water trough. As Zeke attempts to keep preaching, the crowd undulates before him, and as the scene goes on, more and more people get up and join the hypnotic motion. Chick and Zeke dance at the center of the chaos, but they are not separate from or above it; their bobbing heads emphasize their continuity with the crowd's motion. As the excitement builds, more and more hands are raised in the air until the mass of people becomes indistinct; only the hands, and the writhing shadows cast by them, are clear.

These waving hands recall an earlier shot from Zeke's conversion. In that scene, the camera lingered on the swaying hands of several worshippers; in the revival scene, our attention is drawn to the shadows cast by the swaying hands. Those shadows, like Zeke's boxing shadow, are larger than life, and their motions are distinct and clear. This scene repeatedly redirects our attention from the real, writhing bodies of the congregation

to their shadows on the wall. When Zeke and Chick finally leave, Missy Rose runs after them. As she leaves, we cut once again to the exterior shot of the building. These exterior shots always offer the same perspective: we look at the doorway to the building, through which we can see a dancing crowd. From without, the people are a throbbing mass with hands raised, but their shadows, stretching high above them on brightly lit white walls, snake and sway wildly. This repeating shot—all darkness without, all light and moving shadows within—identifies the ecstatic black bodies with the cinema itself.

What seems clear here is that while the mass hysteria and wild abandon of the prayer meeting may be bad for Zeke and his family, it is good for cinema. The meeting comes to figure cinematic representation, as the flesh and blood bodies become "mere shadow[s] on a plane surface." This is the archetypal moment of "dramatic negro life" that critics and filmmakers were looking for during this transition from silents to sound: the "intoxicating . . . dervish dance" of which Oswell Blakeston spoke so highly. The scene accomplishes the intertwining of motion, expression, and race to which many critics of the time alluded when speaking of the need for "real life" and the "real Negro" in cinema. Therein lies meaning:

And we don't get [meaning] by blacking our faces and wearing white gloves. . . . We want the real thing, always, and the cinema demands the real thing, and heaven knows there is enough reality waiting there, if black shadows might move on our screens in their own patterns, and have their own screens, too, to do it on—For surely they are as tired of all the as of yet white, yellow, white—nothing but white—films; and heaven knows I am.[71]

As if these dancing figures on the movie screen weren't enough to satisfy the desire for a truer cinematic expression, *Hallelujah!* offers audiences a screen on the screen where the figures are transformed into "pure cinema": two-dimensional black shadows projected on a white screen, clearly expressive figures flitting in the light.

If we return to Fatimah Tobing Rony's study of cinema and the "ethnographic spectacle," we recall how shadows functioned as a racializing technique in Felix-Louis Regnault's work on West Africans:

In most of the films of West Africans . . . the bodies are rendered as *shadows*. Wearing tight long johns, French bathing shorts, Peul-type pantalon bouffon or just ngebu (shorts), these men do not look up and acknowledge the presence of the camera: they are often filmed in such a way that they are

turned into ciphers, their faces indistinct. Although the performers walk in the foreground, they often appear to be behind a screen, like shadow puppets.[72]

The ethnographer looked to these "native" bodies for a clear expression of race; turning them into shadows erases distinguishing marks in order to make the bodies (and race) more legible. In this sense, "the Ethnographic Body is always in a contradictory position, both 'real' and sign . . . cinema makes the native person, man or woman, into unmediated referent."[73] In *Hallelujah!* Vidor takes the "Negro" body apart and puts it back together again in a dematerialized form—the shadows on the wall. His cinematography recalls the fetishistic rhetorical strategy at work in the promotion of the black-cast talkies: praise the racialized body and denigrate it; feature African American performers but frame them within stereotypes, cartoons, and other clear markers of difference. Above all, reiterate the link between black bodies and the apparatus.

Like the articles that rave over Stepin Fetchit's head, hands, feet, mannerisms, and timing in an effort to forever marry image and soundtrack, *Hallelujah!*'s black bodies—at once fragmented, over-embodied, and distorted—make the cinema whole again. Ironically, the climactic revival scene is not "sync-sound" in the strict sense. Most of the location shooting for *Hallelujah!* was done without sound, which was recorded and added later. Whether it was shot with sync-sound or not, the scene itself, once the crowd hysteria takes over, does not feature sound emanating from people's mouths; rather, we hear music and other group sounds—like screaming and wailing—that are not tied to particular, identifiable characters. Yet everything (and everyone) comes together in the revival scene as the little meetinghouse is filled with sound and motion. The ecstatic cohesion of the group only ends when Missy Rose announces that Chick has taken Brother Zeke away (Figure 29). With its repeated shots of shadows on the wall and its generalized sounds of religious ecstasy, the scene could be experienced as a moving picture merely *accompanied* by sound. Yet it produces a kind of synchronization that depends on something other than "moving lips." In other words, the brand of synchronization offered by *Hallelujah!*'s climax depends on racialized bodies in motion. Sound and motion, in pure form, are linked. The dancing shadows reference the cinema while calling forth the supposed talent of "the Negro" for expressing the inexpressible with his body. And thus these bodies that have been fragmented and vexed throughout the film are made more perfect through the two-dimensional image projected in the light. In turn, that image, the

Figure 29. Missy Rose leads a prayer at the end of the final revival scene. *Hallelujah!* (MGM, King Vidor, 1929). Courtesy Museum of Modern Art Film Study Center.

cinematic image, is itself made seamless, legible, and powerful. Vidor extracts from the potentially threatening black body the perfect figure—the dancing shadow that brings the real and the sign together, synchronizing sound, motion, and race to guarantee the rebirth of cinema.

The climactic scene described above offers another example of an imagined communion formed by a merger of bodies and images made possible through the exploitation of race. Over the past few chapters, we have looked at similar climactic moments. These scenes suggest continuity between the formation of a community based on faith and the formation of an audience based on faith in the image. In *The Cheat,* we saw how an audience formed around racial antagonism and the mark on the skin that functioned simultaneously as physical evidence and as the sign of racial identity and sexual transgression. In *Shadows,* the racialized figure is sacrificed to form a community, but his difference also enables the replacement of false images (shadows as illusions) with those that promise unmediated truth (shadows as substance). In each case, the screen image, figured as a shadow, plays a key role. And in *Hallelujah!,* dancing shadows are bound to black bodies and promise a communal, cinematic experience—

not the cinema exposed by inadequate sound, but a pure, expressionistic shadow that "talks" without words. All these moments suggest the way the communal experience on screen projects a communal experience for the film audience, and that the two kinds of communion are bound together by a screen image that gains presence and power through the exploitation of race difference. In this operation, the rhetoric of race anchors meaning in the image in order to supplement the audience's faith in the image. But it is important to remember that this is very much an *imagined* communion, as actual audience responses to the early talkies—and in particular to Hollywood's black-cast experiments—were hard to predict. The studios knew they were gambling with these films in terms of their potential for mainstream box office appeal, and the two features made in 1929 hardly heralded a new direction for Hollywood—rather, as discussed, they were promoted as novelties, appropriate within a very limited context. In the decades following, black performers in Hollywood films would be relegated to brief musical or dance numbers clearly set off from the rest of the film, or they would simply be absent, represented by whites in blackface, or, in some cases, transformed into animated figures featured in musical cartoon shorts.[74]

The ecstatic fusion that we saw at the end of *Hallelujah!* would continue to resonate in later films, however, particularly musicals, which repeatedly aimed for something I would call a "dream of pure cinema": the merging of sound and image in which meaning comes to the surface, a fantasy of cinema as communion. While a fuller study of the musical lies beyond the scope of this book, the genre's dependence on the comedy, music, and performers inherited from minstrelsy and vaudeville made it a repository for "spectacle" and the direct address that had seemed to die out with early cinema.[75] This also meant the genre continued to mine its past and to rely on imagined blackness—whether through stereotypes and blackface or through the circumscribed use of African American performers in an atmosphere of racial segregation in Hollywood film. Long after the birth of sound, these films and their "dreams of pure cinema"—whether in the excessive, geometric patterns of Busby Berkeley musicals or in the shadow dance performed by a blacked-up Fred Astaire in *Swing Time* (1936); whether in the Technicolor ballet performed by Cyd Charisse and Gene Kelly in *Singin' in the Rain* (1952) or in the "pink elephant" and "black crow" dream sequence in *Dumbo* (1941)—often seem to reach back, to look for some essentially cinematic thing, some sort of primordial soup of image and sound. In so doing, they often, and not so coincidentally,

exploit race. As "black voices" are tuned in (on the radio, with *Amos 'n' Andy*) and African American faces are tuned out (on the Hollywood screen), the gaps between sound and image, between racial signs and real bodies, between shadow and act, must continually be closed, and the screen image must repeatedly be reincarnated.

Conclusion

RED, WHITE, AND BLUE:
DIGITAL CINEMA, RACE, AND *AVATAR*

A MAN'S SHADOW, REFLECTED IN GLASS, moves toward the camera, obscured by dingy snowflakes floating in the air. We dissolve to a medium long shot of the man, but he is still merely a dark, shadowy figure walking down an alleyway in a hazy, bluish night scene. A few cues tell us we are in a Chinatown-like space—a vendor dumps a bucket of water on the street, a young Asian man with a Mohawk turns to look menacingly at the man as he passes. He walks up a flight of stairs and knocks on the door. Cut to the interior, where an old, stooped Chinese man looks through the peephole. The man wears traditional robes, wire-rimmed spectacles, and a black skullcap; he sports a long white goatee, speaks with an accent and is played by the instantly recognizable actor James Hong, whose career has been filled with Chinese stereotypes.[1] The stranger enters; we now see that he is a young man, but as he sits at the table, shadows from the blinds cut across his face so that he remains a mystery. He hands the old man a piece of paper and says, "Can you do it?" The old man looks surprised, almost frightened: "I've only heard about this in stories, legends really . . . the last man who wore this lived over a century ago." This cues a flashback, and you can almost see the slug line: "Interior—Saloon—Old West." Tinkling piano music plays in the background, and the scene features smoke and candlelight. A card game is in progress between a grizzled white man wearing a cowboy hat and a young man of Asian descent. The older man turns out to be Mr. King (Powers Boothe), owner of the establishment, while the young stranger (Daniel Henney) remains unnamed. When the stranger (as he's called in the credits) accuses his opponent of cheating (perhaps unwittingly recalling the story of Bret Harte's 1870 poem, "The Heathen Chinee"), a fight breaks out. Fists and chairs fly until the saloon owner puts a gun to the young man's head: "You ain't fast enough to dodge

a bullet, are you?" The young man answers, "I am," but the bar owner gives the order: "String 'im up." The men tie him up with rope and rip his shirt; as the saloon owner prepares to whip him, he stops. He and the other men stare at the stranger's back; we don't get to see what they see, as the film denies us the expected cut to the object of their gazes. "Cut him loose," the man suddenly urges. "Cut him loose now." We then cut back to the old man and the present day; he is cleaning his tools, having apparently just finished tattooing the young stranger. He explains that the man in the story had "some mark of greatness, a mythical power that no one had ever seen; but the world was unprepared, and the man simply vanished, never to be heard from again." He then looks at the young man and says, "Legend tells of a day when a descendant would . . ."; but then he laughs at himself and the "silly little story": "I never believe in that nonsense anyway." At this point, the stranger stands up, and the tattoo on his back comes briefly into focus before he puts his shirt back on. What we didn't see before, we glimpse now: a red dragon. The next shot offers a close-up of the stranger's face, fully visible for the first time: he and the mythical stranger in the flashback are one and the same. He smiles knowingly; cut to black.

This is the plot of a nine-minute short called *Tattoo*, produced in 2011 by the makers of the Red Epic camera as a promotional film to showcase what the new digital (5K) camera could do. Billed as the future of digital cinema, the Epic, like Red's earlier camera (the Red One) went beyond "HD" to promise "resolution that exceeds 35 mm motion picture film."[2] With early adopters of the Red camera including big-name directors like Steven Soderbergh and Peter Jackson, and more and more Hollywood films being shot on Red since 2008, the digital revolution (and the consequent "death of film") that has been heralded for so long seemed finally about to come to pass. Directors looking at the images from these cameras were having full-on conversion experiences, with Soderbergh, Jackson, and a host of cinematographers among the true believers. After Soderbergh shot *Che* (2008) on Red, a number of big budget Hollywood films followed suit, including, most notably, *The Social Network* (Columbia, David Fincher, 2010) and the 3D films *Pirates of the Caribbean: On Stranger Tides* (Disney, Rob Marshall, 2011) and *The Hobbit* (MGM, Peter Jackson, 2012). Soderbergh's *Contagion* (Warner Bros., 2011) was the first feature shot on Epic, with many films slated to follow. The company's website featured the following review from legendary cinematographer Vilmos Zsigmond, whose work includes *Close Encounters of the Third Kind* (1977), *McCabe and Mrs.*

Miller (1971), and *The Long Goodbye* (1973) to name a few: "After seeing *Tattoo* shot on the new EPIC camera at Red Studios Hollywood on a 40' screen, the only thing I could think was that this looked like it was shot on 65mm film or with an IMAX camera. There was no visible grain or noise with beautiful shadow and highlight detail . . . I was so impressed that I will be shooting my next feature on EPIC 2.40:1 widescreen." And this from John Schwartzman, director of photography on *The Amazing Spiderman* (Columbia Pictures, 2012): "This is the best footage I have ever seen from any camera. Ever."[3]

Reviews and paid endorsements blur here, as one wonders what deals the directors have made with the camera maker, but the point is clear from the company's marketing perspective. This is not just as good as film; it's better. For decades, the divide between video and film has been narrowing, and digital technologies have become a seamless part of the filmmaking process. In 2000, George Lucas announced that he would shoot the second of his *Star Wars* prequels with the Sony HDW-F900 camera—an HD camera capable of shooting at 24 frames per second. This made *Star Wars Episode II: Attack of the Clones* (2002) the first Hollywood feature shot entirely in a digital medium.[4] As more theaters were becoming equipped with digital projection, it seemed that the days of expensive, clunky film reels were numbered. And yet, like the many technological transitions in cinema history, the transition to an entirely digital process—that is, with digital formats replacing film in both production and exhibition—proved to be gradual, with stops and starts. On the production side, this had largely to do with the fact that filmmakers were not fully convinced. Detractors noted that high-definition video not only lacked the resolution of 35mm film, but it also failed to provide the flexibility that cinematographers and directors have come to expect: a wide range of control over depth of field, the ability to shoot at film speeds of up to 120 frames per second, the ability to handle low light, the ability to provide a rich quality of color, and so forth. Film still provided a much richer palette for filmmakers than HD and other digital formats. In other words, digital formats, even HD and 4K iterations, still ran the risk of looking "like video." When, shortly after the release of the Epic camera, Ted Schilowitz, "leader of the rebellion" (his actual title) for Red Digital Cinema, was asked about other company's cameras, he was quick to dismiss them by claiming the *cinema* for Red: he describes their cameras, and Epic in particular, as "the first true high resolution *digital cinema* cameras on the planet" and notes, dismissively, that other companies are producing "TV resolution cameras,

not movie resolution cameras."[5] The company's promotional strategies, including the mythology, secrecy, and industry speculation around these cameras and their development, very self-consciously position Red at the forefront of a new era in cinema. Certainly this extends to other companies producing DSLRs (digital single-lens reflex cameras, e.g., Canon and Sony), but Red has gone to great lengths to catch filmmakers' eyes and to involve them in their promotional strategies, which very much emphasize the definitively cinematic image—and the opening of a new frontier in motion pictures.

This is why *Tattoo*, which is, after all, just an ad for a new camera disguised as a short film, is telling nonetheless. When the people at Red wanted to promote their Red One camera, Peter Jackson himself offered to film the promotional short. These "ads" are made to impress filmmakers and cinematographers, and they must emphasize the flexibility of the cameras, the cinematic quality of the images, and how that can and will translate when projected on the big screen. The style of *Tattoo* is determined by the effort to show off what the camera can do in specific settings in which film has typically performed better than digital formats. Thus the film makes ample use of low light, shadows, and even candlelight in order to test the limits of the camera (or to prove the lack thereof). The film is filled with cinematic clichés, which here serve a purpose, effectively saying "anything film can do (and has done) this medium can do better." The film begins with a reference to no less than *Citizen Kane:* a reflection in glass with snowflakes suggesting the "Rosebud" snow globe. From there, the present-day scene looks like film noir, while the flashback takes us not only into the past but into another definitive film genre: the Western. And in a move that should by now come as no surprise, the film just happens to rely on another set of film clichés: a dark and mysterious Chinatown, the Oriental stereotype, and a mysterious racialized figure. Further, these racial and cinematic clichés come together in a mark on the body that becomes a symbol of power: the dragon tattoo. That the tattoo turns out to be a red dragon would seem just an expected part of the "Oriental" aura that the film exploits. But beyond that, it references the film's real subject: the power and potential of this new technology. At the industry trade shows where the film was shown and where the Epic camera was introduced, the people from Red made an announcement that was itself shrouded in mystery: they had begun work on their next generation sensor, called . . . "the red dragon." No details were given. The company spokesperson cited competition and industry espionage to explain

the secrecy, but reports from the NAB (the National Association of Broad-casters) noted that "there was no official announcement, just a mention that they are, in fact, working on the sensor."[6] So it seems more likely that the sensor was in the very early stages of development, and thus more of an idea than an actual thing.

Why was this a big deal? In digital cameras, the sensor is the sensitive medium—that is, it does what the 35mm film does in a film camera or what any sensitive medium (whether flexible film or a glass plate) would do in still photography. It processes picture information coming into the camera, determining how much information can be captured and thus the image resolution and sheer amount of material a filmmaker will have to work with. The mysterious new sensor would replace the existing sensor, the mystery at the heart of the Epic camera, already appropriately named the "Mysterium-X." This is the sensor that enables Epic to "exceed" the resolution of 35mm film. So what is this new sensor promising? The "Mysterium X" sensor was either *not* really capable of image quality equal to 35mm film, so they needed to improve it, or the new sensor was going where no camera had gone before, leaving 35mm film (and film as the standard) behind.[7] Either way, the technology is never complete, and constant upgrades are part of the allure. And in this case, the image is not just trying to reproduce "reality," but the way that reality has looked on film.

The end of *Tattoo* suggests both the continuity of digital cinema with the past and the birth of something new. When the stranger first shows him the picture of the tattoo, the old man says, "The last man who wore this lived over a century ago." While this serves as an entry point for a flash-back to the Old West, it also references the history of cinema, itself "over a century" old. Later, upon finishing the tattoo (and the story), the old man notes that "legend tells of a day when a descendant would . . ." and then trails off. The stranger with the red dragon tattoo is that descendant of the man with "a mythical power that no one had ever seen." The film wants to suggest that the "red dragon" sensor is a descendant of film, the "next generation." Motion picture cameras brought forth a "mythical power" that the world had never seen, and the "red dragon" sensor will do the same. By ending with the red dragon tattoo, the film heralds not just Red's next generation product but the next generation of filmmaking, a rebirth—or perhaps the second coming—of cinema as digital cinema. The company withholds information about its sensor in light of industry competition, but at the same time they do so to create an aura around the product. The sensor is the "soul" of the camera, if you will, and the rhetoric around it

must be equal parts technological and mystical. As Jim Jannard, the founder of Red put it, "Cameras are magic."[8] In this case, the product itself (the red dragon sensor) did not exist at the time of its "depiction" in *Tattoo*—it was an idea, perhaps still mythical "nonsense," that hadn't yet been materialized. This follows a pattern for the company. When they were still developing their first camera, they offered future customers the option of putting down a thousand-dollar deposit for the right to "stand in line" to be the first owners of this as-yet-non-existent camera; the marketing strategy worked, as "rumors swirled through Hollywood about some kind of mysterious supercamera in the works," while skeptics countered that the whole thing was an elaborate hoax. No such supercamera could be real, could it?[9]

In order to represent the red dragon sensor—to materialize their idea—the company turns to Oriental mysticism and a tattoo. A tattoo is permanent, and it is written on the body. In a very real way, the stranger in *Tattoo* embodies the apparatus, while retaining the sense of magic and mythology that suggests the new power is about something more than mere technology. In the brief shot that reveals the red dragon tattoo, we see the man's shoulder blade in medium close-up in the foreground; his shirt is half off, and the old man's face is visible (though out of focus) in the background. (Figure 30). We barely get a long enough look to recognize the tattoo, and it is partially hidden by the shadows from the blinds that stripe the stranger's skin. The composition and lighting add to the mystery surrounding the tattoo, but the shot also seems to offer another way to figure both the sensor's promise and the history of the medium (in this case, video). Between the stripes on the body and the plaid pattern of the shirt, the image seems to reference lines of resolution, the standard by which the video image

Figure 30. The "red dragon" tattoo in *Tattoo* (Red, 2011).

has historically been measured, with ever-increasing numbers promised by HD and now "5K" (indicating a resolution of five thousand pixels per inch). Here, the "lines" merge not only with the body but also with the more "filmic" measure of image quality: light and shadow. Thus the fusion of the image with the skin in the red dragon tattoo is redoubled by the fusion of "lines" with light. The sensor promises this fusion, and the tattoo represents the sensor as the elusive spirit fused with the (racialized) body. If we recall the Oriental figures discussed in earlier chapters, we can see how familiar patterns are replayed in *Tattoo*. Here we see both sides of the stereotypical coin: the ancient, stooped, unchanging "Chinaman" figure and the "Oriental" body aligned with magic and mobility. In the latter role, the stranger not only travels through time, but he is also "fast enough to dodge a bullet" (also a reference here, no doubt, to shooting speeds). Further, the racialized body becomes a site for inscribing the power of the apparatus. In *Tattoo*, the racialized figure stands in for the prowess of the apparatus and extends or supplements that power, referencing a magical or spiritual dimension and tying the apparatus to the body and its signs.

In this sense, *Tattoo* recalls the earliest motion pictures, in which the subjects chosen were often those that best displayed what the new technology could do. Indeed, the test films for earlier cameras and prototypes from Red very much resemble early actualities and the jokes and surprises of the cinema of attractions. These tests, typically only seconds long, feature some early film favorites: smoke effects and milk. One test of a camera using the Mysterium X sensor (shot by David Fincher) features Leonardo DiCaprio lighting a cigar in a darkened room. "Milk Girls," an early test shot with a prototype camera named "Frankie," features two young women in 1940s garb drinking milk from glass bottles (and one of them laughing as she wipes the milk that "accidentally" dribbles down her chin). "Milk Girls" obviously plays on titillation and eroticism (much like the "What Happened" genre of films from cinema's first decade) with male heterosexual technophile viewers in mind, while also showing off color (it has a "Technicolor" look) and contrast.[10] And in the age of the Internet and the technology fetishist gone mainstream, many people who are not necessarily "industry professionals" are willing and able to watch films like this. As we have seen, racialized and exoticized bodies played an important role in showing off and extending the powers of the apparatus from the very beginning. In this sense, *Tattoo* truly is the "descendant" of those films from "over a century ago," carrying on the questionable legacy of American

cinema. In addition to showing off the Epic camera's ability to shoot in low light and to provide a dynamic depth of field (the film makes use of rack focus in key moments, including the reveal of the tattoo), the film may also have found its subject in an effort to prove it could "deliver skin tones." In an interview on the "red centre" podcast (dedicated to "digital cinema" and "cutting edge imaging"), Shane Hurlbut, director of photography on *Terminator: Salvation* (Warner Bros., 2009), expressed his doubts about the then forthcoming cameras from Red. He predicted that "you [will] have a camera that still doesn't know how to deliver skin tones, and when it's all said and done, that's the heart of the film. You're identifying with these characters because of who they are and something that is real to your eye." He sums up what he wants from a camera: "skin tones and a picture that looks real."[11]

The mark on the body in *Tattoo* is both a racial signifier and a figure for the cinema, a combination we have seen before. Indeed, the shot of the red dragon tattoo recalls the brand in *The Cheat;* they are even located in the same place on the body (the shoulder). While the woman is on display in The *Cheat* and must reveal the mark on her body, here the exoticized and eroticized male body bears the sign. In *The Cheat,* the brand on the body was analogous to the eloquent shadows on the screen, binding the surface image to a deeper, essential (and racialized) meaning. In that film, the surface of the screen is linked to skin, and the screen boundary is linked to racial boundaries. Through violence and the threat of miscegenation, these boundaries are crossed, and the shadows on the screen give way to the bodies that burst through it, and to the blood (a signifier of race) that stains the surface. If Sessue Hayakawa's "race" supplemented (and came to signify) the power of the close-up in the film, the cinematic signifier itself seemed to be underwritten by the blood of the racialized other. In *Tattoo,* the future, mythical power of digital cinema claims a body and exploits "Oriental" mystery in order to meld the real and mythical. Though certainly less incendiary and influential than *The Cheat, Tattoo* offers another link in the chain that connects the cinema's ongoing negotiation of embodiment and immateriality to racialized bodies and the rhetoric of race difference. Like many films before it, especially in times of technological or aesthetic shifts, *Tattoo* exploits "race" in order to embody the apparatus; in so doing, it marks one more attempt to accommodate impossible contradictions—real and magical, body and spirit, motion and stasis, presence and absence—in order to (re)produce something like a purely cinematic "essence."

Avatar and the End(s) of Cinema

While many have predicted or declared the death of film (and of the cinema as we know it), simultaneous efforts to declare the birth of something new—and to characterize that "something"—have proved thornier. It is not so easy to define a beginning (or an end), it turns out, especially without the benefit of hindsight. This is made more difficult when the experience of the cinema (i.e., theatrical moviegoing) has not changed substantially enough with the rise of digital filmmaking to designate a definitive break with the past. In other words, while something like synchronized sound had a clear effect on the audience experience, audiences don't always know whether a movie was shot on 35mm film or a digital format, and unless something looks terribly wrong, they likely don't care. As Thomas Elsaesser puts it, despite the changes wrought by digital cinema, the audience "is still offered a social experience along with a consumerist fantasy."[12] For some, the increasing use of digital technologies in production suggested a significant moment for the stakes of "realism" and seemed to point to a fundamental change in the "ontology" of the film image—bringing back and re-organizing classic debates about "realism" and "formalism" in film. Others focused more on the increasing sites and modes for interacting with moving images and the sense that "media convergence" and the proliferation of screen culture have produced a more "participatory" and "immersive" mode of spectatorship and, perhaps, a shifting balance of power between producers and consumers.[13]

Despite the various examples of merger and boundary blurring of media, formats, and platforms (e.g., live action /animation, spectator/spectacle, film/video, television/cinema/Internet, phones/computers/cameras), a great deal is still invested in the discrete experience (and industrial infrastructure) associated with each venue and platform. That is to say, much still depends upon the specificity of the cinema, for audiences and producers alike. One model of spectatorship doesn't simply replace another; rather, the "power" and "control" of some viewing experiences exist in fluid relation with more "traditional" modes of spectatorship. As viewers have increasing opportunities to watch at home and to carry moving images in their pockets, cinema screens have taken on the big, bigger, biggest challenge, with attractions like IMAX and 3D promising sensual immersion and sensory overload. Mary Ann Doane sums up the economy of scale and the cultural logic of these "two extremes of screen size": "Miniaturized, the image it bears can now literally be held in the hand, sustaining the

illusion of its possession. Made gigantic in Imax theaters, it presents the spectator with a vision of impossible totality, of modern transcendence."[14] She also suggests that this manipulation of the enormous and the miniature has long been a key to the cinema's ideological operations; in this way the big screen / small screen experiences are crucially intertwined. The theatrical experience has once again taken center stage in the "digital era," in part precisely because of the increasingly fragmented nature of the market and of the viewing experience.

This effort to associate the theatrical experience with transcendence was crystallized in the marketing and reception of *Avatar* (Fox, James Cameron, 2009). In its review of the much-anticipated film, *Variety* cheered Cameron for "deliver[ing] again with a film of universal appeal that just about everyone who ever goes to the movies will need to see."[15] Those words would certainly be music to any studio head's ears, but they also speak to the increasing tendency, in the decades since the studio era, for films to target smaller and smaller demographics. A film of "universal appeal" is an old-fashioned thing, and one that not only fulfills producers' desires to bring that fragmented audience together, but that also holds out the fantasy of "totality" and "transcendence" for audiences. The efforts to redefine the cinematic experience with the props of 3D, increasingly spectacular special effects, and IMAX screens recalls the 1950s, when the advent of television spurred the cinema to bank on widescreen formats, Technicolor, and 3D in its first iteration. Our contemporary moment is one in which the spectacle of the moviegoing experience is touted above all, backed up by major shifts in technology and aesthetics, suggesting that the early twenty-first century marks not "the end of cinema" but rather "another of cinema's more profound transitions, equal to those that brought about the shift to feature-length filmmaking in the 1910s, the shift to recorded sound in the late 1920s and early 1930s, and the rise of Widescreen and color cinema in the 1950s."[16]

In this context, the release of *Avatar* remains a signature moment for "digital cinema" (and thus for cinema) both because of the digital animation technologies used in the film and because of the reinvention and resurgence of 3D as a viable and lucrative option for Hollywood producers. As a highly touted and self-conscious marker of another transitional moment for cinema, *Avatar* must be understood in the context of those earlier transitions and the repetitive gestures and patterns we have been tracing. The film is repeatedly positioned at the threshold of a new era, and while it is not technically a "first" in its technical achievements (i.e.,

digital creatures and 3D), the film marshals its digital effects and consolidates them in the rhetoric of a new experience for the spectator, one defined as quintessentially cinematic. The studio exploited the film's "groundbreaking" status in prerelease publicity while also trading on the big-budget reputation of James Cameron. The film's monumental box office success (estimated at $2.5 billion worldwide) provided the only kind of end that could justify the means (in this case, the number of years and technical innovations needed to make the film and the consequent $310 million budget).[17] Perhaps equally important, the release of the film succeeded in gaining the status of an "event," helped along by a great deal of prerelease teasers and promotion. Most prominent among these strategies was "Avatar Day," in which select audiences in theaters around the world watched a fifteen-minute, 3D clip of the film (for free) almost four months before its official release. Again and again, promotional materials, publicity, and reviews centered on the "fact" that after *Avatar,* movies and moviegoing would change forever. A number of trailers for the film began with the line spoken by Colonel Quaritch (Stephen Lang) in the film: "Anyone feel like makin' history?" Those trailers ended with a barrage of action-packed images intercut with bold text hurtling toward the viewer: "On December 18 . . . MOVIES . . . WILL NEVER . . . BE THE SAME."[18]

The filmmakers certainly saw themselves as working on a frontier, and there were many comparisons to other key moments in film history, especially the coming of sound and Technicolor. As Kenneth Turan of the *Los Angeles Times* put it, "Think of *Avatar* as the *Jazz Singer* of 3-D filmmaking."[19] Indeed, this glib observation is true in a way that Turan didn't intend—not only because of the film's questionable racial politics and its plot (in which a white man takes on the disguise of a blue-skinned other in order to achieve personal transformation), but because of its continuity with the many transitional moments that have come before, marked by the tendency to exploit "race" in order to show off and shore up the apparatus. The latter similarity—the behind-the-scenes rhetorical links between cinematic specificity and racialized essentialism—are much harder to see than the racially charged plotlines, but the two strands are crucially intertwined. Turan does note that like *The Jazz Singer, Avatar* allows viewers to feel as if they are seeing film anew, as if for the first time: "'Avatar' is not the first of the new generation of 3D films, just as 'Jazz Singer' was not the first time people had spoken on screen. But like the Al Jolson vehicle, it's the one that's going to energize audiences about the full potential of this medium." Turan adds that the film allows audiences to "understand

filmmaking in three dimensions for the first time." If we recall the last chapter, *The Jazz Singer* also enabled people to feel as if they were seeing blackface for the first time. In these films, the medium and the spectator are born-again, and we must recognize the role race plays (and replays) in this sort of religious experience.

For his part, Cameron has fashioned himself a sort of filmmaker–explorer, with his offscreen exploits including expeditions to the wreck of the (real) Titanic, from which he made *Ghosts of the Abyss* (Disney, 2001), shot on 3D HD and released by Sony for Imax theaters.[20] In that case, the real-life adventure was also a cinematic adventure, as Cameron experimented with 3D equipment, special "lipstick cameras" planted in submersibles, and a lighting platform capable of lighting the ship from above, such that they were able to get images of parts of the ship that had never been recorded before. Cameron's sympathies with scientists and explorers can be seen in *Avatar,* where botanists and other scientists are the "good guys." This is not lost on at least one reviewer. Biologist Carol Kaesuk Yoon calls the film "a biologist's dream" and notes that the film "recreate[s] what is the heart of biology: the naked, heart-stopping wonder of really seeing the living world."[21] This is a scientific version of Siegfried Kracauer's notion that film will bring about "the redemption of physical reality."[22] Significantly, though, given *Avatar*'s subject matter, Yoon identifies the pleasures of the film with those of taxonomy. She suggests that the film works "to bring our inner taxonomist back to life, to get us to really see." The review's equation of "really seeing" with the urge to categorize and name seems to point unwittingly to the (visually) colonizing model of desire and knowledge at the heart of a film posing as environmentally progressive and anti-exploitation. Cameron typically talks about *Avatar* in terms of an adventure into the unknown, the opening of a new frontier in cinema—the irony of the cinema–explorer making an anti-imperialist fable perhaps not entirely lost on him. In the making of the documentary *Capturing Avatar,* he at least notes the irony of the "high-tech treatment of a low-tech subject,"[23] the "low-tech" subject(s) being the Na'vi, an idealized indigenous civilization in harmony with nature, and the notion that "we" have lost that connection due to our technology-driven, exploitative way of life.

This is just one of the many ironies one could ascribe to *Avatar,* but for our purposes, I want to focus on the way the film replays and recasts the gestures we have seen throughout the cinema's early history: the turn to

racialized bodies and the rhetoric of race difference to prop up or "rein-troduce" the cinema, especially in times of transition; the effort to authen-ticate the image through appeals to a racialized essentialism; the use of racial boundaries to figure cinematic boundaries; and the exploitation of race to "embody" the apparatus and to suggest a communal, transforma-tional model of ideal spectatorship. Because of its heavy dependence on animation and the centrality of the digital creatures, the film must parry the threats to realism and the potential loss of the audience's faith in the cin-ematic illusion that hover over its achievements. At multiple levels, the film and the extra-filmic materials exploit "race" in order to embody the apparatus, to re-invent cinema, and to garner faith in the digital image.

The film's plot is much simpler than its technology: Military mercenar-ies working for "the company" mine an alien planet called Pandora, rich in a mineral called "unobtainium." The indigenous people (the Na'vi) are in the way. A group of scientists attempt to befriend the people and learn about them by using "avatars," replicas of Na'vi bodies with which humans can mentally merge. They sleep in a pod and "operate" a Na'vi body by virtue of which they can roam the planet and "blend in." As the movie opens, a wheelchair-bound Marine named Jake (Sam Worthington) joins the crew. When he inhabits his avatar with the intention of spying for the military, he ends up falling in love with Neytiri (Zoe Saldana), a Na'vi female, and ends up taking their side, leading the fight against the invaders. After an epic battle (which the Na'vi win thanks to their hybrid leader and their connection with the plant and animal life on the planet), Jake nearly dies, but Neytiri saves him. In a ritual ceremony at the end, Jake is permanently "transferred" from his human body to his avatar body, and he remains on Pandora, while the rest of the human invaders (with the exception of a few "good guy" scientists) are expelled.

Certainly the film's subject matter and thematic patterns are familiar: the white man goes into the jungle and "goes native," falling in love with a princess; the invaders are militaristic, hyper-technologized, and discon-nected from nature, while the indigenous beings are idealized innocents in the "noble savage" tradition. The film humanizes the aliens (even though they look like big cats) while depicting the "overcivilized" humans as sav-age in their greed, violence, and disrespect toward other living creatures and the natural environment. Many reviewers noted the predictability of the film's plot and themes, as "play[ing] too simplistically into stereotyp-ical evil-white-empire/virtuous-native clichés."[24] Despite various iterations

of this critique, the film was generally well received, primarily because of its dazzling and convincing visual effects. As Manhola Dargis put it in the *New York Times* review, the "movie's truer meaning is in the audacity of its filmmaking."[25] Like many others, she was dazzled by the opportunity to declare a new era. Dargis notes that the movie is "a trippy joy ride about the end of life—our moviegoing life included—as we know it," and yet, at the same time, she relishes the film for the way it "return[s] us to the lost world of our first cinematic experiences, to that magical moment when movies really were bigger than life (instead of iPhone size)." Dargis's comments suggest the way the film activates the nostalgia for the new that we discussed in chapter 2, everywhere and always associated with children, rubes, and alien others who are still "fooled" by the cinema. The reference to the iPhone also demonstrates the way the gigantic spectacle compensates for the many ways in which the pictures have gotten small (to paraphrase Norma Desmond in *Sunset Boulevard*)—in part because of the ways in which the proliferation of screens and the "culture of distraction" potentially diminish the cinema's power.[26] While *Avatar*'s storyline is certainly about racial boundary crossing (Jake's crossover, including his relationship with Neytiri, is described in the film as a "betrayal of his race"), I am interested here in the way racialized essentialism informs the film's style, the rhetoric around its "groundbreaking" technology (especially "performance capture"), and the nature of its reflexivity.

Dargis's recollection of "the lost world of our first cinematic experiences" calls to mind the work of Jean Louis Baudry, foundational to the "apparatus theory" of the 1960s and 1970s. Baudry insisted that what the dominant cinema reproduced was not "the real world" or the content of a fantasy, but rather a particular condition of the subject: a regressed state in which the subject cannot distinguish between reality and fantasy, a womb-like condition in which all its needs are met. In his influential essay "The Apparatus: Metapsychological Approaches to the Impression of Reality in the Cinema," Baudry compares the movie-watching subject to the dreamer, but he is not interested in what the subject dreams about (or watches on screen): "It is evident the cinema is not dream but it reproduces an impression of reality, it unlocks, releases a cinema effect which is comparable to the impression of reality caused by dream. The entire cinematographic apparatus is activated in order to provoke this simulation: it is indeed a simulation of a condition of a subject, a position of the subject, a subject and not reality."[27] In this schema, the cinema is just one more machine that allows the unconscious to assert itself, to "get itself represented by a

subject who is still unaware of the fact that he is representing to himself the very scene of the unconscious where he is" (317). Regardless of the many critiques of apparatus theory since then, I recall Baudry here in order to point out both the old-fashioned portrait of spectatorship painted by *Avatar* and the recurring references (by critics) to the film's ability to return viewers to a childlike state.

In a film that announces (with its title) its "hipness" to new viewing practices—especially those associated with the 3D role-playing environments of gaming—the film's dominant metaphor for participant observation is still the dream. The movie opens with aerial footage and Jake's voice-over: "When I was lying there in the VA hospital, a big hole blown through the middle of my life, I started having these dreams of flying. I was free. Sooner or later, though, you always have to wake up." We cut to Jake's eye, opening in extreme close-up. The blue hue of the shot tints his skin, foreshadowing his later transformation into a blue Na'vi body. He is in his cryogenic pod, having just finished his journey to Pandora. And so the film opens not just with the cliché of a dream, but with most clichéd of dreams: the fantasy of flying (not to mention the cliché of waking up from "cryo" in a sci-fi film). He begins the film asleep and spends much of it in an unconscious state. Later, Jake and the other humans will have to "sleep," lose consciousness, in a pod in order to connect with and operate their avatars, making the Pandora scenes equivalent to long dream sequences. When human Jake is conscious, his avatar is unconscious, and vice versa. The Na'vi call the human avatars "dreamwalkers"; indeed, in his real life, Jake can't walk, so his avatar life is much like his dream of flying. In the end, he remains in his avatar body, and so his dream becomes his reality, and we end as we began, with Jake opening his (now big yellow) eyes.[28]

But if Jake represents the film viewer as dreamer, the difference between him and Baudry's dreamer (or the prisoners in Plato's Cave) would seem to be the emphasis on embodiment.[29] Here, Jake gets to participate; he loses one body but gains another ("better") one. This again would seem to reflect not just the shift to a body-centered action genre, but also to new modes of interacting with images. With touchpad devices on which we scroll and pinch and video game systems operated by bodily movement, the model of the "disembodied eye" seems less relevant to contemporary spectatorship (at least in theory). But in *Avatar*, how much difference does this sense of embodiment make? A fantasy is still a fantasy, and not knowing the difference between reality and fantasy is still a goal that, in real life, would mean one is either dreaming or insane. As he falls in love

with Neytiri and becomes more seduced by Na'vi culture, he wakes up in his pod and says (in voice-over), "Everything is backwards now; like out there is real, in here is the dream." In the end, though, he leaves his human body behind and takes up permanent residence in his Na'vi body. In essence, the film is less about "new" viewing practices than it is about accessing the not-so-new ideal of participant observation. The film intertwines two versions of participant–spectatorship: one associated with gaming, and one associated with anthropology. As discussed later, the relation between the two allows the film to send a mixed message that enables spectators to (fittingly enough) have it both ways: critiquing the treatment of the Na'vi while also encouraging participant–spectators to wear the skin of the native Other as a thrill ride. But if the film sends a mixed message about participant spectatorship, the relationship between the humans and their avatars references more than that. In fact, in this case, focusing too hard on debates about this or that model of spectatorship simply enmeshes us in the film's own rhetorical strategies, when in fact the film's reflexive energy and mythologizing, celebratory power lie elsewhere. The reflexivity of the film works in another direction (and dimension) entirely because the human/avatar relation directly references the situation of the actors in the film and the "performance capture" process itself. As a result, audiences are positioned between two discourses of realism, both dependent upon racialized bodies, real and virtual.

Capturing "Race": Performing Bodies and Digital Images

Every discussion of *Avatar* begins with the origin story, in which James Cameron came up with the idea for the script in 1995, but "the technology didn't exist" to make the movie he wanted to make. By most accounts, the performance capture process was one of the most important pieces of that technological puzzle. Cameron prefers the term "performance capture" to differentiate the process from motion capture, which previously included bodily movement but still could not handle facial expressions very well. Additionally, earlier methods of motion capture were "blind"; that is, the director could not see the performer and the environment together in real time. A host of innovations made performance capture feasible on the scale needed for *Avatar,* including the development of a device (a "virtual camera" that was really just a monitor) that allowed Cameron to see the actors in the virtual environment. This gave him a better sense of how to direct and position the actors, thus providing digital artists with

more useable material to work with in terms of re-creating these movements in a way that would work with the digital world they would inhabit in each scene. In addition to advancements in capturing bodily motion, capturing facial expressions became a crucial part of "performance capture." But the face, as previously discussed, is not like the body—and the cinema, with its deep investment in the close-up, must insist upon the difference. Motion capture for the face is much more complex, precisely because of the "minute" and subtle nature of its movements (which we don't typically understand as "movement" but as "expression"). There are many scenes in the film in which everything on screen is computer generated. And yet, "live action" rules apply—that is, not only must the digital figures and landscapes meld seamlessly with live action elements, but the film also has to avoid seeming like a "cartoon." In this sense, the rhetoric of performance capture is as important as the technology itself in terms of the desire to differentiate *Avatar* from, say, a Pixar film, to define it as "live action," even though it is largely an animated feature. Performance capture is meant to solve multiple problems, chief among them the audience's ability to believe in and identify with the digital creatures. This depends not merely on emotive faces, but on a sense of these bodies' material reality and their humanlike (but not strictly human) quality.

The creation of Gollum for Peter Jackson's *Lord of the Rings: The Two Towers* (2003)—using motion capture techniques and the performance of Andy Serkis as a reference—was seen as a major advancement in computer-generated (CG) character work.[30] Taking significantly more than was given him, Serkis's "spirited portrayal had a significant influence on the creature's look, behavior, and personality."[31] Serkis and Gollum changed the nature of CG characters and raised the profile of the performer in the digital animation process. Previously, reactions to entirely digital (and human-ish) characters had been mixed. In superhero movies like *Spider-man* (Columbia, Sam Raimi, 2002) and *Hulk* (Universal, Ang Lee, 2003), for example, moments when "entirely virtual" bodies replaced the live actor made impossible stunts possible but drew pans for their cartoonish, unreal qualities—for the lack of connection between the live action hero and his digital counterpart, between the digital body and the "real" world of the movie. Summarizing reactions to these films' digital bodies and their "unstable and inconsistent physical dynamics," Lisa Purse notes that "in order for processes of engagement and identification to work, virtual heroes' bodies must convincingly convey their (fictional) materiality—and their physical limits—to the spectator."[32] Even superheroes must have human-scale

limitations, it seems; the freedom and possibility associated with CG characters must be grounded in limitation and impossibility in order to seem "real" to the extent that we not only believe but also remain identified with the human character/performer (in the case of Spiderman, Peter Parker/Toby Maguire) even through the digital substitutions.

If digital bodies need human limitations, one of the extreme limits for CG characters, so far, has been the human itself. Referencing the so-called uncanny valley associated with CG characters, Cameron notes that in creating the Na'vi creatures, the filmmakers and effects artists had "to find ways to push away from human" to avoid the "dead eye effect" and the "disconnect we sometimes have" with CG characters. The "uncanniness" describes an effect whereby, as the CG figure looks more and more human, we sympathize/identify more until, at a certain point, the similarity becomes uncanny—"life-like" rather than alive.[33] At the same time, the characters had to be "attractive" to the humans in the film (and the humans in the audience), lest the love scenes become comic or monstrous. As effects supervisor John Rosengrant put it, "Finding the right look for Neytiri was especially critical because if she didn't work, if you weren't attracted to her, the whole story wouldn't work."[34] Indeed, the success of these creatures can be registered in the number of critics who called them "sexy" in reviews. For all these reasons, Cameron notes, "just a blue-skinned human" wouldn't work.[35]

Driven by these aesthetic concerns and technological parameters, a "capture" system was used for the actors' faces as well as their bodies. But despite the technological leaps made, the truth is that only a fragment of the final character composition comes from motion and performance capture. For the rest, the effects artists and animators rely on reference cameras, photographs, and sculptures made from life casts of the actors' faces. Ultimately, the animators are digitally painting and sculpting these 3D models, using the actors' bodies and their movement as a reference; that is, while the actors' physical movements and facial expressions "drive" the digital characters' movements and expressions to some extent, the rest is simple resemblance. The idea was to up the percentage of movements that were actually tied to the performance capture. Earlier in the decade, animating Gollum's face posed a challenge. Serkis's captured bodily movements controlled Gollum's "only 20% of the time,"[36] and the face was a different matter entirely. They used Serkis's face as a reference, but his expressions did not "drive" Gollum's. In animating facial expression, they chose a "sculptural approach, where you sculpt every possible combination

of muscle shapes in a computer, and then an animator selects those and animates between them."[37] In researching facial expressions, they turned to no less than the late nineteenth-century photographs from the Salpetrière, in which the expressions were artificially created ("driven" by electrodes) in order to simulate real human expression—except they were using real humans, Charcot's "hysterics" and other patients, not computer-generated models.[38]

The performance-capture techniques in *Avatar* improved significantly on this process. To capture facial performances, the actors wore tiny video cameras, about the size of lipstick containers, in harnesses around their necks, so that the "lipstick cameras" were held in front of their faces. By Cameron's calculations (and depending upon which source you read) 85–90 percent of what you see is the "actor's performance," and keyframe animation is characterized as "maybe 10 percent," or a kind of final booster. Walking a fine line between giving his actors the same sort of credit they would get for live action performances and acknowledging the work of the animators, Cameron says, "[The animators] gave us 100% of what Zoe [Saldana] did, with a turbocharger on top of that."[39] He typically points to the catlike ears and tails when elaborating on the "turbocharge"—thus being careful to praise the animators for elements that could not have come from the actors. These animal features, according to special effects supervisor Nolan Murtha, "greatly enhance the emotive quality of the characters."[40] Or as those working closely with the animators are quick to add, "It is that last ten percent that makes it real."[41] But all this parsing of percentages elides the work that is being done between the actors' performances and the corresponding digital characters: work that includes the creation and programming of "facial rigs" (3D models that can translate and extrapolate from the captured data) as well as the many layers of digital sculpting and painting based on or *inspired by* the performances. In other words, it is not as if 90 percent of the characters' movements and expressions were driven by the actors' movements and expressions; rather, it's a combination of those "direct" relations and the extrapolated and inspirational ones. More importantly, though, when the filmmakers proffer these numbers, they do so with various goals in mind: they hope to differentiate this "live action" film from animated features, but they also very much want to distinguish this film (and the technology used on it) from all the effects-heavy films that have come before. At the same time, they want to give the audience a human interface, if you will—the familiar touchstone of the actor to function as the intermediary who connects the

fantasy to reality. In a sense, the human actors are to the audience as the avatars are to the Na'vi: just as humans take Na'vi form so that the Na'vi will become comfortable with them, will "trust them," the assurance that there were real humans inside the Na'vi bodies enables audiences to be comfortable, to "trust" or "believe in" the digital characters. This is perhaps one reason why Cameron felt so strongly about emphasizing the actors' importance to his film and why the rhetoric of performance capture is equally if not more important than the actual captured movements to selling these digital characters and supplementing their realism. Cameron was aware, no doubt, of the significant role the actors would play, not just in providing real bodies in production, but in helping to sell the film's technical achievements and defining their success for audiences.

Cameron was vociferous in championing his actors. He complained that they should be accorded the same respect (and Oscar nods) as live-action actors, rather than being treated as if they had merely done "voice work." Some even suggested that his rants on this subject hurt his Oscar chances (*Avatar* lost Best Picture to Kathryn Bigelow's *The Hurt Locker*); while others suggested that actors, who make up a large percentage of Academy voters, were concerned about Cameron's role in making them potentially obsolete.[42] This latter point may have something to do with Cameron's theatrics—that is, his defense of his actors can be seen as an overcompensation for (and defense against) the notion that he is a mad cinema scientist trying to body-snatch them and deny them work. Cameron and the publicity for *Avatar* emphasized the rigorous physical requirements of the process; this was a more extreme version of the typical publicity around actors doing their own stunts in action films, which is of course meant to deflect audiences' attention away from (or make up for) those moments when the actor's body has been replaced on screen by a stunt double. It also reflects the way the physical demands of the production process compensate for the potential loss of realism that accompanies effects-heavy spectacles (in effect using the authenticity of bodily labor to prop up the realist illusion). As shown in chapter 2, however, the rhetoric of danger, physical labor, and bodily harm faced by actors has been part of the cinema's rhetoric of realism since the silent era; in the teens, as "quieter" acting styles took hold and demands for realism grew, the actors' physical exploits and the real world collisions and casualties of the production process became a regular part of publicity and fan culture. But Cameron's job in selling the believability of his fantasy epic and his digital creatures seems to have been doubly focused. If it was, as

usual, about convincing the audience, it was also about "making it real for the actors."[43]

Discussions of the actors' relationships with their digital characters sound very much like the human characters' relationships with their avatars in the film, and the process of becoming an avatar in the film certainly functions reflexively as a metaphor for what the performers are doing. Essentially, the actors playing Na'vi roles performed the entire film as if in front of a camera (although the process is more like stage acting, since it doesn't require the stops and starts necessitated by lighting and camera setups). They wore motion capture helmets and suits; they rode models meant to represent flying dragon-like creatures ("banshees"), and so on. They went through all the usual physical training paces a "live action" performer would for an action film (learning to shoot a bow, ride horses, dance, etc.). And if that weren't enough labor to redeem them, they also had to learn the Na'vi language, written especially for the film by a linguist. Cameron even brought the cast to Kauai so they could experience a real jungle setting. Because of this meticulous attention to the performances, Cameron boasts, "the actors were convinced that what they did on the day that they did a scene was definitive; that that's what their CG character would be seen doing."[44] The actors certainly made an effort to be both convincing and convinced in publicity and in DVD extras and other extra-filmic materials. In *Capturing Avatar,* Zoe Saldana relishes the "sexiness" of "her" CG body; Wes Studi (who plays Neytiri's father and Na'vi chief Eytukan) notes that the performance capture technique "kind of gives us wings"; and Sam Worthington does his part in making the case: "That's my performance; it's my interpretation. Even though I'm nine feet tall and blue, it's got my personality . . . it's got my soul." Jake's soul is transferred to his avatar body at the end of the film, and Worthington's comments call on that moment, echoing it, while also seeming to reinforce it. The "fact" that the soul or essence of the actor is really *in* the digital character links him to his role, and believing in that bond links Jake's/Sam's transformation to a transformational viewing experience for the audience.

At the end of the making-of-the-film documentary, Cameron declares that the "most important goal" was "to be able to capture and preserve the actors' performances in their CG characters." This adds a kind of ritual element to performance capture that aligns it perfectly with the plot and themes of the film itself. Producer Jon Landau elaborates: "Our goal in using performance capture was not to replace the actor with our computer animated character, but to *preserve* the actor—because what a great

actor does and what a great animator does are antithetical to each other."[45] Again, we see the strict line drawn between the actor's performance and the animator's toolbox. It gets fairly mystical, however, as animation supervisor Richard Baneham discusses a climactic scene as it was performed by the actors in their mo-cap gear: "Magic had happened, and we had to try to do our damnedest not to lose any of that magic, any of that emotional content."[46] In Bazin's famous discussion of the "ontology of the photographic image" (which also applied, for him, to the cinematic image as it was photographically based), he attributes the motivation for artistic reproductions of reality to a "mummy complex."[47] Photography "embalms time" (14), and for Bazin, because of the indexical relation of the photograph to its referent, the photographic image "shares, by virtue of its very process of becoming, the being of the model of which it is the reproduction; it *is* the model" (14). There has been a renewed interest, of late, in the index, in part because questions of realism and the "ontology" of the image have returned with a vengeance in the digital era. Bazin's realism is of a magical sort, however, with the index lending a mystical element to the photograph that goes beyond the merely evidentiary. The "performance capture" process is nothing like the photographic process, it would seem. Indeed, the actors are not even performing for a camera (other than the "reference cameras" that provide footage that the animators use for guidance). Critics have been quick to point out that "digital imaging operates according to a different ontology"[48] than photography. Lev Manovich calls traditional cinema "the art of the index," and while he acknowledges that Hollywood cinema's realist illusion is produced by multiple manipulations and representational strategies, he notes that mainstream cinema "pretends to be a simple recording of an already existing reality, both to the viewer and to itself."[49] In truth, the animator's relationship with his or her subject is more akin to the painter's than the photographer's. That is, the person or object in question does not have to be there in the flesh for a 3D digital model of them to be made. And so what you have, in the digital image, is not evidence or the "embalming of time," but rather resemblance, as in a painting (and Bazin defines photography's "ontology" by opposing it to painting). The pervasiveness of digital imaging in contemporary films has led some to extreme "ontological" diagnoses. Manovich, for his part, declares that the cinema "is no longer an indexical media technology but, rather, a subgenre of painting" (295).

Nonetheless, "embalming" is precisely what Cameron says he is after when he attempts to "preserve" the actors' performances in the digital

characters. The motion capture process is unlike the filming of live action, but motion capture does convert actual bodily movements into information. As Tom Gunning reminds us, indexicality should not be confused with iconicity—that is, a sign can be "indexical" without bearing or producing any resemblance to its referent (e.g., a weathervane, a thermometer); yet when the two come together (as in a fingerprint, say), the effect is particularly strong, not just in terms of evidence or "truth value" but in terms of our fascination with the image.[50] In this sense, there is both an overestimation of the importance of the index (to the photograph's power) and too great a rush to declare its irrelevance in the digital age. The effort to incorporate (and publicize) more "capture" into the production process is an effort to *reconnect* the digital image with "real-world" referents, even though the alien world and its creatures do not strictly have real-world referents. This is particularly difficult because the goal is not to make a digital likeness of the actors—indeed, they needed to avoid that because of the unattractiveness (or "uncanniness") of digital humans. The image must bear some kind of resemblance, but more importantly, to that resemblance something "more" is added by the capture process and by the rhetoric of presence and identity around it. It is very much like saying that the "spirit" or "essence" of the actor's performance is captured and preserved. In this sense, that "something extra" is something "like" the indexical relation of photography that Bazin sketches, in which the reproduction takes on the very "being" of the model. The problem lies in linking the "ontology" of cinema too strictly to its "process of becoming," to the nature of the technology. Indeed, efforts to rigidly define the specificity or "ontology" of the medium tend to get caught up in precisely the mystifications that the cinema offers in its own anxious but celebratory self-portraits. Too much credit is given to the immanence of the technology and not enough to the social discourses that define its use and the audience's perception of it. Gunning has suggested that the desire to see the digital as "post-photographic" is itself a kind of mystification.

Bazin's account is, in fact, something more than "ontological." Despite his repeated use of the terms "ontology" and "objective" (to mean the "impassiveness" of the camera and the weaker role of the photographer as compared with the painter), Bazin really speaks more to the subjective and phenomenological. That is, he speaks to how we, the viewers, understand the photographic image—to "the irrational power of the photograph to bear away our faith."[51] *Our* faith in the image is precisely what is at stake here. And since, with digital characters like the Na'vi, we don't have

a replica of the actors, the "resemblance" must be produced, suggested to us by a series of props: the rhetoric of physicality, race, and authenticity, as well as the extra-filmic materials (e.g. DVD extras, websites, wikis) themselves. Although earlier theorists of the changing media landscape suggested that these extra-filmic materials might weaken the cinematic illusion, they are produced and disseminated in the service of that illusion, taking full advantage of the "cinema fetishist" that Metz describes and that was elaborated upon in the last chapter. As a result, even though the actors' movements only "drive" a portion of the final animated figure, the actors believe, and their belief "drives" the audience's.

Throughout cinema's early years and beyond, the sense of transformation associated with the apparatus has been produced through a dialectic between performing body and performing image, and between the rhetoric of freedom and limitation. And as discussed, these oppositions are often mediated by race. Throughout the discussion of the production process on *Avatar*, there is a constant push and pull between freedom and limitation. This is reflected in critical takes on digital imaging as well, as those that aim to get at the specific attributes of digital imaging (beyond its potential assault on "truth") point to the greater range of possibility and "a flexibility that frees it from the indexicality of photography's relationship with its referent."[52] Yet, the very thing that gives the actors "wings," that allows them to defy their physical limits, also grounds the CG characters. Cameron and his actors describe digital characterization as augmenting the actor's toolbox, giving them limitless possibilities, as opposed to replacing them. One of those possibilities is the chance to play characters who don't look like them: age, body type, skin color, planet of origin—none of these are limiting factors for the actor, in theory. Sigourney Weaver notes that she can now play "any age" (and indeed her avatar in the film is based on a much younger version of the actress). This is a knowing comment since older women do not need digital thespians in order to be "replaced" in Hollywood. Performance capture frees the actor up to do (and be) anything, while the very contours of their bodies define real and imaginary limits for the digital images, granting them a feeling of materiality and weight.

In the casting of the film, we can see an extension of this play between freedom and boundaries, digital and physical, particularly in terms of race and performance. Jake and the other humans who inhabit avatars are hybrids, and their avatars bear a noticeable facial resemblance to their human counterparts (and thus the actors). The script makes a winking

reference to this fact—and the impact it might have on the audience—when Jake first sees Dr. Grace Augustine (Sigourney Weaver) as her avatar-self: "Grace?" he asks of the younger, more lithe, but still very Grace-like creature, to which she replies, "Who were you expecting, numb nuts?" Indeed, whom (or what) were we expecting, other than Sigourney Weaver? The star factor figures in here, since the audience "knows" what Sigourney Weaver should look like and thus the demand for resemblance would be greater. Weaver's avatar looks the most like her, it turns out, because she is missing a prominent Na'vi feature: the "broad, lion-like nose." While the Na'vi are typically described as attractive, when it comes to turning Weaver into a Na'vi, things shift. Cameron says the Na'vi nose "is like a brick in the middle of the face," and Sigourney Weaver, with her "narrow, patrician" nose, would simply cease to be Sigourney Weaver if she had the Na'vi nose.[53] So they just made her a different one. Apparently everyone else's face could tolerate it. Her avatar's youth is accounted for in the story, in which it is supposed to have been made eighteen years earlier. This was convenient, as it meant that the younger Weaver of Cameron's *Aliens* (20th Century Fox, 1986) served as the model for animators (again revealing the minimal interplay between actual capture data and final resemblance).

The "convincing" resemblance is also largely due, I would argue, to the fact that we see the human characters in both their human and avatar forms in the film, and so a kind of afterimage effect takes place, as our minds map the two versions of these characters onto one another. Indeed, because we see both the human and avatar versions of these actors, resemblance was more of an explicit goal for their characters. The actors playing Na'vi, however, never appear in a human body in the film, and thus audiences never "see" the live actor behind the characters. There is thus less need for resemblance, and the Na'vi, in fact, do not really look like the corresponding actors. While acknowledging that the viewers "never have that reference point," the filmmakers insist that the characters do end up resembling the actors: "[I]f you know CCH Pounder, you recognize her as the matriarch. You recognize Zoe Saldana. You can definitely see them in those characters," says producer Jon Landau. But that sort of recognition is largely retroactive, more suggestion than likeness, and heavily dependent upon extra-filmic materials. The featured Na'vi characters—Neytiri, Mo'at (Neytiri's mother), Eytukan (Neytiri's father), and Tsu'tey (a young warrior who is Jake's chief rival)—are all played by actors of color. Saldana, CCH Pounder (Mo'at), and Laz Alonso (Tsu'tey) are African American, while Wes Studi is native Cherokee.[54] Given that the characters in question are

blue-skinned extra-terrestrial creatures, the race/ethnicity of the actors playing them shouldn't matter, should it? We know that race has often factored into the casting of performers to voice animated characters. This is in part a holdover from essentialist understandings of (and expectations about) the "black voice" discussed in the last chapter. In the case of *Avatar*, the choices are telling. The Na'vi are envisioned by Cameron and visualized by the effects team as "indigenous" in the broadest sense. That is, their tribal culture was influenced by (and bears traces of) indigenous peoples from the Americas, Africa, and the South Pacific. Cameron's first ideas about how the Na'vi language should sound came from his understanding of "Polynesian languages"; the landscape of Pandora was heavily influenced by the Venezuelan rainforest and by areas of China. So, in a sense, the combination of sci-fi setting and animation grant a kind of racial and geographic license, that, at best, allows the Na'vi to symbolize the struggles of indigenous people generally throughout history and across the globe.

But that same "racial license" leads to a more predictable sort of essentialism and limitation in terms of casting. If authenticity were the goal, one might expect Cameron to choose indigenous actors—after all, the fact that they would never be seen on screen gave the director the freedom to cast unknowns if he so chose. No doubt this was part of the motivation for casting Wes Studi. Perhaps Cameron was doing his best to avoid a one-to-one correspondence. But why is every other performer African American? Was Cameron imagining how the actors would look, standing next to the posters, promoting the film? Would they not only need to bear some resemblance to their corresponding CG creatures, but also to line up with some idea audiences might have of how they should look? Were they chosen for the quality of their voices, for their body types? Although photographs and life casts of the actors' faces guided animators, the elongation of the bodies and exaggerated facial features (not to mention eyes, ears and tails modeled on big cats) gave the Na'vi a defined racial identity and a family resemblance among the tribe; thus the final look of the characters diverged quite drastically from the actors who inspired them. They are about as recognizable as the characters on the various *Star Trek* series who wear facial prosthetics.[55] So not much about the actors' physical appearance (much less a sense of their race or ethnicity) would come through in the final product. Or would it?

Despite Cameron's protestations, the actors' voices are still the most important element that they bring to these characters. No doubt some of the essentialist notions about the "black voice" that we saw in the last

chapter influenced the casting. These beliefs about African American per-
formers' voices have major casting consequences—and as late as 2009 there
was evidence of continuing bias that had legal consequences in France.
The French film industry was found guilty of racial discrimination for its
practice of excluding black performers from dubbing white voices in the
translation of English language films. France's Higher Authority for the
Fight Against Discrimination and for Equality recognized the double stan-
dard in the industry, whereby white actors' voices were deemed "univer-
sal" and thus freely dubbed nonwhite actors' voices, but black actors were
limited. As one actress put it, "Directors in the dubbing world believe that
black people have black voices."[56] As discussed in the last chapter, the dis-
courses of authenticity and naturalness surrounding African American
performers linked the synchronicity of racialized bodies and the voices that
emanated from them to fantasies of synchronization (of body and spirit,
image and meaning) that bolstered the film image. The casting director
for *Avatar* notes that she thought Zoe Saldana was perfect for the role of
Neytiri because of her "fierceness" and her "incredible physicality." This
despite the fact that stunt performers handled the mo-cap sessions for
the more strenuous action sequences. And so Neytiri's "lithe yet powerful
athleticism"[57] is a product of multiple bodies, multiple technologies, and
multiple layers of animation; but sci-fi fans would be familiar with Sal-
dana from J. J. Abrams's *Star Trek* (released earlier in 2009), and, of course,
the actress would be featured in all the publicity. That she is described as
"fierce" suggests the animalistic, and this "animal" attractiveness supple-
mented Neytiri's, whose body blends the humanoid and the animal. Sal-
dana's features are quite delicate, but there was no suggestion that the
Na'vi nose should be changed in her case. This was certainly due, in part,
to the fact that we don't see any human version of Neytiri in the film, but
it also speaks to the model of sexual attractiveness the filmmakers were
trying to achieve with the female Na'vi figure (the attractiveness they saw
as so crucial to the whole film), and quite different from, say, Grace's ava-
tar. Cameron also brought in Lula Washington, an African American cho-
reographer who worked with Alvin Ailey and who leads an L.A.–based
dance company, to create ritual ceremonies and dances for the film, and
to be a kind of "movement coach," who consulted on the way this tribal
people—who happen to be nine feet tall and have tails—would move. In
her work, Washington "specializes in reflecting the African American expe-
rience through movement," and in an interview she says that Cameron
chose her because her works "are ritual oriented."[58] In a number of ways,

the film seems to reach for an authenticity here associated primarily with blackness, which substitutes for that of an imaginary tribal, indigenous people.

Despite the generally good reviews for the film (in which its landmark status generally made up for its clichéd script), complaints about the film's racial politics proliferated both in the mainstream press and across the Internet. Most of these critiques focused on the storyline and its dependence on the "white messiah" fantasy, in which the white man is the chosen one to save the native people. As *New York Times* commentator David Brooks put it: "[O]f all the directors who have used versions of the White Messiah formula over the years, no one has done so with as much exuberance as James Cameron in 'Avatar'."[59] Jake is special; early on, the seeds of the sacred tree form a halo around him, which Neytiri sees as a sign. He not only communicates with the goddess Eywa, but he also brings the tribe together by being the first in generations to summon and successfully ride the flying beast called Taruk (which in Na'vi means, appropriately enough, "Last Shadow"). Taking issue with Cameron's claim, in an interview, that he was trying to write from an indigenous point of view, Haitian American blogger Ezili Danto writes that the film is an "obvious white fantasy."[60] In an oft-quoted piece, Will Heaven of the *Telegraph* online calls the film "nauseatingly patronizing" and declares, "Pandora is to Cameron what Africa was to Joseph Conrad."[61] Like others, he mostly focuses on questions of stereotype and plot, but he also questions the use of African American actors to play the Na'vi, whom he characterizes as "a childish pastiche of the 'ethnic', with recognisably human features." Meanwhile, John Podhoretz of the *Weekly Standard* comes closer to the heart of the matter when he writes, "Cameron has simply used these familiar bromides as shorthand to give his special-effects spectacular some resonance."[62] The resonance is not merely with real-life political issues or melodramatic tales of exclusion and suffering, however; the film resonates with the history of American cinema, and the "supporting" role that racialized others (and particularly African Americans) have played in that history is itself a prop on which the authenticity of the digital characters rely. That is, the links between racialized essentialism, the apparatus, and the audience have been handed down, providing precisely the kind of continuity (of faith) that cinema's future seeks to maintain with its past.

The rhetoric of authenticity abounds in discussions of creating digital worlds, as it would if conventional effects methods were being used; but when it comes to the relationship between computer-generated images

and the "real world," a certain mysticism comes into the mix. In working on the weapons and other props for the Na'vi—elements that would all be fully digital—the people at Weta Workshop "most often built physical representations of them—both to get a more visceral understanding of the item, and also to fulfill Jim Cameron's mandate that there should be nothing in the Na'vi virtual world that could not be built in the real one."[63] This is part of the commitment to the authenticity of the world they were creating. In speaking of this commitment to physical reality, Joe Letteri of Weta describes a shift in the entire process, the production pipeline and the philosophy behind it: "The goal of everyone over the years has been to make shots *look* real . . . But we decided to bite the bullet and *make* them real, to actually calculate the reality."[64] In creating the costuming for the Na'vi, designers did their research and wove meticulous leather adornments, feathers, bracelets, and so on. Why do that instead of having CG artists look at pictures? Well, for one, they were creating "alien" versions of traditional garb, so in theory it should look different and follow different rules; but more importantly, having live actors wear these objects when they moved would help digital artists know how these objects would move in "real life," which could then determine their digital movements. Nonetheless, there is another dimension to it. It is as if the handmade nature of these objects would somehow "come through" in their digital counterparts. That is, there's a way in which the artisanal quality of these objects lends them an aura that will then somehow transfer over to the 3D digital model. Not just the objects themselves, but also the labor with traditional materials (leather, feathers, beads) is then linked to the labor at computers with intangible "digital" materials.

You can see this kind of auratic function of the physical (and physical labor) in the rhetoric around the actors' performances as well. The actor's labor is part of the spectacle; but the emphasis on their physical labor elides other kinds of labor—namely the cultural and rhetorical work done by the actors' racialized bodies. The actors "captured" as Na'vi not only perform their roles; they also perform "race" in a story about interracial (interspecies?) romance, racial disguise, and cross-racial identification. Indeed, the emphasis on "capture"—the making-of documentary is called *Capturing Avatar,* after all—installs Cameron as another "hunter of images" in the tradition of Robert Flaherty, looking for the real bodies that will authenticate (and mythologize) the romantic primitives that he has created.[65] In her work on Flaherty's *Nanook of the North,* Fatimah Tobing Rony likens Flaherty's cinematic project to "taxidermy." Rather than using real

Inuit people to create fictional, romanticized, racialized, and seemingly "extinct" characters, as *Nanook* does, *Avatar* creates a fictional indigenous people and makes them "real" by creating connections (both real and imagined) to the authenticity of real actors' bodies. Cameron even emphasizes the authenticity of acting in a performance capture situation, making it sound more real than typical film acting: "For [the actors] it was black box theatre. It was pure acting. It was all about emotion and reacting to each other—no hitting marks, no worrying about the lighting, costumes, makeup and hair. It worked well."[66] So, performance capture and digital imaging do not sever the film even further from reality; rather, the film's technology actually undoes the fragmentation of the filmmaking process and puts authentic bodies and authentic emotions back together.

In her work on race and Internet identities, Lisa Nakamura has discussed the relationship between the "fetish of interactivity" and "racial ideology."[67] She discusses the practice of "passing," or posing as a different racial identity on the Internet (in its early, text-based iteration), critiquing the utopian notion that the Internet would be a "post-racial" or "color-blind" environment in which users would gain ultimate control over identity, making race somehow obsolete. In the advent of the image-based Web, she notes, "identity tourism lets users 'wear' racially stereotyped avatars without feeling racist," adding that "the logic of identity tourism figured race as modular, ideally mobile, recreational, and interactive in ways that were good for you" (1675). She notes the interplay here between (Internet) freedom and (racial) limitation, as identity tourism typically included a "narrow range of racialized performance" and "promoted a comforting amnesia in regard to the lack of choice racial minorities faced in everyday life" (1675–76). She emphasizes racialized labor as part of that everyday life, and the racializing of labor to produce "the Internet" and the consumer's feeling of entitlement and infinite possibility—infinite possibility including the "illusion of diversity through digitally enabled racial passing and recombination [that] produces a false feeling of diversity and tolerance born of entitlement" (1674). Nakamura looks at a series of ads for Cisco Systems that dubbed the company's global networking services "the Human Network." The ads showed people from across the globe and primarily featured people of color performing for the camera, joining the do-it-yourself cinema of attractions revolution by making and uploading videos of themselves. They are represented as the empowered producers of this "human network," and they also symbolize it. Nakamura argues that this global portrait of technology and its ever-expanding network is tied to the performance of race.

The dynamic she describes between Internet and racial freedom and between real life and racial limitation suggests the back and forth between technological freedom and physical limitation (both tied to race) in *Avatar*'s rhetoric of performance capture and in the film's narrative strategies. *Avatar* imagines its own "human network," albeit one composed of Na'vi bodies. As Parker Selfridge (Giovanni Ribisi), head of the corporate mining operation, prepares to destroy "Home Tree" (where the Na'vi live), Grace explains that the trees on Pandora are more than just trees: "There's some kind of electro-chemical communication between the roots of the trees, like synapses between neurons." She goes on to say that there are more connections than there are in the brain: "Get it? It's a network; it's a global network and the Na'vi can access it!" It's not hard for us to "get it," as the film reaches out to reference one more aspect of digital technology in order to dismiss our "artificial" online network in favor of an organic one. Destroying the natural world will mean destroying the "data" held there, the "memories" the Na'vi "upload and download" through this network. This network is visualized in the film during the healing ceremony that we see twice (once when they try, unsuccessfully, to transfer Grace into her avatar body, and once when they do the same for Jake). The scenes feature overhead shots of the entire Na'vi community, sitting and moving in unison, limbs intertwined to form a kaleidoscopic, Busby Berkeley–like web of bodies. The roots of the trees merge with the quivering threads that dangle from the braids of the Na'vi, lighting up to form what looks like a glowing fiber optics network. *Avatar*'s Na'vi network references and rivals the Internet and computer networks (and thus the colonizer's technology), but the relation between the body and technology is complex and contradictory. If the Na'vi are opposed to the hyper-technologized way of life, the inhabiting of their bodies by Jake and the others fulfills an updated version of racial disguise-turned-identity tourism in which "racialized others and primitives" become "signs of cosmopolitan technofetishism"[68]— an operation in which the film's immersive strategies are heavily invested. Again, the film simultaneously critiques and exploits the anthropological model of participant observation. Late in the film, when Jake and the others realize they cannot stop the assault on home tree, Jake waves a thick book in Grace's face and says, "This is how it's done." The book is titled "The Na'vi" and is obviously an ethnographic work; the moment suggests the way that anthropological activities are implicated in colonization and exploitation. At the same time, however, the participant–observation mode is legitimized as a route to profound knowledge, a chance to "play" the

Other in both senses of the term—"acting a role" and using as in a game (both a sign of and a path to privilege).

Fed up with hearing about "home tree" and eager to get at the unobtainium underneath it, Selfridge calls the Na'vi "flea-bitten savages" and says: "Look around. I don't know about you, but I see a lot of trees. They can move!" The slippage in the referent for "they" (does he mean the Na'vi or the trees?) suggests that *Avatar* might go the *Macbeth* route, unleashing the natural world on the invaders by way of a moving forest. The film does not, in fact, include moving trees (perhaps because this effect was already achieved in *The Lord of the Rings: The Two Towers*); but the trees do "move" in other ways more in line with *Avatar*'s aesthetic and thematic goals. The trees don't physically "move," but they do move Jake and the Na'vi emotionally, spiritually, and sensually. Some have said that today's 3D doesn't so much come *at* the viewer as immerse the viewer within its worlds. But the goal of cinematic spectacle, with or without 3D, is that there be no difference between these two models: If Sessue Hayakawa "aimed his mask" like a gun at spectators, they were also drawn in as if through a "funnel." If the male voyeur tries to enter a window, poster, or doorframe to "touch" the image, he was often "punished" by someone or something crossing the boundary and touching him. The train that takes us nowhere in early motion pictures—that doesn't, in fact, move at all—moves us in other (racially and sexually charged) ways. The goal is not merely to sever the spectators from the space of theater or from their own bodies, but to make them feel, at times, both presences all the more. And that "trippy ride" between presence and absence, between physicality and immateriality, has always been part of the cinema's mythology and of its continuing status as "attraction."

The film seems to set up the notion of technology and imaging devices as prosthetics— in choosing a paralyzed hero, the sense of the technology extending the powers of his body is quite literal. In fact, the "disabled" body functions merely as a symbolic device and as a pivot point for racialized transformation: if Jake's injured body represents the disembodied and "crippled" culture of the colonizer, the native other "completes" this body (understood as partial) through its identification with excessive embodiment.[69] But, in fact, what's going on for the digital image (and for the audience) is the reverse. The live actor becomes the prosthetic for the digital image—a kind of backward move, not to extend beyond the real, but to reach back to the real, to ground or anchor the image in a way that provides a sense of physicality. We see again a kind of reciprocal relation in

which the "inadequacy" of the digital image is covered over by the live actor (and by the rhetoric of racialized difference), while the limitations of the live actor are made up for by the digital image (and an imaginary racialized body). In this sense, the body of the performer becomes the referent for the digital image—a symbolic relation disguised as a quasi-indexical one. In the early days of cinema, the racialized or otherwise exoticized body acted as a prosthetic for the stationary camera, making up for its limitations by providing literal and figurative motion; here the actors' authenticity—produced through a combination of the rhetoric of presence surrounding performance capture and the racial identity of the actors—extends the power and significance of the digital image by giving it bodily limits.

The actors are redeemed by their physical labor—that is, they are given their value back. And in turn, they redeem the digital image. The digital image would seem in special need of this kind of redemption; but, in fact, this move is one that goes back to the origins of cinema, as we have seen in the many reflexive portraits of the apparatus and in the many ways "race" has helped to negotiate the transaction between the performing body and the performing image. The story of the cinema has long been about the redemption of screen reality. This has especially been the case in moments of transition or crisis. Despite the cinema's identification with "the essence of reality," the screen image's immateriality, its absence, has often needed props, as it does again. The cinema must "re-embody" its image and reconnect that image to reality in light of the digital image's ascendance and the threat it could pose to the cinema's tenuous but definitive balance between realism and magic.

Capturing Cinema: From Animated Picture Studio to *Avatar*

Avatar is full of obvious metaphors and clichés, including the multiple meanings of its title; from the world of gaming, the movie references the controlling of an online or game-world identity or "avatar" by a "user." The film combines the gaming terminology with the earlier, spiritual sense of the term, which refers to "the incarnation of a deity" (from the Sanskrit) and to incarnation and embodiment more generally. The "game" that Jake is playing quickly turns into a conversion experience, but one in which he is the deity, the chosen one who has descended to Pandora in embodied (Na'vi) form. "Avatar" is more loosely used to suggest the embodiment of an idea, and the film wants to bring together various ideas of embodiment. Perhaps most importantly, the film attempts to "embody" digital

cinema itself; this goes beyond "preserving the actor's performances." According to the origin story, the technologies developed and used to make this film essentially bring to life the idea Cameron had in 1995. Thus the origin story helps to characterize the entire film as the embodiment of that idea, its manifestation. And the discourse surrounding the 3D technology, the immersive experience, and the material reality behind the digital creatures aid in making the Na'vi bodies the incarnation of digital cinema—the avatars of cinema's future. These digital figures must make good on the film's promise: to "make history" by ensuring that "movies will never be the same." In this sense, *Avatar* offers yet another fantasy of incarnating the cinema by giving it a (racialized) body. Importantly, the film relies on the circuit between the beliefs of the imagined native Other and our own ability to believe in the image—through that circuit, both spectator and cinema are made new.[70] If films like *Avatar* and *Tattoo* herald the second coming of cinema as digital cinema, they also simply mark one more in a series of "second comings" and "rebirths" that have accompanied technological and aesthetic shifts in the cinema, shifts linked to and buoyed by the rhetoric of racialized difference.

Avatar sets out to be a landmark film, one that sought to get over (and eliminate) a number of technical hurdles. As Cameron says at the end of *Capturing Avatar*, "Whatever one thinks of the movie, I know what we accomplished in solving these technical challenges." At the same time, the filmmakers would certainly want to avoid being "*The Jazz Singer* of 3D" in terms of racial politics. Although Cameron guides audiences to think about the digital figures as actors wearing "CG makeup," the racial parameters of the fantasy are varied and multiple, and the fantasy of screen creatures coming to life and breaking through the barrier of the screen is at least as old as cinema itself. One might guess that if you don't need "real bodies" anymore (or if you only need them behind the scenes), then you certainly shouldn't need racialized bodies on or off the screen. But, in fact, the cinema needs them all the more in moments when its immateriality is highlighted and its realism is challenged. If both *Avatar* and *Tattoo* use racialized bodies and stereotypes in order to embody the apparatus, they also demonstrate how the specific screen histories of African Americans, Asian Americans, and other marginalized subjects have been bound up with a racial imaginary that has repeatedly "solved" technical, aesthetic, and narrative problems in American cinema.

This operation has in every instance required a push and pull between the body and the image, and the merger of presence and absence promised

by the racialized body has repeatedly bolstered the apparatus. Many of the films we have looked at in this study have exploited the rhetoric of race difference in order to disembody, fragment, or otherwise leave the physical body behind and to replace it with a newly empowered and iconic image. The rhetoric of race difference alternately offers up the body as the site of authenticity and positions it at the meeting place of impossible contradictions—and this has been very productive for cinema in times of technological or aesthetic transitions. Racialized figures and the rhetoric of race difference have helped to solve cinematic problems in different ways at different junctures. In the earliest motion pictures, we saw how racial boundaries were linked to screen boundaries, and how racial disguise and transformation allowed films to transcend the limitations of the apparatus (such as the static frame) in order to produce narrative meaning. In the turn to feature films, close-ups, and the increasing demands for realism, we saw how the "Oriental" stereotype functioned to grant an almost mystical meaning to the surface image, and to the screen itself. In the transition to sound, the "black voice" and its strict alignment with the body became an important prop to authenticity and synchronicity. And yet in many examples from these transitional moments, the racialized body must also be fragmented, displaced, or disappeared for the transaction between body and image to be complete. In this transaction, the racialized body often becomes a figure for the cinematic apparatus itself. Through these multiple strategies, the cinema repeats its claims to presence and authenticity, asserts its uniqueness, and regains the audience's faith in the image. If the specific cultural histories and stereotypes associated with African Americans and Asian Americans suit the cinema's needs at different moments and in different ways, as discussed, this toggling between body and essence also joins them.

The underlying fantasy of *Avatar* might be that of a bodiless cinema after all, but, in fact, the digital image must make enough contact with the real body to keep that image from floating too far away from a realist aesthetic (packaged inside a fantasy film). We saw this fantasy in the 1930s and 1940s when, after a brief experiment with black-cast films, Hollywood turned away from African American performers, and many jazz and blues musicians ended up on film screens in animated forms. Animation, it seems, could take what Hollywood needed from African American performers (voices, music) while utilizing iconic visual stereotypes and nonthreatening images.[71] If only, the fantasy seems to go, the cinema didn't need real bodies at all. If only we could find this perfect body that unifies

reality and fantasy, real and symbolic, material and immaterial, motion and stillness, freedom and limitation—without all the nasty, offensive racist baggage. As the monster tells Dr. Frankenstein when looking for a viable mate: "This being you must create." Hint: Use a computer; make the creature blue. Give it cat ears and a tail.

If we think back to the cinema's earliest days, we can see the continuity of *Avatar* with what came before: both in terms of the linking of racial boundaries to cinematic ones and in terms of the "immaterial" screen image challenging the material reality of real-world bodies. I began this study with a consideration of *The Animated Picture Studio*, an early motion picture from 1903. In that film, tiny moving images break free of a picture frame and perform at the corner of the screen while their flesh and blood counterparts look on with a mixture of horror and curiosity. That film dramatized a competition between performing bodies and performing images and imagined the way images might invade our (3D) space. A number of the films discussed in the first chapter featured literal or figurative crossings of the screen boundary (often helped along by the crossing of racial boundaries). The triumph of the current generation of 3D cinema, announced and epitomized by *Avatar*, lies in its difference from earlier iterations of 3D. Rather than emphasizing people and objects poking out toward the audience, this brand of 3D equally draws the audience in, "amplify[ing] the immersive experience" of cinema by "clos[ing] the space between the audience and the screen."[72] In *Animated Picture Studio*, the image breaks through the frame, but that image refers to the spectator—and to the anxious but attractive possibility of spectators becoming spectacle and vice versa. As demonstrated in many instances from early cinema and beyond—and again in *Avatar*—that anxious but pleasurable transaction between performing body and performing image would be mediated by racialized bodies and the rhetoric of race difference.

Many critics have drawn links between early cinema and our current moment, alternately called "late," "postmodern," "postclassical," or "digital era" cinema. The comparisons usually point to the diversity of "attractions" in our current media landscape, and to the more active spectator who, like spectators in the early silent era, is not simply subsumed into a textually constructed spectator position by a "totalitarian" cinema. While these parallels may work to a certain extent when thinking about YouTube and Internet media culture, mainstream cinema retains the modes and methods of the classical era, even as it eventually finds its way into the twitchy hands of consumers. Certainly the advent of digital visual effects

neither changes mainstream Hollywood's codes nor the narrative structures and goals of classical realism. It has not been my goal to draw a parallel between early cinema and contemporary cinema that sets them utterly apart from the classical studio era. In general, as recent scholars have suggested, the "similarities" between our moment and preclassical cinema demonstrate a tendency in film studies to overestimate the singularity and sameness of classical-era cinema (especially in the dismissal of spectacle and the downplaying of the body that resulted from excluding popular genres such as the musical).[73] Rather, I would suggest that the gestures I have been identifying here began with the earliest motion pictures and are most recognizable in moments of transition and times of technological, aesthetic, and cultural vulnerability. These moments tend to spur reflexive portraits of the apparatus and re-estimations of its power and potential; these reflexive moments also attempt to reconstitute and reinforce the transformative potential of cinema for audiences, thus suggesting an ideal identity for the film spectator.

The story of cinema, especially as it has been told in film studies and film theory, is one in which what is severed is fantasmatically put back together. Continuity editing is, of course, the classical cinema's definitive oxymoron. But if cinema composes itself through severance—the severance of the bodies in the theater from those on screen, the severance of cinematic space from real space, the severance of the apparatus from the image—it also attempts to sever itself from its own roots. In American cinema, this includes the repression of the large role race difference played in the cinema's foundational years—not merely in terms of racist jokes and other racialized content, but in terms of form. Film theory has repeated the repression of cinema's childhood by either ignoring it or sequestering it. But cinema cannot exist apart from its long shadow. There is still much to dissect in the film image, and going back to the beginning—to early cinema and to close engagement with the way films create meaning—is crucial for understanding the way the rhetoric of race difference has fundamentally informed both film language and the relationship created between image and audience. Cinema's power has been figured by its shadow—a present absence that finds its analogue in "race," that magical quality that promises to align physical traits and spiritual essences, the ineffable with the perfectly legible. In a medium defined by fundamental absences and discontinuities, it turns out that the rhetoric of race has functioned to keep body and soul together: re-animating the cinema by reincarnating its shadow.

NOTES

Introduction

1. The group recently collaborated on a performance with Art Spiegelman titled "Hapless Hooligan in Still/Moving." A description of their work can be found on the Pilobolus website, http://www. pilobolus.com/home.jsp. The performances featured at the Oscars can be viewed on YouTube.

2. *The Devil Wears Prada* (David Frankel, 20th Century Fox, 2006); *The Departed* (Martin Scorsese, Warner Bros, 2006); *Little Miss Sunshine* (Jonathan Dayton and Valerie Faris, Fox Searchlight, 2006); *Snakes on a Plane* (David Ellis, New Line, 2006).

3. Cited in Charles Musser, *Edison Motion Pictures, 1890–1900* (Washington, D.C.: Smithsonian Institution Press, 1997), 250. This is just one of many takes on the subject; Biograph's version was called *A Hard Wash.*

4. Ibid.

5. André Gaudreault coined the term "monstration" to describe the show-and-tell function of the camera in these early films. See André Gaudreault, *From Plato to Lumiere: Narration and Monstration in Literature and Cinema,* trans. Timothy Barnard (Toronto: University of Toronto Press, 2009).

6. When I speak of "realism" here, I mean to suggest the shifting definitions and desires around the relationship between motion pictures and "the real" in the silent era. This would include not only the traditional sense of verisimilitude, transparency, and spectatorial absorption, but also the way those claims are often bolstered by appeals to "physical reality." If Sigfried Kracauer suggested that the cinema offers the "redemption of physical reality," I am focusing here, instead, on the redemption of screen reality. See Kracauer, *Theory of Film* (London: Oxford University Press, 1960).

7. On ethnography and cinema, see Fatimah Tobing Rony, *The Third Eye: Race, Cinema, and Ethnographic Spectacle* (Durham, N.C.: Duke University Press, 1996) and Allison Griffiths, *Wondrous Difference: Cinema, Anthropology, and Turn-of-the-Century Visual Culture* (New York: Columbia University Press, 2002); on medical discourse and visual technologies, see Lisa Cartwright, *Screening the Body: Tracing Medicine's Visual Culture* (Minneapolis: University of Minnesota Press, 1995). On

the links between stereotypes and pathology in scientific and popular discourses, see Sander Gilman, *Difference and Pathology* (Ithaca, N.Y.: Cornell University Press, 1985).

8. Homi K. Bhabha, *The Location of Culture* (New York: Routledge, 1994), 70.

9. Ibid., 82.

10. Maxim Gorky [I. M. Pacatus, pseud.], "A review of the Lumière programme at the Nizhni-Novgorod Fair, as printed in the *Nizhegorodski listok*" (4 July 1896), cited in Jay Leyda, *Kino: A History of the Russian and Soviet Film* (Princeton, N.J.: Princeton University Press, 1983), 407.

11. I'm thinking in particular of Jacqueline Najima Stewart's impressive and influential *Migrating to the Movies: Cinema and Black Urban Modernity* (Berkeley: University of California Press, 2005); Linda Williams, *Playing the Race Card: Melodramas of Black and White from Uncle Tom to O. J. Simpson* (Princeton, N.J.: Princeton University Press, 2002); and Jane Gaines, *Fire and Desire: Mixed-Race Movies in the Silent Era* (Chicago: University of Chicago Press, 2001), to name some prominent examples.

12. As Jonathan Crary has shown, proto-cinematic and other visual techniques were key to fundamental shifts in the way vision itself was conceptualized and understood. Crary traces a nineteenth-century rupture with perspectival models of vision inherited from the Renaissance, whereby vision becomes a contingent, embodied process. Crary theorizes the viewing subject as an "observer," rather than the "disembodied eye/I" of the Renaissance subject. See Crary, *Techniques of the Observer: On Vision and Modernity in the 19th Century* (Cambridge, Mass.: MIT Press, 1992). That contingency is a product of (and continues to fuel) the need to visualize the processes of the human body and to define its "essential" qualities. See also Linda Williams, "Corporealized Observers: Visual Pornography and the 'Carnal Density of Vision,'" in *Fugitive Images: From Photography to Video*, ed. Patrice Petro (Bloomington: Indiana University Press, 1995). For a discussion of the multiple, fluid, and productive discursive sites of contact between bodies and machines in the late nineteenth- and early twentieth-century American literature and culture, see Mark Seltzer, *Bodies and Machines* (New York: Routledge, 1992).

13. On the interrelated constructs of race, gender, and sexuality in turn-of-the-century U.S. culture, see Siobhan B. Somerville, *Queering the Color Line: Race and the Invention of Homosexuality in American Culture* (Durham, N.C.: Duke University Press, 2000). See also Robyn Wiegman, *American Anatomies: Theorizing Race and Gender* (Durham, N.C.: Duke University Press, 1995).

14. In *The Third Eye,* Fatimah Tobing Rony calls this hunger for racialized images "fascinating cannibalism" (10). On the trade in lynching photographs and the eventual use of early motion pictures to circulate and reenact spectacles of racially motivated violence, see Jacqueline Goldsby, *A Spectacular Secret: Lynching in American Life and Literature* (Chicago: University of Chicago Press, 2006).

15. Tom Gunning coined this now familiar term to describe the logic and modes of address of early motion pictures (which he defines as films made before 1906). These films function according to the expectations of display, exhibition, jokes,

tricks, and show-and-tell, rather than according to the narrative logic of causality and closure that will come later. See Gunning, "The Cinema of Attractions: Early Film, Its Spectator, and the Avant-Garde," in *Early Cinema: Space, Frame, Narrative,* ed. Thomas Elsaesser with Adam Barker (London: BFI, 1990), 56–62.

16. David Palumbo Liu, *Asian/American: Historical Crossings of a Racial Frontier* (Stanford, Calif.: Stanford University Press, 1999), 3.

17. Rony, *Third Eye,* 62.

18. Many critics have suggested that the turn to psychoanalysis in feminist film studies privileged sex difference over race difference, and that the insistence on sex difference as the basic condition of the look precluded (or at least postponed) the discussion of race in film theory. See Laura Mulvey, "Visual Pleasure and the Narrative Cinema," *Screen* 16, no. 3 (Autumn 1975): 6–18. For critiques and responses to the place of race in theories of identification and the gaze, see Jane Gaines, "White Privilege and Looking Relations," *Cultural Critique* 4 (Autumn 1986): 59–79; Manthia Diawara, "Black Spectatorship: Problems of Identification and Resistance," *Black American Cinema,* ed. Manthia Diawara (New York: Routledge, 1993), 211–20; Mary Ann Doane, "Dark Continents: Epistemologies of Racial and Sexual Difference in Psychoanalysis and Cinema," *Femmes Fatales* (New York: Routledge, 1991), 209–49; Lola Young, *Fear of the Dark: "Race," Gender, and Sexuality in the Cinema* (New York: Routledge, 1996); bell hooks, "The Oppositional Gaze: Black Female Spectators," *Black American Cinema,* ed. Manthia Diawara (New York: Routledge, 1991).

19. Matthew Jacobson, *Whiteness of a Different Color* (Cambridge, Mass.: Harvard University Press, 2002), 3. This is particularly clear in the case of white femininity and its importance in the policing of race and the threat of miscegenation. The protection of the white woman from the black man, the definition of the white woman against the black woman in terms of relative virtue vs. promiscuity, the movement of the white woman in public space, and the definition of gender norms more generally depend upon race difference and on an image of blackness tied to uncontrolled sexuality. For the enshrinement of white femininity in early film, see Richard Dyer, "Into the Light: The Whiteness of the South in *The Birth of a Nation,*" in *Dixie Debates: Perspective on Southern Cultures,* ed. Richard H. King and Helen Taylor (New York: NYU Press, 1996), 165–76.

20. In this focus, I have been influenced by Jacques Aumont's work on D. W. Griffith. See Aumont, "Griffith-the Frame, the Figure," in Elsaesser, *Early Cinema.*

21. Matthew Jacobson, *Whiteness of a Different Color: European Immigrants and the Alchemy of Race* (Cambridge, Mass.: Harvard University Press, 1999), 41–42. Jacobson traces this "variegated" scale of whiteness and the shifts in the way various immigrant groups were positioned on this scale; he also traces how these ethnicities, formerly understood as "less white," would eventually be subsumed under the heading of "Caucasian."

22. While the tenuous and shifting legal status of African Americans derived from the legacy of slavery and the growing, legalized segregation in post-Reconstruction America, immigrants from China and Japan could not attain American citizenship and were ultimately the targets of the exclusionary immigration policies enacted

in 1882 and again in 1924. The groups were also linked to debates about free labor and the working class, with slave labor and nineteenth-century Chinese "coolie" labor functioning as counterpoints and wedges in nineteenth-century disputes about wage labor and immigration. Racially motivated violence and white supremacist rhetoric played important and well-documented roles, for example, in the New York City draft riots of 1863, and while this was most obviously directed at blacks, the Chinese were also targets of the mob violence and supremacist logic. For a discussion of race and the formation of the American working class, see David R. Roediger, *The Wages of Whiteness: Race and the Making of the American Working Class* (New York: Verso, 1991). Asians and Africans were not, of course, the only groups to be alienated and racialized, and I am not attempting to privilege these groups over others including Native Americans and Mexican Americans. For a discussion of how Asian American identity is defined or "triangulated" through the categories of Black and White, see Claire Jean Kim, "The Racial Triangulation of Asian Americans," *Politics & Society* 27, no. 1 (March 1999): 105–38. Kim argues for a more fluid "field of racial positions" as opposed to a scale or spectrum.

23. *Plessy v. Ferguson,* 163 U.S. 559–63 (1896).

24. For a discussion of Chinese stereotypes in early U.S. cinema, see John Haddad, "The Laundry Man's Got a Knife!," *Chinese America: History and Perspectives* (2001): 31, *Expanded Academic ASAP*; Eugene Wong, "The Early Years: Asians in American Films Prior to World War II," *Screening Asian Americans,* ed. Peter X. Feng (New Brunswick, N.J.: Rutgers University Press, 2002), 53–71; and Sabine Haenni, *The Immigrant Scene: Ethnic Amusements in New York, 1880–1920* (Minneapolis: University of Minnesota Press, 2008), 143–89.

25. See Clyde Taylor, "The Re-Birth of the Aesthetic," in *The Birth of Whiteness,* ed. Daniel Bernardi (New Brunswick, N.J.: Rutgers University Press, 1996), 15–37; Michael Rogin, *Blackface, White Noise: Jewish Immigrants in the Hollywood Melting Pot* (Berkeley: University of California Press, 1996); Williams, *Playing the Race Card,* 10–45. Jacqueline Stewart references Toni Morrison's discussion of the "Black presence" in American literature and calls for the same attention to that formative presence in American film. See Stewart, *Migrating to the Movies,* 5, and Toni Morrison, *Playing in the Dark* (New York: Vintage, 1993).

26. In her introduction to the "comparative racialization" issue of the *PMLA,* Shu-mei Shih notes the multiple ways we might think about comparison and calls for a "fuller understanding of racialization as a comparative process" (1350). Race is inherently comparative, she argues, as racial identity has historically been defined by the comparison of one marginalized group to another and by the comparison of subjugated identities to the whiteness of colonial discourse. Further, she notes (relying on Fanon), the weight and force of comparison is internalized, dividing the racialized subject against himself or herself. Shih argues that "we must recognize the conjuncture of time and place in each instance of racialization without losing sight of the totality produced by the colonial turn that heralded race as a structuring principle" (1349). She also notes the lingering distrust or disconnect between theory (especially French-influenced poststructuralist theory) and race studies.

We certainly see this in film theory as well. See Shu-mei Shih, "Comparative Racialization: An Introduction, *PMLA* 123, no. 5 (October 2008): 1347–62.

27. Miriam Hansen, *Babel and Babylon: Spectatorship in American Silent Film* (Cambridge, Mass.: Harvard University Press, 1994), 23. On spectatorship and the bourgeoning narrative cinema, see also Tom Gunning, *D. W. Griffith and the Origins of American Film* (Urbana: University of Illinois Press, 1993).

28. Mary Ann Doane, "The Close-Up: Scale and Detail in the Cinema," *differences* 14, no. 3 (2003): 110.

29. Kristen Whissel, *Picturing American Modernity* (Durham. N.C.: Duke University Press, 2008), 214, emphasis added.

30. The understanding of *apparatus* in film theory has relied, since the 1970s, on Althusser's definition of "ideological state apparatuses" from his influential essay "Ideology and Ideological State Apparatuses," in *Lenin and Philosophy, and Other Essays,* trans. Ben Brewster (London: New Left, 1971), 121–76.

31. As I discuss further in chapter 3, the early 1920s can be read as a borderline moment, culturally and politically, both for the film industry and for American society more generally. But in terms of their representational strategies, the films of this period were not facing as stark a technological or aesthetic transition as those I analyze in the first two chapters.

32. Here I refer to André Bazin's well-known essay "The Evolution of Film Language," *What Is Cinema?,* vol. I, trans. Hugh Gray (Berkeley: University of California Press, 1967), 23–40. Bazin's progress narrative and his essays on realism rely on the binary of "faith in the image" vs. "faith in reality," one version of the long-held boundaries drawn in cinema histories between the "Lumières" (reality) and the "Méliès" (tricks/illusion) branches of cinema. Scholars have more recently identified this as a false opposition and have argued for the interdependence of various modes—attractions, trick films, actualities, narratives—in early cinema. After years of being a bit of a whipping boy for critiques of naive realism, Bazin has had a bit of a return of late, with re-readings suggesting greater complexity and (perhaps productive) contradiction in his vision of cinematic realism. See especially Philip Rosen, *Change Mummified: Cinema, Historicity, Theory* (Minneapolis: University of Minnesota Press, 2001).

33. "The Birth of a New Art," *Independent*, April 1914, 8.

1. Performing Body, Performing Image

1. I refer here to longstanding debates in film studies and film theory. For a refutation of the camera obscura model for the situation of the film viewer and the construction of a vision-centered subjectivity, see Crary, *Techniques of the Observer*. Crary focuses on nineteenth- century discourses of vision as a bodily, physiological (and flawed) process and on proto-cinematic techniques that took advantage of optical illusions to propose a more Foucauldian model of the "observer" rather than the classic vision-centered subject. For a classic iteration of film as the answer to the primordial urge to reproduce reality, see André Bazin, "The Myth of Total Cinema," in *What Is Cinema?,* 17–23. Since the 1960s, numerous scholars, especially those coming out

of a Marxist tradition, have rejected Bazin's seemingly naive approach to realism. For a more recent reconsideration of Bazin's theories, see Philip Rosen, *Change Mummified* (Minneapolis: University of Minnesota Press, 2001). Recent work in early cinema has tended to refute the "primitive" label and the teleological reading that judges early motion pictures only in terms of the development of classical style. I discuss those particular critics and debates in more detail in the coming pages.

2. I viewed this film at the Library of Congress, where it is part of their paper print collection. It was produced by Hepworth, but American Mutoscope and Biograph copyrighted the film in 1903; AM&B had become the importers and U.S. distributors for films produced by the British company.

3. For example, Biograph produced a series of shorts including *The Picture the Photographer Took* (1904) and *One Way to Take a Girl's Picture* (1904), both of which offered "living photographs," with women posing and becoming photos. Films such as Edison's *Old Maid Having Her Picture Taken* (1901) and Biograph's *Fun in a Photograph Gallery* (1902) also use a very similar setup to *Animated Picture Studio*.

4. Her dress and her dance likely reference vaudeville "skirt dances" and to the very popular performer Loie Fuller and her "serpentine dance," in which her flowing, billowing, wing-like silk skirts played a key role. Fuller appeared in a 1906 film called *Fire Dance* (Gaumont); Edison may also have filmed Fuller. See Elizabeth Coffman, "Women in Motion: Loie Fuller and the Interpenetration of Art and Science," *Camera Obscura* 17, no. 1 (2002): 73–105.

5. See Karen Beckman, *Vanishing Women: Magic, Film, Feminism* (Durham, N.C.: Duke University Press, 2003). Beckman situates the vanishing woman at the center of the new medium's anxiety over its own (im)materiality and argues that, despite being part of a history of exposure and display of the female body, the vanishing woman resists this exposure "because she is never fully present" (69).

6. This miniature picture show is also reminiscent of camera obscura attractions, in which spectators were treated to "real life" scenes in miniature. The circuit between technological reproduction and the human body suggests the "body-machine complex" in turn-of-the-century culture that Mark Seltzer has elucidated. See Mark Seltzer, *Bodies and Machines* (New York: Routledge, 1992). For an account of the various proto-cinematic spectacles and their role in the invention of the nineteenth-century "observer," see Crary's *Techniques of the Observer.*

7. "Birth of a New Art," *Independent*, April 1914, 8.

8. In discussing a tension between figure and frame, I am drawing on Jacques Aumont's discussion of D. W. Griffith in "Griffith: The Frame, the Figure," in Elsaesser, *Early Cinema.*

9. Tom Gunning, "'Primitive Cinema': A Frame-up? Or the Trick's on Us," in Elsaesser, *Early Cinema,* 97.

10. Beckman, *Vanishing Women,* 71.

11. Ibid., 69–93. Beckman's examples include Edison's *Hooligan Assists the Magician,* but she also looks at photographs of the infamous female medium Eva C., in which this material is supposed to be the "ectoplasm" that is produced through (and that serves as evidence of) her supernatural abilities.

12. As excerpted on the Library of Congress American Memory website, "Inventing Entertainment: The Motion Pictures of the Edison Company," http://memory.loc.gov/ammem/edhtml/edhome.html.

13. See Stephen Bottomore, "The Panicking Audience? Early Cinema and the 'Train Effect,'" *Historical Journal of Film, Radio, and Television* 19, no. 2 (1999): 177–216.

14. Lynne Kirby traces the intertwined histories of motion pictures and trains in *Parallel Tracks: The Railroad and Silent Cinema* (Durham, N.C.: Duke University Press, 1997).

15. Given work in feminist film theory that has noted the way the apparatus has been aligned, in classical Hollywood cinema, with the male gaze and the way women are framed as spectacle, this early encounter with the apparatus suggests the way class and ethnicity complicate the gendering of the apparatus and point up the unstable nature of the boundary between spectator and spectacle in early cinema.

16. For example, *One Girl Swinging* (1897), an early motion picture made for the mutoscope peep show device, featured the titular character swinging, offering a glimpse up her skirt with every swing/turn of the crank. Charles Musser describes this film in *The Emergence of Cinema: The American Screen to 1907*, vol. 1, *History of American Cinema*, ed. Charles Harpole (New York: Scribner, 1990), 228.

17. Reprinted in Stephen Bottomore, *I Want to See This Annie Mattygraph: A Cartoon History of the Coming of the Movies* (Gemona: Le Giornate del cinema muto, 1995; Bloomington: Indiana University Press, 1996).

18. Miriam Hansen, *Babel and Babylon: Spectatorship in American Silent Film* (Cambridge, Mass.: Harvard University Press, 1991), 27. Subsequent references are noted parenthetically.

19. Noel Burch, *Life to Those Shadows* (Berkeley: University of California Press, 1990), 69.

20. Audience behavior, the physical space of the theater, and different sorts of stage attractions were all interrelated in the increasingly class-based divisions in American theater, most explosively expressed in the Astor Place Riot of 1849. For the changing orientation of the theater audience and the class hierarchy of American stage culture in the nineteenth century, see Lawrence W. Levine, *Highbrow/Lowbrow: The Emergence of Cultural Hierarchy in America* (Cambridge, Mass.: Harvard University Press, 1988).

21. Gilles Deleuze, *Cinema 1*, trans. Hugh Tomlinson and Barbara Habberjam (Minneapolis: University of Minnesota Press, 1986). Subsequent references are noted parenthetically. With this emphasis I depart from the philosophical thrust of Deleuze's argument, in which the movement-image is really only a transitional element on the way to the time-image and cinema's achievement—the manifestation of a way to think or materialize duration.

22. Like other "actualities," these films blurred the distinction between document and exhibition, showing and telling: "monstrating" rather than narrating or simply recording its subjects. This is Andre Gaudreault's term for the exhibition films' "show and tell" quality, not simple "presentation," but not "narration" in the sense of telling a story. See Gaudreault, *From Plato to Lumière: Narration and Monstration in Literature and Cinema*, trans. Timothy Barnard (Toronto: University of Toronto Press, 2009).

23. From the catalog description of *Sioux Ghost Dance* in *Edison Films*, March 1900, 19. Cited in Musser, *Edison Motion Pictures*, 126.

24. For an account of the complexity of the relation between "real" and "reenacted" scenes, and between exhibition, performance, and witnessing, see Whissel's discussion of Wild West shows and battle re-enactments in *Picturing American Modernity*, 63–117.

25. Deleuze, *Cinema 1*, xiv.

26. "Birth of a New Art," *Independent*, April 6, 1914, 8.

27. See Mary Ann Doane, "Temporality, Storage, Legibility: Freud, Marey, and the Cinema, *Critical Inquiry* 22 (Winter 1996): 313–43. See also Marta Braun, *Picturing Time: The Work of Etienne-Jules Marey* (Chicago: University of Chicago Press, 1992).

28. Doane, "Temporality, Storage, Legibility" 333.

29. Rony, *Third Eye*, 48. Subsequent references are noted parenthetically.

30. Regnault's "La Langage par gestes" was published in 1898 and featured the chronophotographs of which Rony speaks. His chronophotography of West Africans was also featured at the 1895 Ethnographic Exposition in Paris. His work in anthropology was part of the discourse of scientific racism of the nineteenth century and also of the drive to visualize and inscribe bodily signs. On scientific racism, sexuality, and visual culture, see Gilman, *Difference and Pathology* and Somerville, *Queering the Color Line*. On medical inquiry and visual technologies, see Carpenter, *Screening the Body*.

31. Cited in Thomas Elsaesser, "Early Cinema: From Linear History to Mass Media Archaeology," in Elsaesser, *Early Cinema*, 22. Elsaesser summarizes Burch's comments in the introduction to this volume. See also Noel Burch, "Passion, Poursuite," *Communications* 38 (1983): 30–50.

32. Burch, *Life to Those Shadows*, 149. As noted above, Gunning's and others' recent accounts of early cinema have moved away from the "primitive" label.

33. Burch, *Life to Those Shadows*, 148.

34. In addition to miller/sweep films and the others discussed here, some other examples of films with blackening/whitening mishaps include *A Bucket of Cream Ale* (AM&B, 1904), *A Drop of Ink* (AM&B, 1904), *A Hard Wash* (AM&B, 1896), *Fun in a Photograph Gallery* (AM&B, 1902); *Let Uncle Ruben Show You How* (AM&B, 1904); *Fun in a Bakery* (Edison, 1902); *Flour and Feed* (AM&B, 1904), and *The Magic Pill* (Lubin, 1908). The fact that a number of films involve an exploding camera that ends up blackening the face again seems to make a connection between the motion picture camera and this particular kind of transformation. For further discussion of stereotypes and racist humor in films, see Gerard Butters, *Black Manhood on the Silent Screen* (Lawrence: University of Kansas Press, 2002); Jacqueline Stewart, *Migrating to the Movies*; and Eileen Bowser, "Racial/Racist Jokes in American Silent Slapstick Comedy," *Griffithiana 53* (May 1995): 35–43.

35. Since these films were often keyed to ethnic stereotypes, "white" is often not a neutral category; ethnicity is sometimes signaled by style of hair or dress or behavior. In the case of *A Drop of Ink*, for example, the man without a sense of humor is identified, in the Biograph catalog description, as "a phlegmatic Dutchman." Cited in

Kemp R. Niver, *Biograph Bulletins, 1896–1908,* ed. Bebe Bergsten (Los Angeles: Locare Research Group, 1971), 203.

36. *American Mutoscope and Biograph Picture Catalogue,* November 1902, 32. Cited in the *AFI Catalog* online (June, 2011 release).

37. A number of cartoons of the period featured movie patrons doing things like opening umbrellas when it rains onscreen—this was not merely to mock spectator naïveté but to highlight the realism or witchcraft of the movies and the very real effect they could have on patrons. Since the "attraction" of the cinema of attractions is partly the promise of a physical or sensory thrill, shock, or surprise, the difference between a "rube" mistaking the film for reality and the patron getting what he or she paid for is a tenuous one. In this context, the black/white transformations offer a figure for the extreme transformation or absorption of film, the potential for the spectator to "cross over" the boundary.

38. I'm thinking here of the "misdirected kiss" genre I discuss later in the chapter, as well as films that turn on the "switching" of white and black babies, such as *Mixed Babies* (AM&B, 1908) and *How Charlie Lost the Heiress* (AM&B, 1900).

39. Burch, *Life to Those Shadows,* 147–48.

40. Gunning, "'Primitive' Cinema," 101.

41. Musser, *Emergence of Cinema,* 228.

42. For example, Biograph's wildly successful *Personal,* a chase film that unfolds over several shots, was released in 1904 and promptly copied by, among others, the Edison Company's *How a French Nobleman Got a Wife through the New York Herald 'Personal' Columns* (1904), setting off a lawsuit that figured prominently in the way films came to be copyrighted. Andre Gaudreault discusses the importance of this case to the question of filmic narration in *From Plato to Lumière,* 102–12.

43. The relation between the sight gag in film and the comic strip has been elucidated in studies of film comedy. Burch, for example, notes the similarity of many early chase films to a series of postcards or travel scenes (particularly in the French context): "A spontaneous expression of primitive autarchy, this schema embraced all the comic genres" (*Life to Those Shadows,* 160). The divided set would have been familiar from the stage, as well, where it was used to create comic situations, including those involving ethnic humor. For more on this formal device in early cinema, see also Barry Salt, *Film Style and Technology: History and Analysis* (London: Starword, 1983).

44. See Brian F. LeBeau, "African Americans in Currier and Ives's America: The Darktown Series," *Journal of American Culture* 23 (Spring 2000): 71–83.

45. Donald Crafton, "Pie and Chase: Spectacle and Narrative in Slapstick Comedy," in *The Cinema of Attractions Reloaded,* ed. Wanda Strauvan (Amsterdam: Amsterdam University Press, 2006), 356.

46. Gunning's discussion of the "cinema of attractions" borrows and adapts Eisenstein's notion of the "montage of attractions." See Gunning, "Cinema of Attractions," 59.

47. Susan Gubar, *Racechanges: White Skin, Black Face in American Culture* (New York: Oxford University Press, 1997), 3–6.

48. Ibid., 10.

49. Sigmund Freud, *Jokes and Their Relation to the Unconscious*, 1916, trans. James Strachey (New York: W. W. Norton, 1982), 266. Subsequent references are noted parenthetically.

50. Definitions taken from the *Oxford English Dictionary*, 2d ed. (New York: Oxford University Press, 1991).

51. Noel Burch discusses the film in terms of early (and, in his terms, vain) attempts to assault the utter "externality" of the spectator from the film world before filmmakers had the ability to "center the subject." See Burch, *Life to Those Shadows*, 202–3. Jonathan Auerbach discusses the film in terms of what he calls "the vocal gesture" and links it to the early experiments with film sound and with studies of the relation between sight and sound. He notes that the subject tries to swallow the camera, but that the camera is still all-seeing, inescapable. See Auerbach, *Body Shots* (Berkeley: University of California Press, 2007), 63–81. Gunning cites it as an example of early innovative uses of the frame in "Primitive Cinema," 100–101.

52. Richard Allen, *Vaudeville and Film, 1895–1915* (New York: Arno Press, 1980), 130. Allen notes that the film inspired raves throughout the country, provoking cheers among the already "blasé" audiences of New York, Boston, and Philadelphia.

53. *Daily Chronicle*, October 28, 1897. The review was included in a compilation in the *Biograph Bulletin* titled "English Press Comments on the Biograph View of the Haverstraw Tunnel on the West Shore Railroad," reprinted in Nivers, *Biograph Bulletins, 1896–1908*, 35.

54. Allen, *Vaudeville and Film*, 131.

55. Kirby, *Parallel Tracks*, 94.

56. Jacqueline Stewart, *Migrating to the Movies*, 114.

57. Ibid., 114.

58. See, for example, Jane Gaines's reading of the film in *Fire and Desire: Mixed-Race Movies in the Silent Era* (Chicago: University of Chicago Press, 2001), 52–57. Lauren Rabinovitz reads this film alongside other films that challenge, reverse, or strip away the power tied to the man's gaze. See Rabinovitz, *For the Love of Pleasure: Women, Movies, and Culture in Turn-of-the-Century Chicago* (New Brunswick, N.J.: Rutgers University Press, 1998), 85–90.

59. Here I quote Edison's catalog description.

60. For a discussion of the panoramic view and the railroad that has influenced film scholars' take on the relation between cinema, the railroad, and the modernizing of vision, see Wolfgang Schivelbush, *The Railway Journey: The Industrialization and Perception of Time and Space*, trans. Anselm Hollo (New York: Urizen Books, 1979).

61. Decades later, Hitchcock's *Strangers on a Train* (1951) takes the trading places and train ride plot further when one man suggests to another that they solve each other's problems by switching murders, each man killing the other's victim. Bruno Anthony (Robert Walker) sums up the strategy: "Criss-cross."

62. Franz Fanon, *Black Skin, White Masks*, trans. Charles Lam Markmann (New York: Grove Press, 1967), 112. Subsequent references are noted parenthetically.

63. Bhabha, *Location of Culture*, 82.

64. Ibid.

65. Tom Gunning , "Now You See It, Now You Don't: The Temporality of the Cinema of Attractions," in *Silent Film,* ed. Richard Abel (New Brunswick, N.J.: Rutgers University Press, 1996), 76.

66. Gubar, *Racechanges,* 10.

67. *The Animated Poster* (Edison, 1903); *Barber's Dee-Lite* (AM&B, 1905).Viewed at the Library of Congress paper print collection.

68. This is especially clear in the many self-referential portrayals of male spectatorship in early cinema. Linda Williams discusses early pornographic slides in terms of a more body-centered model of vision in "Corporealized Observers: Visual Pornographies and the 'Carnal Density of Vision,'" in *Fugitive Images,* ed. Patrice Petro (Bloomington: Indiana University Press, 1995), 3–41.

69. Lauren Rabinovitz compares this film to others that involve various looking devices (binoculars, glasses, telescopes) and notes that the switch of power/looking relations recurs in various ways in early cinema. See Rabinovitz, *For the Love of Pleasure,* 87–89.

70. The servant is certainly played by an actor in blackface, but it was unclear to me whether it was a man or a woman. Given the typical practices at the time, and the physical stature of the actor, it was likely a man.

71. From *Biograph Bulletin* 55 (November 27, 1905): 12. Quoted in Nivers, *Biograph Bulletins, 1896–1908,* 202.

72. Jacqueline Stewart, *Migrating to the Movies,* 114.

73. For more on the history of the mammy figure and other black stereotypes in cinema, see Donald Bogle, *Toms, Coons, Mulattoes, Mammies, and Bucks* (New York: Continuum, 1990) and Patricia Turner, *Ceramic Uncles and Celluloid Mammies* (New York: Anchor, 1994).

74. Erik Barnouw, *The Magician and the Cinema* (New York: Oxford University Press, 1981), 92. Barnouw catalogs a number of these films under the heading "transformations." He lists films including Méliès's *The Living Playing Cards* (1904) and *A Mysterious Portrait* (1899), Biograph's *The Poster Girls,* and others.

75. Hansen, *Babel and Babylon,* 28.

76. Tom Gunning, "Embarrassing Evidence: The Detective Camera and the Documentary Impulse," in *Collecting Visible Evidence,* ed. Jane Gaines and Michael Renov (Minneapolis: University of Minnesota Press, 1999), 46–64.

77. *Biograph Bulletin* 67 (May 1, 1906). Reprinted in Nivers, *Biograph Bulletins, 1896–1908,* 242. The ad noted that the film was taken from the "recent experience of the Standard Oil magnate," and went on to emphasize the many rooms, modes of escape, and methods of disguise included in the film.

78. In his study of blackface in American cinema and culture, Michael Rogin argues that blackface allowed the white protagonists in films to "exchange selves"; the ability to wipe race on and off re-emphasized the fact that the new life offered to Old World (white) immigrants by the American dream depended upon a mobility that differentiated them from the fixed racial and social status of African Americans. See Rogin, *Blackface, White Noise: Jewish Immigrants in the Hollywood Melting Pot* (Berkeley: University of California Press, 1996).

2. Face, Race, and Screen

1. "Moving Picture Drama for the Multitudes," *Independent,* February 1908, 306–10.

2. "The Birth of a New Art," *Independent,* April 1914, 8.

3. For histories of the cinema's transitional era, see Eileen Bowser, *The Transformation of Cinema, 1907–1915,* vol. 2 of *History of the American Cinema,* ed. Charles Harpole (New York: Scribner's, 1990), and Charlie Keil, *Early American Cinema in Transition: Story, Style, and Filmmaking, 1907–1913* (Madison: University of Wisconsin Press, 2001). Keil and Bowser both point to the effort to uplift the cinema from its "low" reputation, and Keil traces two related trends in the trade press's efforts to do so: the increasing call for realism and the various strategies for comparing film to (and differentiating it from) theater. See Keil, *Early American Cinema,* 29–44.

4. "The Moving World," *Independent,* April 27, 1914, 165.

5. Bowser, *Transformation of Cinema,* 18–20.

6. Christian Metz, *Film Language: A Semiotics of the Cinema,* trans. Michael Taylor (New York: Oxford University Press, 1974), 249.

7. Ibid., 249.

8. Discussing the competition between theater and cinema in the transitional years, Roberta Pearson notes that theatergoing declined precipitously around 1912, with some blaming the movies. She suggests, however, that the victory of the cinema as a mass medium also freed the theater to focus on more "elite" audiences and productions. See Pearson, "The Menace of the Movies," in *American Cinema's Transitional Era: Audiences, Institutions, Practices,* ed. Charlie Keil and Shelley Stamp (Berkeley: University of California Press, 2004), 315–31.

9. Garrett Stewart argues for a recognition of the often ignored or bypassed photographic basis of cinema, arguing that the suppression (and occasional emergence) of the photogram is fundamental to cinematic meaning (and to a truly material/ textual theory of the cinema). Stewart's argument suggests the important connection between the cinema's repressed material base (the photogram) and the repressed stillness of cinematic motion. Looked at in this context, the familiar binary of narrative versus spectacle is preceded (and informed) by the more fundamental dialectic between stasis and motion, which is itself inextricably intertwined with questions of absence and presence in cinema, with "the photogram, rendered imperceptible on film in order to make cinema visible" (Garrett Stewart, *Between Film and Screen: Modernism's Photo-Synthesis* (Chicago: University of Chicago Press, 1999, 119). The intertwining of the shadow with the racialized body is another way to cover over that material fact by consecrating the screened "effect" of the technology as the cinematic "body" or essence.

10. The "close-up" existed in early motion pictures but was treated differently than in films from the transitional era and the early teens. Very early motion pictures—the *May-Irwin Kiss* (Edison, 1896), for example, or the numerous "facial expression" films—used close or enlarged views of the face, but typically for comic or exaggerated effect. Tom Gunning traces the roots of the close-up in photography and film to

forms of knowledge including physiognomy and scientific studies of the face, and to continuing notions that one could read spiritual or otherwise intangible truths on the surface of the face. See Gunning, "In Your Face: Physiognomy, Photography, and the Gnostic Mission of Early Film," *Modernism/Modernity* 4, no. 1 (1997): 1–29.

11. Musser, *Emergence of Cinema*, 75.

12. Edward Harrigan's *The Mulligan Guard Ball* was one of the most popular plays on the vaudeville stage in the late nineteenth century. It featured stock stereotypes of Irish, German, African American, and other ethnic groups and featured "Sim," an African American barber. The barbershop was one of the recurring settings for comic bits and mix-ups. Each ethnic group had its own "Guard" organization, and the plot revolved around a forbidden romance between a German boy and Irish girl; much ethnic and racial humor was generated by a mix-up involving the Irish ball and the African American ball being mistakenly booked for the same hall. Edward Harrigan, *The Mulligan Guard Ball* (1879), in *Dramas from the American Theatre: 1762–1909*, ed. Richard Moody (Boston: Houghton Mifflin, 1969). The play is excerpted with commentary and contextualized within nineteenth-century stage culture in Robert M. Lewis, *From Traveling Show to Vaudeville: Theatrical Spectacle in America, 1830–1910* (Baltimore: Johns Hopkins University Press, 2003), 96–102.

13. The decapitation trick was a popular one used in many different ways—perhaps most ingeniously by Méliès, whose films removed, duplicated, inflated, and exploded heads (usually his own). See, for example, *Un Homme de tetes* (*The Four Troublesome Heads*, 1898) and *L'Homme a la tete caoutchouc* (*The Man with the Rubber Head*, 1901). Erik Barnouw discusses the origins and various versions of this trick genre in *The Magician and the Cinema*, 85–105.

14. Both of these films can be viewed at the Library of Congress, where they are part of the paper print collection. Given the poor condition of the print I viewed, it is hard to tell whether the role of the black man in *The Barber's Queer Customer* was played by an African American performer or a white performer, but either way the actor was wearing dark makeup.

15. In this sense the film can also be linked to other changing-face films, such as *Fun in a Bakery* (Edison, 1902), a trick film in which a baker throws dough on the wall and proceeds to "sculpt" different faces out of it.

16. Douglas Walter Bristol, *Knights of the Razor: Black Barbers in Slavery and Freedom* (Baltimore: Johns Hopkins University Press, 2009), 106. According to Bristol, "in the North, the upper South, and the lower South, more than two-thirds of the white barbers in 1860 were foreign-born" (106). Bristol gives a comprehensive history of African Americans and the barbering trade from the slave era through the early twentieth century.

17. Gunning, "In Your Face," 24.

18. Ibid., 23.

19. Georg Simmel, *On Individuality and Social Forms: Selected Writings*, ed. Donald N. Levine (Chicago: University of Chicago Press, 1971), 359.

20. Georg Simmel, "The Aesthetic Meaning of the Face," in *Georg Simmel: 1858–1918: A Collection of Essays*, ed. Kurt Wolff (Columbus: Ohio State University Press, 1959),

276–81. A longer excerpt from Simmel's essay serves as the epigraph to Jacques Aumont's "The Face in Close-up," trans. Ellen Sowchek, in *The Visual Turn*, ed. Angela Dalle Vacche (New Brunswick, N.J.: Rutgers University Press, 2003), 127–48.

21. Deleuze, *Cinema 1*, 87.

22. "Life Boiled Down," *Motography*, April 1911, 5.

23. H. Z. Levine, "In the Moving Picture World: Madame Alice Blaché," *Photoplay*, March 1912, 38.

24. "Solax Burns Auto for Realism," *Photoplay*, June 1912, 69.

25. "Another Sensational Jump," *Photoplay*, July 1912, 72.

26. See Richard DeCordova, *Picture Personalities: The Emergence of the Star System in America* (Urbana: University of Illinois Press, 1990).

27. "Actress Lost Life Making This Film," *Motography*, August 1, 1914, 171.

28. Horace Plimpton, "Horace Plimpton vs. Reckless Realism," *Motography*, August 1914, 174.

29. On the increasing use of "close views," see Barry Salt, *Film Style and Technology* (London: Starword, 1983), and Charlie Keil, *Early American Cinema in Transition* (Madison: University of Wisconsin Press, 2001).

30. Roberta Pearson, *Eloquent Gestures* (Berkeley: University of California Press, 1992), 93.

31. For some examples of these reactions to close-ups, see Keil, *Early American Cinema in Transition*, 164 74.

32. Louis Reeves Harrison, "Eyes and Lips," *Moving Picture World*, February 18, 1911, 349.

33. "Europe's Foremost Star Now in Films," *Motography*, July 1914, 127.

34. Gunning, "In Your Face," 24.

35. "The Sign of the Rose," *Photoplay*, June 1915, 31–32. Beban's play *(The Sign of the Rose)* originated as a one-act play on the vaudeville stage. The better-known film featuring Beban, *The Italian* (1915), also produced by Ince and directed by Reginald Barker, features an entirely different plot, not based on Beban's play. I have not been able to locate a copy of *The Sign of the Rose*, but *The Italian* survives in its entirety and is available on DVD.

36. *AFI Film Catalog*, electronic resource, December 2010 release.

37. *Variety*, June 4, 1915, 18.

38. "The Feature Has a Future," *Moving Picture World*, August 14, 1915, 1166.

39. "George Beban Scores in 'Sign of the Rose,'" *New York Times*, October 12, 1911.

40. Ibid.

41. Rick Altman details the many kinds of sound associated with "silent" film in *Silent Film Sound* (New York: Columbia University Press, 2004). *The Sign of the Rose* was a planned and specific version of the combination of live actors and film; for an earlier and quite different effect known as "talker" films, see Jeffrey Klenotic, "'The Sensational Acme of Realism': 'Talker' Pictures as Early Sound Practice," in *The Sounds of Early Cinema*, ed. Richard Abel and Rick Altman (Bloomington: Indiana University Press, 2001) 156–67.

42. "Reflections of the Critic," *Photoplay*, June 1912, 71.

43. "The Sign of the Rose," *Photoplay,* June 1915, 32. There was much resistance in the early trades to the slang term "movie" (and, later, to "talkie"). Thus the tendency to gravitate toward names like "photoplay."

44. Gunning, "In Your Face," 23.

45. Harry Furniss, "Those Awful Cinematograph Faces," *Motography*, May 1913, 329. The article originally appeared in the British periodical the *Bioscope* and was republished in the American magazine. Subsequent references are cited parenthetically.

46. In his *Introduction to the Photoplay: 1920,* for example, Conrad Nagel praises Charles Ray as the "outstanding pantomimic artist of the silent screen." Like many other critics of his era, Nagel equates great pantomime with "a minimum of gestures and facial expressions." Cited in Richard Dyer MacCann, *The Stars Appear* (Metuchen, N.J.: Scarecrow Press, 1992), 27.

47. Gunning, "In Your Face," 23.

48. Blackface minstrelsy is, of course, still very much alive in 1913 and will continue to play a key role in the movies. If shifts in performance codes and shot scale evoke the ghost of blackface minstrelsy for Furniss, it does not signal cinema's demise, of course, but rather re-animates cinema's origins while also heralding its future. On the continuing role of blackface in cinema, see Rogin, *Blackface, White Noise;* on the meaning of the exaggerated facial features in the minstrel mask, see also Eric Lott, *Love and Theft: Blackface Minstrelsy and the American Working Class* (New York: Oxford University Press, 1995).

49. Jacques Aumont, "The Face in Close-Up" in *The Visual Turn,* ed. Angela Dalle Vacche (New Brunswick, N.J.: Rutgers University Press, 2003), 139.

50. Kwame Anthony Appiah, "The Uncompleted Argument: Du Bois and the Illusion of Race," in *Race, Writing and Difference,* ed. Kwame Anthony Appiah and Henry Louis Gates (Chicago: University of Chicago Press, 1986) 21–37.

51. Bela Belazs, "The Close-Up and the Face of Man," in Vacche, *Visual Turn,* 120.

52. Doane, "Close-Up," 89–111. Subsequent references are cited parenthetically.

53. Sabine Haenni, "Filming 'Chinatown': Fake Visions, Bodily Transformations," in Feng, *Screening Asian Americans,* 27. As Haenni has argued, early films featuring Chinatown sometimes belied the stereotype of the ancient, unchanging "Chinaman." A number of early Edison and Biograph shorts offered actualities and Chinatown scenes for the urban tourist, and while many of these do offer up the unchanging, ancient Chinese subject crucial to the stability of racial categories fueling early twentieth-century nativism, these depictions co-exist with other contradictory images. By parodying the urban tour as its subject, *The Deceived Slumming Party* offers an example of the way the cinema tended to "both capitalize on and differentiate itself from other leisure practices" (27). In other words, by referencing urban tours, but adding cinema-specific tricks (as when a woman is cranked through a sausage machine and then the sausage is "uncranked" back into a woman), the film displays simultaneously the transformative qualities of the cinema *and* Chinatown (or, more precisely, Chinatown as seen via the cinema).

54. Ibid., 40–42.

55. Lea Jacobs, "Belasco, DeMille, and the Development of Lasky Lighting," *Film History* 5 (December 1993): 405–18.

56. Ibid., 405.

57. Rogin, *Blackface, White Noise,* 118. In his work on blackface, Rogin argues for the relation between mobility and fixity. The white spectator (and especially the urban immigrant) gains mobility by taking on the mask of the most fixed and oppressed subject, the African American.

58. Henry James notes in his 1907 travelogue, *The American Scene* (which features his own version of "slumming" on the Lower East Side of New York), that the Italians, like "the Negro and the Chinaman," do not lose their "colour" so easily to the process of Americanization; he also lumps the Italians with the "Negro and the Chinaman" as "the human value most easily produced." James, *The American Scene* (New York: Penguin, 1994), 98.

59. Rony, *Third Eye,* 54.

60. I'm drawing here from two influential sources on *The Cheat:* Sumiko Higashi, "Ethnicity, Class, and Gender in Film: DeMille's *The Cheat,*" in *Unspeakable Images,* ed. Lester Friedman (Urbana: University of Illinois Press, 1991), 112–40; and Gina Marchetti, *Romance and the Yellow Peril: Race, Sex, and Discursive Strategies in Hollywood Fiction* (Berkeley: University of California Press, 1993), 10–46.

61. In its initial release, Tori was a Japanese character. Due to pressure from the Japanese (and the fact that Japan was America's ally in World War I) the character's nationality was changed for the 1918 release to Burmese. See Marchetti, *Romance and the Yellow Peril,* 18. Both Marchetti and Higashi discuss the film in the context of exclusionary U.S. immigration policies and shifting U.S. foreign policy toward the Pacific.

62. Daisuke Miyao, *Sessue Hayakawa: Silent Cinema and Transnational Stardom* (Durham, N.C.: Duke University Press, 2007), 203.

63. "Hayakawa," *New York Times,* October 5, 1919, 5.

64. "The Cheat," *Variety,* December 17, 1915, 18.

65. Miyao, *Sessue Hayakawa,* 203–4.

66. Miyao compares the stage directions in the script to the acting on screen, pointing out a number of examples where the script calls for particular expressions from Tori. He notes that Fanny Ward tends to make clear gestures and expressions according to the script's direction while Hayakawa's expressions remain more neutral or ambiguous. See ibid., 204–7.

67. Pearson, *Eloquent Gestures,* 27.

68. German Expressionist films also sometimes included shadow play work; I discuss this further in the next chapter.

69. Deleuze, *Cinema 1,* 87.

70. Ibid.

71. See D. N. Rodowick, *Gilles Deleuze's Time Machine* (Durham, N.C.: Duke University Press, 1997), for a good explanation of how Deleuze translates elements of Peirce's semiotic, especially in terms of image having material existence or co-substantiality with the thing itself. Deleuze's account in *Cinema 1* of Dreyer's *Joan of Arc* suggests the potentially "spiritual" dimension of the flattened image: "the more the image is

spatially closed, even reduced to two dimensions, the greater is its capacity to open itself on to a fourth dimension which is time, and on to a fifth which is Spirit" (17).

72. Jacques Aumont, cited in Doane, "Close-Up," 94.

73. Ibid.

74. Gilles Deleuze and Felix Guattari, *A Thousand Plateaus: Capitalism and Schizophrenia* (Minneapolis: University of Minnesota Press, 1987), 186. Deleuze specifically references the work of Josef von Sternberg and others who took advantage of the expressionistic style, here turning the face into an effect of light and shadow.

75. I am quoting various critics here, including Jean Epstein, Mary Ann Doane, Daisuke Miyao, and Béla Balázs. Even for Miyao, who deftly delineates the discourses producing the meaning of Hayakawa's performance styles, the actor's "mask-like facial expressions" in close-up "come to embody the tension between this stillness of photography and the flowingness of cinema or to problematize the innate contradiction of cinema: stillness and motion; timelines and timelessness" (206).

76. "The Cheat," 18.

77. On the reception of *Birth of a Nation,* see Janet Staiger, "*Birth of a Nation:* Reconsidering Its Reception," in *Birth of a Nation,* ed. Robert Lang, Rutgers Films in Print (New Brunswick, N.J.: Rutgers University Press, 1994), 195–214. For responses to *The Cheat* in Asian American communities, see Miyao, *Sessue Hayakawa,* 26–28.

78. Jacqueline Goldsby, *A Spectacular Secret: Lynching in American Life and Literature* (Chicago: University of Chicago Press, 2006), 227–28. Goldsby argues that not just the depiction of race difference or racist violence but the culture of lynching itself, was important to the intimacy of spectacles and audiences in the early years of the twentieth century.

79. Jean Epstein, "Magnification," in *French Film Theory and Criticism: A History/ Anthology, 1907–1939,* vol. 1: *1907–1929,* ed. Richard Abel (Princeton, N.J.: Princeton University Press, 1988), 239–40.

80. In this sense, we might compare and contrast Hayakawa's appeal to that of screen idol Rudolph Valentino, whose "Sheik" characters were eroticized (and racialized) objects of desire. See Miriam Hansen, "Pleasure, Ambivalence, Identification: Valentino and Female Spectatorship," *Cinema Journal* 25, no. 4 (Summer 1986): 6–32.

81. Haenni, *Immigrant Scene,* 179. Haenni discusses the clear differentiation between Hayakawa's Japanese characters (and the way his Japaneseness was promoted) and his Chinese characters in the Chinatown films he made with Lasky. As she notes, "the Japanese were seen as closer to being white than the Chinese" (176). I take this up further in the next chapter.

82. Colette, cited in Abel, *French Film Theory and Criticism,* 1:129.

83. Colette, *Colette at the Movies: Criticism and Screenplays,* trans. Sarah W. R. Smith, ed. Alain and Odette Virmaus (New York: Ungar, 1980), 19.

84. Colette, *Colette at the Movies,* 35. Miyao discusses this in detail in *Sessue Hayakawa,* 25–30.

85. In a different context, Michael Taussig has discussed the play of similarity and difference in early twentieth-century anthropology, in particular the way motion

picture cameras and phonographs were standard equipment on many encounters between Whites and native peoples, as were stories of natives' reactions to the "magic" of recording technologies. See Taussig, *Mimesis and Alterity: A Particular History of the Senses* (New York: Routledge, 1993).

86. Nathaniel Pfeffer, "Honolulu's Garish Night," *Photoplay,* July 1915, 147.

87. Bhabha, *Location of Culture,* 75; Christian Metz, "The Imaginary Signifier (excerpts)" in *Narrative, Apparatus, Ideology,* ed. Philip Rosen (New York: Columbia University Press, 1986), 244–78.

3. Recasting *Shadows*

1. *Moving Picture World,* November 11, 1922, 130–31.

2. Miyao, *Sessue Hayakawa,* 154.

3. For example: *The Secret Sin* (Lasky, 1915), *The City of Dim Faces* (Lasky, 1918), *The Chinatown Mystery* (NYMP, 1915), *The Tong Man* (Haworth, 1918); on Hayakawa and Chinatown films, see Haenni, *Immigrant Scene,* 169–89. For a discussion of Hayakawa's persona and stereotypes, see Donald Kirihara, "The Accepted Idea Displaced: Stereotype and Sessue Hayakawa," in *The Birth of Whiteness,* ed. Daniel Bernardi (New Brunswick, N.J.: Rutgers University Press, 1996).

4. Wilbur Daniel Steele's "Ching Ching Chinaman" originally appeared in the June 1917 issue of the *Pictorial Review.* Preferred Pictures ultimately went bankrupt, and B. P. Schulberg would become a top executive at Paramount Studios.

5. Cited in Anthony Slide, ed., *Selected Film Criticism* (Metuchen, N.J.: Scarecrow Press, 1982), 259.

6. *Moving Picture World,* October 7, 1922, 476.

7. Richard Koszarski, *An Evening's Entertainment: The Age of the Silent Feature Picture, 1915–1928,* vol. 3 of *The History of American Cinema,* ed. Charles Harpole (New York: Scribner, 1990), 9–63; 88–139. While the smaller motion picture houses still dominated outside the city centers in 1922, the move toward larger theaters playing one feature film a week was beginning and would be the norm only a few years later.

8. Lucy Fischer, *American Cinema of the 1920s: Themes and Variations* (New Brunswick, N.J.: Rutgers University Press, 2009), 1. On the year 1922 specifically, see Sara Ross, "1922: Movies and the Perilous Future," in Fischer, *American Cinema of the 1920s,* 70–95.

9. In using the term "yellowface," I am continuing the practice of critiquing caricatured portrayals of Asian or Asian American characters by white actors (and their use of makeup, exaggerated accents, costuming, etc.). The term "yellowface" has been used with the comparison to blackface in mind, as the practice has continued long after white actors performing in blackface was deemed unacceptable. See Krystyn Moon, *Yellowface: The Chinese in American Popular Music and Performance, 1850s–1920s* (New Brunswick, N.J.: Rutgers University Press, 2005) and Matthew Bernstein and Gaylyn Studlar, *Visions of the East: Orientalism in Film* (New Brunswick, N.J.: Rutgers University Press, 1997).

10. Since the Chinese Exclusion Act of 1882, Chinese immigrants had been barred from entering the United States. Initially covering a period of ten years, the exclusion

act was renewed indefinitely in 1902. More important legislation on immigration would be passed in the early 1920s, including the Cable Act (1922), which kept intact a law declaring that any American woman who married an Asian would lose her citizenship. In 1924, the U.S. Congress passed the Immigration Act (which drastically reduced immigration, especially from southern and eastern European countries, by imposing quotas) and the Oriental Exclusion Act, which prohibited most immigration from Asian countries. For the impact of the Chinese exclusion acts on American immigration policy in general, see Erika Lee, "The Chinese Exclusion Example: Race, Immigration, and American Gatekeeping, 1882–1924," *Journal of American Ethnic History* 21 (Spring 2002): 36–62.

11. Ross, "1922," 70.

12. The 1924 legislation reduced the number of immigrants allowed from a given country to a percentage of the number of people from that country residing in America in 1890 (when the number of immigrants from southern and eastern Europe were still relatively small). For a discussion of how eugenics informed immigration policy, see Jacobson, *Whiteness of a Different Color,* 77–91.

13. Moon, *Yellowface,* 38–40.

14. Linda Williams, "Surprised by Blackface: D. W. Griffith, Blackface, and *One Exciting Night,*" vol. 12 of *The Griffith Project,* ed. Paulo Cherchi Usai and Cynthia Rowell (London: Palgrave Macmillan, 2008): 122–39.

15. Both films feature a character that reveals the essential or spiritual truths hiding behind social masks. In the German film, an illusionist shows a group of partygoers the (potential) error of their ways by releasing their repressed desires, which are represented by their shadows. In her landmark study of German Expressionism, Lotte Eisner describes the work of the illusionist in *Warning Shadows:* "The little illusionist steals shadows and opens the flood-gates of the repressed unconscious desires of the other characters in the film, who suddenly start acting out their secret fantasies. In a momentous phantasmagoria, shadows temporarily replace living beings, who become for a time passive spectators." See Eisner, *The Haunted Screen: Expressionism in the German Cinema and the Influence of Max Reinhardt,* trans. Roger Greaves (Berkeley: University of California Press, 1969), 136.

16. Alice Van Leer Carrick, "Vogue for the Silhouette," *Country Life,* December 1922, 60–63.

17. "Resurrecting Chinese Movies a Thousand Years Old," *Current Opinion,* July 1921, 67.

18. This is consistent with treatments of China and Chinatown in film and theater. China was often treated as an ancient, rural world untouched by the anxieties and confusion of the modern city. And increasingly in the early twentieth century, Chinatowns were offered up as tourist destinations, where Chinese businesses catered to the exoticism of white patrons. In theatrical and filmic representations, as well as in urban leisure activities, China and Chinatown offered two sides of the same fantasy of otherness: ancient bucolic splendor on the one hand and a menagerie of exotic attractions on the other—both romanticized and cordoned off as oasis-like spaces for the white Western traveler or curiosity seeker. See Moon, *Yellowface,* 119–23, and Haenni, *Immigrant Scene,* 143–89.

19. Steele's writing tended to be pictorial in its descriptions. The story makes ample use of shadow imagery, and sometimes moments are more or less directly translated into film (such as a scene in which the minister can be seen in silhouette on his window shade). But the film extrapolates a great deal, adding additional shadow play moments, including in the climactic confession scene near the end of the film. In general, while shadows offer pictorial effect in the story, their thematic function is more central to the film, in part because the film aligns Yen Sin with the shadows much more explicitly than the story does.

20. See David Palumbo-Liu, *Asian/American: Historical Crossings of a Racial Frontier* (Stanford, Calif.: Stanford University Press, 1999), 6, 82. Palumbo-Liu traces the development of what he calls "Asian America" in terms of policies, semiotics, and the shifts in the national imaginary (and the contested status of Asian bodies in that imaginary) over the course of the twentieth century.

21. For example, in *Robetta and Doretto* (Edison, 1894), vaudeville comic acrobats Robetta and Doretto were featured playing "Chinese" characters in a staged comic bit in a Chinese laundry. The catalog description offered: "The pursuit of Hop Lee by an irate policeman." See the "Edison Motion Picture" collection on the Library of Congress American Memory website, http://memory.loc.gov/ammem/edhtml/edmvhm.html.

22. Barnouw, *Magician and the Cinema*, 19–32. Barnouw discusses these techniques in detail; he notes the use of real projection in these spectacles (anticipating special effects) as well as translucent screens made of gauze.

23. Michael Rogin has argued that the blackface in *The Jazz Singer* functions like the double or doppelganger figure in German Expressionism (he invokes *The Student of Prague*, and also Chaplin's *The Idle Class* for the double in the vaudeville/slapstick tradition). He notes that the blackface allows Jakie Rabinowitz to take on a new personality (Jack Robin) and that the double allows him to get what he wants (success, assimilation, his mother, and his girlfriend). What's interesting about the Asian figure is that the function of the shadow/doppelganger is displaced onto him, which effaces (rather than doubles) his existence. See Rogin, *Blackface, White Noise*, 73–121.

24. Bhabha, *Location of Culture*, 70.

25. Steele, "Ching Ching Chinaman," 109.

26. Moon, *Yellowface*, 119. Through much of the nineteenth century, the presentation of Chinese performers as "human curiosities" coexisted with those featuring exotic or skilled performers or whites performing increasingly familiar caricatures. See Moon, 59–64.

27. Sabine Haenni, "Filming 'Chinatown': Fake Visions, Bodily Transformations," in *Screening Asian Americans*, ed. Peter X. Feng, Rutgers Depth of Field Series (New Brunswick, N.J.: Rutgers University Press, 2002), 23.

28. As Matthew Jacobson points out, the case against eastern European or "Slavic" immigrants was often made by arguing their similarity to the Chinese or other Asian races. On the debates surrounding the 1911 Dillingham Commission Report's *A Dictionary of Race or Peoples*, see Jacobson, *Whiteness of a Different Color*, 39–91.

29. Liu, *Asian/American*, 84. For Park, the "marginal man" is cultured and interesting, but he tends to use the Jewish immigrant as the prominent example of the cultural hybridity that is equated with intelligence and modernity.

30. Robert E. Park, "Behind Our Masks," *Race and Culture*, vol. 1 of *The Collected Papers of Robert Ezra Park*, ed. Everett Cherrington Hughes et al. (Glencoe, Ill.: Free Press, 1950), 246–47.

31. On the intrinsic importance of race to the development of villain and victim status and "the American melodramatic mode," see Williams, *Playing the Race Card*.

32. Robert E. Sherwood, *The Best Motion Pictures of 1922–23* (Boston: Small, Maynard, 1923), 27–30, cited in Anthony Slide, *Selected Film Criticism* (Metuchen, N.J.: Scarecrow, 1982), 260.

33. Bhabha, *Location of Culture*, 82.

34. Cecil Holland, *The Art of Make-up for Stage and Screen* (Hollywood, Calif.: Cinematex, 1927), 70.

35. Moon, *Yellowface*, 130–42.

36. Holland, *Art of Makeup*, 98. The spectrum of blackface makeups can be seen fairly clearly, for example, in *Birth of a Nation*, in which the "dramatic" characters and villains wear dark but less exaggerated makeups, whereas the servants who perform comic scenes right out of blackface minstrelsy wear the more exaggerated minstrel mask. Linda Williams also discusses the multiple kinds of blackface used by Griffith in "Surprised by Blackface."

37. Park, "Behind Our Masks," 250.

38. "The Screen," *New York Times*, November 15, 1920.

39. Mordaunt Hall, "The Screen," May 16, 1927, in *New York Times Film Reviews, 1913–31*, 365. For another take on Chaney's persona, see Karen Randell, "Masking the Horror of Trauma: The Hysterical Body of Lon Chaney," *Screen* 44 (Summer 2003): 216–21. For biographical information and technical discussion of Chaney's innovations in makeup effects, see Robert G. Anderson, *Faces, Forms, Films: The Artistry of Lon Chaney* (South Brunswick, N.J.: Barnes, 1971).

40. Mordaunt Hall, "The Road to Mandalay," June 29, 1926; Mordaunt Hall, "The Screen; An Imaginative Crook," *New York Times*, March 26, 1928.

41. While Robert E. Sherwood named *Shadows* one of the best films of 1922, others were less impressed. *Variety* found *Shadows* comparable to Griffith's *Broken Blossoms*, but only for its "grimness"; the review summarily stamped the film "a feature of just ordinary weekly release caliber." *Variety*, November 2, 1922, in *Variety Film Reviews, 1921–25* (New Providence, N.J.: RR Bowker, 1983).

42. "Phantasmagoria and the Manufacturing of Illusions and Wonder: Towards a Cultural Optics of the Cinematic Apparatus" in *The Cinema, A New Technology for the 20th Century*, ed. André Gaudreault, Catherine Russell, and Pierre Veronneau (Lausanne: Editions Payot Lausanne, 2004), 31–44.

43. See Peter Brooks, *The Melodramatic Imagination: Balzac, Henry James, Melodrama, and the Mode of Excess* (New Haven, Conn.: Yale University Press, 1995), and Ben Singer, *Melodrama and Modernity: Early Sensational Cinema and Its Contexts* (New York: Columbia University Press, 2001).

44. In a way, Yen Sin offers a "theatrical" introduction/transition to the cinema in much the same way as movie theaters did in the 1920s. Movie palaces sprang up in the teens and twenties throughout the United States, culminating in 1927 with the opening of Grauman's Chinese Theater. Luxury movie houses were often built with "Oriental" themes—often meaning the Near East, with Egyptian themes but with some theaters using Chinese-inspired designs as well. As Lary May points out, the architecture and lobby design tended to mix many disparate elements, and the "Eastern" themes were certainly seen through a Western, Orientalizing lens. But the theatrical settings, paintings, and props in the lobby essentially offered an extension of (and preparation for) the movie experience. Even theaters that weren't designed in this style were often decorated according to the feature they were showing—often creating an exotic, theatrical "entrance" to the film for the moviegoer. For a discussion of Orientalism in early film theory, see Nick Browne, "Orientalism as an Ideological Form," *Wide Angle* 11 (October 1989): 23–31.

4. "Cinema at Its Source"

1. See Tom Gunning, "Doing for the Eye What the Phonograph Does for the Ear," in *The Sounds of Early Cinema*, ed. Richard Abel and Rick Altman (Bloomington: Indiana University Press, 2001), 16. Gunning contrasts the cultural and historical moment that saw the development of phonography and motion pictures to André Bazin's idealist notion of the "myth of total cinema." For an in-depth tracing of the cultural, perceptual, and technological intersections between sound and image recording and reproduction, see James Lastra, *Sound Technology and the Early Cinema* (New York: Columbia University Press, 2000). For a discussion of how nineteenth-century proto-cinematic devices were part of a larger cultural and historical moment in which the coherence of the human body and the reliability of the senses were being undercut, marking a profound shift in the positioning of the human subject as a firm center for cognition and understanding, see Crary, *Techniques of the Observer*.

2. Lastra, *Sound Technology*, 92.

3. Robert Benchley, "'Hearts in Dixie' (The First Real Talking Picture)," *Opportunity* 7 (April 1929), 122.

4. This and subsequent definitions are taken from the *Oxford English Dictionary*.

5. There has been in the past several years a concerted effort on the part of film scholars to redress the neglect of sound in the analysis of films and to be more attentive to the material conditions of silent cinema by exploring the way music, lectures, crowd noise, and other sounds formed part of the movie-going experience. Critics including André Gaudreault, Noel Burch, and Rick Altman have pointed out the way sound and image worked (and did not work) together in the early days of cinema, with Burch even noting the primacy of sound and the status of the image as an "appendage" to the phonograph in the years before the motion picture. See Norman King, "The Sound of Silents," in *Silent Film*, ed. Richard Abel, Rutgers Depth of Field Series (New Brunswick, N.J.: Rutgers University Press, 1996), 31–43.

6. "King Vidor Gambling on 'Hallelujah!,'" *Motion Picture News*, February 1929, 547.

7. King Vidor, *A Tree Is a Tree* (New York: Harcourt Brace, 1952), 175.

8. "The Birth of a New Art," *Independent,* April 6, 1914, 8.

9. Floyd C. Covington, "The Negro Invades Hollywood," *Opportunity* 7 (April 1929): 131. This article appeared in the same issue as the Benchley review of *Hearts in Dixie* and included a table listing the numbers of extras and wages paid according to Hollywood's Central Casting: "In general the wage scale of the contract group ranges from $25.00 per day to $300.00 per week and above. Perhaps the largest salaries paid to Negroes in the industry were those paid to principals of the two all-Negro talking pictures, 'Hearts in Dixie' . . . and 'Hallelujah.' . . . The salaries in some instances approximated $1,250 per week and above" (112).

10. "Employment of Colored Actors Reaches Peak," *New York Amsterdam News,* October 30, 1929, 9.

11. Vidor, *Tree Is a Tree,* 181.

12. "Silent Pictures Will Be an Antique in 30 Years, Says D. W. Griffith," *Exhibitors Herald-World,* January 19, 1929, 5.

13. Vidor, *Tree Is a Tree,* 175; Oswell Blakeston, "Black Fanfare," *Close Up* 2 (1929): 124.

14. Thomas Cripps, *Slow Fade to Black: The Negro in American Film, 1900–1942* (New York: Oxford University Press, 1977), 219–20.

15. Rogin, *Blackface, White Noise,* 90.

16. Michael Rogin, "Two Declarations of Independence," *Representations* 55 (Summer 1996): 21–22.

17. "Minstrel Show Next Vogue," *Motion Picture News,* March 1929, 618.

18. *The New York Times Film Reviews,* project manager Abraham Abramson, vol. 1 (New York: New York Times and Arno Press, 1970), 35.

19. *New York Times Film Reviews,* 54.

20. Rogin, *Blackface, White Noise,* 80.

21. Rogin, "Two Declarations of Independence," 13.

22. While many of the "black" characters in silent films were played by white actors in blackface, African American performers did play roles (albeit minor ones) in these early films—including the earliest short subjects and "actuality films."

23. Rick Altman, "MOVING LIPS: Cinema as Ventriloquism," *Yale French Studies* 60 (1980): 68. According to Altman, the "most important difference between silent and sound narrative film is the latter's increased proportion of scenes devoted to people talking—devoted, that is, to moving lips" (69).

24. The letters from Sherwood and other readers offering suggestions were collected under the heading "The Public and Industry Speak" in the January 5, 1929, issue of *Exhibitors Herald-World,* one of the earliest of the cinema's trade magazines. The magazine continued to publish these suggestions in the subsequent weeks.

25. "How Talkies Are Made," *Photoplay,* January 1930, 28. Subsequent references are cited parenthetically.

26. "Two New Types of Actors for Audien Seen by Director," *Exhibitors Herald-World,* February 16, 1929, 4, emphasis added.

27. Michael Chion, *The Voice in the Cinema,* trans. Claudia Gorbman (New York: Columbia University Press, 1999), 8.

28. Clyde Taylor, "The Re-Birth of the Aesthetic in Cinema," in Bernardi, *Birth of Whiteness*, 13. Taylor notes that by emphasizing the formal and historical benchmarks represented by films such as *Birth of a Nation* and *The Jazz Singer*, film historians have (implicitly and explicitly) argued for the separation of aesthetic and ideological concerns.

29. Throughout 1929, the *Exhibitors Herald-World* featured ads from competing studios in which they attempted to make their names synonymous with the talkies. They emphasized the number of talking films being produced and the amount of talking the films contained, and Paramount-Christie ads in particular boasted of its all-black cast productions in a way that suggested the all-black cast films were even more definitively talkie than other talkies, a way to trump the other studios.

30. Robert Herring, "Black Shadows," *Close Up* 2 (August 1929): 99.

31. "Stepin Fetchit" was the stage name of performer Lincoln Perry. For an account of his complex, controversial, and highly successful career, see Mel Watkins, *Stepin Fetchit: The Life and Times of Lincoln Perry* (New York: Random House, 2005). As Watkins describes, what began as a "doting" (75) relationship between Perry and the Hollywood studios (and between the actor and the black community) became more fraught and complicated in later years.

32. Kenneth MacPherson, "As Is," *Close Up* 2 (August 1929): 87–88. MacPherson edited the avant-garde film journal *Close Up* along with the novelist Bryher and the poet H.D. The journal ran from 1927 to 1933 and reflected the modernist sensibilities of its contributors, including an interest in psychoanalytic thought. The editors saw the coming of sound as the death of the cinema as an art form, but the "Negro in Film" number they published in 1929 celebrated what they saw as sound cinema's only hope. I discuss the journal's fetishization of race (and its anticipation of *Hallelujah!*) later in the chapter. For a general introduction to *Close Up*, see James Donald, Anne Friedberg, and Laura Marcus, eds., *Close Up, 1927–1933: Cinema and Modernism* (London: Cassell, 1998).

33. Benchley, "Hearts in Dixie," 122.

34. In his consideration of sound in the semiotics of cinema, Christian Metz theorizes the secondary status of the "aural object." The "primary qualities that determine the list of objects (substances)" (24) include the "visual and the tactile." Sound is subordinated to the visual, but it occupies the same experiential and linguistic field as some "secondary" visual phenomena: among secondary qualities he lists sounds, smells, and "even certain sub-dimensions of the visual order such as color" (28). The linguistic and phenomenological link Metz draws between sound and color is an interesting if not necessarily intuitive one. And their secondary status changes in the context of the early talkies. Here, race and sound both become prominent objects that the new cinema must serve. The very construction "Black voices" or "the Negro voice" demonstrates how race confuses the division between "primary" object and secondary attribute—because while "Negro" is a modifier here and "voice" the object, the voice is really only an object insofar as it registers race, which is the ultimate signified. See Metz, "Aural Objects," *Yale French Studies* 60 (1980): 24–32.

35. Benchley, "Hearts in Dixie," 122; Elmer Carter, "Of Negro Motion Pictures," *Close Up* 2 (August 1929): 119.

36. Cited in Cripps, *Slow Fade to Black*, 220.

37. I am referring here to the structure of disavowal that defines the fetishist's behavior: "I know very well, but just the same." See Christian Metz, "The Imaginary Signifier [Excerpts]," in *Narrative, Apparatus, Ideology,* ed. Philip Rosen (New York: Columbia University Press, 1986), 273. In other words, the fetish includes within it both the reminder and the denial of the lack (in this case the lack refers to the shortcomings of the apparatus, and more basically to the fact that the apparatus is standing in for the real thing—the absent objects reproduced on film).

38. Ibid., 268–69.

39. But in the wake of Laura Mulvey's "Visual Pleasure and the Narrative Cinema," feminist film theorists re-emphasized the gendered nature of the gaze in Freudian and Lacanian psychoanalysis. Mulvey theorized the "male gaze" of classic Hollywood cinema and identified fetishism as one of the strategies through which the castration threat (posed by the female stars on screen) is mitigated.

40. This is not to say that the fetishism of race exists apart from the sexual fetish or from a structure informed by gendered binaries. But in order to recognize the relevance of fetishism to the historical moment represented by Hollywood's all-black cast talkies, it is necessary to uncouple, at least momentarily, fetishism and gender.

41. Many critics have since suggested that this insistence on sex difference as the basic condition of the look has precluded the discussion of race in psychoanalytic film theory. Theorists including bell hooks and Lola Young have been more pointed in their criticism. In her work on what she calls the "oppositional gaze," hooks notes the (un)marked absence of black women from (white) feminist film theory. Lola Young notes that Mulvey's essay "is about white people's relationship to the look and cinema." With specific reference to the function of the fetish, Young points out that since African American women "have not been subject to overvaluation in the same sense that white women have," Mulvey's theory of the fetishization of the female star can only be applied to the white female. See Lola Young, *Fear of the Dark: "Race," Gender, and Sexuality in the Cinema* (New York: Routledge, 1996), 16–17. On the intersections and blind spots between race, psychoanalysis, and feminist critique, see also Jane Gaines, "White Privilege and Looking Relations, *Cultural Critique* 4 (Autumn 1986); Mary Ann Doane, *Femmes Fatales* (New York: Routledge, 1996); bell hooks, *Black Looks: Race and Representation* (Boston: South End, 1992); and Ann Pellegrini, *Performance Anxiety: Staging Psychoanalysis, Staging Race* (New York: Routledge, 1997).

42. Kaja Silverman, *The Acoustic Mirror: The Female Voice in Psychoanalysis and Cinema* (Bloomington: Indiana University Press, 1988), 46.

43. Benchley, "Hearts in Dixie," 122.

44. We can perhaps speak more precisely here about the performance of Fetchit's race, since his entire persona, in films and publicity, was a caricature of black stereotypes. As Cripps points out, Fetchit's accommodation of racist stereotypes was a large reason for the longevity of his career, as whites could accept him more easily than other black performers.

45. Silverman, *Acoustic Mirror*, 57–61.

46. In its first few years, the "talkie" was treated as an experiment by audiences and filmmakers alike. While *Variety* and other trade magazines were filled with articles predicting the death of silent movies, there were just as many that reflected industry caution. Most studios continued to make silent movies after the birth of synchronized sound, just in case the public taste tired of the novelty of talking pictures. This prolonged (and costly) uncertainty led to questionable strategies like the one offered to studios and exhibitors in a *Motion Picture News* headline from February 23, 1929: "Studio Executive Cautions, Provide for Quick Switch Back to Silent Pictures" (545).

47. Metz, "Imaginary Signifier," 272.

48. Ibid.

49. MacPherson, "As Is," 90.

50. Dismond mentions a rumored attempt by Paul Robeson to start a "Negro film corporation" called "Tono-film" that would make sound pictures. She also mentions the successful production companies that were making black-cast movies in 1929: "perhaps the three best known are The Micheaux Pictures Company of New York City. . . . The Colored Players Film Corporation of Philadelphia, a white concern . . . and the Liberty Photoplays, Inc., of Boston, a mixed company" ("The Negro Actor and the American Movies," *Close Up* 2 (August 1929): 96.

51. Benchley, "Hearts in Dixie," 122.

52. Covington, "Negro Invades Hollywood," 113.

53. Ibid., 112.

54. Cripps, *Slow Fade to Black*, 223–26.

55. *Photoplay*, May 31, 1929.

56. Herbert Howe, "Stepin's High-Colored Past," *Photoplay*, May 31, 1929, 123–25.

57. Silverman, *Acoustic Mirror*, 57.

58. "How Talkies Are Made," 32.

59. Metz, "Imaginary Signifier," 272, emphasis added.

60. Kenneth MacPherson was particularly interested in this dichotomy, and he exploited it in his 1930 film *Borderline*, starring Paul Robeson. See Susan McCabe, "Borderline Modernism: Paul Robeson and the Femme Fatale," *Callaloo* 25 (Spring 2002): 639–53.

61. Herring, "Black Shadows," 98.

62. Harry A. Potamkin, "The Aframerican Cinema," *Close Up* 2 (August 1929): 109.

63. Ibid.

64. "King Vidor Gambling," 545.

65. Dismond, "Negro Actor and the American Movies," 95.

66. Thomas Cripps chronicles the way in which the African American community slowly warmed up to the picture. He cites W. E. B. Du Bois, who critiqued the film's omission of the role of white oppression in the economic and social ills afflicting African Americans. But Du Bois "praised 'the scenes of religious ecstasy [which] rise to magnificent drama, unexcelled in my experience and singularly true to life'." Cripps, *Slow Fade to Black*, 252.

67. Vidor, *Tree Is a Tree*, 175.

68. This moment is particularly interesting for thinking about constructions of stardom in Hollywood and how black stars were treated both by the camera and by the publicity surrounding the studios and their actors. Nina Mae McKinney was highly eroticized, and Vidor himself clearly thought her particularly beautiful and talented (he picked her out of a chorus line, and in his memoirs he still recalls her as "third from the right in the chorus of the musical show 'Blackbirds' on Broadway" (177). While she receives similar treatment in this film as a white actress might, she also appears particularly grotesque at other moments—especially during her religious hysteria and her death—and she is shot in ways a white actress would not be in an American studio film.

69. Gilles Deleuze, *Cinema 1,* trans. Hugh Tomlinson and Barbara Habberjam (Minneapolis: University of Minnesota Press, 1986), 87.

70. "Vidor Hopes Film Will Vie with Best," *New York Amsterdam News,* January 16, 1929.

71. Herring, "Black Shadows," 104.

72. Rony, *Third Eye,* 54.

73. Ibid., 62.

74. On black performance, blackface minstrelsy, and racial masquerade in 1930s animation, see Nic Sammond, "Gentlemen, Please Be Seated: Racial Masquerade and Sadomasochism in 1930s Animation," in *Burnt Cork: Traditions and Legacies of Blackface Minstrelsy,* ed. Stephen Johnson (Amherst: University of Massachusetts Press, forthcoming 2012).

75. Tom Gunning points to the musical as one of the places where elements of the cinema of attractions went after the advent of classical style. See Gunning, "Cinema of Attractions."

Conclusion

1. James Hong is one of the most prolific and successful Asian American actors of the last several decades and has served as one of Hollywood's "go-to" actors for portraying all sorts of "Oriental" stereotypes in film and television. He began his career as the "Number One Son" in *The New Adventures of Charlie Chan,* a television series that premiered in 1957 and has played notoriously racist roles in films including *Blood Sport* 2 and 3 (1996) and *Big Trouble in Little China* (1986). The PBS documentary *Hollywood Chinese* (Arthur Dong, 2009) includes interviews with Hong and numerous other Asian American actors.

2. Red Digital Cinema, http://www.red.com.

3. Ibid.

4. For more on this, see Jody Duncan, "Love & War," *Cinefex,* July 2002, 60–130.

5. Interview with Ted Schilowitz at NAB (National Association of Broadcasters), *NextWaveDV,* April 15, 2011, http://www.nextwavedv.com. All of these new cameras are DSLRs, cameras designed to be both still cameras and motion picture cameras.

6. "Watch RED's Short Film 'Tattoo,' Shot on EPIC at 5k and Screened at NAB," *Business Week,* May 1, 2011, http://bx.businessweek.com/.

7. In truth, the image, once processed, is not equal to the raw images coming into any digital camera. So with 4k resolution, you wind up with an image that is not quite at the resolution of 35mm (it approximates this but doesn't exactly end up there); Red's claim is that Epic, by shooting in 5k, will output an image that equals 35mm.

8. Michael Behar, "Analog Meets Its Match in Red Digital Cinema's Ultrahigh-Res Camera," *Wired,* August 18, 2008, www.wired.com.

9. Ibid.

10. This can be viewed on YouTube, http://www.youtube.com/watch?v=4sTg-WZ7RXk. The film seems to function as porn, both for camera fetishists and just plain old fetishists. Posts range seamlessly from the quality of the images to the seemingly eternal quality of watching women and milk: as "DarkEmergence" put it in a comment from July 29, 2011: "God help me, I can't stop watching this." The Leonardo DiCaprio test can be viewed at http://www.youtube.com/watch?v=jJpLgdD7r3c. In the DiCaprio test, we can see a kind of reverse of the traditional screen test, in which the actor's face had to pass the test, to stand up on film. Here, the camera itself is under scrutiny, to see if it can stand the test of one of the world's most "cinematic" faces. The various camera tests for Red cameras posted on YouTube list anywhere from 7,000 to 25,000 views or more (as of July 2011). The films can be viewed on vimeo.com as well.

11. Shane Hurlburt, interview on "redcentre #56" podcast, February 16, 2011, http://www.fxguide.com/podcasts/.

12. Thomas Elsaesser and Malte Hagener, *Film Theory: An Introduction through the Senses* (New York: Routledge, 2010), 175.

13. The influential "media convergence" model elucidated by Henry Jenkins, for example, essentially extended an industry term (describing the "convergence" of previously discrete media as a result of the Internet and mobile devices) in order to define the accompanying model of spectatorship that blurs the boundary between consumers and producers, potentially shifting the power dynamic. Not only could previously "passive" spectators now comment upon, remix and share TV, movies, music, etc., but they could also exert a certain amount of control over the content and destiny of programming formerly controlled by networks, broadcasters, and producers. See Henry Jenkins, *Convergence Culture* (New York: New York University Press, 2006).

14. Doane, "Close-Up," 110.

15. Todd McCarthy, "Avatar," *Variety,* December 10, 2009, www.variety.com.

16. Kristen Whissel, "Digital Visual Effects and Popular Cinema: An Introduction," *Film Criticism* 32, no. 1 (2007): 3.

17. The film took in a record-setting $77 million domestically in its opening weekend and ended up grossing over $2 billion worldwide, breaking the previous record set by Cameron's *Titanic,* according to *Variety.*

18. Several versions of this spot were cut for television. A number of different versions can be viewed on YouTube. The one I reference is listed as "Avatar—TV spot #17."

19. Kenneth Turan, "A Dazzling Revolution," *Los Angeles Times,* December 17, 2009, http://articles.latimes.com /2009/dec/17/entertainment/la-et-avatar17-2009dec17.

20. Since the release of *Avatar*, Cameron has also lent his fame to environmental crusades, including supporting the indigenous people in a fight to stop the damming of the Xingu River in Brazil and a visit to the Alberta oil sands in Canada at the invitation of the Indigenous Environmental Network and the Cree Nation in 2010. See Alexei Barrionuevo, "Tribes of Amazon Find an Ally out of 'Avatar,'" *New York Times*, April 10, 2010, www.nytimes.com/2010/04/11/world/americas/11 brazil.html.

21. Carol Kaesuk Yoon, "Luminous 3-D Jungle Is a Biologist's Dream," *New York Times*, January 19, 2010, D1.

22. Siegfried Kracauer, *Theory of Film* (Oxford: Oxford University Press, 1960). Kracauer and Walter Benjamin both turn to the notion of film as microscope, bringing the world and its typically unseen movements into view, as in Benjamin's notion of the "optical unconscious." See "The Work of Art in the Age of Mechanical Reproduction," in Walter Benjamin, *Illuminations*, trans. Harry Zohn (New York: Knopf, 1968).

23. *Capturing Avatar* on *Avatar* (U.S., James Cameron, 20th Century Fox, 2009), Extended Blu-Ray Collector's Edition, 20th Century Fox Home Entertainment, 2010.

24. Todd McCarthy, "Avatar," *Variety*, December 10, 2009.

25. Manhola Dargis, "A New Eden, Both Cosmic and Cinematic," *New York Times,* December 17, 2009, http://movies.nytimes.com/2009/12/18/movies/18avatar.html.

26. In her 1993 essay "Early Cinema, Late Cinema," Miriam Hansen noted that complaints about talking in movie theaters had reached its highest point since the silent era. Now, it is more common to see teens (and others) texting while watching films, a quieter but even more distracting activity. See Hansen, "Early Cinema, Late Cinema: Permutations of the Public Sphere," *Screen* 34 (Autumn 1993): 197–210.

27. Jean-Louis Baudry, "The Apparatus: Metapsychological Approaches to the Impression of Reality in the Cinema," in *Narrative, Apparatus, Ideology,* ed. Philip Rosen (New York: Columbia University Press, 1986), 316.

28. Many articles and interviews note that James Cameron's favorite film is *The Wizard of Oz*. The film makes many references to the film, from including the line "you're not in Kansas anymore," to the fact that Jake wakes up in an alien land defined mostly by its vivid colors.

29. Jake also resembles another famous sleeping hero/spectator: Jeffries (James Stewart), the protagonist of *Rear Window* (Alfred Hitchcock, 1954). Like Hitchcock's definitive voyeur, Jake is wheelchair bound; and like Jake, Jeffries falls asleep a lot, making the world across the way seem like something of his own creation, something he "dreamed up." The hero of *Rear Window* became a darling of film studies precisely because his predicament rendered him entirely scopic in nature, fully aligned with the camera (he is a photographer by profession) and thus ripe for psychoanalytically informed analyses of voyeurism and scopophilia. He also, of course, gets to "participate" in the action by using another body—his "avatar" is his girlfriend, Lisa (Grace Kelly). Laura Mulvey discusses *Rear Window* in her groundbreaking essay, "Visual Pleasure and Narrative Cinema," *Screen* 16, no. 3 (1975): 6–18; see also, for example, Tania Modleski's discussion of *Rear Window* in *The Women Who Knew Too Much* (New York: Methuen, 1988), 73–87.

30. The role earned Serkis a great deal of attention, and he is generally considered to have "played" Gollum, rather than just voicing the character. This marked a shift in how actors would be credited for these sorts of roles. Serkis would go on to do a number of other digital roles using motion and performance capture, including playing Caesar the chimp in *Rise of the Planet of the Apes* (Fox, Rupert Wyatt, 2011).

31. Joe Fordham, "Middle Earth Strikes Back," *Cinefex* 92 (January 2003): 78.

32. Lisa Purse, "Digital Heroes in Contemporary Hollywood: Exertion, Identification, and the Virtual Action Body," *Film Criticism* 32 (Fall 2007): 10.

33. Cameron's comments taken from *Capturing Avatar* (Laurent Bouzereau, 2010), Disc 2, *Avatar* Collector's Edition Blu-Ray, directed by James Cameron, 20th Century Fox Home Entertainment, 2010. The term "uncanny valley" is usually credited to Masahiro Mori, who coined the term when speaking of the appearance of robots in 1970. This problem is perhaps part of the reason why digital creatures have so often been associated with death in mainstream films, as Kristen Whissel has argued. Whissel, "Vitalizing Technologies: The Life and Death of Digital Creatures" (paper, Society for Cinema and Media Studies Conference, March 11, 2011).

34. Rosengrant, quoted in Jody Duncan, "The Seduction of Reality," *Cinefex*, January 2010, 109.

35. From an interview with Cameron in *Capturing Avatar*. For comments on the sexiness of the Na'vi, see the aforementioned reviews in *Variety, New York Times,* and the *Los Angeles Times,* for example.

36. "From Gollum to 'Avatar,'" *Economist*, June 10, 2010, http://www.economist.com/node/16295602.

37. Fordham, "Middle Earth Strikes Back," 78.

38. Ibid., 78–80. Parallels between the motion capture of today and late nineteenth-century motion studies (especially those of Étienne-Jules Marey) have been noted; and here, in facial expression, we see again the similarities. In an effort to tame the face, they also looked into the work of Paul Ekman, a psychologist who "break[s] down the face into "action units" of neurological and muscular combinations" (78–80). Certainly, Georg Simmel would be vindicated (as would Deleuze) both by the endless difficulty posed by the face in the realm of "motion capture" and by the efforts to "break it down" into "units."

39. Duncan, "Seduction of Reality," 138.

40. Murtha, quoted in Andrew Penn Romine, "Digital Lifeforms: Creating the Characters of Avatar and Tron: Legacy," *Lightspeed Magazine,* February 2011, http://www.lightspeedmagazine.com.

41. Duncan, "Seduction of Reality," 135. Quotation attributed to Andy Jones, one of the art directors on *Avatar.*

42. See, for example, Alex Ben Block, "Why Oscar Chose 'Hurt Locker' over 'Avatar,'" *Reuters*, March 8, 2010, www.reuters.com.

43. From the interview with James Cameron in *Capturing Avatar.*

44. From *Capturing Avatar.*

45. Duncan, "Seduction of Reality," 70.

46. Ibid., 137.

47. André Bazin, "The Ontology of the Photographic Image," *What Is Cinema?*, vol. 1, trans. and ed. Hugh Gray (Berkeley: University of California Press, 1967), 9.
48. Stephen Prince, "True Lies: Perceptual Realism, Digital Images, and Film Theory," *Film Quarterly* 49 (Spring 1996): 29–30.
49. Lev Manovich, *The Language of New Media* (Cambridge, Mass.: MIT Press, 2001), 299.
50. Tom Gunning, "What's the Point of an Index? or, Faking Photographs," in *Still Moving: Between Cinema and Photography*, ed. Karen Beckman and Jean Ma (Durham, N.C.: Duke University Press, 2008): 23–40.
51. Bazin, "Ontology of the Photographic Image," 14.
52. Stephen Prince, "True Lies," 30.
53. Duncan, "Seduction of Reality," 110.
54. According to the actor's bio on the Internet Movie Database (imdb.com), Studi was born in Norfire Hollow, Oklahoma, "where he exclusively spoke his native Cherokee language until beginning school at age five." Pounder is listed as having been born in Guyana, but moving to the United States "while she was still a young girl."
55. Indeed, Cameron, Landau, and others often describe the digital characters as "CG makeup" or "a 21st century version of prosthetics." See Duncan, "Seduction of Reality, 72. See also *Capturing Avatar.*
56. Adam Sage, "French Film Industry Racist for Barring Black Actors from Dubbing White Stars," *Times* (London), January 2, 2009, http://www.thetimes.co.uk.
57. Duncan, "Seduction of Reality," 117.
58. Julie Bloom, "Questions for Lula Washington, Who Helped 'Avatar' Move," *New York Times*, January 27, 2010, http://artsbeat.blogs.nytimes.com/tag/lula-washington/.
59. David Brooks, "The Messiah Complex," *New York Times*, January 8, 2010, A27.
60. Ezili Danto, "Black Avatar: The Avatar Movie from a Black Perspective," *Pacific Free Press*, January 4, 2010, http://www.pacificfreepress.com /news/1/5331-black-avatar.html.
61. Will Heaven, "James Cameron's Avatar Is a Stylish Film Marred by Its Racist Subtext," *Telegraph* (London), December 22, 2009, http://blogs.telegraph.co.uk/news/willheaven/100020488.
62. John Podhoretz, "Avatarocious," *Weekly Standard*, December 28, 2009, http://www.weeklystandard.com.
63. Duncan, "Seduction of Reality," 107. This was also part of Weta's stated expertise and loving attention to creating a culture and to "know[ing] the history of a people" (107). They mean creating a history of a fictional people, but they (and fans of sci-fi/fantasy genres more generally) take this cultural knowledge very seriously, with the *Lord of the Rings* trilogy having been their proving ground.
64. Ibid., 128.
65. For a discussion of Robert Flaherty as a hunter of images, see Rony, *Third Eye*, 99–129.
66. Duncan, "Seduction of Reality," 86.
67. Lisa Nakamura, "Cyberrace," *PMLA* 123, no. 5 (2008): 1675.
68. Ibid., 1679.

69. Nowhere does the film suggest that Jake's actual body might be a satisfactory one to inhabit. On the "disabled body" itself functioning as a prosthetic device in literary and cultural discourse, see David T. Mitchell and Sharon L. Snyder, eds., *Narrative Prosthesis: Disability and the Dependencies of Discourse* (Ann Arbor: University of Michigan Press, 2001).

70. For an important take on this operation in the context of the history of anthropology, see Taussig, *Mimesis and Alterity.*

71. For a discussion of race and the genealogy of American animation, see Nic Sammond, "Gentlemen, Please Be Seated: Racial Masquerade and Sadomasochism in 1930s Animation," in *Burnt Cork: Traditions and Legacies of Blackface Minstrelsy,* ed. Stephen Johnson (Amherst: University of Massachusetts Press, forthcoming).

72. Dargis, "New Eden," 3.

73. I refer here to the "Classical Hollywood Narrative" sketched, for example, by David Bordwell, Kristin Thompson, and Janet Staiger in *The Classical Hollywood Cinema: Film Style and Mode of Production to 1960* (New York: Columbia University Press, 1985) and re-examined for its exclusion of certain popular genres including the "woman's picture," the musical, horror films, and other examples of what Linda Williams has called "body genres." See Williams, "Film Bodies: Gender, Genre, and Excess," *Film Quarterly* 44 (Summer 1991): 2–13.

FILMOGRAPHY

The Adventures of Prince Achmed. Dir. Lotte Reiniger. Germany. UFA, 1926.

Animated Picture Studio. Cecil Hepworth. American Mutoscope and Biograph, 1903.

The Animated Poster. Edison Manufacturing Company, 1903.

Avatar. Dir. James Cameron. 2009. Collector's Edition Blu-Ray. 20th Century Fox Home Entertainment, 2010.

Barber's Dee-Lite. American Mutoscope and Biograph, 1905.

The Barber Shop. Edison, 1893.

The Barber's Queer Customer. American Mutoscope and Biograph, 1900.

The Big Swallow. James Williamson, 1901.

Birth of a Nation. Dir. D. W. Griffith. D. W. Griffith Corp., 1915.

The Black Diamond Express. Edison Manufacturing Co., 1896.

Blackmail. American Mutoscope and Biograph, 1905.

Bowery Kiss. Edison Manufacturing Co., 1901.

Bowery Waltz. Edison Manufacturing Co., 1897.

A Bucket of Cream Ale. American Mutoscope and Biograph, 1904.

Capturing Avatar. Dir. Laurent Bouzereau. *Avatar* Collector's Edition Blu-Ray. 20th Century Fox Home Entertainment, 2010.

The Cheat. Dir. Cecil B. DeMille. Lasky, 1915.

The Chimney Sweep and the Miller. American Mutoscope and Biograph, 1900.

Chinese Rubbernecks. American Mutoscope and Biograph, 1903.

The Clumsy Photographer. Pathé, 1906.

Countryman and the Cinematograph. Robert Paul, 1901.

The Deceived Slumming Party. Dir. D. W. Griffith. American Mutoscope and Biograph, 1908.

A Drop of Ink. American Mutoscope and Biograph, 1904.

Facial Expression. Edison Manufacturing Co., 1902.

Fire Dance. Gaumont, 1906.

Flour and Feed. American Mutoscope and Biograph, 1904.

Fun in a Bakery. Edison Manufacturing Co., 1902.

Fun in a Photograph Gallery. American Mutoscope and Biograph, 1902.

Girl at the Window. American Mutoscope and Biograph, 1903.

Hallelujah! Dir. King Vidor. MGM, 1929.

Happy Days. Dir. Benjamin Stoloff. Fox, 1929.

A Hard Wash. American Mutoscope and Biograph, 1896.

Haverstraw Tunnel. American Mutoscope and Biograph, 1897.

Hearts in Dixie. Dir. Paul Sloane. Fox, 1929.

Hooligan Assists the Magician. Edison Manufacturing Co., 1900.

How a French Nobleman Got a Wife through the New York Herald "Personal" Columns. Edison Manufacturing Co., 1904.

How Charlie Lost the Heiress. American Mutoscope and Biograph, 1900.

How They Do Things on the Bowery. Edison Manufacturing Co., 1902.

The Jazz Singer. Dir. Alan Crosland. Warner Bros., 1927.

A Kiss in the Dark. American Mutoscope and Biograph, 1904.

Kiss Me! American Mutoscope and Biograph, 1904.

L'Arrivée d'un Train. Lumière, 1895.

Let Uncle Ruben Show You How. American Mutoscope and Biograph, 1904.

The Living Playing Cards. Méliès, 1904.

Lord of the Rings: The Two Towers. Dir. Peter Jackson. New Line, 2003.

The Magic Pill. Lubin, 1908.

The Maniac Barber. American Mutoscope and Biograph, 1899.

The Miller and the Sweep. Hepworth, 1897.

The Miracle Man. Dir. George Loane Tucker. Mayflower Photoplay Co., 1919.

Mixed Babies. American Mutoscope and Biograph, 1908.

A Morning Bath. Edison Manufacturing Co., 1896.

Mr. Wu. Dir. William Nigh. MGM, 1927.

A Mysterious Portrait. Georges Méliès, 1899.

Nanook of the North. Robert Flaherty, 1922.

Old Maid Having Her Picture Taken. Edison Manufacturing Co., 1901.

One Exciting Night. Dir. D. W. Griffith. D. W. Griffith Productions, 1922.

One Girl Swinging. American Mutoscope and Biograph, 1897.

One Way to Take a Girl's Picture. American Mutoscope and Biograph, 1904.

Parisian Dancer. Edison Manufacturing Co., 1897.

Peeping Tom. American Mutoscope and Biograph, 1897.

Peeping Tom in the Dressing Room. American Mutoscope and Biograph, 1905.

The Penalty. Dir. Wallace Worsley. Goldwyn, 1920.

Personal. American Mutoscope and Biograph, 1904.

Photographing a Country Couple. Edison Manufacturing Co., 1902.

The Picture the Photographer Took. American Mutoscope and Biograph, 1904.

The Poster Girls. American Mutoscope and Biograph, 1899.

Princess Ali. Edison Manufacturing Co., 1895.

Pull Down the Curtain, Susie. American Mutoscope and Biograph, 1904.

Queen Christina. Dir. Rouben Mamoulian. MGM, 1933.

Sabotage. Dir. Alfred Hitchcock. Gaumont British Film Corporation, 1936.

Sandow. Edison Manufacturing Co., 1894.

Shadows. Dir. Tom Forman. Preferred Pictures, 1922.

The Sign of the Rose. Dir. Reginald Barker. New York Motion Picture, 1915.

Silhouette Scene. American Mutoscope and Biograph, 1903.

Singin' in the Rain. Dir. Stanley Donen and Gene Kelly. MGM, 1952.

Sioux Ghost Dance. Edison Manufacturing Co., 1894.

Star Wars Episode II: Attack of the Clones. Dir. George Lucas. 20th Century Fox, 2002.

The Story the Biograph Told. American Mutoscope and Biograph, 1904.

Strangers on a Train. Dir. Alfred Hitchcock. Warner Bros., 1951.

A Street Arab. Edison Manufacturing Co., 1898.

The Student of Prague. Dir. Henrik Galeen. Germany, UFA, 1926.

The Subpoena Server. American Mutoscope and Biograph, 1906.

Swing Time. Dir. George Stevens. RKO, 1936.

Tattoo. Dir. Bill Paxton. Red Studios Hollywood, 2011.

The Unappreciated Joke. Edison Manufacturing Co., 1903.

Uncle Josh at the Moving Picture Show. Edison Manufacturing Co., 1902.

Warning Shadows. Dir. Arthur Robison. Germany. Pan-Film, 1923.

What Demoralized the Barber Shop. Edison Manufacturing Co., 1897.

What Happened in the Tunnel. Edison Manufacturing Co., 1903.

What Happened on 23rd Street. Edison Manufacturing Co., 1901.

INDEX

Abrams, J. J., 213
Academy Awards, 1, 206
acting, 81–86, 89, 93, 97–98, 120, 127, 140, 142, 164, 180, 206–7, 210, 216. *See also* performance styles
Adventures of Prince Achmed, The, 126
affection-image, 80, 100, 102
Africa, 124, 212, 214
African American performers: in contemporary film, 211–13, 214; in talkies, 154–55, 158–62, 165–68, 170, 171, 172, 251n68; on stage, 138. *See also* black-cast films; "black voice"
African Americans, 10–11, 36, 78, 156, 160, 175, 176, 213, 220, 250n66
Ailey, Alvin, 213
Alonso, Laz, 211
Amos 'n' Andy, 186
Animated Picture Show, 18–28, 29, 34, 222
Animated Poster, The, 54, 59–61
animation, 88, 126, 203, 205, 208, 221
anthropology, 32, 95, 180, 202, 217, 232n30, 241–42n85
apparatus, cinematic, 13, 28, 83, 94, 152, 158, 166–70, 181, 183, 193, 194, 200, 221
apparatus theory, 200–201
art, film as, 71, 73, 81, 95
Asian Americans, 115, 129, 220, 221
Asian shadow puppetry, 95, 96, 127, 129, 145, 151

assimilation, 113, 132, 134
Astaire, Fred, 185
audience, 14–16, 24–25, 38–39, 73, 76, 88, 109–14, 116–22, 132, 143, 151–52, 163, 170, 185, 195–97, 222
authenticity, 13–14, 138, 156, 180, 206, 210, 214–15, 216, 219, 221
Aumont, Jacques, 91, 92, 100
Avatar, 196–222, 253n20. *See also* indigenous peoples; performance capture

Balázs, Béla, 92
Barber's Dee-Lite, The, 54, 75, 78
Barber Shop, The, 75
barbershop films, 74–80
Barber's Queer Customer, The, 76–78, 77, 79
Barrymore, Lionel, 164
Baudry, Jean Louis, 200
Bazin, André, 208–9, 229n32
Beban, George, 85–87
Beckman, Karen, 21, 23, 230
Benchley, Robert, 156, 157, 166, 168, 170
Bergson, Henri, 31
Berkeley, Busby, 185, 217
Bhabha, Homi, 4, 51, 115, 136
Big Swallow, The, 46
Biograph, 37, 39, 48, 65, 129
Birth of a Nation, 71, 85, 94, 110, 124
Blaché, Alice, 81–82

black-cast films, 16, 154–61, 165, 170, 172, 174, 180, 183, 185, 221, 248n29. See also *Hallelujah!*; *Hearts in Dixie*; talkies

Black Diamond Express, The, 25

blackface, 41, 53, 67–68, 90, 124–25, 137–38, 139, 154, 160–61, 180, 185, 198, 235n70, 239n48, 244n23, 245n36

Blackmail, 64–65

blackscreen, 46–48, 102, 103

"black voice," 16, 155–58, 167, 170, 180, 186, 212–13, 221, 248n34

bodies: black, 16, 158, 161, 167, 169, 172, 174, 182, 183; disabled, 256n69; female, 51, 75–76, 79, 230; performing, 2, 70, 82, 88; racialized, 2, 9–10, 75, 119, 129, 151–52, 183, 194, 199, 213, 220; severance of, 79–80, 237n13. *See also* faces; movement

Boothe, Powers, 187

Borelli, Lyda, 84

Bowery Kiss, 30

Bowery Waltz, 30

Bucket of Cream Ale, A, 36

Buddhism, 131

Burch, Noel, 27, 33–34, 37, 38

burlesque, 3, 59, 75, 83, 88, 90, 159, 160, 164, 172

camera, stationary, 3, 29–31, 158–59, 161, 219. *See also* movement

Cameron, James, 17, 196, 197, 198, 202, 204–16, 220, 253n20

Capturing Avatar, 198, 207, 215, 220

Carter, Elmer, 167, 170

casting, and race, 210–12

catalogs, 3, 23, 36, 56, 76, 85

Chaney, Lon, 16, 116, 117, 119, 121, 122, 125, 137, 139–40, 148, 171. See also *Miracle Man, The*; *Mr. Wu*; *Penalty, The*; *Shadows*

Charisse, Cyd, 185

chase films, 33, 41, 66–68, 233n42

Cheat, The, 15, 73, 93–112, 116, 125, 184, 194. *See also* Hayakawa, Sessue; "Oriental"; shadows; silent era

Chicago, 175

Chimney Sweep and the Miller, The, 34–36, 38, 40, 41

Chinatown, 94, 129, 187, 239n53, 243n18

Chinese: in film, 10, 116, 117, 118, 129, 131, 140, 187, 239n53; immigrants, 16, 96, 123, 134, 227–28n22, 242–43n10; stereotype, 119, 121, 131, 187. *See also* Orientalism; yellowface

Chinese Rubbernecks, 94

"Ching Ching Chinaman," 116, 118, 127, 131

Christianity, 109, 121, 122, 136, 145, 146

Christie, Al, 172

chronophotography, 32

cinema of attractions, 6, 8, 9, 21, 41, 52, 75, 78, 89, 193, 216, 233n37

cinematic apparatus. *See* apparatus, cinematic

cinematograph, 5

cinematography, 154, 161, 188, 189, 190

Citizen Kane, 190

class, 7, 26–27, 28, 64, 228

classical cinema, 8, 12, 17, 38, 69, 70–71, 74, 93, 119, 168, 169, 222–23. *See also* studio era

Close Encounters of the Third Kind, 188

Close Up, 165, 170, 174, 175, 248n32

close-ups, 70, 71, 73, 79–93, 100, 102, 105, 111–12, 177–80, 236–37n10

Clumsy Photographer, The, 27

Clune's Auditorium, 85

colonialism, 4, 51–52, 115

"comparative racialization," 228–29n26

computer-generated (CG) characters, 203–5, 207, 210, 212

Conrad, Joseph, 214

contrast, 3, 11, 28, 36, 47, 148, 158, 161, 193

Countryman and the Cinematograph, The, 23

Crafton, Donald, 41–42

Crary, Jonathan, 153, 226n12, 229n1

dance, 1, 30, 176, 177, 181, 182, 185, 213, 230n4

Danto, Ezili, 214

Dargis, Manhola, 200

Deceived Slumming Party, The, 94, 239n53

Deleuze, Gilles, 9, 29–31, 80, 92, 99, 100, 179, 231n21

DeMille, Cecil B., 73, 94, 95, 110, 119

DePriest, Oscar, 175

DiCaprio, Leonardo, 193, 252n10

digital cinema, 189, 191, 194–96, 217, 220

disability, 256n69

disguise, racial, 9, 10, 66–68, 117, 119, 121, 138–40, 152, 197, 215, 217. *See also* blackface; yellowface

Dismond, Geraldyn, 170, 175

Doane, Mary Ann, 12, 92–93, 101, 195

double exposures, 18, 61, 132, 150, 161

dreams, 185, 200–201

Du Bois, W. E. B., 51, 175

Edison Manufacturing Co., 3, 11, 19, 23–24, 28, 30, 46, 49, 75, 82, 153

editing, 26, 50, 61, 147, 161

embodiment, 13, 14, 74, 102, 104, 109, 152, 176, 194, 201, 219

Epstein, Jean, 92, 111–12

essence, 29, 31–34, 81, 95, 101, 110, 158, 194

"Ethnographic Body," 6, 46, 182–83. *See also* Rony, Fatimah Tobing

ethnography, 32, 95, 96, 124, 217, 232n30

Exhibitors Herald-World, 162, 165, 172–73, 248n29

exoticism, 6, 28, 113, 123, 135, 243

expressionistic style, 99–100, 117, 119, 148, 176

extra-filmic materials, 10, 199, 210, 211

faces, 80–81, 83–84, 88–91, 100, 108–9, 121, 138, 177, 179, 186, 203, 204. *See also* close-ups

Facial Expression, 30

fade to black, 46–48, 50, 52, 58

Famous Players–Lasky, 118, 119

Fanon, Franz, 51–52

feature films, 70–71, 74, 80, 86, 87, 95, 118, 120, 221

feminist film theory, 7, 9, 114, 167–68, 227n18, 231n15

Fetchit, Stepin, 156, 162, 165–69, 171–72, 183, 248n31, 249n44

fetish, 45, 51–52, 104, 114–15, 156, 158, 167–70, 174, 216, 249n37, 249nn40–41, 252n10

Fincher, David, 188, 193

Flaherty, Robert, 123, 124, 215

Forman, Tom, 16, 116, 119

frame, 18, 22–24, 34, 37–41, 44, 46, 54, 59, 62, 63, 64, 101, 102, 128, 176

France, 81, 213

Freud, Sigmund, 42–43, 44, 115, 167

Furniss, Harry, 88–91, 112, 140

gags, 29, 39, 44, 75, 76, 158, 160, 233n43. *See also* disguise; trick films

gaming, 201, 202, 219

gender, 7–8, 40, 49, 54–59, 61–62, 75–76, 94, 169, 170, 172, 227n19, 249n40. *See also* women in film

German Expressionism, 95, 100, 119, 126, 130, 244n23

ghosts, 132–33, 145

Ghosts of the Abyss, 198

Girl at the Window, 54–55

Gorky, Maxim, 5, 113

Griffith, D. W., 18, 71, 83, 94, 110, 123, 124–25, 159

grotesque, 79, 80, 87, 88, 90, 112, 177, 178

group identity, 73, 115, 120, 121, 141–42

Gubar, Susan, 42–43, 53

Gunning, Tom, 23, 38, 41, 52, 65, 79, 84, 88, 145, 153, 209, 226–27n15, 246n1

Haenni, Sabine, 94, 111, 131, 239n53

Hallelujah!, 16, 155–58, 159, 166, 168, 174, 175–86. *See also* black-cast films; Vidor, King

ALICE MAURICE is associate professor of English at the University of Toronto.